The Sourcebook of Contemporary Graphic Design

The Sourcebook of Contemporary Graphic Design

COLLINS DESIGN
An Imprint of HarperCollins Publishers

First Edition published by
maomao publications in 2009
Tallers, 22 bis, 3º 1ª
08001 Barcelona, Spain
Tel.: +34 93 481 57 22
Fax: +34 93 317 42 08
mao@maomaopublications.com
www.maomaopublications.com

English language edition first published in 2009 by
Collins Design
An Imprint of HarperCollins*Publishers*
10 East 53rd Street
New York, NY 10022
Tel.: (212) 207-7000
Fax: (212) 207-7654
collinsdesign@harpercollins.com
www.harpercollins.com

Distributed throughout the world by
HarperCollins*Publishers*
10 East 53rd Street
New York, NY 10022
Fax: (212) 207-7654

Publisher: Paco Asensio

Editorial Coordinator: Anja Llorella

Editor: Maia Francisco

Introduction: Niklaus Troxler

Art Director: Emma Termes Parera

Layout: Gemma Gabarron Vicente

English Translation: Antonio Moreno

Library of Congress Control Number: 2008937642

ISBN: 978-0-06-170438-3

Printed in Spain
First Printing: 2009

Contents

Index

The Passion of Creative Personal Design

"Poster design requires a complete renunciation of the painter. He may not express his own personality in his work. Yet if he did so, he would not have the right to. Painting always ends in itself. The poster, however, is but a means of communication from the salesman to the clientele, comparable to a telegraph. In poster design, the artist assumes the role of the telegraph—he does not convey a personal message, he just communicates it. His personal opinion is not asked for; he is merely supposed to establish a clear, exact and good-working connection." The person who said this, back in 1928, was the outstanding and groundbreaking French poster artist and designer A.M. Cassandre. Undoubtedly, his analogy of the poster artist and the telegraph officer can be regarded as a double understatement, which in promotional psychology is an effective procedure still well known today.

However, what Cassandre wanted to say in quite unmistakable terms is: the poster designer is not an artist, he has to "submit" to the job. On the other hand: artists are free, they are not public servants. And art, of course, has an end in itself. Nowadays, it appears strange that such a statement comes from a groundbreaking and capricious character of the early history of graphic design, *nota bene* from a designer who was very successful in creating an unmistakable personal style!

A judgment of this kind would rather be attributed to the generation of the 50s and 60s style of the Neue Moderne, i.e. to the representatives of a new and reduced way of design, such as Josef Müller-Brockmann, Richard Paul Lohse, Paul Rand or Massimo Vignelli.

However, if we take a closer look at the œuvre of the above-mentioned personalities, we can see that the extraordinary design quality of their work still bears an artistic nature. Subsequently, their successors—in comparison—appeared miserable.

Beside the rather minimalist, down-to-earth design, there always existed a movement that wished to be "artistic." Especially where handwritten features came to the fore, it was referred to as the "art" of design. From Jean Carlu and Lucian Bernard to Savignac, Herbert Leupin, Henryk Tomaszewski, Hans Hillmann, Milton Glaser, Seymour Chwast, M/M, Ronald Curchod—the variety of illustrative and artistic designers can be traced until today.

During the 80s and 90s, the younger generation boldly overcame the influence of the so-called "Modern Style" which had become omnipresent over the years. All of a sudden, an immensely vital and multi-faceted wave broke free. Suddenly, the experimental aspect turned to be the focal point. There seemed to be no bounds to creative playfulness and "free" integration of typographic and illustrative material. Graphic design turned to be the focus of attention in visual communication. The customers of the most different sectors wanted to express their own individual appearance by means of corporate or product communication. This was a welcome reason for the young designers to pursue their profession in a way that reflected their own personality. Suddenly, eccentricity and individual expression were much sought after and ceased to be looked down upon. Instead of concepts that had to win majorities, design was back offering cheeky and surprising design solutions.

As opposed to the 80s and 90s, where big design agencies in the form of advertising agencies were created, towards the end of the last and the beginning of the new millennium "lone fighters" increasingly get their chance in the business. What else do you need other than good professional equipment, heaps of fantasy and a Mac? After the completion of studies at a design or art college, young designers are perfectly capable of finding ambitious design solutions.

These young and talented designers have a worldwide network and know the hippest people in New York, London, Paris or Shanghai. They spare no pains to go their own way and live a modest life until they get attention and a more ambitious job. If they receive a wide-ranging assignment, they easily find the suitable colleagues to solve the complex tasks.

Back in my young days, when I studied graphic design in Switzerland, at college everybody talked about Marshall McLuhan's "The medium is the message." It was all about the development of communication and shrinking down the world to a tiny village: the world as a "global village," that was the vision. Even national qualities, specialities and characteristics were said to decrease with McDonald's, Coca-Cola and CNN creating a "homogeneous" and "assimilated" society.

It seemed logical to everybody that regional and national features would disappear in graphic design.

Today, despite ultra-rapid and worldwide networking communication, we can affirm that luckily this is not the case.

In graphic design, we find the most different characters and a wide range of styles throughout the world. The designers of our times pursue their individual ways and draw inspiration from their individual environment. And this individual environment is inevitably affected—locally, nationally and regionally.

In the world of graphic design, the exceptional designer Stefan Sagmeister is celebrated like a superstar. Sagmeister is European, or—to be precise—Austrian. And to be even more precise: he comes from Bregenz, in the region of Vorarlberg. And this is reflected in his work, it affects his quality. He has brought his own roots into his way of designing and into his communication with American society. And this is exactly what makes his design so special, so personal. It was possible for many designers of the younger generation to copy and adapt designers like David Carson, but it is hard to do the same with Stefan Sagmeister's design. His ideas individually relate to the substance of each assignment and they differ from each other just like the different tasks he is asked to do.

This phenomenon is an opportunity for the new generation of designers. They become aware of the fact that form evolves from substance and that it can be as divergent as possible, as it does not have to commit to any international style. This is perhaps also a reason for the current absence of a particular style of design. Some may characterize this as a lack or deficiency, but I can only regard it in a positive way and as an encouragement for the new generation to create their own personal and new design!

Niklaus Troxler

Aloof Design

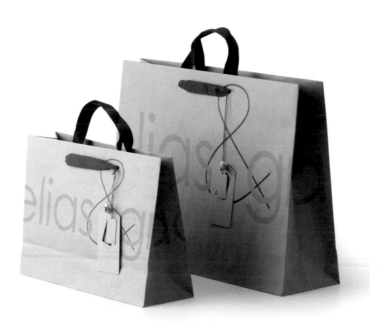

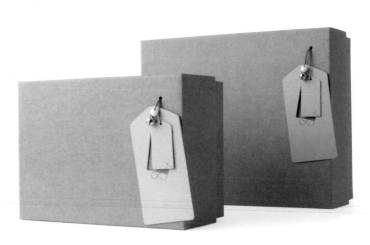

> Packaging > Elias & Grace

5 Fisher Street
Lewes
BN7 2DG East Sussex
United Kingdom
+44 1273 470 887
michelle@aloofdesign.com
www.aloofdesign.com

> Established in 1999, Aloof remains an independent studio for creating innovative conceptual design. It is also a branding and design consultancy that works on national and international projects across a range of business sectors. Aloof specializes in graphic and structural design for brand identity, promotion and packaging. Its main idea consists in fomenting a creative relationship with its clients, committing to communicate and define brand and product values through distinctive and efficient design. Their goal is to present results that are simple, honest and sincere. Their daily work involves a process of filtering unnecessary content in order to leave the bare essence. Aloof has developed a lot of experience in the field of packaging with an eye towards helping people see packaging as an integral and pleasant part of the consumer experience.

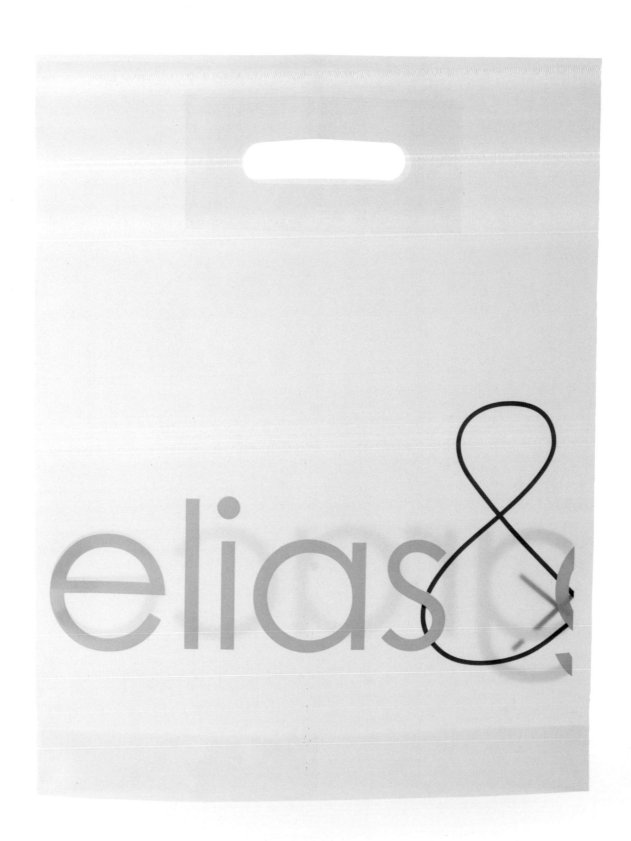

> Bag > Elias & Grace

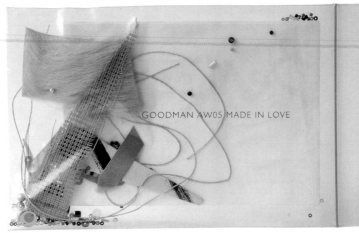

> Promotional material, packaging, invitations > Georgina Goodman

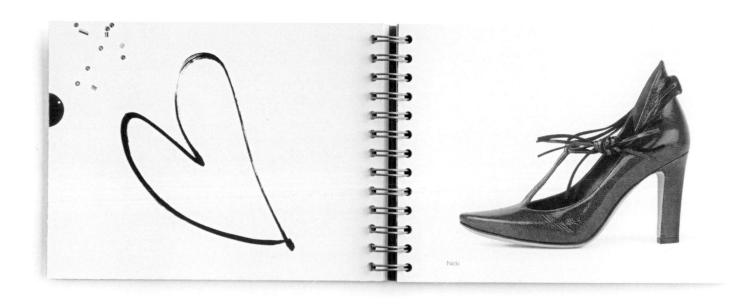

Nicki

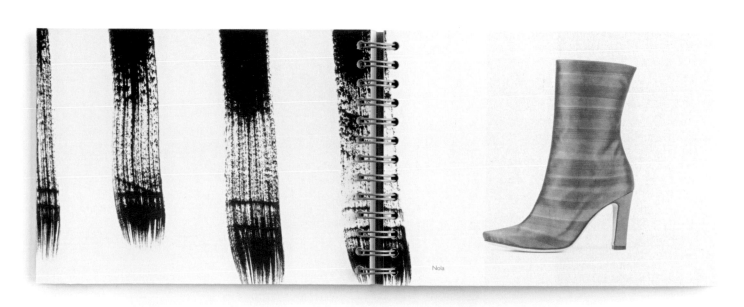

Nola

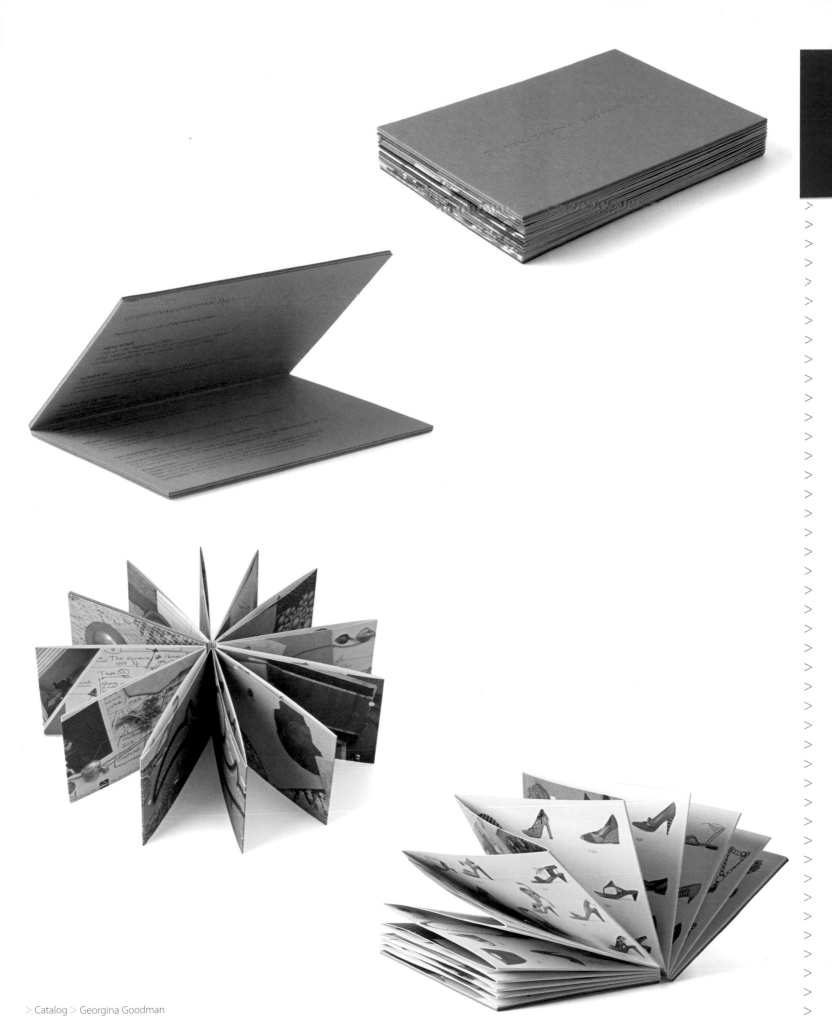

COCKTAILS

U'LUVKĄ
VODKA

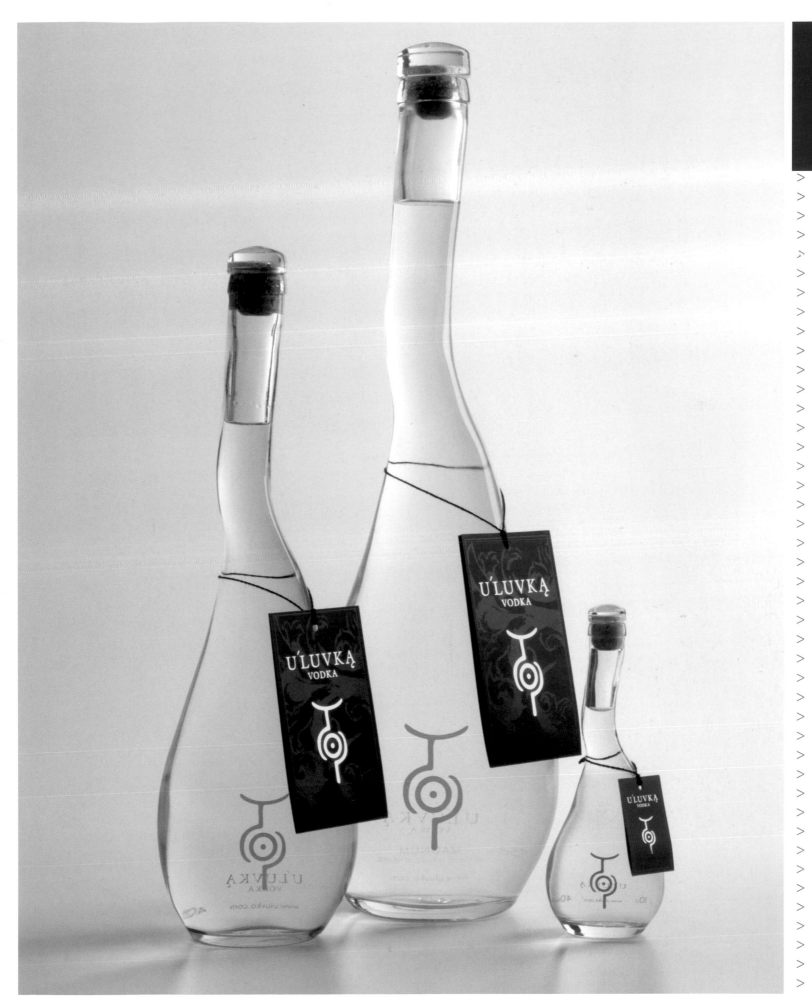

Amen

Dipl.-Ing. Claudia Wiedemann
Hans-Sachs-Str. 5 80469 München
fon +49.89.23 68 45 41
fax +49.89.23 68 45 42
cell +49.179.463 52 82
wiedemann@formstelle.de
www.formstelle.de

> Invitations > Formstelle

Klenzestrasse 99
80469 Munich
Germany
+49 89 20 20 65 00
amen@soseies.com
www.soseies.com

> The principal idea behind Amen consists of communicating through design, setting the mind in motion, to stimulate and seduce. Amen is a design studio for the graphic arts, advertising and designs that actually consider the everyday in order to transcend it. This design studio is centered around corporate designs with the intention of creating products, necessities and ideas with spirit. Amen doesn't just decorate, it transforms the material in shape, color and text in such a way that a complex result is still easy to interpret. Michaela Mansch and Claudio Prisco are the two members of the studio. Michaela—specializing in corporate design—has a degree, and Claudio—who studied communication design at the Art Center College of Design in Montreux obtaining a degree in fine arts—deals primarily with conceptual development.

BELLA STOFF

Teilen Sie unsere Leidenschaft für Stoffe,
lassen Sie sich umgarnen. Von neuem Design
in gewohnter Qualität. Wir freuen uns auf Sie.
In München und Paris.

IDEA PRISCO // München 06.-08.02.07
MUNICH FABRIC START // München 07.-09.02.07
PREMIÈRE VISION // Paris 20.-23.02.07

Becker & Führen Tuche GmbH & Co. KG
Telefon 0241/52970

BECKER

FABRICS

HOTEL

WC

2.UG

600
BOUTIQUE SUITE WÄSCHELAGER

3.OG

200 202 204 205 206 207 208 209

BITTE NICHT STÖREN
PLEASE DO NOT DISTURB

BITTE ZIMMER AUFRÄUMEN
PLEASE MAKE UP THE ROOM

300
307 - 312

2.UG

⟶

REZEPTION

SICH FINDEN

von Reiner Bollmann und Karin Bohrmann
Plastik und Malerei 1988-2006

Einladung zur Eröffnung der Ausstellung am
29.04.2006 um 11 Uhr im Stadtmuseum Weilheim.
Die Ausstellung ist bis zum 21.05.2006 zu sehen.

Öffnungszeiten
Di.- Fr. und So. 10 - 12 Uhr und 14 - 17 Uhr
Sa. 10 - 13 Uhr

Weilheim Stadtmuseum
Marienplatz 1
82362 Weilheim Obb.
T. +49.(0)881.68 21 00

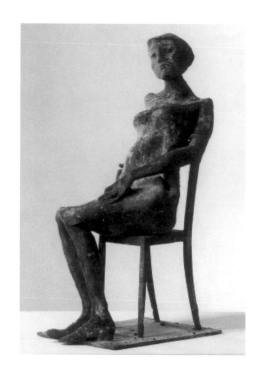

Freundliche Förderung:

ERZBISCHÖFLICHES ORDINARIAT
MÜNCHEN

KUNSTREFERAT DER ERZDIÖZESE MÜNCHEN UND FREISING

SICH FINDEN

> Flyer > R. Bollmann

SICH FINDEN
von Karin Bohrmann
und Reiner Bollmann
Plastik und Malerei
1988 - 2006

29.04.06 - 21.05.06

Montag geschlossen
Dienstag - Freitag 10-12 und 14-17 Uhr
Samstag 10-13 Uhr
Sonn- u. Feiertage 10-12 und 14-17 Uhr

Stadt Weilheim
Postfach 1664
82380 Weilheim
T. +49.(0)881.682100

> Poster > R. Bollmann

André Baldinger

> Mural > Bridel & River Architects

9 Av. Taillade, bâtiment A
75020 Paris
France
+33 6 12 92 49 99
info@ambplus.com
www.ambplus.com

> Living in Paris, André Baldinger is a graphic designer and typographer of Swiss origin. He studied typography with Hans Rudolf Bosshard in Zurich. After obtaining his diploma in 1993 he moved to Paris and enlisted in the National Institute for Typographic Research. In 1995, he created his own design studio and began work for cultural institutions and "alternative" projects alike, like theater stages and 3-D design. André Baldinger has also established himself as a qualified font designer: his Newut font (New Universal Typeface) is distinguished by its modernity and originality. Since 2006, he has taught at the National Superior School of Decorative Arts. His work has been published and awarded all over the world. Baldinger's work can be found in the permanent collections of the Museum of Design in Zurich, the National Library of France and the Museum of Modern Art in Toyama (Japan).

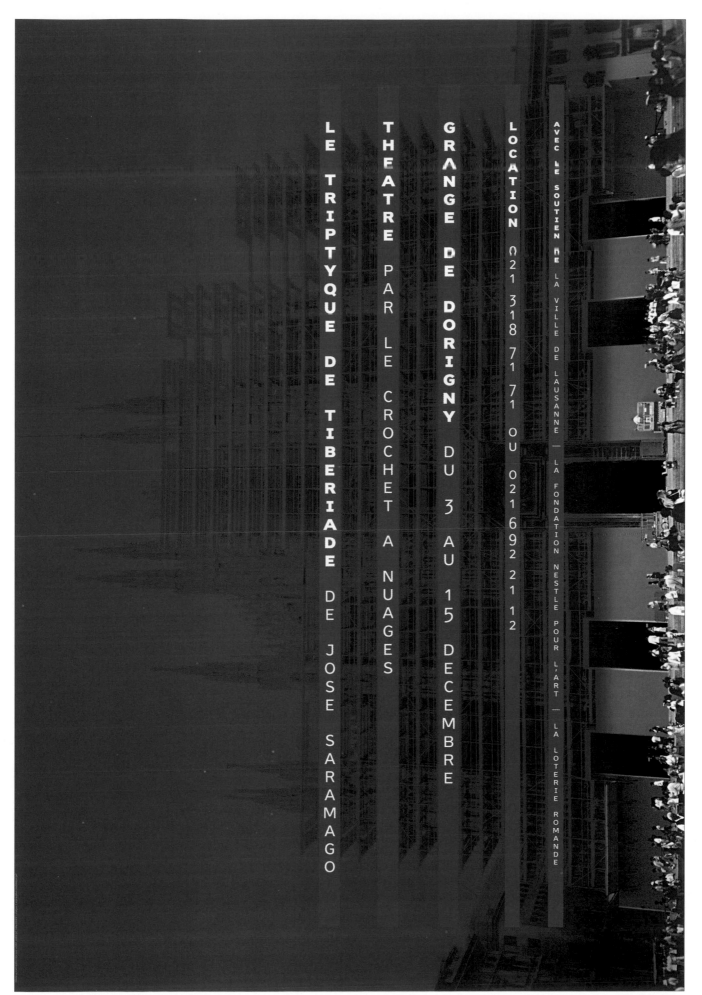

LE TRIPTYQUE DE TIBERIADE DE JOSE SARAMAGO

THEATRE PAR LE CROCHET A NUAGES

GRANGE DE DORIGNY DU 3 AU 15 DECEMBRE

LOCATION 021 318 71 71 OU 021 692 21 12

AVEC LE SOUTIEN DE LA VILLE DE LAUSANNE — LA FONDATION NESTLE POUR L'ART — LA LOTERIE ROMANDE

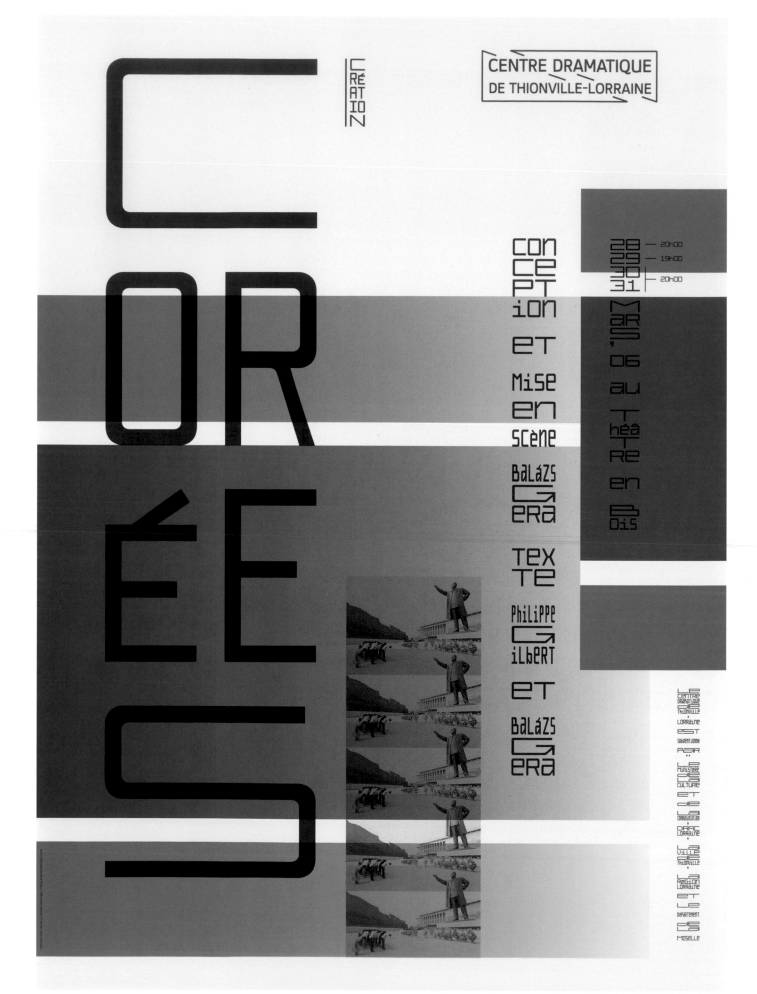

CORÉES

CENTRE DRAMATIQUE
DE THIONVILLE-LORRAINE

conception et mise en scène Balázs Gera

texte Philippe Gilbert et Balázs Gera

28 — 20h00
29 — 19h00
30
31 — 20h00

mars '06 au théâtre en bois

le centre dramatique de thionville lorraine est subventionné par le ministère de la culture et de la communication drac lorraine la ville de thionville la région lorraine et le département de la moselle

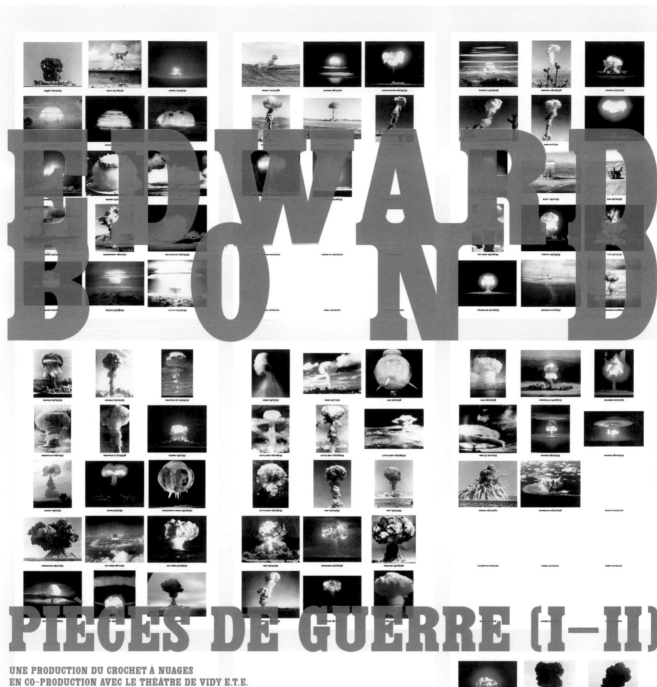

EDWARD BOND

PIÈCES DE GUERRE (I–II)

UNE PRODUCTION DU CROCHET À NUAGES
EN CO-PRODUCTION AVEC LE THÉÂTRE DE VIDY E.T.E.
CENTRE DE CULTURE ABC (LA CHAUX-DE-FONDS)
CENTRE CULTUREL NEUCHÂTELOIS
THÉÂTRE LA GRENADE (GENÈVE) ET USINE C (MONTRÉAL)

AVEC LE SOUTIEN DE LA VILLE DE LAUSANNE, LE CANTON DE VAUD, LA LOTERIE ROMANDE (VAUD ET NEUCHÂTEL), LA FONDATION NESTLÉ POUR L'ART, LE CONSEIL DES ARTS DU CANADA ET L'ÉCOLE SUPÉRIEURE DE THÉÂTRE DE L'UQÀM (MONTRÉAL)

CHANTS D'ADIEU *CRÉATION*

DE ORIZA HIRATA
MISE EN SCÈNE LAURENT GUTMANN

21 22 23 novembre'07 au Théâtre en Bois

20h00

19h00

LE CENTRE DRAMATIQUE DE THIONVILLE-LORRAINE EST SUBVENTIONNÉ PAR
LE MINISTÈRE DE LA CULTURE ET DE LA COMMUNICATION — DRAC LORRAINE
LA VILLE DE THIONVILLE, LA RÉGION LORRAINE ET LE DÉPARTEMENT DE LA MOSELLE

CENTRE DRAMATIQUE
DE THIONVILLE-LORRAINE

LA NUIT
VA TOMBER,
TU ES BIEN ASSEZ BELLE

Conception et mise en scène: Laurent Gutmann

Avec Catherine Vinatier et Eric Petitjean

Production: Centre Dramatique de Thionville-Lorraine

Théâtre à installer partout

Le Centre Dramatique de Thionville-Lorraine est subventionné par
le Ministère de la Culture et de la Communication — DRAC Lorraine,
la Ville de Thionville, la Région Lorraine et le Département de la Moselle

> Poster > Thionville-Lorraine Drama Center

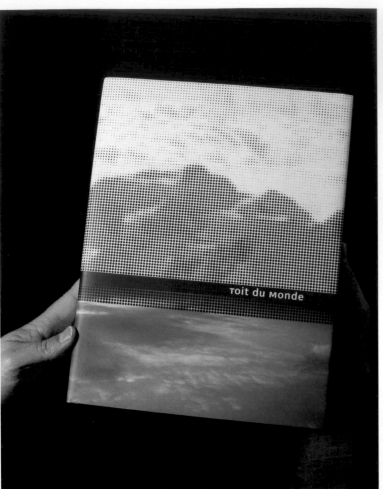

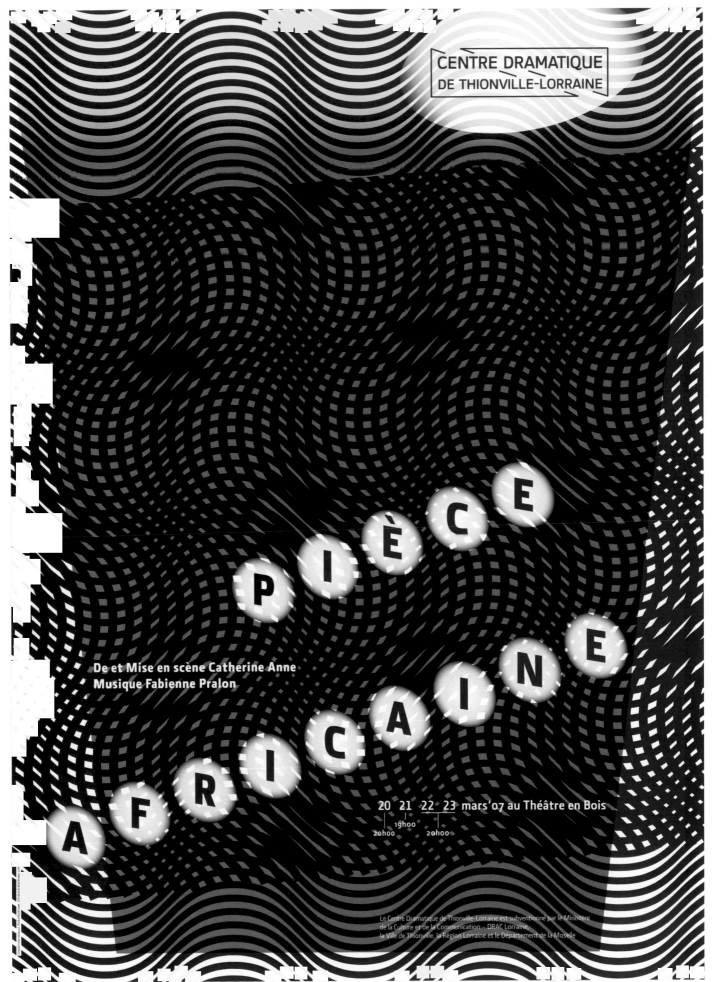

CENTRE DRAMATIQUE
DE THIONVILLE-LORRAINE

PIÈCE AFRICAINE

De et Mise en scène Catherine Anne
Musique Fabienne Pralon

20 21 22 23 mars'07 au Théâtre en Bois
 19h00
20h00 20h00

Le Centre Dramatique de Thionville-Lorraine est subventionné par le Ministère
de la Culture et de la Communication – DRAC Lorraine,
la Ville de Thionville, la Région Lorraine et le Département de la Moselle

Andrey Logvin

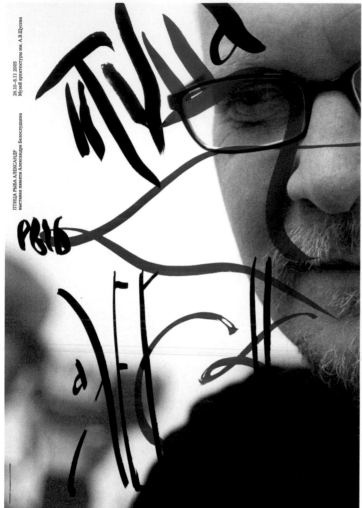

> *Bird, Fish, Alexander* > poster > Museum of Architecture, Moscow

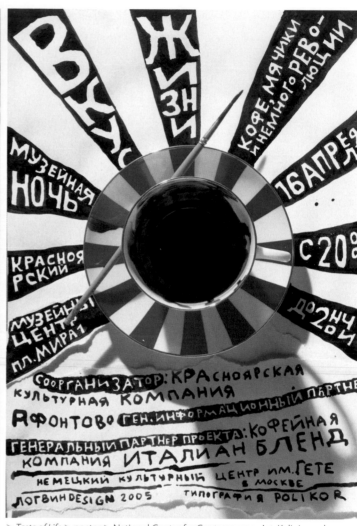

> *Taste of Life* > poster > National Center for Contemporary Art, Kaliningrad

kv. 95, Viktorenko 2/1
125157 Moscow
Russia
+7 499 157 7734
andrey@logvin.ru
www.logvin.ru

> Ipatovo (Russia, 1964) is the native city of Andrey Logvin. In 1987 Andrey graduated from the Moscow Art School, and later started work at the graphic design studio of the Moscow Artists Union. In 1989, he started working as an art director for the IMA-Press publishing house in Moscow. He participated in various poster and graphic design exhibitions in Russia and abroad. His work is found in various collections, including: the Lenin State Library, the Tretiakov Gallery of Moscow, the Ogaki Poster Museum, the New Museum of Contemporary Art in Munich and the Stedelijk Museum of Amsterdam, among others. In 1992 he founded the virtual design studio of the Moscow School of Design as a freelance designer. A member of the Russian Academy of Graphic Design since 1999, he has received various awards, including the Russian State Prize for Art in 2001 and the grand prize at the 17th International Poster Festival of Chaumont (France, 2006).

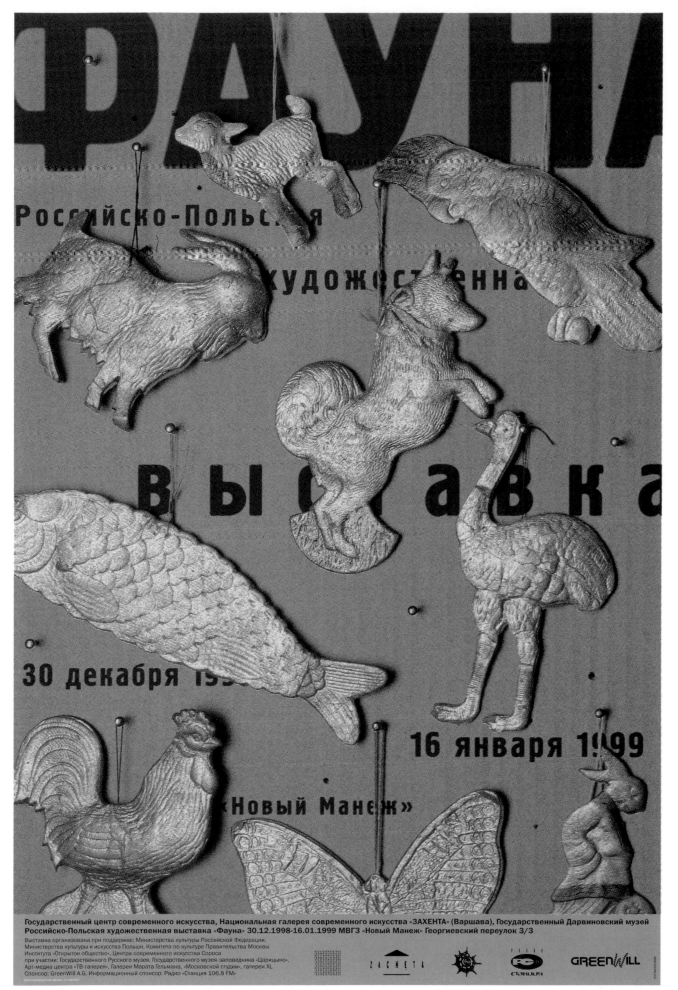

> *We Don't Care!* > poster > National Center for Contemporary Art, Moscow

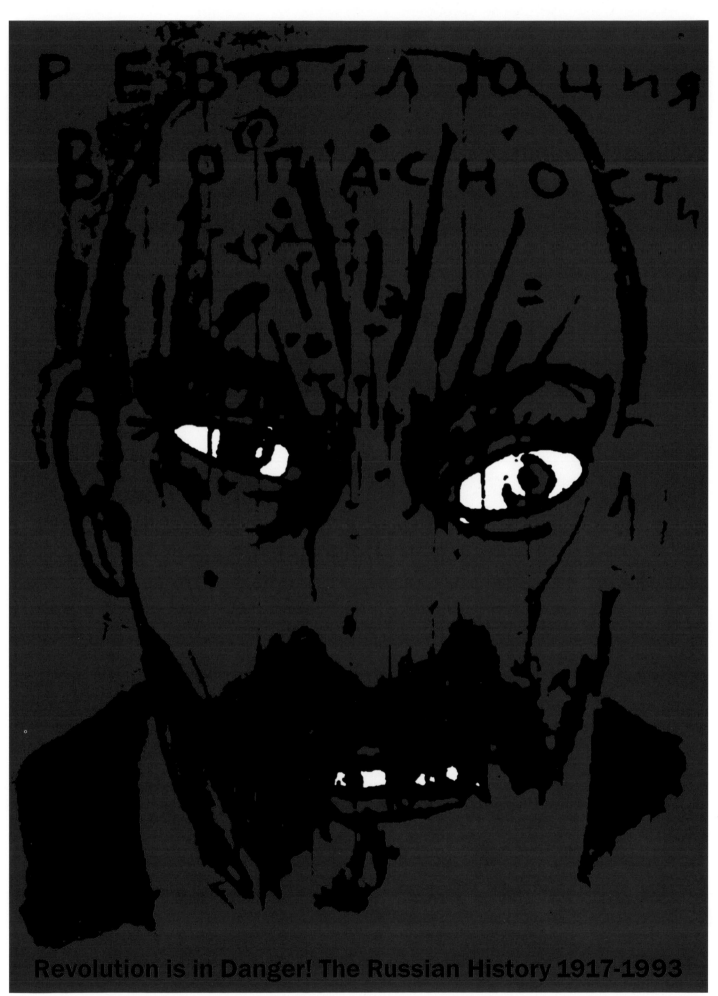

Revolution is in Danger! The Russian History 1917-1993

> *Revolution is in Danger!* > poster > Museum of the Revolution, Moscow

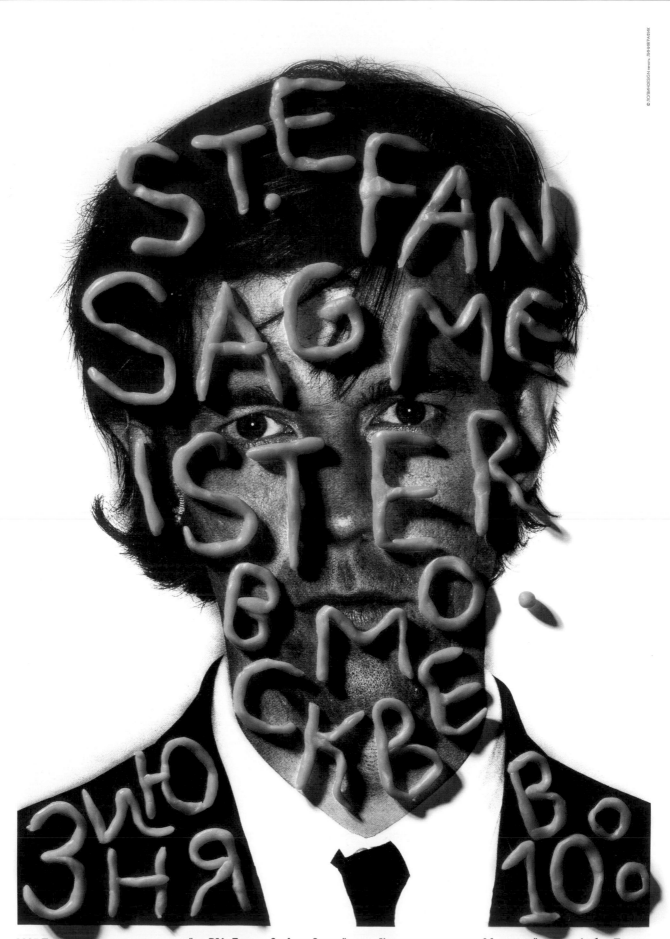

2005 Премия инновационного дизайна DIA. Лекция Стефана Загмайстера. Краснопролетарская 36, деловой центр «Амбер-Плаза»

> *Stefan Sagmeister in Moscow* > poster > Moscow Innovation Award

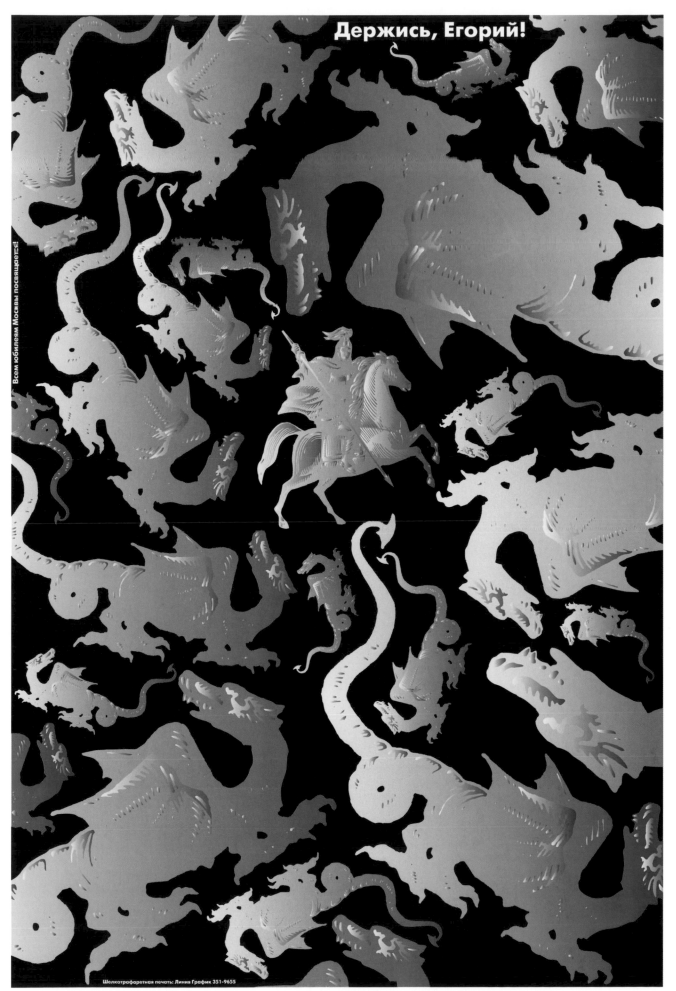

Держись, Егорий!

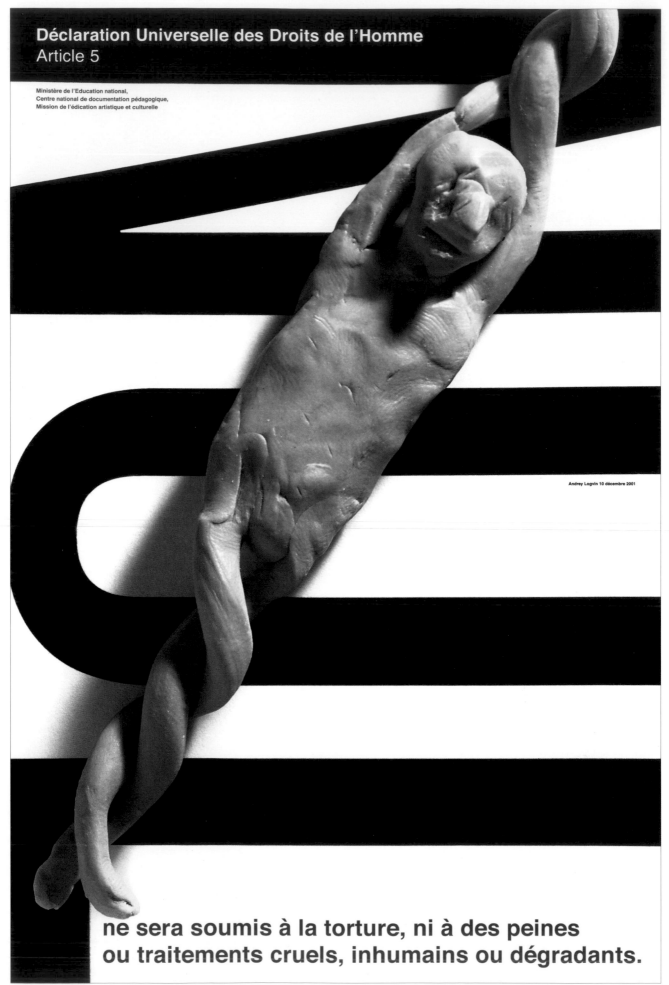

Déclaration Universelle des Droits de l'Homme
Article 5

Ministère de l'Education national,
Centre national de documentation pédagogique,
Mission de l'édication artistique et culturelle

Andrey Logvin 10 décembre 2001

ne sera soumis à la torture, ni à des peines
ou traitements cruels, inhumains ou dégradants.

Angus Hyland/Pentagram

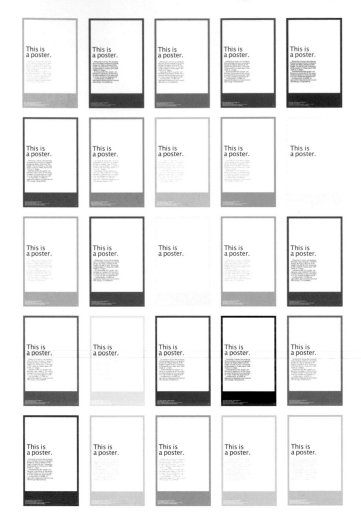

> *This is a Poster* > posters > Plymouth University

11 Needham Road
W11 2RP London
United Kingdom
+44 20 7229 3477
email@pentagram.co.uk
www.pentagram.com

> A member of the design studio Pentagram since 1998, Angus Hyland has worked for a variety of clients both public and private. Some of his clients are: Asprey, Garrard, BMP DDB, Cass Art, EMI, Getty Images, EAT, Penguin Group, Dorling Kindersley, Canongate Books, Verso, Phaidon, BBC, and Nokia. Since September 2002, Angus has been the creative director at Laurence King Publishing, where he supervises every aspect of design and brand management while being responsible for gener-

ating new concepts in books. Angus has received around a hundred creative awards for his work, including the D&AD Silver Award and in 2000 he was awarded the Grand Prize at the Scottish Design Awards. He is the commissioner of "Picture This," a two and a half year long travelling exhibition by the British Council that shows the work of contemporary illustrators based in London, and a member of the International Graphic Alliance since 1999.

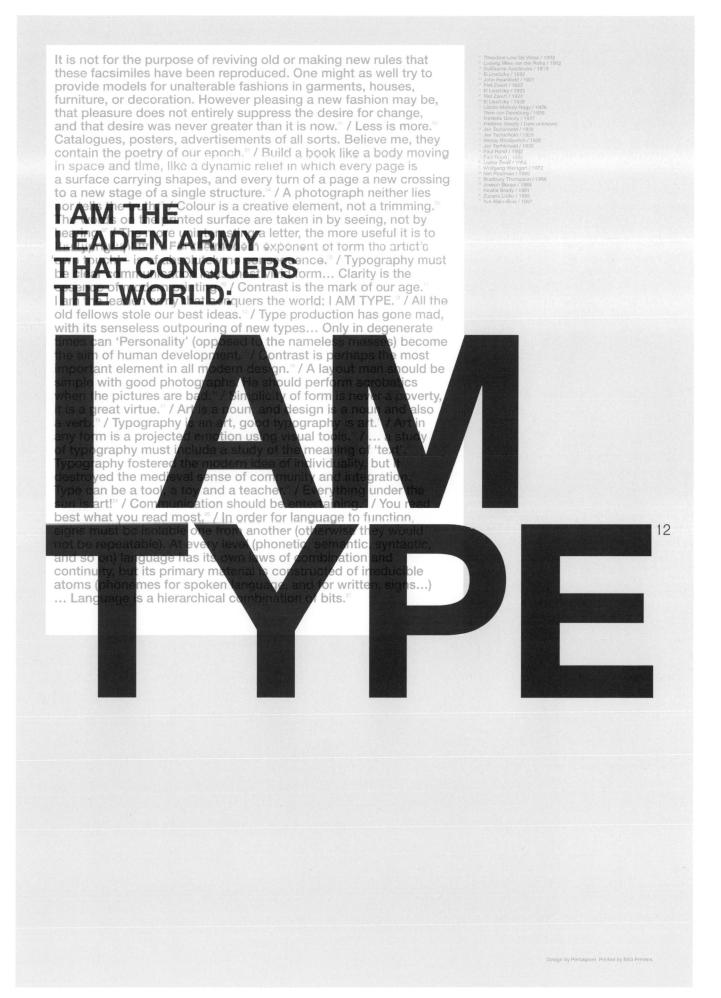

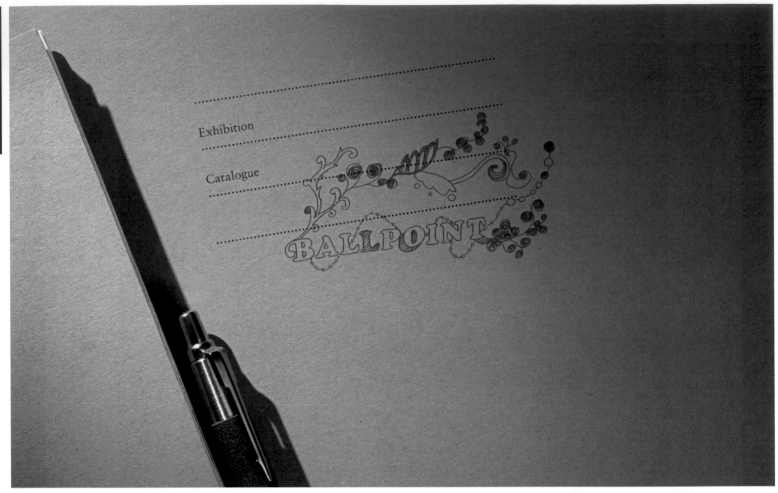

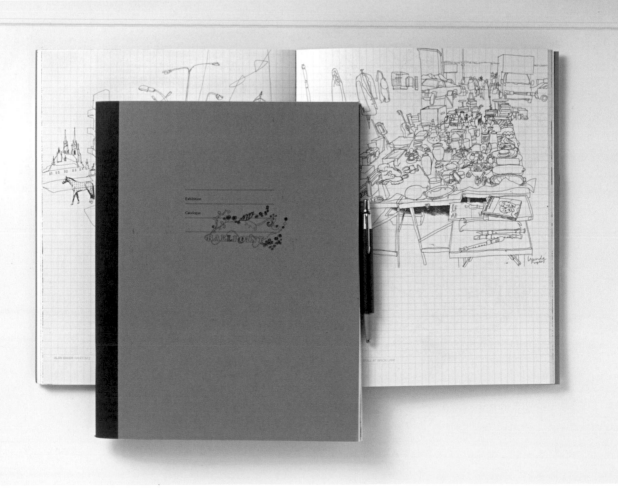

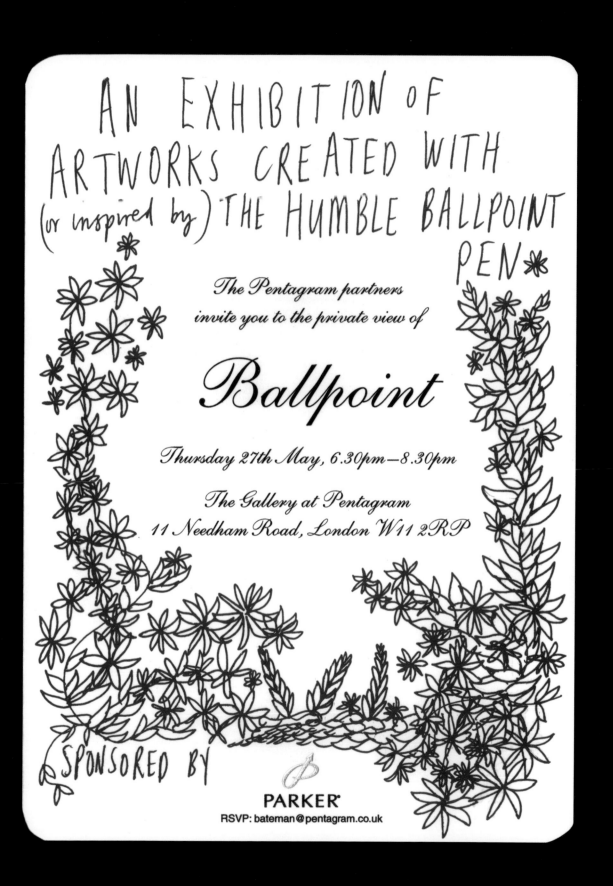

AN EXHIBITION OF ARTWORKS CREATED WITH (or inspired by) THE HUMBLE BALLPOINT PEN *

The Pentagram partners invite you to the private view of

Ballpoint

Thursday 27th May, 6.30pm—8.30pm

The Gallery at Pentagram
11 Needham Road, London W11 2RP

SPONSORED BY

PARKER
RSVP: bateman@pentagram.co.uk

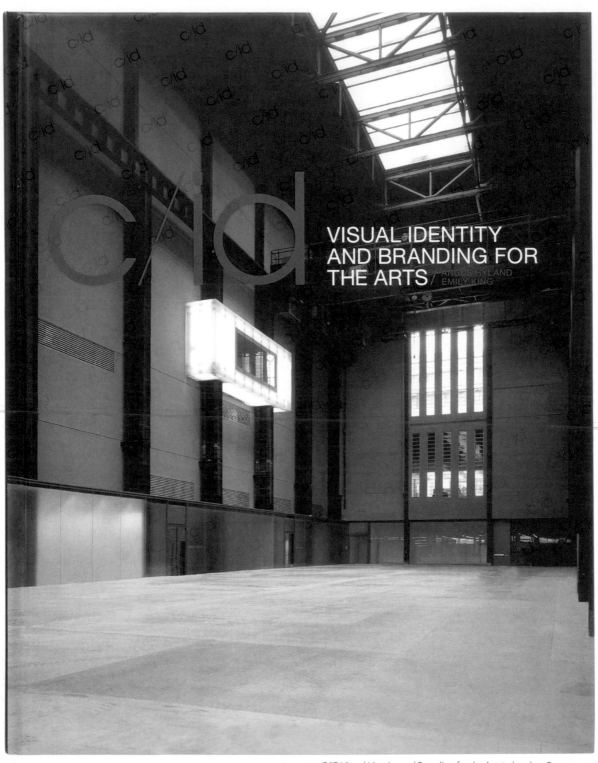

> *C/ID Visual Identity and Branding for the Arts* > book > Pentagram

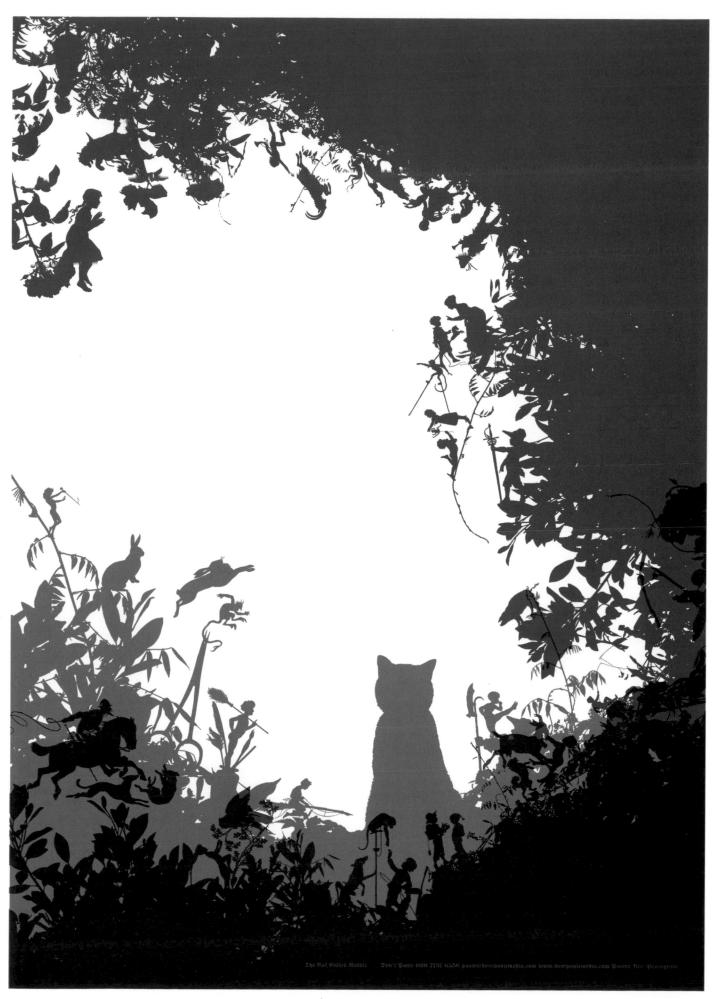

Brandspanking

Branded Content

From Brandspanking

Brandspanking
1 Carlton Mansions
Randolph Avenue
Maida Vale
London W9 1NP
+44 (0)7770 756 280
+44 (0)207 328 9586
www.brandspanking.co.uk

THIS
MEANS
THIS

THIS
MEANS
THAT

A USER'S GUIDE
TO SEMIOTICS

SEAN HALL

Antoine+Manuel

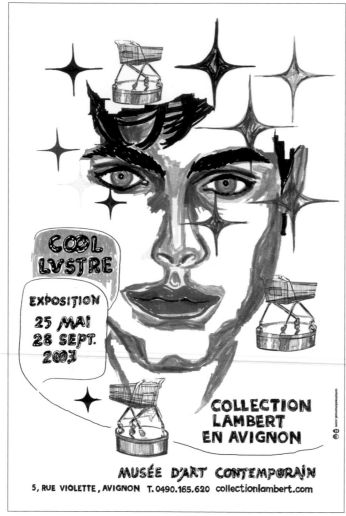

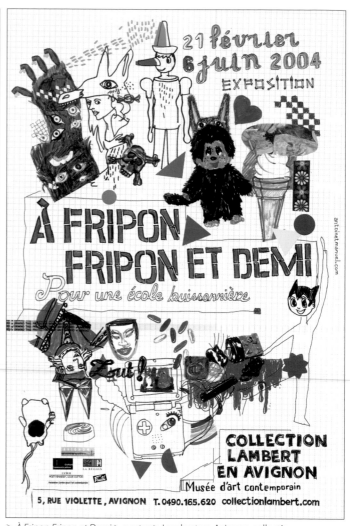

> *Cool Lustre* > poster > Lambert en Avignon collection > *À Fripon Fripon et Demi* > poster > Lambert en Avignon collection

8, rue Charlot
75003 Paris
France
+33 1 44 61 99 00
c@antoineetmanuel.com
www.antoineetmanuel.com

> Having met at a Paris art school, Antoine Audiau and Manuel Warosz quickly decided to work together under the name Antoine+Manuel. From the start they combined hand-made drawings with digital illustrations and their own typography and photography. They've worked for Yvon Lambert; particularly on the Lambert en Avignon collection. They've collaborated with numerous exhibitions at the Museum of the School of Fine Arts, The Centre Pompidou, the Museum of Decorative Arts, and the Museum of Modern Art in Paris. They work in the worlds of fashion (Christian Lacroix), home goods (Habitat, Galeries Lafayette, Domestic), publishing (Larousse), contemporary dance, theater and art. For each of their projects, the design process starts with creating a complete set of shapes with their own conduct and vocabulary. This conceptualization phase centers on the designs and messages they want to transmit.

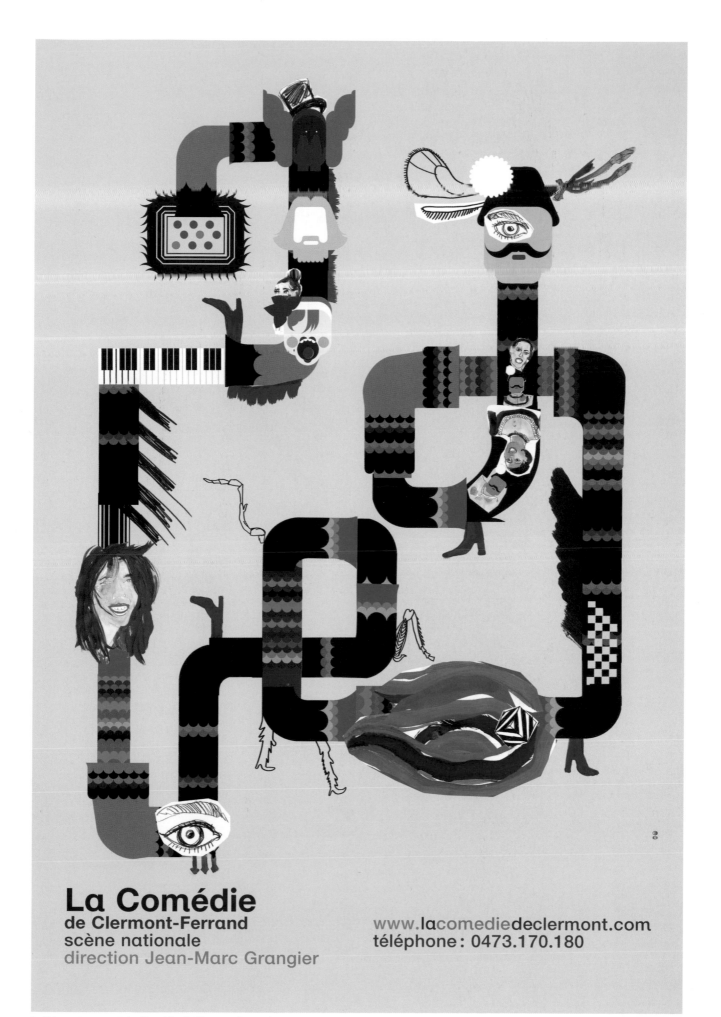

La Comédie
de Clermont-Ferrand
scène nationale
direction Jean-Marc Grangier

www.lacomediedeclermont.com
téléphone : 0473.170.180

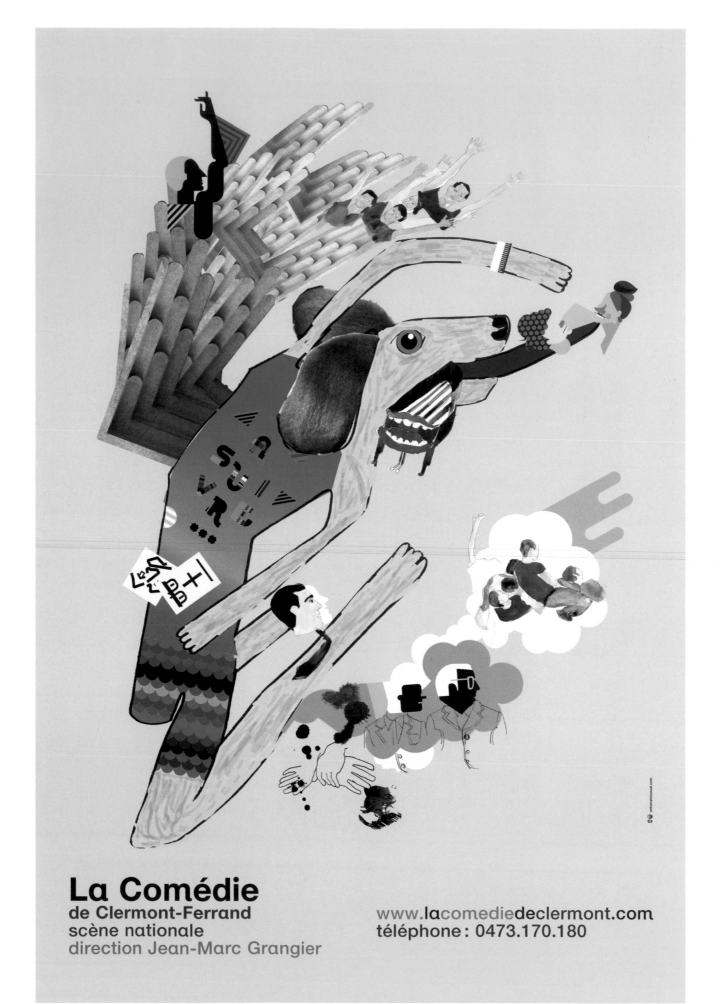

La Comédie
de Clermont-Ferrand
scène nationale
direction Jean-Marc Grangier

www.lacomediedeclermont.com
téléphone : 0473.170.180

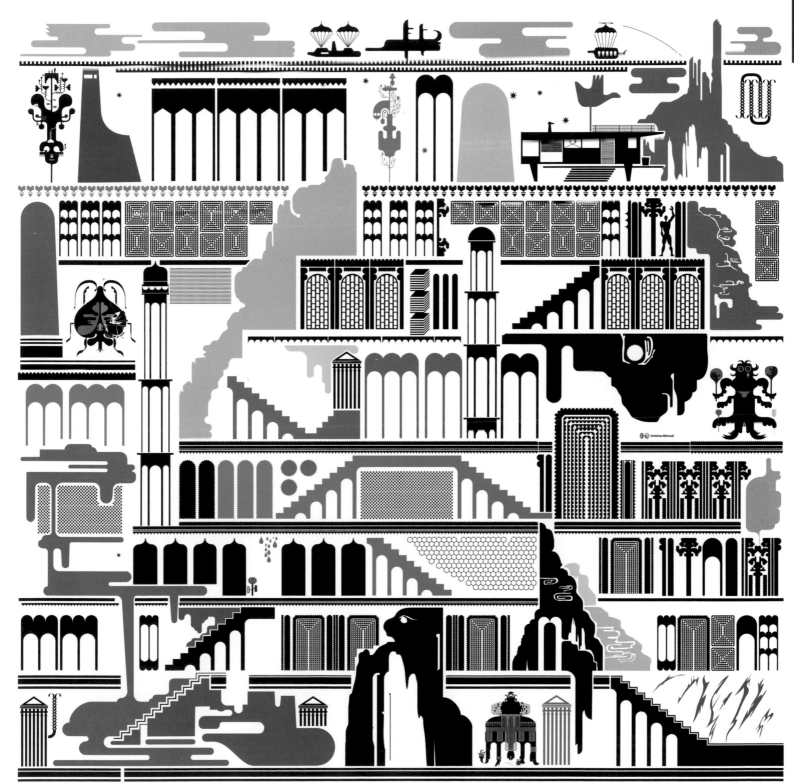

> *Construction* > colored paper > Elitis

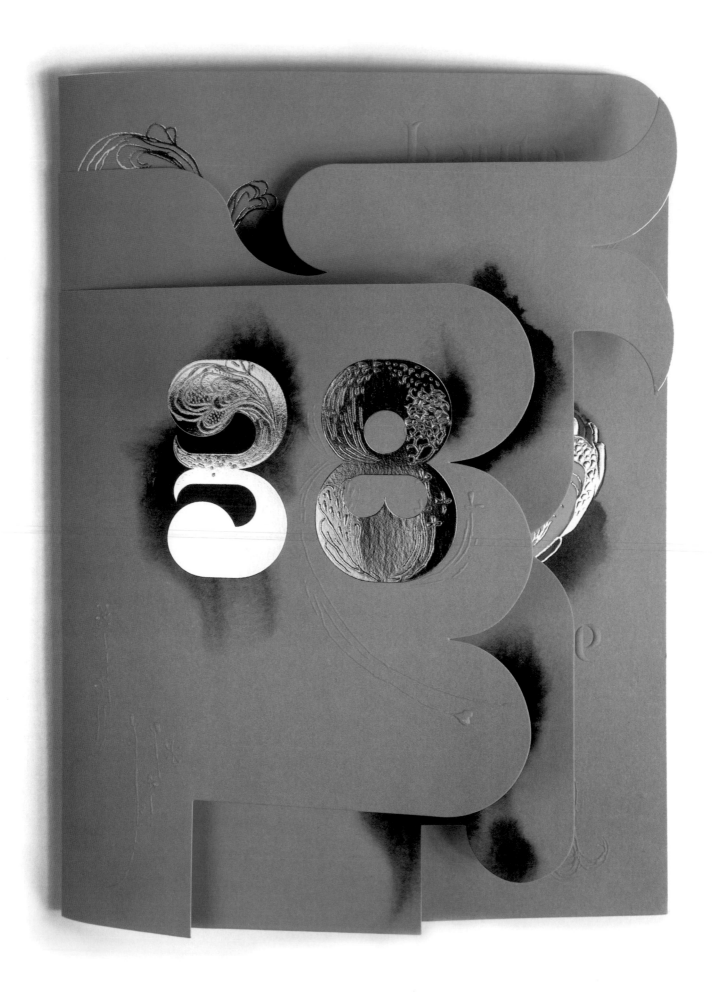

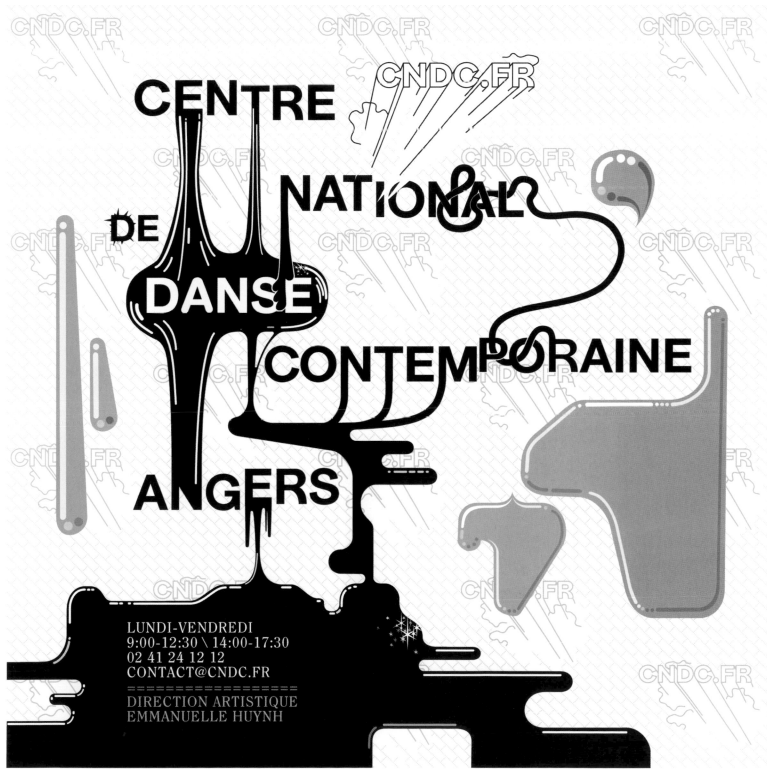

> *CNDC* > poster > National Center of Contemporary Dance, Angers

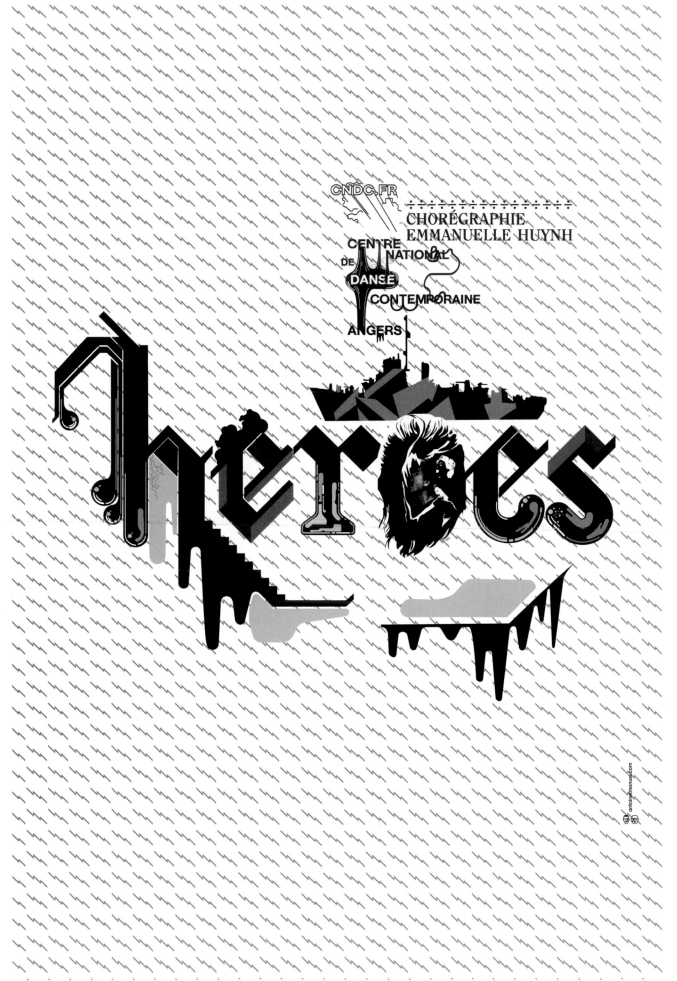

> *Heroes* > poster > National Center of Contemporary Dance, Angers

> Promotional material > National Center of Contemporary Dance, Angers

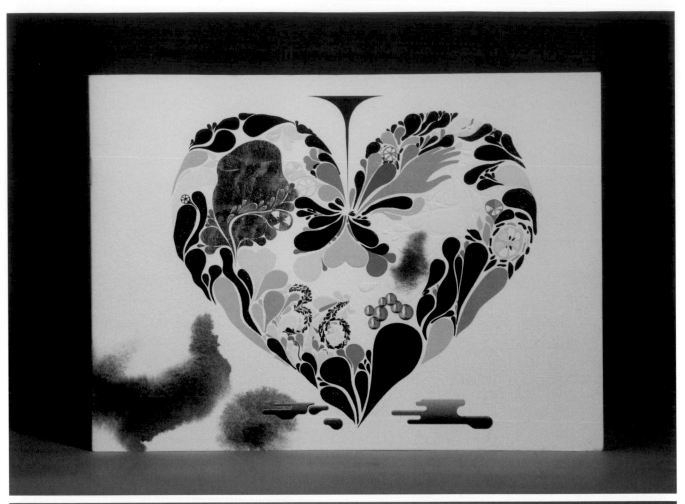

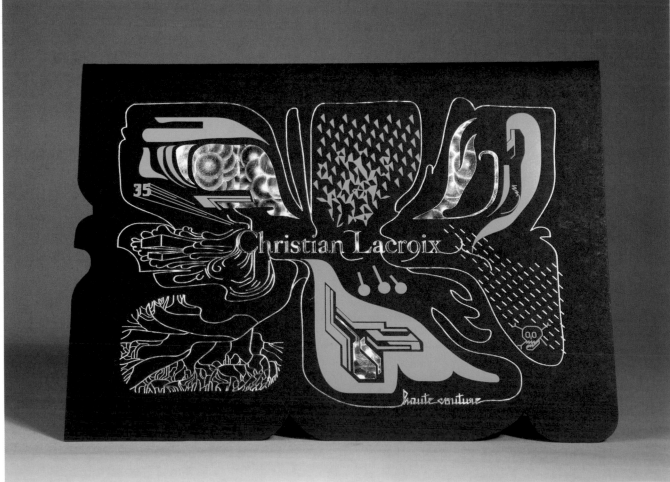

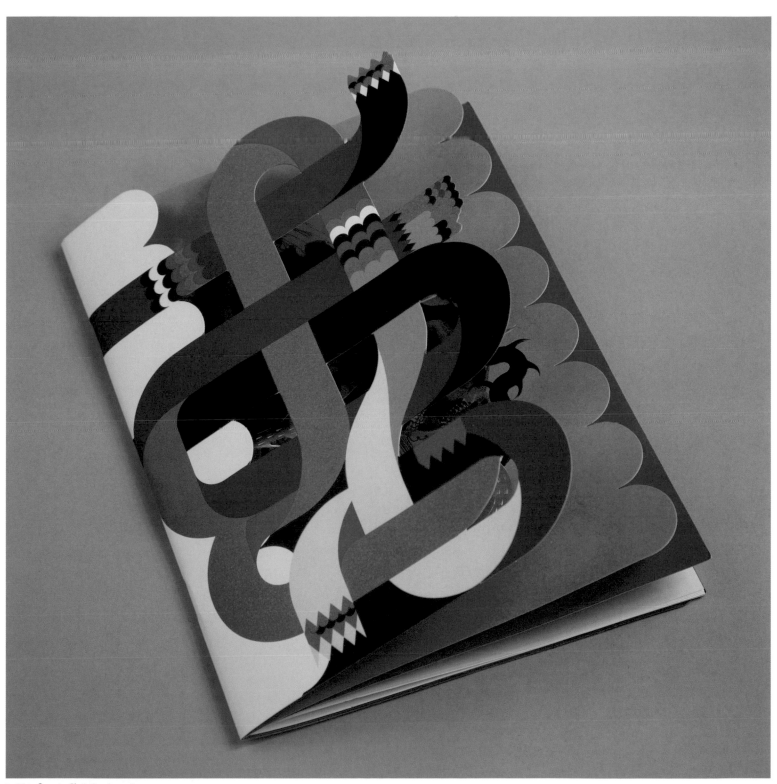

> *39* > flyer > Christian Lacroix

Arjan Groot

> Cover > EPN

Donker Curtiusstraat 25c
1051 JM Amsterdam
The Netherlands
+31 20 68 489 45
arjan@thecoverup.eu
www.thecoverup.eu

> An independent graphic designer, Arjan Groot lives and works in Amsterdam. His design studio specializes in publishing design, corporate identity and typography in relation to architecture. Groot started work as a designer in the mid-90s, mostly for magazines, while studying at the Gerrit Rietveld Academy. In 2000 he graduated with a project titled *Universal Authority for National Flag Registration*, which was published in various books and magazines. In 2004, after spending half a year in Barcelona, he started the bimonthly architectural magazine *A10 New European Architecture* together with architecture critic Hans Ibelings. Since 2007, Groot has collaborated with various designers in The Cover Up, a design studio that specializes in publishing design, corporate identity and graphic design in relation to architecture.

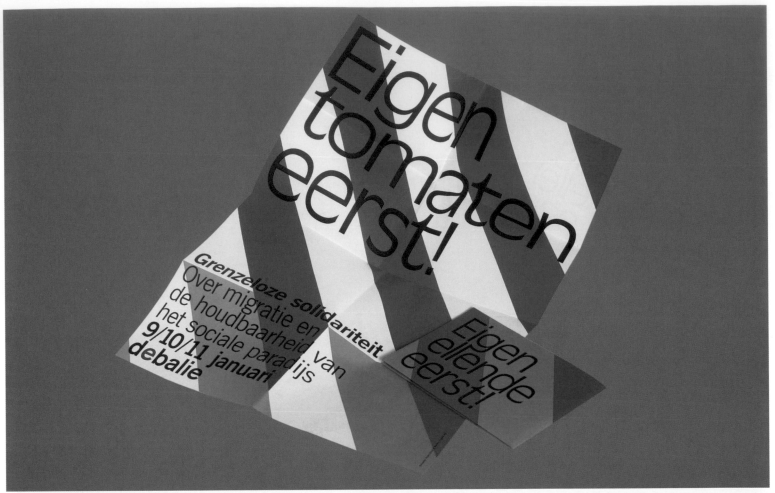

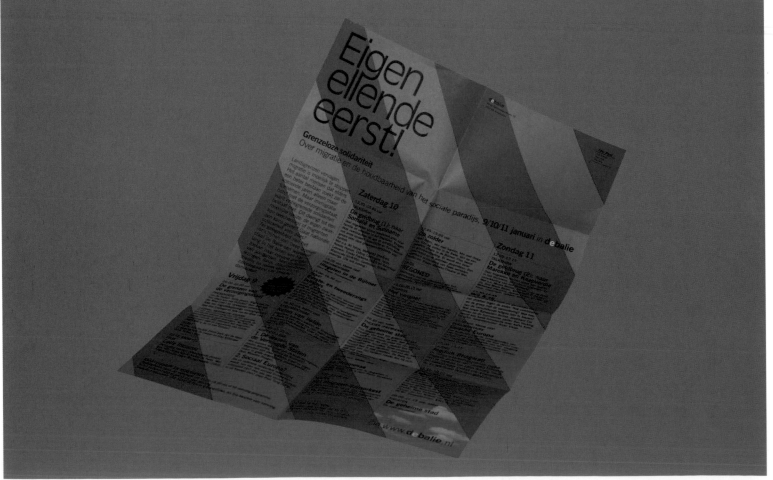

> Advertising campaign > De Balie

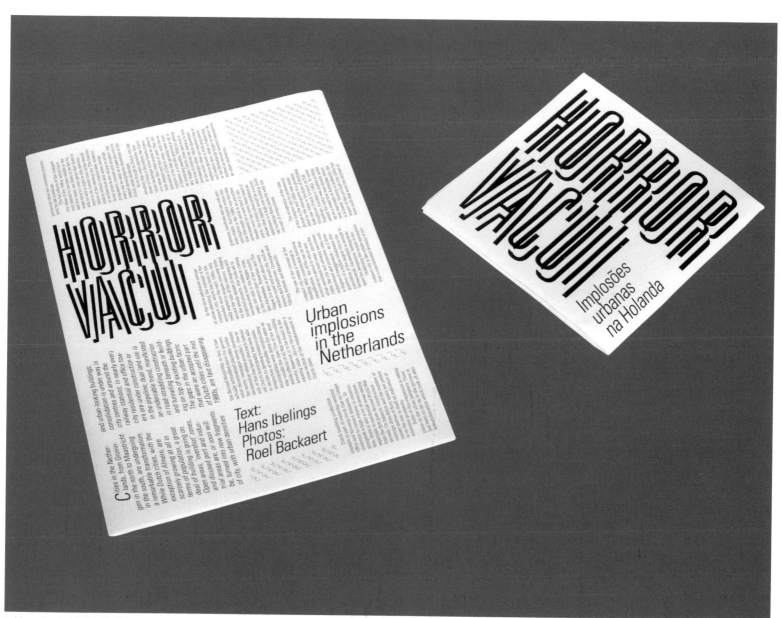

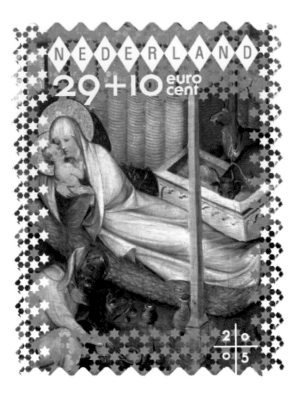

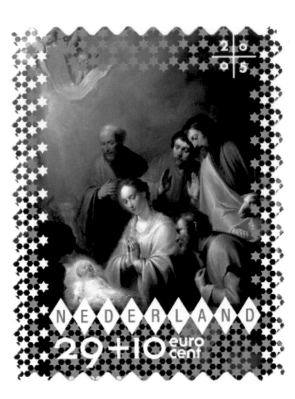

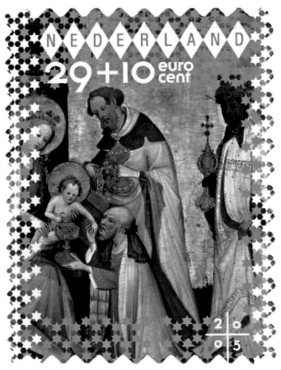

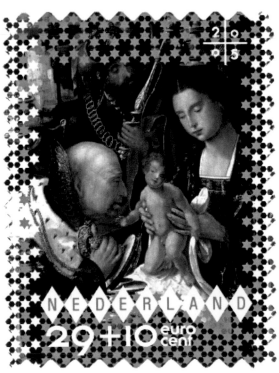

> Postage stamps > TNT Post

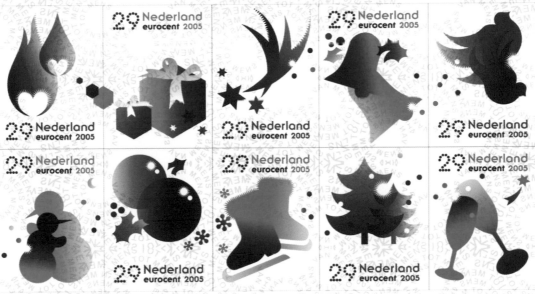

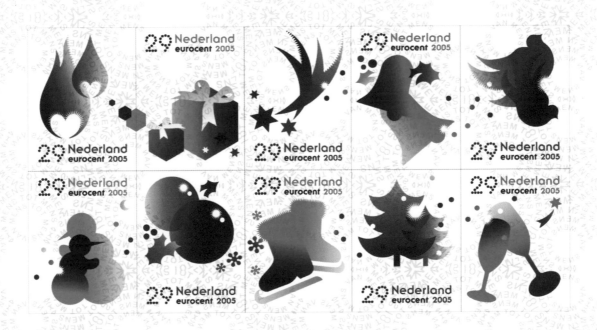

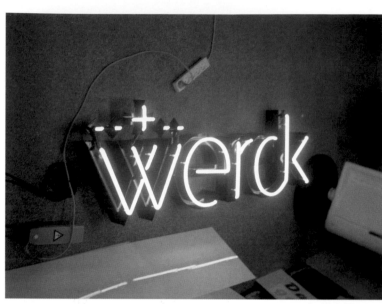
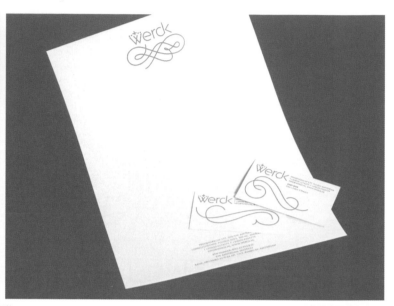
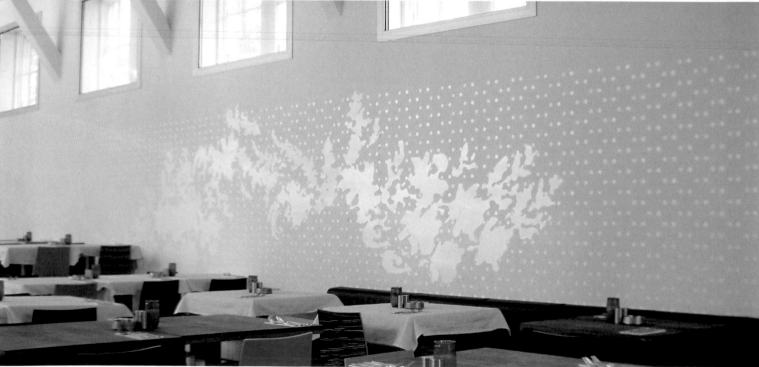

> Logo, signage, interior > Werck Restaurant, Amsterdam

Fig. 1a

Fig. 1b

Fig. 2a

Fig. 2b

Fig. 2c

Fig. 2d

Fig. 3a

Fig. 3b

Fig. 3c

'Birthmarking' is a tattooing
technique whereby new birthmarks
and freckles are added to your
skin in combination with existing
birthmarks.

Groot/Müller/Wittebrood, 2006

Example 1:
Duplication

1a. Two lovers' arms with
 original birthmarks
1b. After duplicating eachothers
 freckles, both partners carry
 identical birthmark patterns

Example 2:
Zodiac signs

2a. Sagittarius
2b. Cancer
2c. Virgo
2d. Libra

Example 3:
Braille

3a. 'Mom'
3b. '14 10 77'
3c. 'Big motherfucking eagle'

Armin Lindauer/sehwerk

> Logo > Mannheim University of Applied Sciences

Dammstrasse 18
68169 Mannheim
Germany
+49 621 819 0891
email@arminlindauer.de
www.arminlindauer.de
www.sehwerk.org

> After studying philosophy at the University of Dusseldorf, Armin Lindauer (Mannheim, 1958) studied graphic design at the University of Applied Sciences Konstanz and the Berlin University of the Arts. His ample teaching experience includes stints in both the Graphic Design and Artistic Education departments of the Berlin University of the Arts. At present, he is a professor of publishing design and typography in the Design Department of the University of Applied Sciences in Mannheim. One of the first prizes he received at the start of his career was bestowed by the German city of Nuremberg. Worth singling out among the titles of his award-winning books is *Helmut Lortz-leicht sinnig*, which received the Red Dot Award. Some of his works form part of the collections at the Austrian National Library and the poster collection at the Zurich Museum of Design.

hochschule mannheim

Dipl.-Bibl. Maria Klein
Leiterin der Hochschulbibliothek

Hochschule Mannheim fon +49 (0)621 292 6141
Windeckstraße 110 fax +49 (0)621 292 6144
68163 Mannheim m.klein@hs-mannheim.de

hochschule mannheim

Prof. Dr. Frank-Thomas Nürnberg

Hochschule Mannheim fon +49 (0)621 292 6217
Windeckstraße 110 fax +49 (0)621 292 6237
68163 Mannheim mobil +49 (0)151 124 117 16
 f.nuernberg@hs-mannheim.de

hochschule mannheim

Prof. Veruschka Götz
Fakultät für Gestaltung

Hochschule Mannheim fon +49 (0)621 292 6156
Windeckstraße 110 fax +49 (0)621 292 6160
68163 Mannheim v.goetz@hs-mannheim.de

hochschule mannheim

Prof. Armin Lindauer

Mannheim University fon +49 (0)621 292 6161
of Applied Sciences fax +49 (0)621 292 661 611
Windeckstraße 110 a.lindauer@hs-mannheim.de
68163 Mannheim www.gestaltung.hs-mannheim.de
Germany

> Calling card > Mannheim University of Applied Sciences

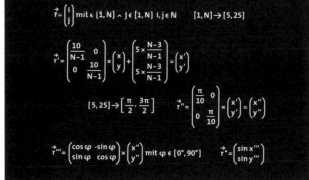

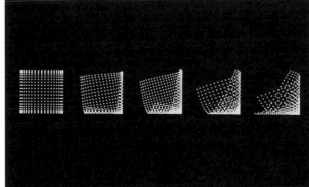

W

1. SEM

2. SEM

I R

3. SEM

4. SEM

E N T

5. SEM

6. SEM

T A E U S C

7. SEM

8. SEM

H E N S I E R I C H T I G .

9. SEM

10. SEM

F A K U L T A E T G E S T A L T U N G

hochschule mannheim

Zweistufiges Lehramtsstudium Bachelor und Master für Technisches Gymnasium und Berufliche Schulen

Kooperativer Studiengang

der Hochschule Mannheim und der Pädagogischen Hochschule Heidelberg

zur Erreichung der Lehrbefähigungen

in Informations- und Systemtechnik und Elektrische Energietechnik

Informationen und Bewerbungen
Hochschule Mannheim
Windeckstraße 110 · 68163 Mannheim

Fon 0621.292.6251 · Fax 0621.292.6260

Internet www.hs-mannheim.de
email lehramt@hs-mannheim.de

hochschule mannheim

Grafik-Design

Grafik-Design
Armin Lindauer
Zillestraße 67
1000 Berlin 10

Auf Verlangen vorzeigen

Telefon 341 34 36

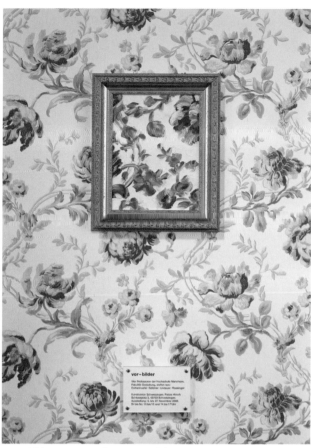

> *vor-bilder* > poster > Kunstverein Schwetzingen

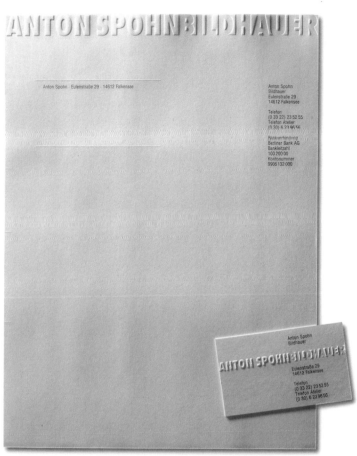

> *Anton Spohn Bildhauer* > promotional material > Anton Spohn

hierfür ausgewählten Schrift praxisgetreu vorzuführen dieser geklebte Blindtext ist gesetzt aus Helvetica die Schriftart sowie hier verwendeten Grade und Garnituren sind auf Konzeption

und Entwurf genau abgestimmt der spätere Druck mit dem endgül Text wird typografisch diesem Layout entsprechen dieser Text st anstelle der Manuskriptfassung er hat inhaltlich keinerlei Beziehun

und Entwurf genau abgestimmt der spätere Druck mit dem Text wird typografisch diesem Layout entsprechen diesem Text

> *Bandbreite* > poster > Professional Association of Berlin Artists

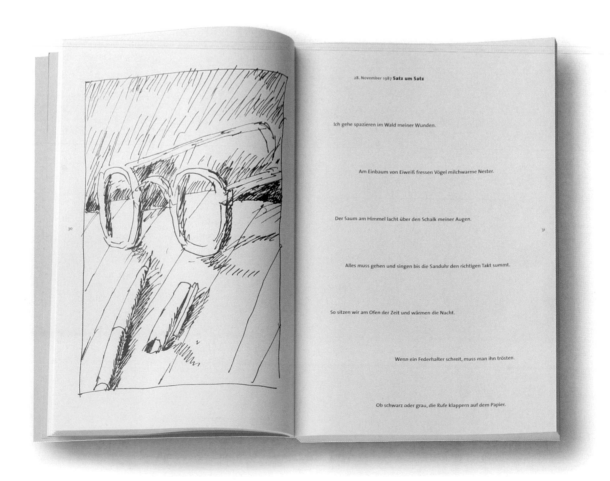

28. November 1983 **Satz um Satz**

Ich gehe spazieren im Wald meiner Wunden.

Am Einbaum von Eiweiß fressen Vögel milchwarme Nester.

Der Saum am Himmel lacht über den Schalk meiner Augen.

Alles muss gehen und singen bis die Sanduhr den richtigen Takt summt.

So sitzen wir am Ofen der Zeit und wärmen die Nacht.

Wenn ein Federhalter schreit, muss man ihn trösten.

Ob schwarz oder grau, die Rufe klappern auf dem Papier.

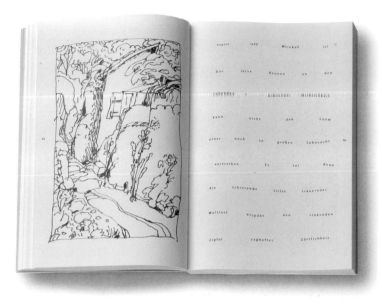

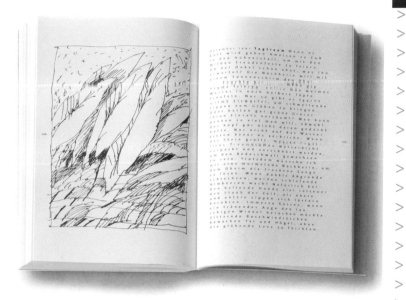

Artless

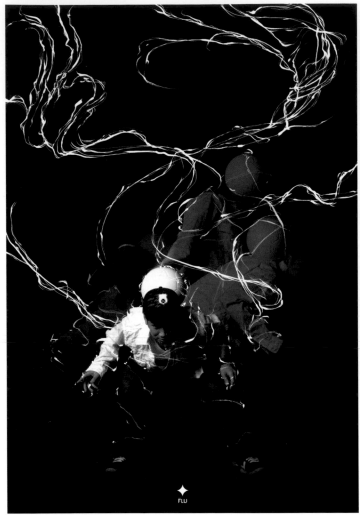
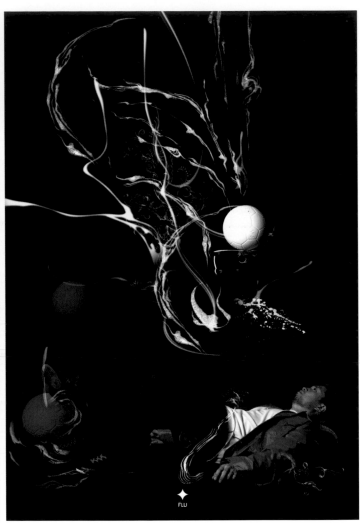

> *Flu* > poster > Levi's

11-4-604 Nibancho
Chiyoda-ku
Tokyo 102-0084
Japan
+81 3 6802 3302
info@artless.gr.jp
www.artless.gr.jp

> Artless is a visual design studio located in Tokyo. Their work generally revolves around graphic design, web design and animation. They also mount exhibitions, events, installations, and a large number of other creative activities in various genres, categories and modes of communication. The Artless worldwide network is continually expanding, they even accept foreign projects. Their creative team includes an art director, graphic designer, web designer, photographer, illustrator, painter, animation designer, sound creator, DJ and a VJ. Artless doesn't just produce graphic arts, photography and animation; they also collaborate with cafes and stores while expanding their mark. Some of their awards include: Japan Typography 2006, Tokyo Interactive Ad Award 2005, Japan Typography 2005 and the Good Design Award 2004. Artless studio is a member of the Japan Graphic Designers Association.

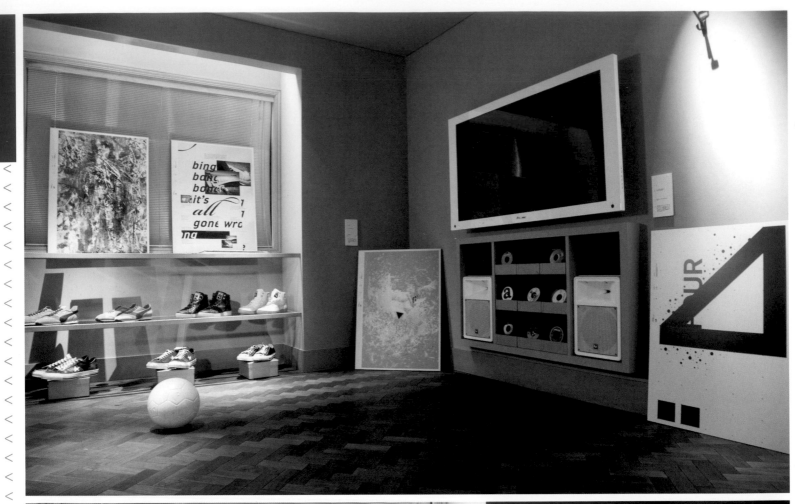

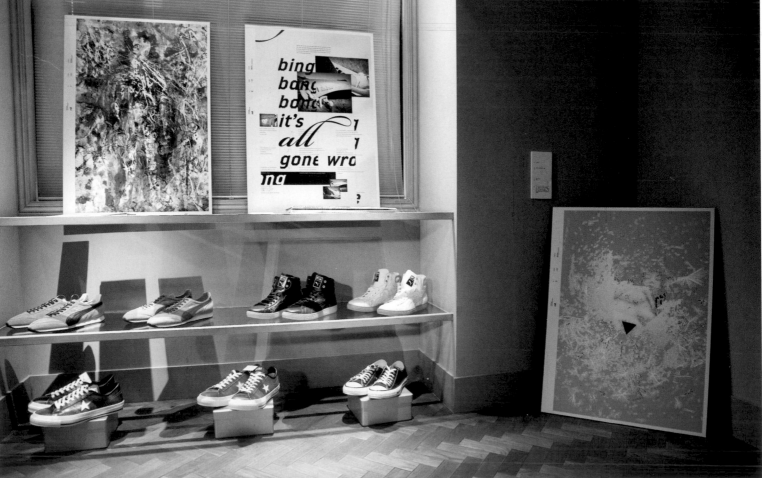

> Null exhibition at Tab Device > Null

> Card > Stomp Stamp

Atelier Bundi

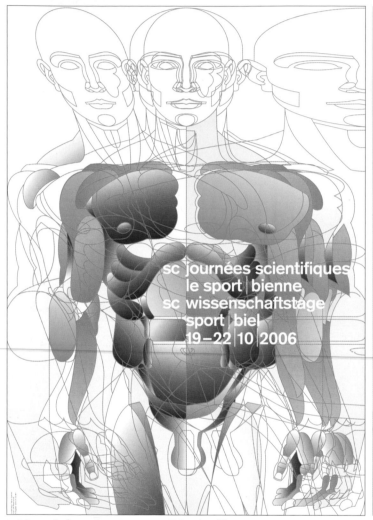

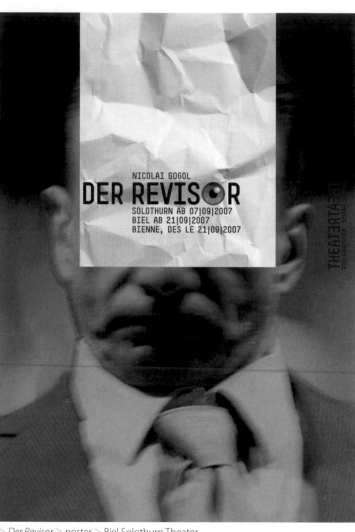

> *Wissenschaftstage Sport* > poster > University of Bern

> *Der Revisor* > poster > Biel Solothurn Theater

Schlossstrasse 78
3067 Boll
Switzerland
+41 31 981 00 55
bundi@atelierbundi.ch
www.atelierbundi.ch

> Having graduated as a graphic designer from the Bern School of Design (Switzerland), Stephan Bundi trained at the Young & Rubicam agency. After various years at the advertising agency, he began studies in book design and illustration at the State Academy of Art and Design in Stuttgart (Germany). Later he went into business for himself and opened the design studio Atelier Bundi. Stephan Bundi now works as an art director for publishers, theaters, con- cert promoters, film producers and museums. Since 1999, he has worked as a lecturer in visual interpre- tation (illustration) at the Bern University of the Arts (Switzerland) and as guest lecturer and expert at different art and design schools around the world. He has won a Swiss national prize for design and became the first-prize winner of the International Poster Triennial in Mons (Belgium). He has also won the silver prize at the Korea Biennial.

Mani Matter **Stücke**
Regie: Norbert Klassen
mit Markus Mathis, Thomas Monn,
Martin Rudolf, Peter Zumstein
Schlachthaus Theater
Rathausgasse 20, 3011 Bern
Mittwoch 23. Oktober bis
Samstag 26. Oktober 2002,
jeweils 20.30 Uhr

> *Mani Matter Stücke* > poster > Stop. P.T. Theater

83 <

THÉÂTRE
L SOLOTHURN BIENNE SOLEURE

MUTTERS
COURAGE GEORGE TABORI
BIEL AB 25|01|2008
SOLOTHURN AB 13|02|2008

> *Mutters Courage* > poster > Biel Solothurn Theater

Marmorera

Dominik Bernet

Roman
Cosmos Verlag

> *Heimet! Heimet! Wunderbari Welt!* > poster > Biel Solothurn Theater

The 20th
Anniversary
Tour. The Zawinul
Syndicate in Concert
Mühle Hunziken
13. März
2007 Joe Zawinul

Gestaltung: Stephan Bundi AGI
Druck: Serigraphie Albin Uldry

Carmen

Georges Bizet

Miguel Gomez-Martinez /
Srboljub Dinic
Eike Gramss
Beatrix von Pilgrim
Catherine Voeffray
Lech-Rudolf Gorywoda
Cristina Teuscher

María José Montiel /
Marie-Claude Chappuis
Emil Ivanov /
Scott MacAllister
Petra Labitzke /
Rachel Harnisch
Kevin Short /
Dimitri Tiliakos
Richard Ackermann
Robin Adams
Gunda Baumgärtner
Eliseda Dumitru
Andreas Hermann
Patric Ricklin
Thomas Mathys
Pablo de Molina

Mit freundlicher
Unterstützung
Vereinigung für Bern

ab 13. Februar 2004
Stadttheater Bern

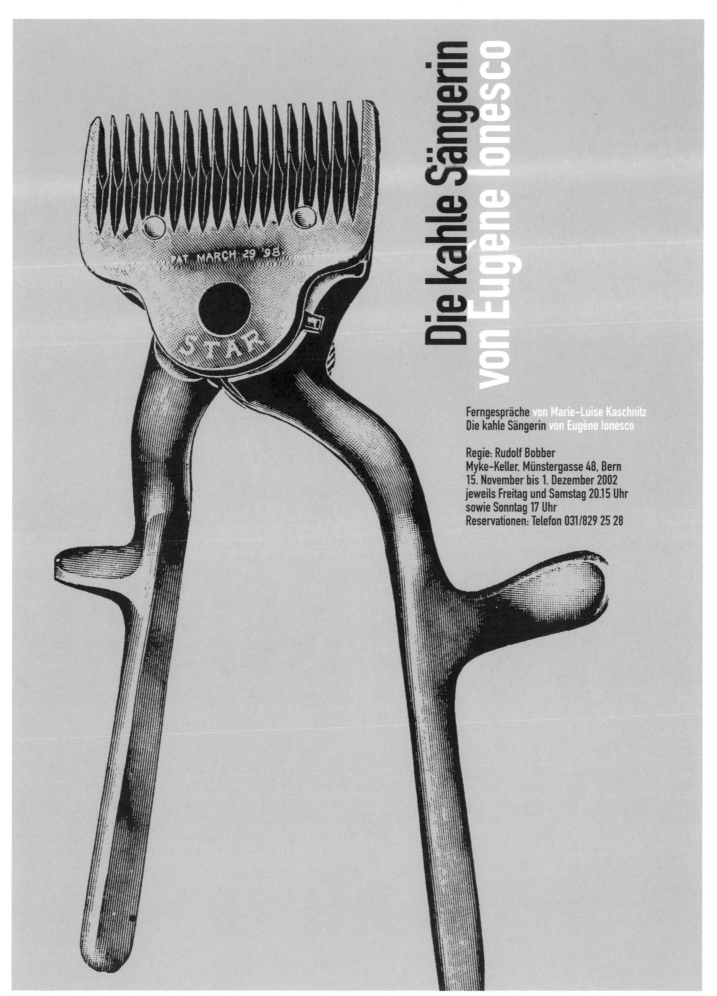

Die kahle Sängerin
von Eugène Ionesco

Ferngespräche von Marie-Luise Kaschnitz
Die kahle Sängerin von Eugène Ionesco

Regie: Rudolf Bobber
Myke-Keller, Münstergasse 48, Bern
15. November bis 1. Dezember 2002
jeweils Freitag und Samstag 20.15 Uhr
sowie Sonntag 17 Uhr
Reservationen: Telefon 031/829 25 28

Atelier Poisson

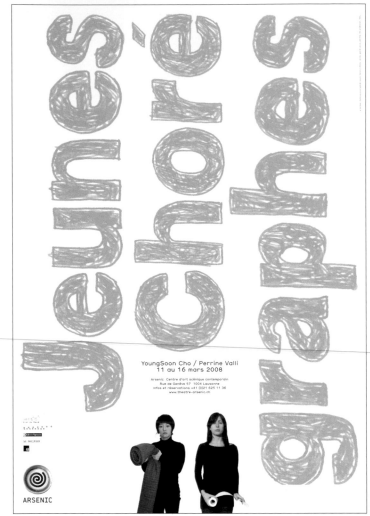

> *Jeunes chorégraphes* > poster > Arsenic Theater

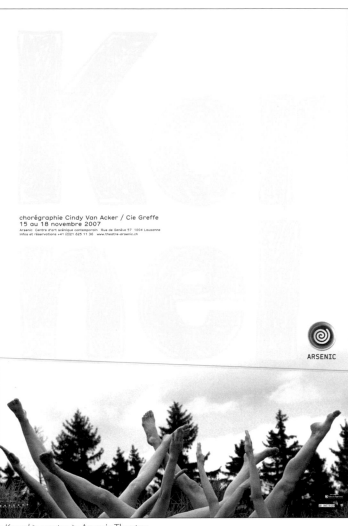

> *Kernel* > poster > Arsenic Theater

33, avenue de Morges
1003 Lausanne
Switzerland
+41 21 311 59 60
poisson@atelierpoisson.ch
www.atelierpoisson.ch

> After studying at the University of Art and Design Lausanne and training in Spain and France, Giorgio Pesce spent a year working in New York. Influenced by Tibor Kalman, he later creates Atelier Poisson, his own design studio, in Lausanne. Giorgio, aside from being a graphic designer, also illustrates all of his own projects, constantly drawing and painting. He likes found objects, old books and signage, often using inspiration from the old in designing his new projects. The majority of Atelier Poisson's projects involve theaters, dance companies, cultural festivals, museums, scientific expositions and architects. A large number of its work has been awarded and seen publication by The Type Directors Club in New York and Tokyo, the Art Directors Club of New York, the International Poster Festival of Chaumont, the Taiwan Poster Award, and various books on design from the United Kingdom, China and the United States.

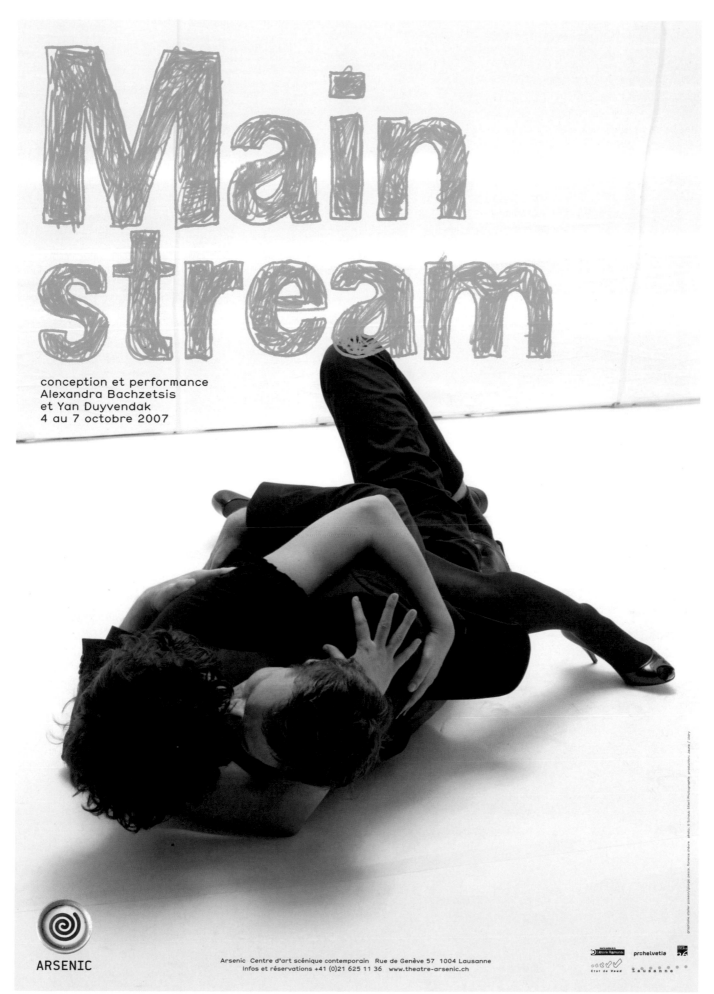

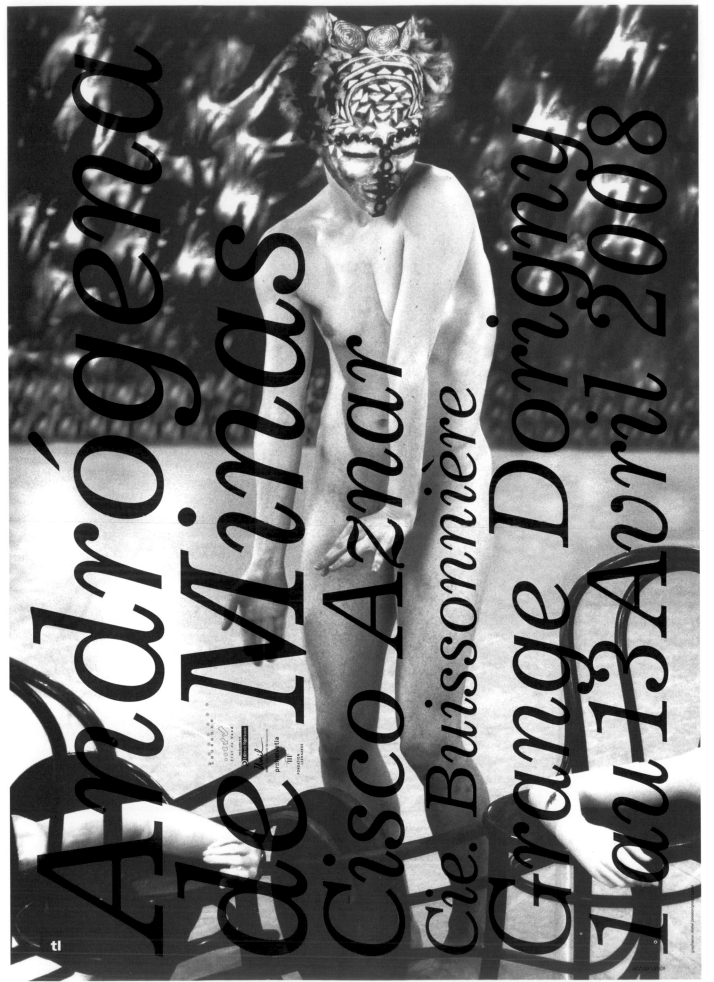

Andrógena de Minas > poster > Cie. Buissonnière

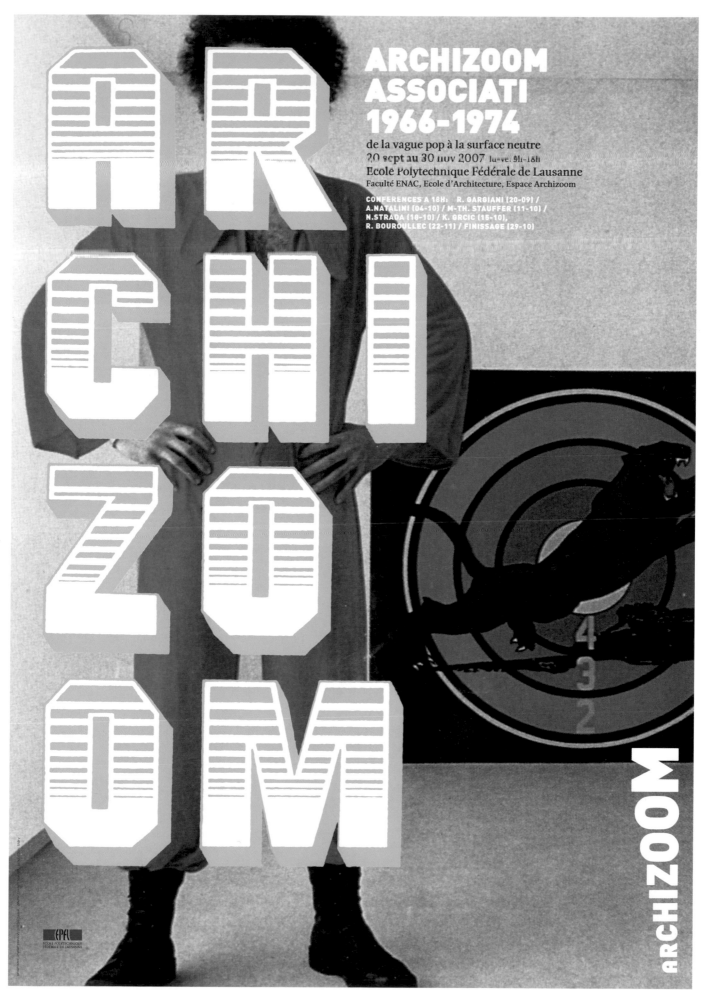

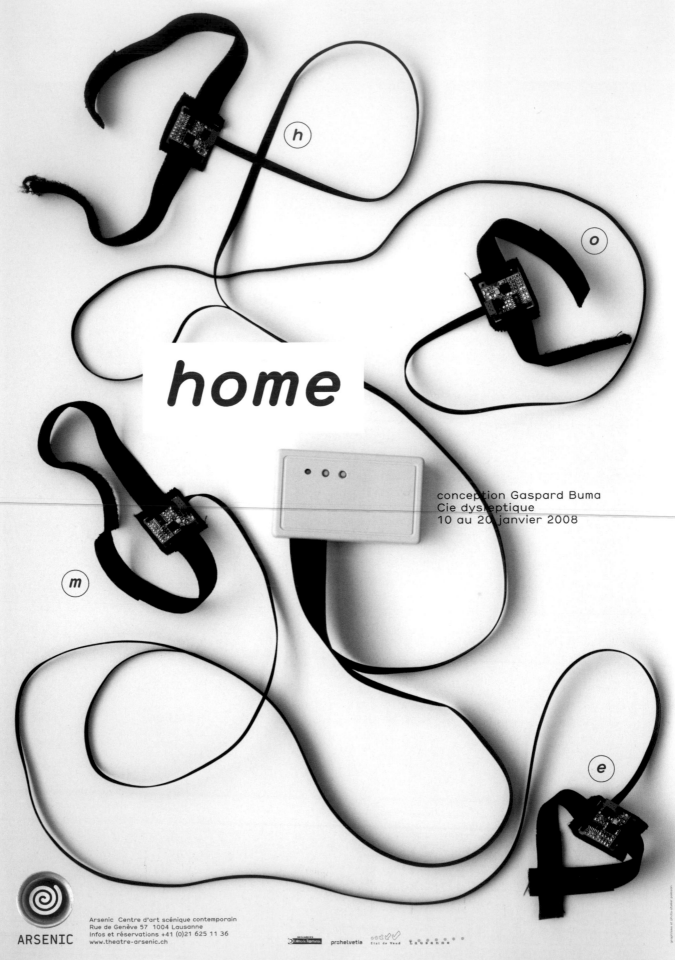

Journées de danse contemporaine suisse 2006

WWW.JOURNEESDANSESUISSE.CH

GENÈVE & LAUSANNE 18-21 JANVIER 2006
18-19 JANVIER À GENÈVE / 20-21 JANVIER À LAUSANNE

texte et mise en scène Marielle Pinsard
26 janvier au 4 février 2007

Pyrrhus Hilton

Arsenic / Centre d'art scénique contemporain / Rue de Genève 57 / 1004 Lausanne
infos et réservations +41 (0)21 625 11 36 / www.theatre-arsenic.ch

ARSENIC

> *Pyrrhus Hilton* > poster > Arsenic Theater

Blok

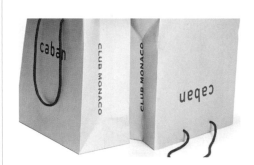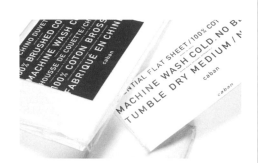

> *Caban* > corporate image > Club Monaco

Sombrerete 515, nº 1
Col. Condesa
Mexico City 06170
Mexico
+52 55 5515 24 23
disinfo@blokdesign.com
www.blokdesign.com

> At Blok, Vanessa Eckstein tackles her varied projects with a great passion for each job's dialogue and commitment. With her international character and range, she attracts talents from all over Mexico and the entire world to collaborate on initiatives that combine cultural conscience with a love of art and the kind of sense of humanity that is needed in order to help society advance. Vanessa's branding, publishing and packaging work includes projects for Nike, Pepsi, the Tamayo Museum, the Cabañas Cultural Institute, Club Monaco, Roots, José Cuervo, Television Groupa and Émigré Film. Currently, she is concentrating on two initiatives: the launch of a publishing house for children's books and spreading liberty of expression throughout the world. Having received numerous awards and honors, Blok's work is exhibited in the permanent collection of the Royal Ontario Museum.

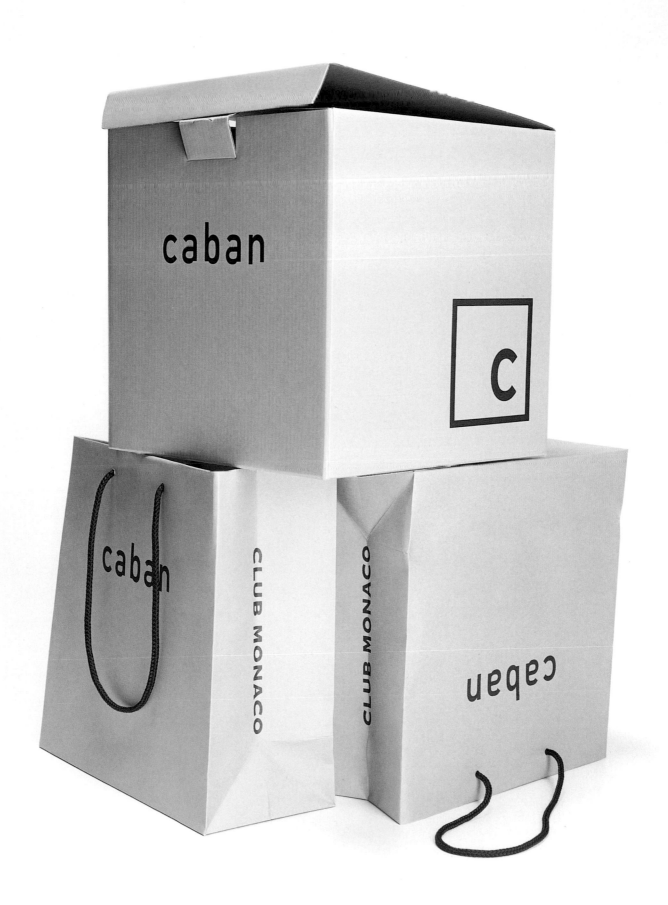

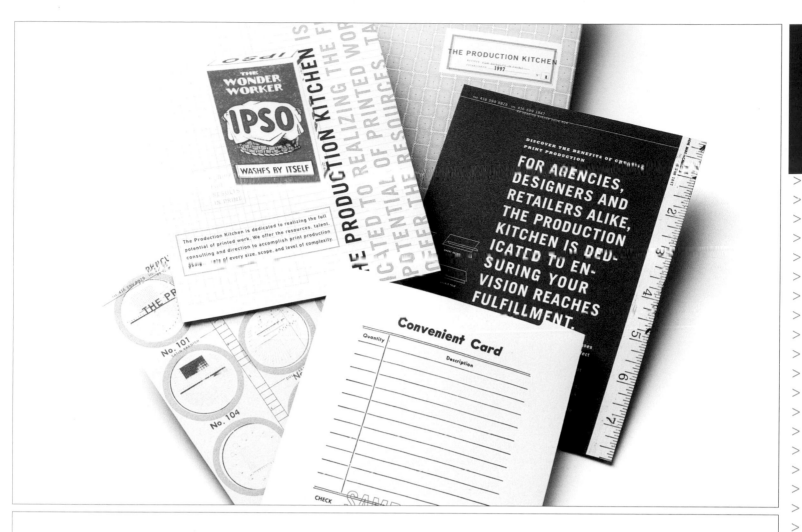

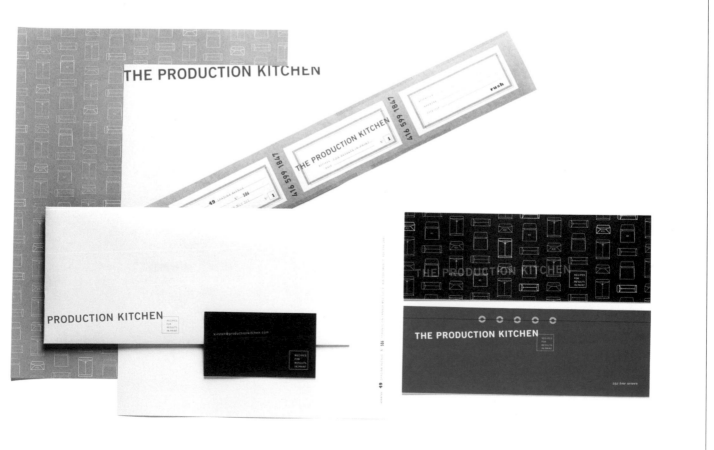

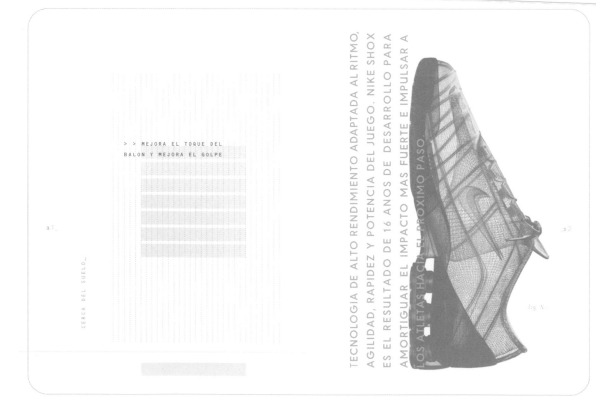

> > MEJORA EL TOQUE DEL
BALON Y MEJORA EL GOLPE

CERCA DEL SUELO_

TECNOLOGIA DE ALTO RENDIMIENTO ADAPTADA AL RITMO,
AGILIDAD, RAPIDEZ Y POTENCIA DEL JUEGO. NIKE SHOX
ES EL RESULTADO DE 16 AÑOS DE DESARROLLO PARA
AMORTIGUAR EL IMPACTO MAS FUERTE E IMPULSAR A
LOS ATLETAS HACIA EL PROXIMO PASO.

> *Nike Passport* > flyer > Nike México

APELLIDOS_

NOMBRE_

NACIONALIDAD_

EQUIPO_

CATEGORIA_

4.1

N°

CIUDAD DE EXPEDICION_

[LLEVALOS AL BAILE]

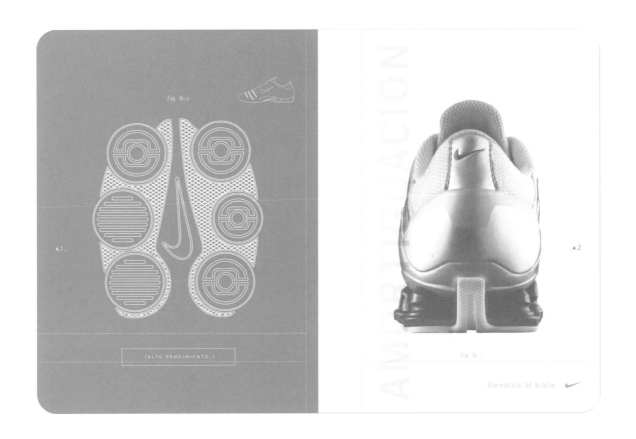

AMORTIGUACION

fig. N.5

4.1

[ALTO RENDIMIENTO.]

4.2

fig. N.

llevalos al baile

Brighten the Corners

Hai! Hai!*

* German for "Shark! Shark!". A little language can make a lot of difference.

Languages Work *

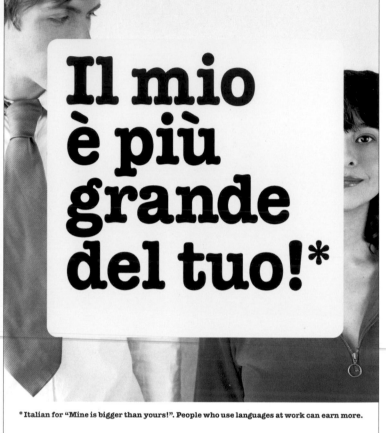

Il mio è più grande del tuo!*

* Italian for "Mine is bigger than yours!". People who use languages at work can earn more.

Languages Work *

> *Languages Work* > posters > CILT, the National Center for Languages

Unit 243
The Bon Marché Centre
241-251 Ferndale Road
SW9 8BJ London
United Kingdom
+44 20 7274 4949
contact@brightenthecorners.com
www.brightenthecorners.com

> Dedicated to advising on strategy and design, the Brighten the Corners graphic studio was founded in 1999. This small studio works on both large and small scale projects. The team of designers is made up of Anastasios Billy Kiossoglou (Athens, 1973), with a degree in graphic design from the Camberwell College of Arts and a masters in art, communication and design from the Royal Academy of Arts London, and Frank Philippin (Stuttgart, 1973), the founder of Brighten the Corners, who holds a degree in graphic design from the Camberwell College of Arts and a masters in graphic design from the Royal Academy of Arts London. Whether it be designing a book, a stamp or a corporate image, they believe that communication should be clear and direct and good design will always bring out the difference. Some of their awards include the D&AD (Brochures and Catalogues, 2007) and the RBI Achievement Award (Marketing Campaign of the Year).

¿Dónde está la playa?*

*Spanish for "Where is the beach?" Even a little Spanish can make a lot of difference.

Languages Work *

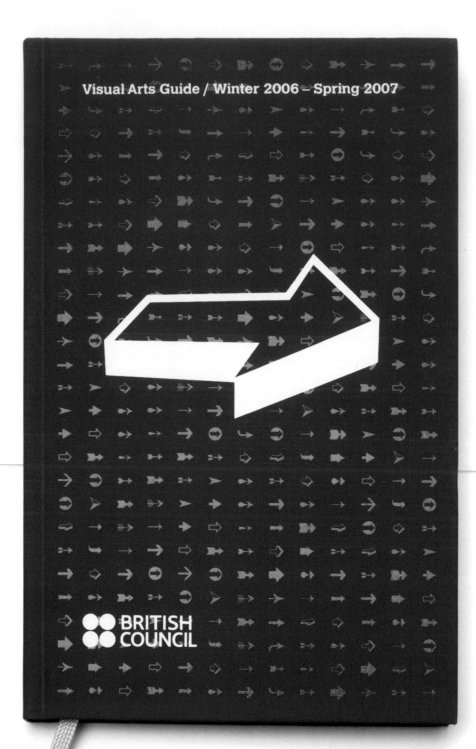

Visual Arts Guide / Winter 2006 – Spring 2007

BRITISH COUNCIL

> *Visual Arts Guide* > cover > British Council

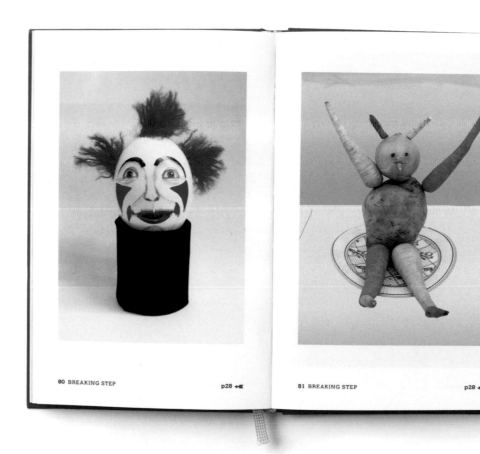

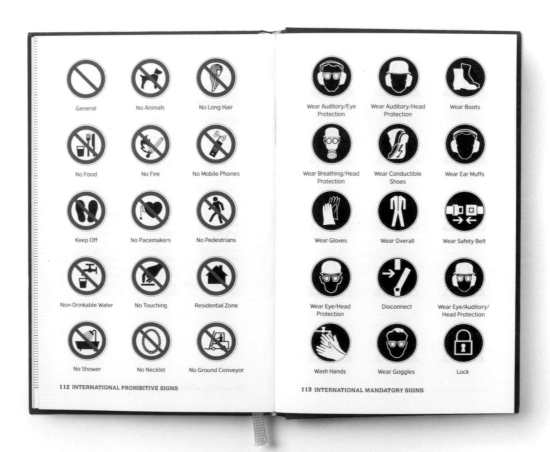

General No Animals No Long Hair

No Food No Fire No Mobile Phones

Keep Off No Pacemakers No Pedestrians

Non-Drinkable Water No Touching Residential Zone

No Shower No Necklet No Ground Conveyor

Wear Auditory/Eye Protection Wear Auditory/Head Protection Wear Boots

Wear Breathing/Head Protection Wear Conductible Shoes Wear Ear Muffs

Wear Gloves Wear Overall Wear Safety Belt

Wear Eye/Head Protection Disconnect Wear Eye/Auditory/Head Protection

Wash Hands Wear Goggles Lock

> *Goethe-Institut Programme* > cover > Goethe-Institut

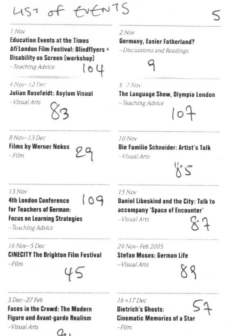

27

VISUAL ARTS

Helfried Kodré

ARNOLDSCHE

> *Helfried Kodré* > cover > Arnoldsche Art Publishers

KREATIV!

Region Stuttgart – Standort für
Unternehmen der Kreativwirtschaft

The Stuttgart Region – A Location
for the Creative Industry

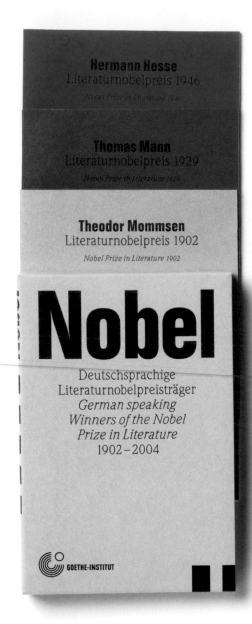

Hermann Hesse
Literaturnobelpreis 1946
Nobel Prize in Literature 1946

Thomas Mann
Literaturnobelpreis 1929
Nobel Prize in Literature 1929

Theodor Mommsen
Literaturnobelpreis 1902
Nobel Prize in Literature 1902

Nobel
Deutschsprachige
Literaturnobelpreisträger
*German speaking
Winners of the Nobel
Prize in Literature
1902–2004*

GOETHE-INSTITUT

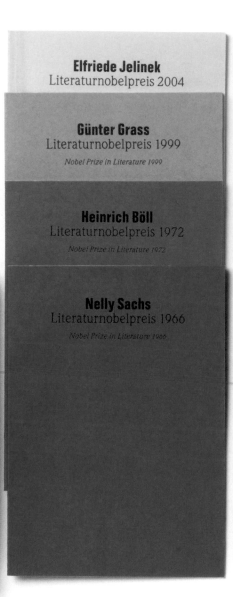

Elfriede Jelinek
Literaturnobelpreis 2004

Günter Grass
Literaturnobelpreis 1999
Nobel Prize in Literature 1999

Heinrich Böll
Literaturnobelpreis 1972
Nobel Prize in Literature 1972

Nelly Sachs
Literaturnobelpreis 1966
Nobel Prize in Literature 1966

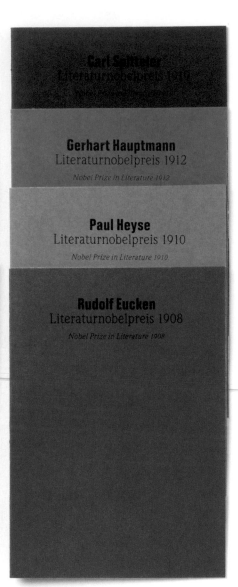

Carl Spitteler
Literaturnobelpreis 1919

Gerhart Hauptmann
Literaturnobelpreis 1912
Nobel Prize in Literature 1912

Paul Heyse
Literaturnobelpreis 1910
Nobel Prize in Literature 1910

Rudolf Eucken
Literaturnobelpreis 1908
Nobel Prize in Literature 1908

> *Nobel* > covers > Goethe-Institut

BOOTH of TRUTH

COME IN AND REVEAL ALL!

Bruno Porto

apresenta

beto silva

JÚLiO SUMiU

suspense com humor

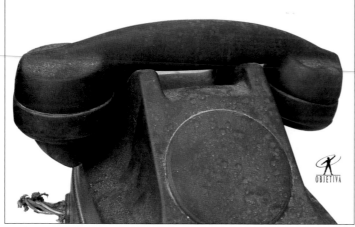

OBJETIVA

Raimundo Carrero

Os segredos da ficção

arte de escrever

AGIR

> *Júlio Sumiu* > cover > Editora Objetiva

> *Os segredos da ficção* > cover > Agir Editora

Av. Epitácio Pessoa 4976/501
22471-001 Rio de Janeiro
Brazil
+55 21 2286 6005
design@brunoporto.com
www.brunoporto.com

> Currently a resident of Shanghai, Bruno Porto was born in Rio de Janeiro, where he obtained a degree in graphic design and a post graduate degree in marketing and enterprise management. He later attended the New York School of Visual Arts. His work has been shown and awarded in many South American countries as well as Brazilian design magazines and about a dozen international books. In 2004 he founded the studio Bruno Porto Comunicação Visual, where he basically works within the cultural fields, in publishing and identity creation. Former director of the Brazilian Graphic Designers Association (2002-2006) and a member of the Society of Illustrators, he has sat on many awards juries. He has also given conferences and organized design events and workshops in various cultural institutions as well as organizing international design congresses and exhibitions.

Maria Clara R. M. do Prado

UMA RADIOGRAFIA DA MOEDA QUE MUDOU O BRASIL

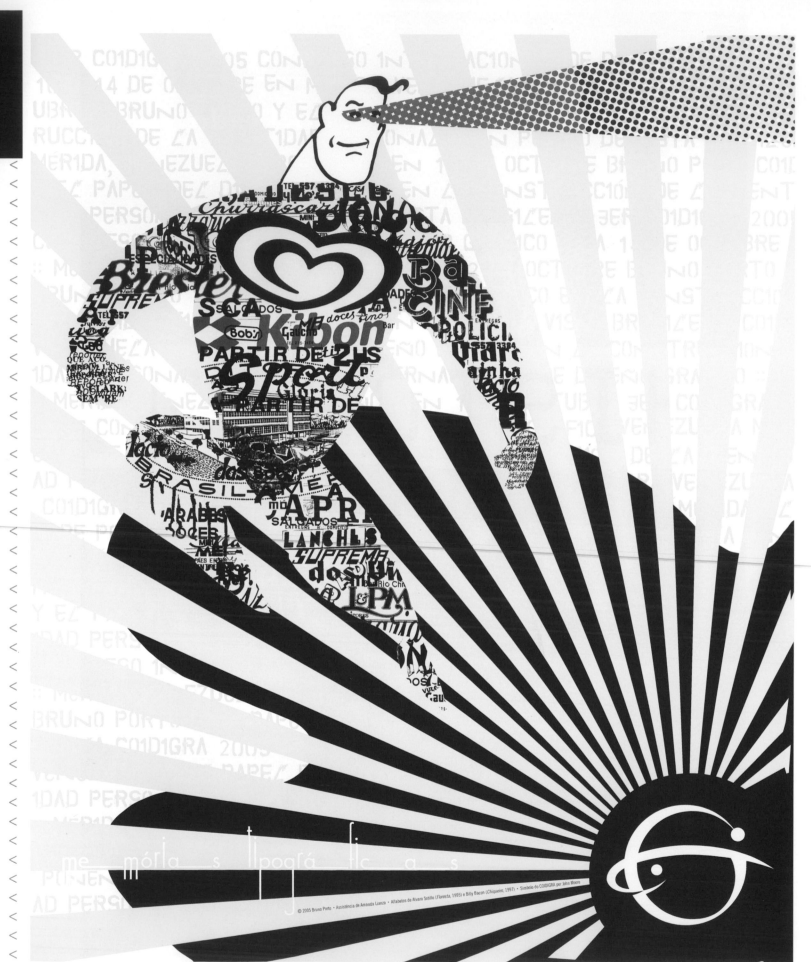

> Memórias tipográficas en Venezuela > posters > Coidigra

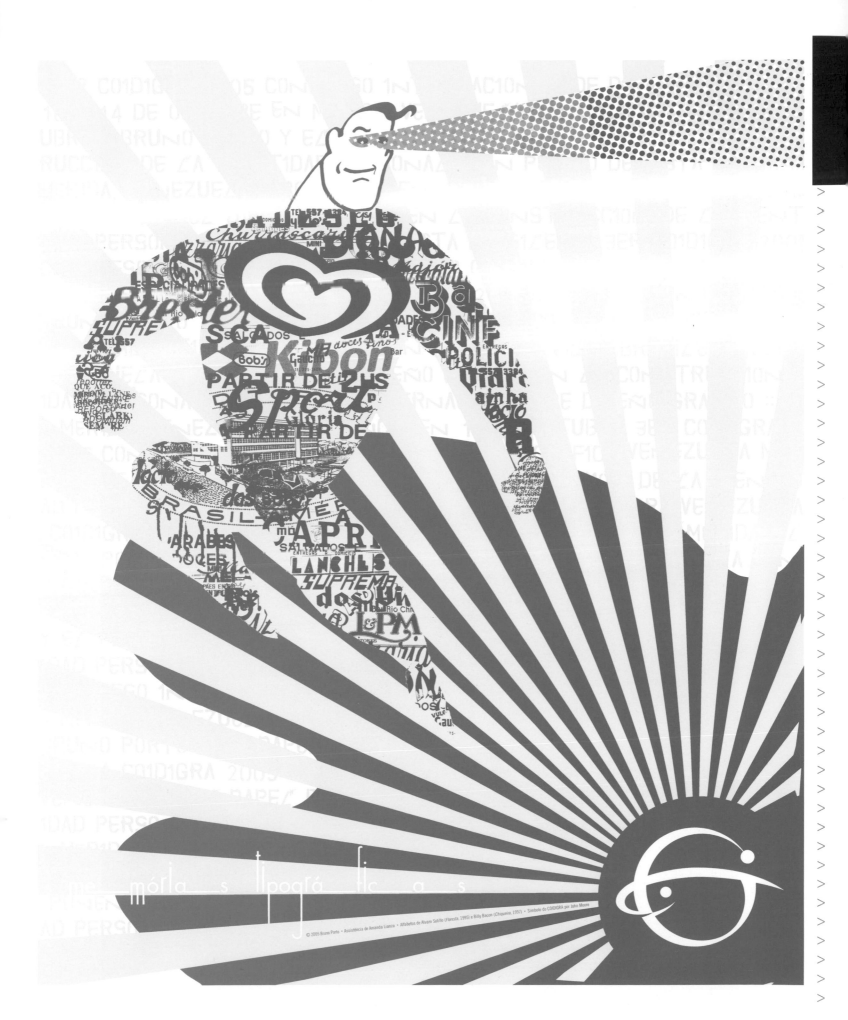

Stewart O'Nan

A MIL POR HORA

Confissões de Speed Queen

{Romance}

"Um romance extraordinário: envolvente, estranho, engraçado, violento e excitante."
Nick Hornby, autor de Alta fidelidade

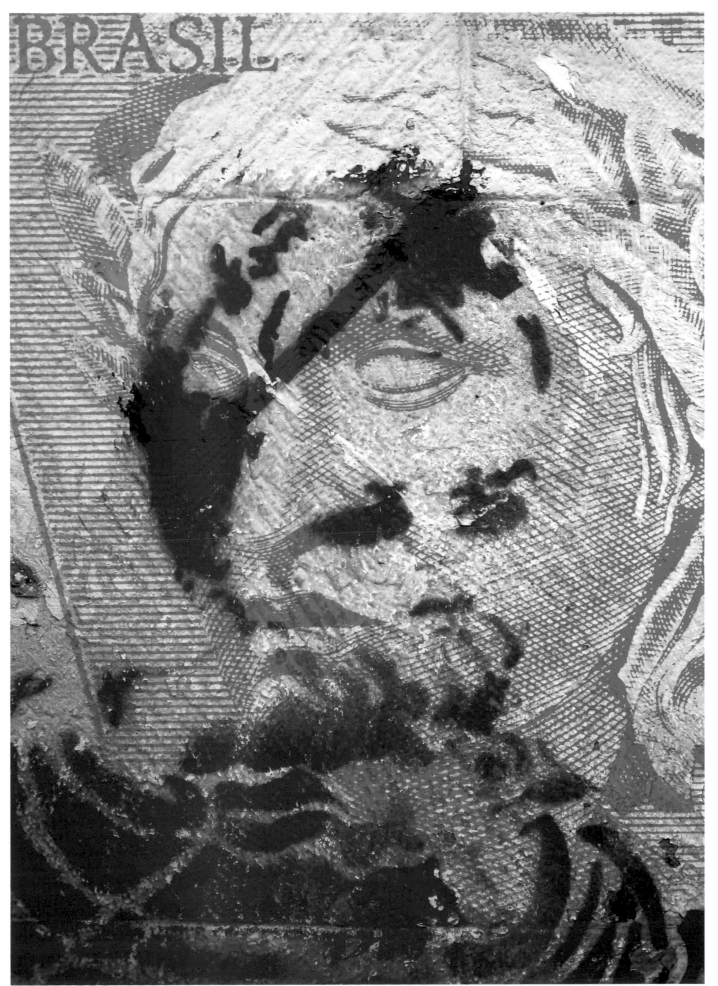

> *O meu Brasil é com S* > poster > European Institute of Design

Christof Nardin, agcn

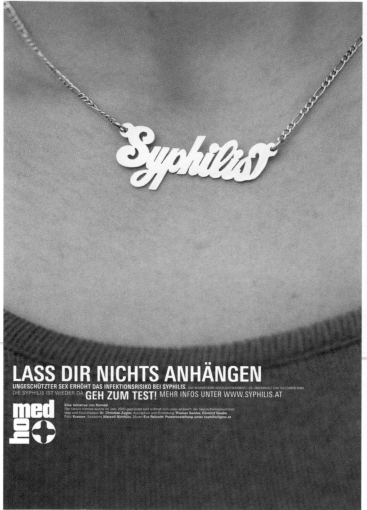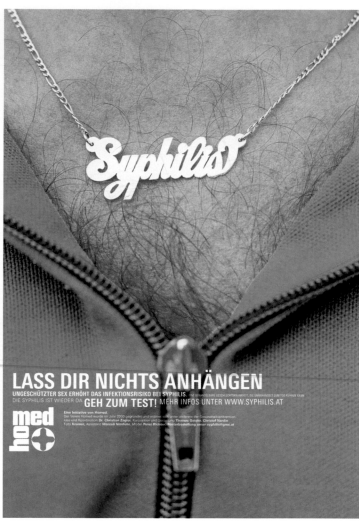

> *Syphilis* > posters > Homed, in collaboration with Thomas Geisler

Mariahilfer Strasse 9/7

1060 Vienna

Austria

+43 699 1 943 22 98

cn@christofnardin.com

christofnardin.com

Portrait: Kramar (Kollektiv Fischka)

> The wide variety of pieces produced by the young and versatile Christof Nardin offer rare interpretations on the classic mediums of communication. His work respresents a rich and creative vocabulary in constant expansion and is full of intelligent, subtle and sometimes even mal-intentioned imagery. His personal style—together with a use of irony coupled with an awareness of social themes—makes Christof Nardin's work solid and striking. His portfolio includes posters, magazines, books and corporate designs while still incorporating interior design at the same time. Christof Nardin has developed designs for the University of Applied Arts in Vienna, the Jewish Museum of Vienna and the German Foundation for the Fashion Industry, among others. He was presented as Best of the Best during the Red Dot Awards and obtained an award from the Art Directors Club of New York. He also received three bronze Joseph Binder Awards. Presently, Christof Nardin resides and works in Vienna.

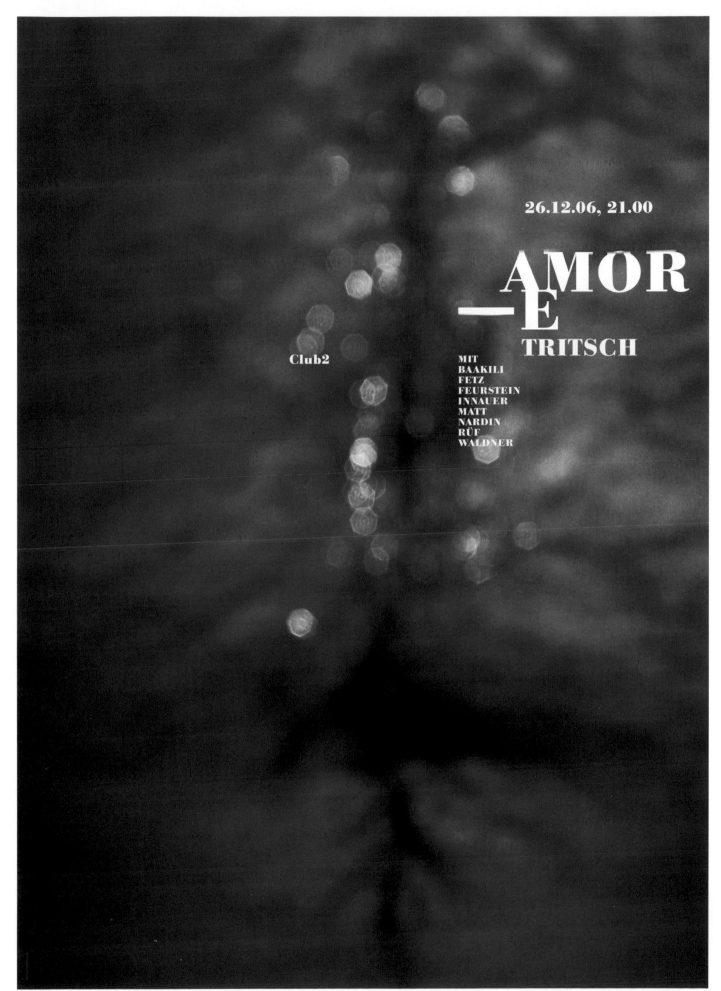

26.12.06, 21.00

AMOR
—E
TRITSCH

Club2

MIT
BAAKILI
FETZ
FEURSTEIN
INNAUER
MATT
NARDIN
RÜF
WALDNER

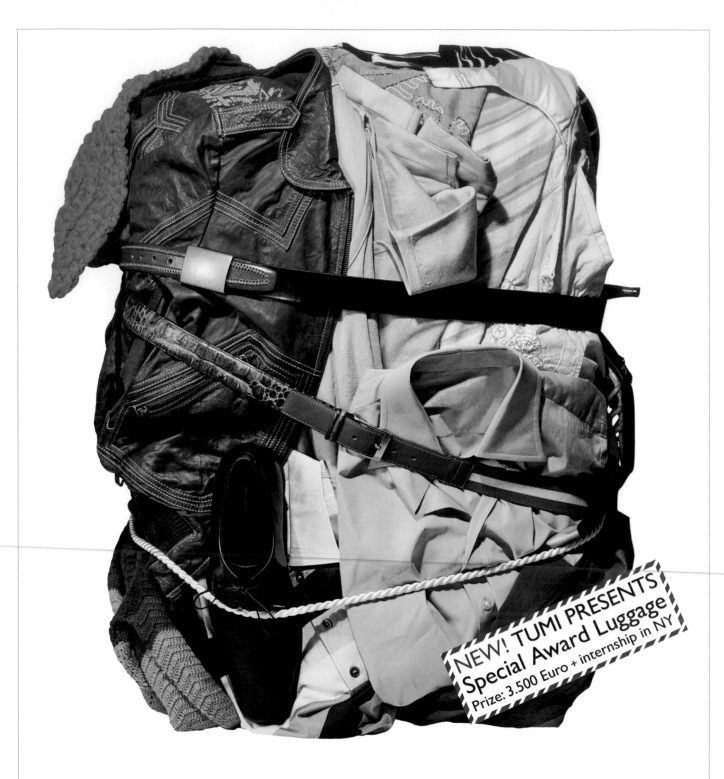

NEW! TUMI PRESENTS
Special Award Luggage
Prize: 3.500 Euro + internship in NY

THE FINE ART OF TRAVELLING is the topic of the Award of the Stiftung der Deutschen Bekleidungsindustrie 2007 (German Apparel Industry Foundation). Regardless of whether business trip or sports vacation, first class or economy, we are looking for travel fashion that meets the multifaceted demands of travellers.

In addition, there is a Special Award 'Fashion Branding' attributed in collaboration with the world's leading brand consulting company Interbrand Zintzmeyer & Lux.

The competition is open to design students of all disciplines in the fourth semester or higher. Registration deadline: December 8th, 2006.

Prizes Fashion Award: 4.000/2.000/1.000 Euro; Special Award: 3.500 Euro
10 Fabric vouchers à 750 Euro, offered by Swiss Textiles
Internships: Akris, Mover, Interbrand Zintzmeyer & Lux, Roxy/Quiksilver
Special Mentions: Freitag bag F12

www.stiftung-bekleidungsindustrie.de

THE FINE ART OF TRAVELLING
EUROPEAN FASHION AWARD

> *The Fine Art of Travelling* > poster > SDBI (project manager: Joachim Schirrmacher; in collaboration with Kasimir Reimann)

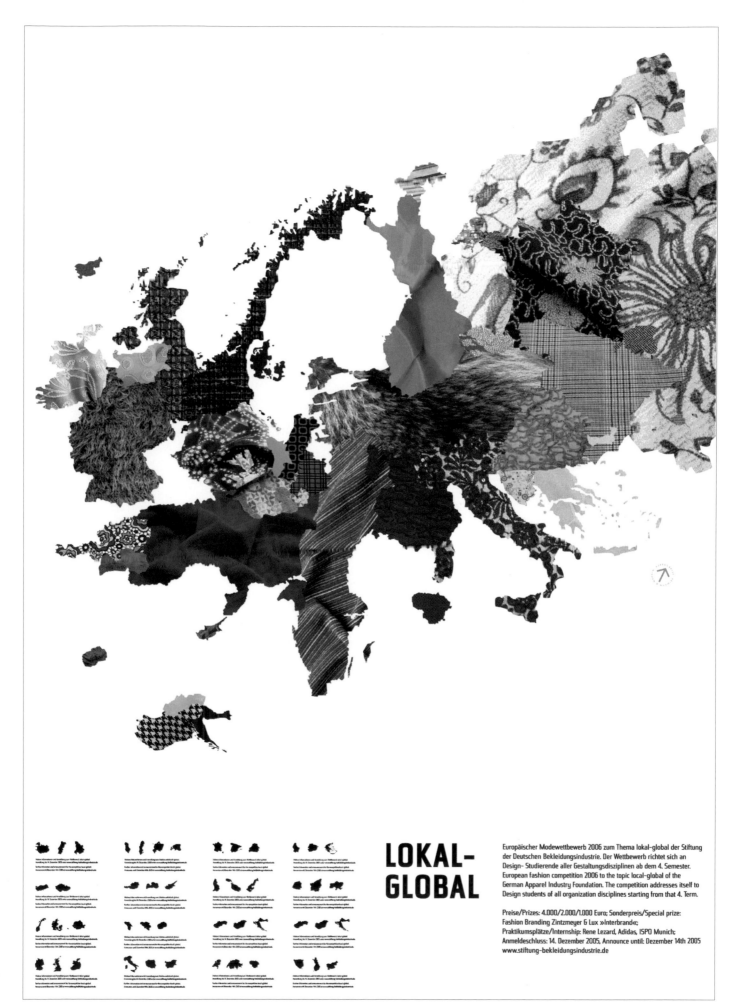

LOKAL-GLOBAL

Europäischer Modewettbewerb 2006 zum Thema lokal-global der Stiftung der Deutschen Bekleidungsindustrie. Der Wettbewerb richtet sich an Design- Studierende aller Gestaltungsdisziplinen ab dem 4. Semester. European fashion competition 2006 to the topic local-global of the German Apparel Industry Foundation. The competition addresses itself to Design students of all organization disciplines starting from that 4. Term.

Preise/Prizes: 4.000/2.000/1.000 Euro; Sonderpreis/Special prize: Fashion Branding Zintzmeyer & Lux »Interbrand«;
Praktikumsplätze/Internship: Rene Lezard, Adidas, ISPO Munich;
Anmeldeschluss: 14. Dezember 2005, Announce until: Dezember 14th 2005
www.stiftung-bekleidungsindustrie.de

> *Lokal-global* > poster > SDBI (project manager: Joachim Schirrmacher; in collaboration with Kasimir Reimann)

University of Applied Arts Vienna presents an
interdisciplinary lecture series organized by the
department of Design History & Theory with
the departments of Graphic Design and Fashion

MON 05/12/05, 7PM
Joanne Entwistle (UK), Fashion Theory

TUE 13/12/05, 7PM
åbäke (UK), Graphic Design

TUE 10/01/06, 7PM
Erik Kessels (NL)
Advertising & Communication

TUE 17/01/06, 7PM
Penny Martin (UK)
Fashion Theory & Publishing

MON 23/01/06, 7PM
Anuschka Blommers, Niels Schumm (NL)
Photographers

diːˈʌŋɡevʌndtə
University of Applied Arts Vienna
Oskar Kokoschka-Platz 2, A-1010 Vienna
www.uni-ak.ac.at/cuts

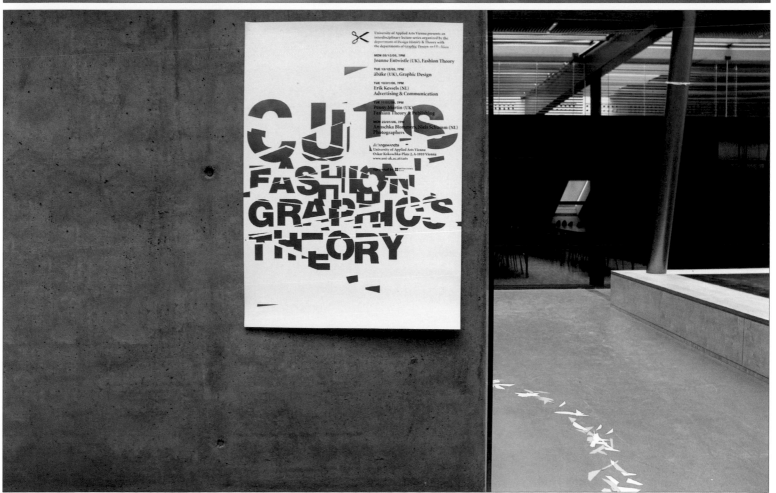

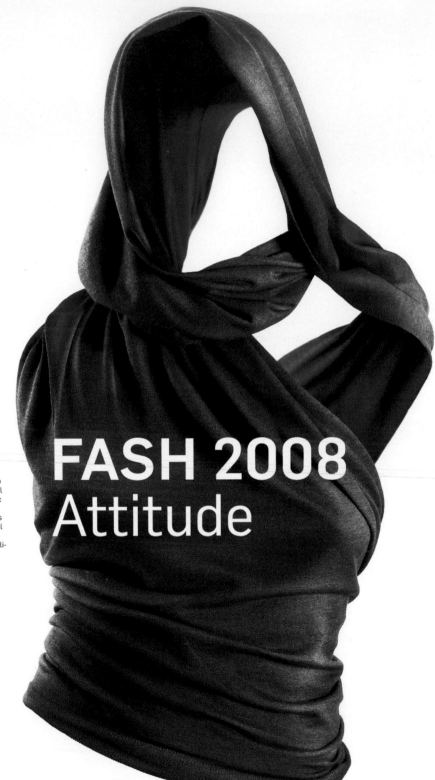

SDBI.DE

EUROPEAN FASHION AWARD

The task of the European Fashion Award „Fash 2008"
of the Stiftung der Deutschen Bekleidungsindustrie
(German Apparel Industry Foundation) – SDBI – is to
design fashion in tune with the environment and social
conditions, which provide expression to both aesthetic
and ethical attitudes.
Submissions can range from relevant partial solutions
all the way to realistic visions and even post-industrial
strategies.
The competition is open to design students of all dicipli-
nes in the fourth semester or higher, interdisciplinary
submissions are expressly requested.

Registration deadline: December 3rd, 2007

Prizes Graduates: 3.000/2.000/1.000 Euro

Prizes Students: 1.250 Euro/750 Euro/500 Euro,
Paid internships by Falke, Schumacher, Otto Group
5 Fabric vouchers at 500 Euros from
Swiss Textiles Federation

www.sdbi.de

FASH 2008
Attitude

Reimann Nardin, Gestaltung

> *Attitude* > poster > SDBI (project manager: Joachim Schirrmacher; in collaboration with Kasimir Reimann)

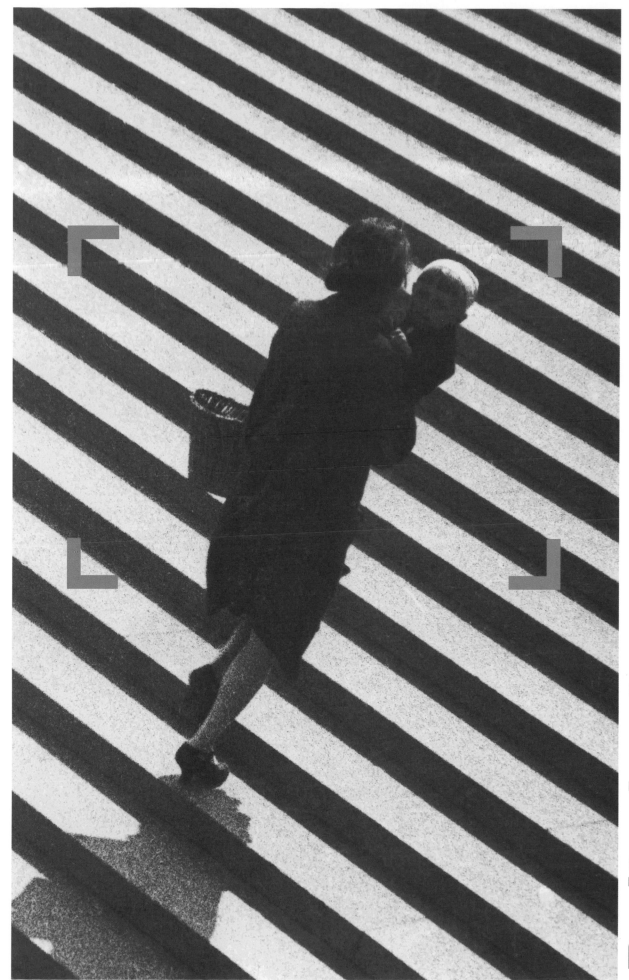

Rodtschenko

Москва
(Moskau – Fotografien
und Postkarten)

11NOV–**12**DEZ **04**
Sonntag bis Freitag 10 bis 18 Uhr
Donnerstag 10 bis 20 Uhr

Jüdisches Museum Wien
Dorotheergasse 11, 1010 Wien
www.jmw.at

> *Rodtschenko* > poster > Jewish Museum, Vienna

> *Landjäger,* issue 3 > magazine > Verein Landjäger

Landjäg

Fleisch

Landjäger No.3 Out Now! das unregelmäßige Magazin aus dem Wald
mit Thema um nur 4 Euro

Coup

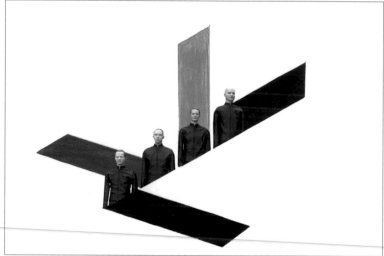

> *Kraftwerk illustrations* > illustrations > Partynews, Lausanne

Zeeburgerpad 51 bg
1019 AB Amsterdam
The Netherlands
+31 20 427 2584
hello@coup.nl
www.coup.nl

> Located in Amsterdam, the design studio Coup is formed by Peter van den Hoogen and Erica Terpstra. It was started in 1998 when Erica left her job at a printing press and united with Peter, who had already worked as a freelance designer after graduating from the Utrecht School of the Arts, where he now gives classes in typography and media communications. Together they began working for clients in the cultural sector with a combination of publishing, web design and television. Some of their clients are TPG Post, MTV Holland, the Rotterdam International Film Festival, the Stedelijk Museum in Amsterdam, VPRO, Submarine, Kunsthalle Fridericianum, Sonic Acts, Driessens & Verstappen, Felix Meritis and SICA. Their work centers on visual translation from a communicative point of view and is eclectic due to their conviction that each project is unique and should be communicated in its own exclusive way.

> 130

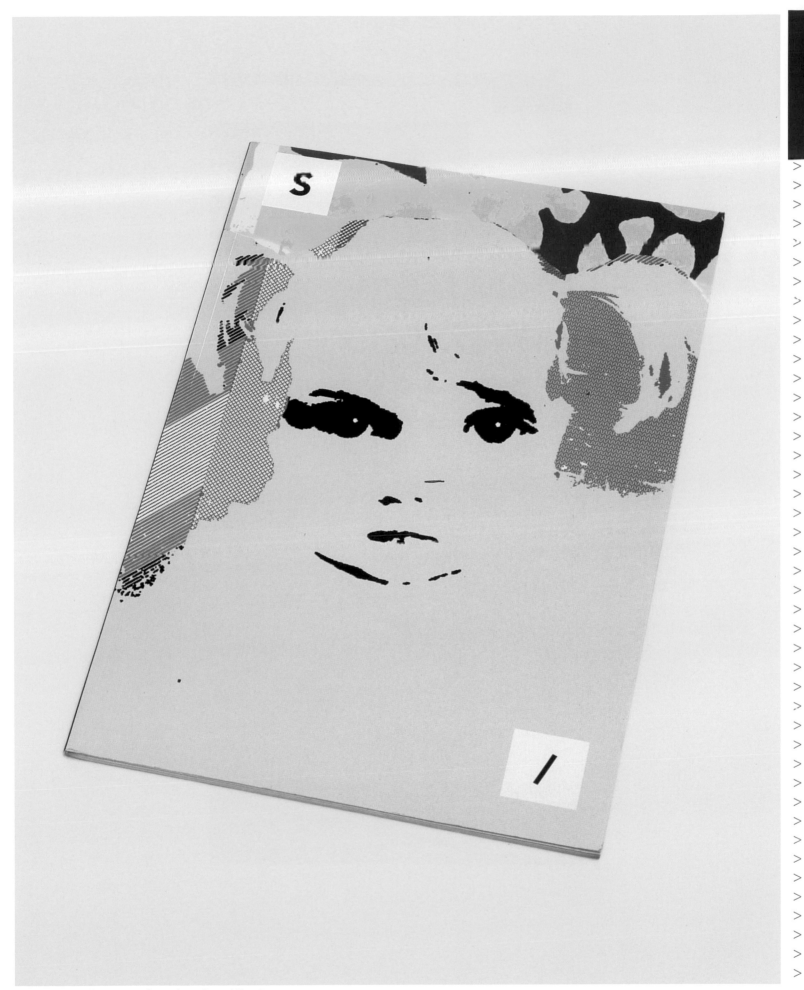

> *Cargo* > catalog > Kunstwerk Loods 6 Foundation

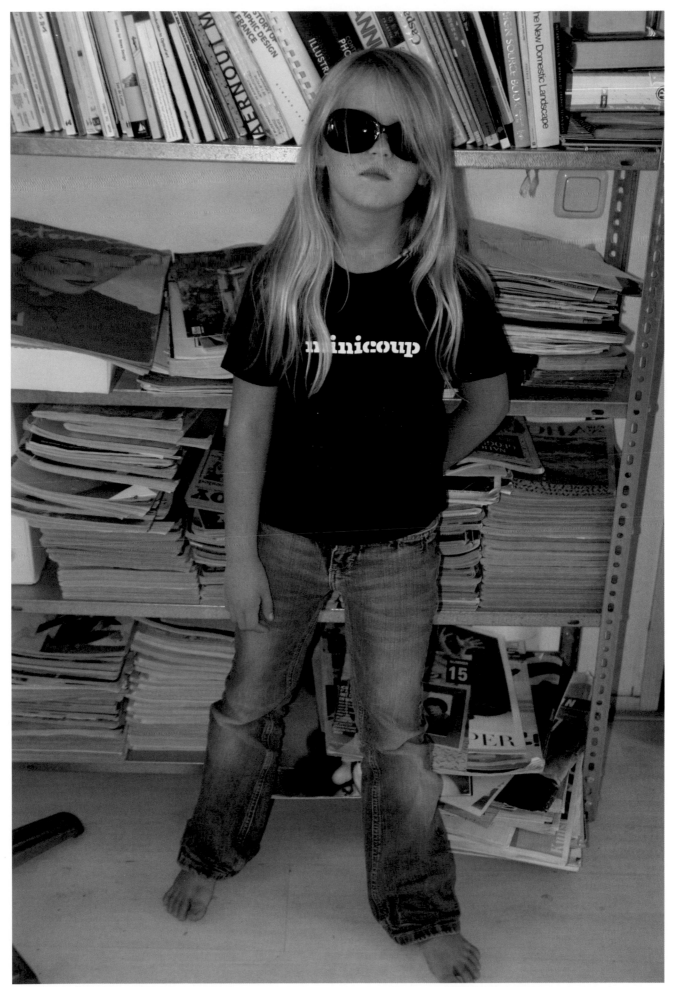

> *MiniCoup* > shirt > personal project

Sonic Acts XI
THE ANTHOLOGY OF COMPUTER ART
23-26 February 2006
Paradiso & De Balie, Amsterdam

www.sonicacts.com

Design by Coup, Amsterdam. http://www.coup.nl

SonicActsXI
THE ANTHOLOGY OF COMPUTER ART

http://www.sonicacts.com

Design by Coup, Amsterdam. http://www.coup.nl

Performances

23/02 Granular Synthesis [AT]
24/02 The Bug feat. Ras B [UK]
25/02 Matthew Dear [US]

Thursday February 23 - Sunday February 26, 2006
Paradiso, Weteringschans 6-8, Amsterdam, +31 20 6264521
De Balie, Kleine-Gartmanplantsoen 10, Amsterdam, +31 20 5535100
http://www.sonicacts.com

Conference passepartout: € 45,– (also valid for the performance programme)
Live Performances: € 12,50 incl. Films: € 6,25

SonicActs XI 2006 is supported by Paradiso, Mondriaan fonds, VSB fonds, Fonds voor
Podiumprogrammering en Marketing, Fonds voor Amateurkunst en Podiumkunsten,
Nederlands Fonds voor de Film, Thuiskopiefonds and Prins Bernhard Cultuurfonds.

23/02

OPENING PERFORMANCES
Granular Synthesis [AT]
Curtis Roads & Brian O'Reilly [US]

24/02

DJ /RUPTURE PRESENTS:
The Bug feat. Ras B [UK]
Beans [US]
Ghislain Poirier [CA]
Vex'd [UK]
DJ /rupture & No Lay & G-Kid [UK]
Team Shadetek presents:
Heavy Meckle feat. Matt Shadetek,
Sheen, Jammer & Skepta [UK/US]
Hrvatski [US]
Aaron Spectre [US]
Ove-Naxx [JP]
Scotch Egg [JP]
Doddodo [JP]
Akuvido [UA]
DJ Sheen [DE]
Drop the Lime [US]
Filastine [US]
Planning to Rock [DE]
Nettle [ES]
2/5 BZ [TU]
Gustav [AU]
Toktek & MNK [NL]

25/02

Matthew Dear [US]
Reinhard Voigt [DE]
Ada [DE]
TBA [DE]
AGF & SUE.C [DE/US]
Moha! [NO]
SKIF & Bas van Koolwijk [US/NL]
OfficeR(6) [NL/US/NO]
Nancy Fortune [FR]
Boris & Brecht Debackere [BE]
Jason Forrest [US]
Erich Berger [AT]
TinyLittleElements [AT/DE]
Portable [ZA]
NotTheSameColor [AT]
Anne Laplatine [FR]

SA.XI FLYER 4. CONFERENCE FILM *PERFORMANCES* EXHIBITION

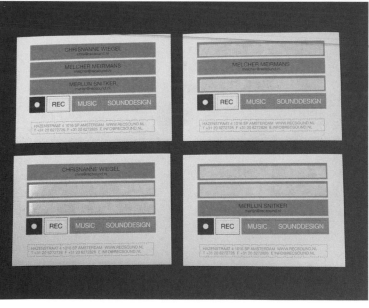

> Brand identity > Recsound

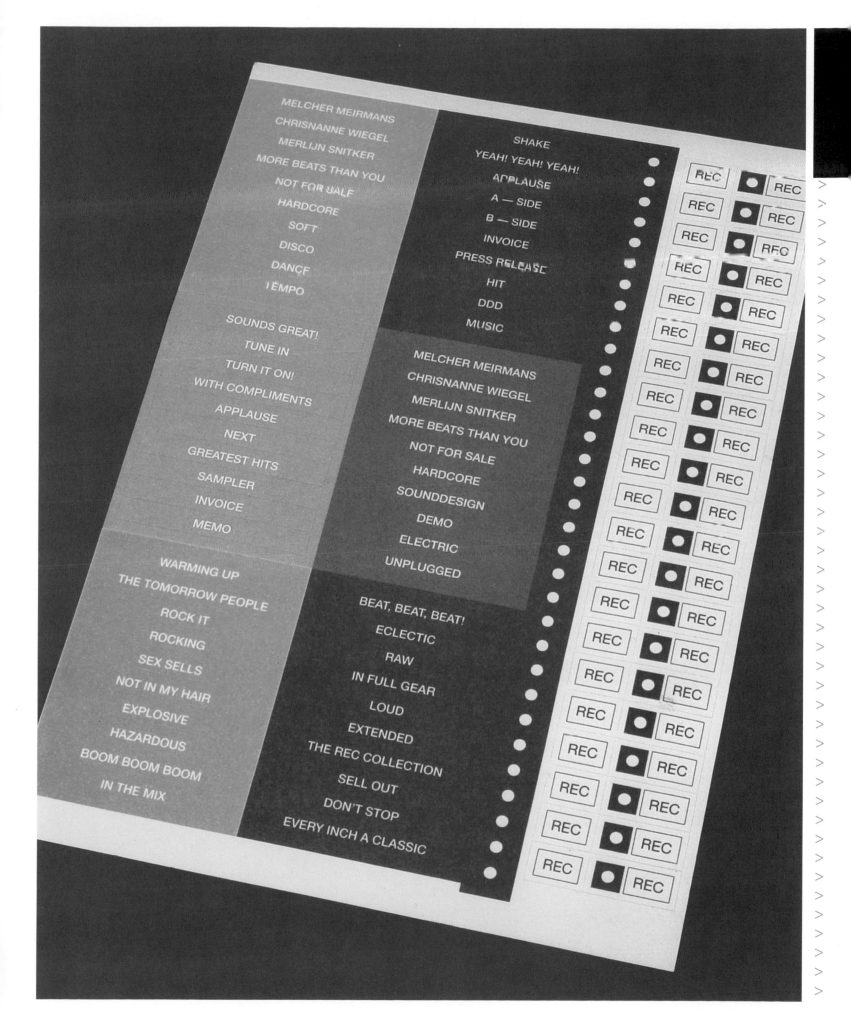

De Designpolitie

> Poster > Hilversum Museum

Graaf Florisstraat 1a
1091 TD Amsterdam
The Netherlands
+31 20 4686 720
studio@designpolitie.nl
www.designpolitie.nl

> Founded by Richard van der Laken and Pepijn Zurburg, De Designpolitie is a graphic design studio based out of Amsterdam (The Netherlands), consisting of a small group of ambitious creative talents. The members were raised with the Dutch design culture and the rich Dutch traditions of art, design and tolerance. Following these traditions, De Designpolitie uses methods that are simple yet ruthless. This Dutch studio is famous for their contemporary, apparently simple and direct approach to graphic design, which, generally, introduces vibrant colors and sans serif typography for a lively and fun style. Their work process often culminates in a stripped image that becomes a critical, yet always communicative, solution. This group of designers has worked for large and small clients from the commercial sector as well as for non-profit organizations.

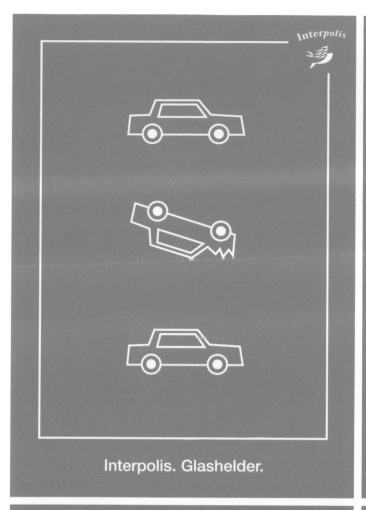

Interpolis. Glashelder.

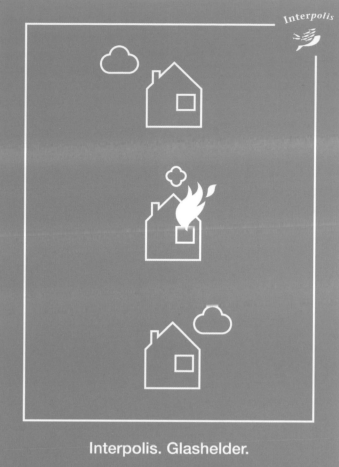

Interpolis. Glashelder.

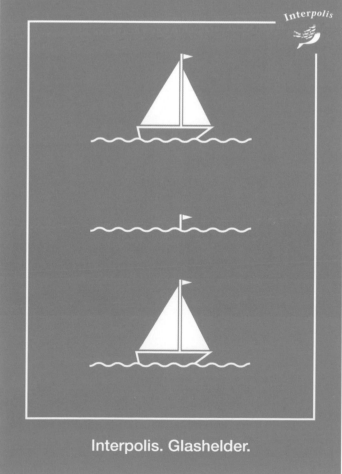

Interpolis. Glashelder.

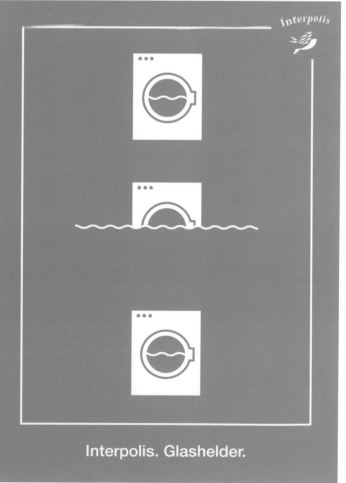

Interpolis. Glashelder.

MUSEUMHILVERSUM <<< >

/// /// \\\ /// \\\ /

Bulletin #01) ((())

>> <<< >>> <<< >>> <<

DROMEN VAN AMERIKA \\

))) ((())) ((())) (

NEDERLANDSE << >>> >>

/ /// \\\ /// \\\ ///

ARCHITECTEN EN))) ((

>>> <<< >>> <<< >>> <

FRANK LLOYD WRIGHT //

) ((())) ((())) (((

Bulletin #01 << >>> <

/ /// \\\ /// \\\ ///

MUSEUMHILVERSUM ((()

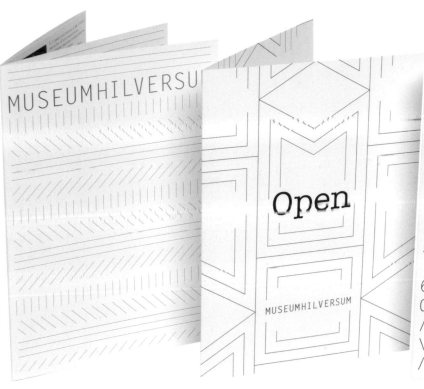

MUSEUMHILVERSUM

\/ MUSEUMHILVERSUM /\
/\ 2006 /\/\/\ 2006 /
\ 2005 /\/\/\ 2005 /\
/\/\/ 2006 \/\/\/ 200
\ 2005 /\/\/\ 2005 /\
/\/\/ 2006 \/\/\/ 200
5 \/\/\/ 2005 \/\/\/
\/\/\/\ AGENDA /\/\/\
/\ 2006 /\/\/\ 2006 /
2005 \/\/\ 2005 /\/\
6 \/\/\/ 2006 \/\/\/
005 /\/\/\ 2005 /\/\/
/\ 2006 /\/\/\/\ 2006
\ 2005 /\/\/\ 2005 /\
/\/\/ 2006 \/\/\/ 200

HI TURKISH ARMY! MAY WE HAVE YOUR VOTES PLEASE?

Gorilla

OORLOG
HONGEROORLO
GHONGEROORLOG
HONGEROORLOGHO
NGEROORLOGHONGE
ROORLOGHONGEROOR
LOGHONGERO
ORLOGHON
EROORLO
GHONGER
OORLOGH O
NGERO O
RLOG

Gorilla

ART=

ART=

A T=

ART=

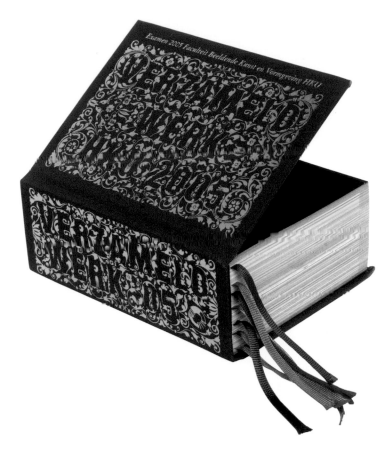

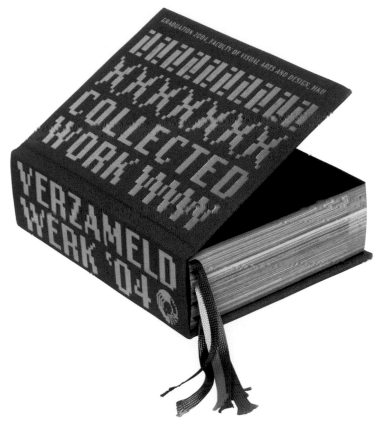

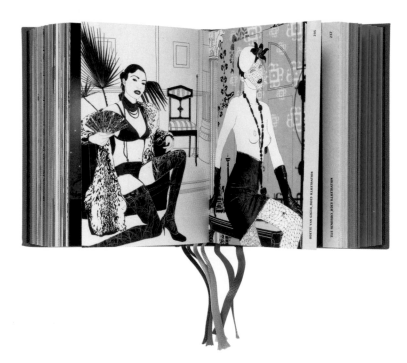

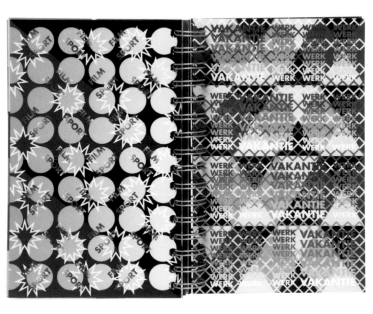

Design Science Office

> Poster > Modus Publicity

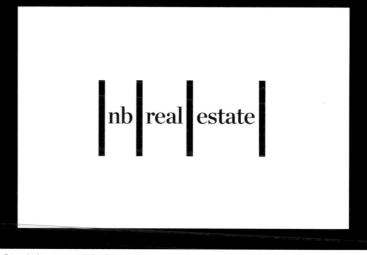

> Brand identity > NB Real Estate

8 Hatton Place
EC1N 8RU London
United Kingdom
+44 207 430 1020
info@designscienceoffice.com
designscienceoffice.com

> The influence of classic Swiss design combined with the task of art director for some of the most luxurious firms in the world have defined Micha Weidmann's career. At the start of his career he worked on corporate designs in collaboration with other studios in Geneva and Basel. In 1997, he moved to London, spending four years working exclusively in advertising and publishing design for the fashion industry. This experience led to his working as an art director for the biannual women's fashion magazine *The Fashion* and to his designing the Tate Modern exhibitions and publications. His ability for publishing design led to his redesigning the Swiss newspaper *Le Temps*, after which he directed the redesigning of *Time Out* magazine. Micha Weidmann teaches typography at the Bern School of Graphic Design while still serving as a member of the jury on international photography and design contests.

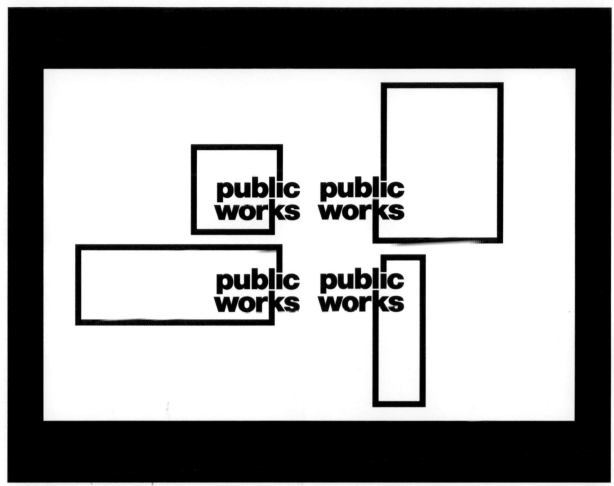

> Brand identity > Public Works

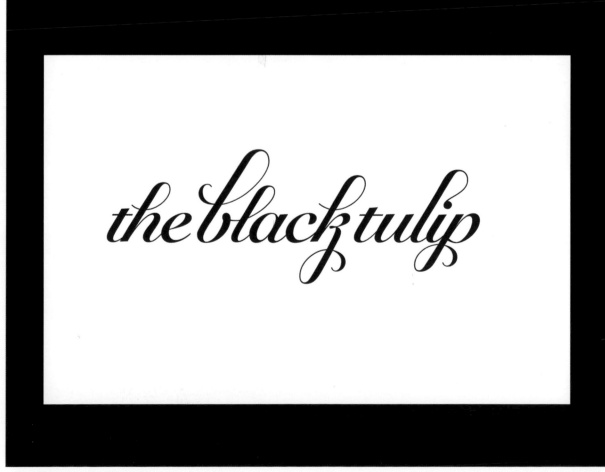

> Brand identity > The Black Tulip

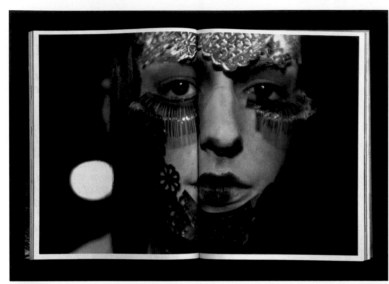

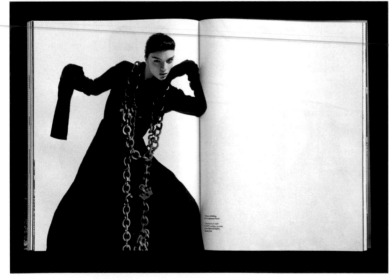
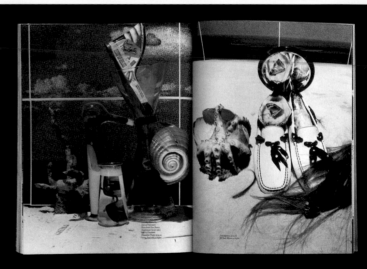

> Magazine > *The Fashion*

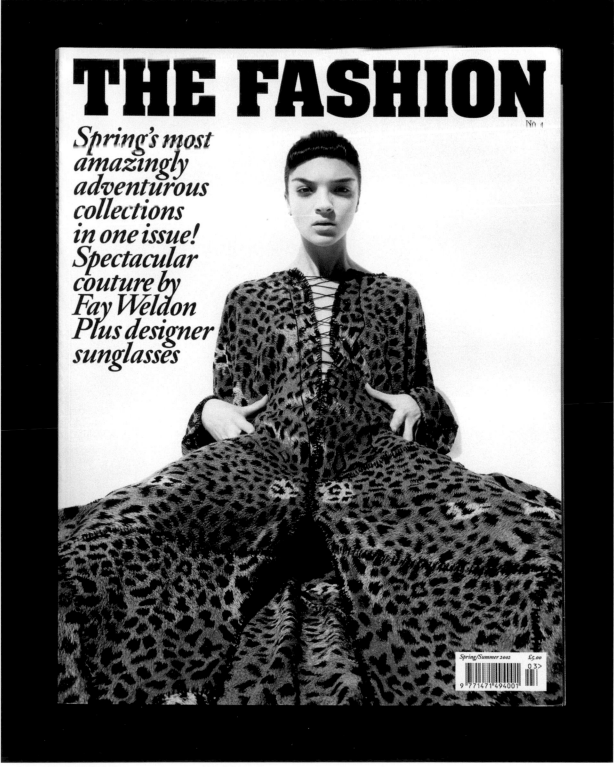

> Cover > *The Fashion*

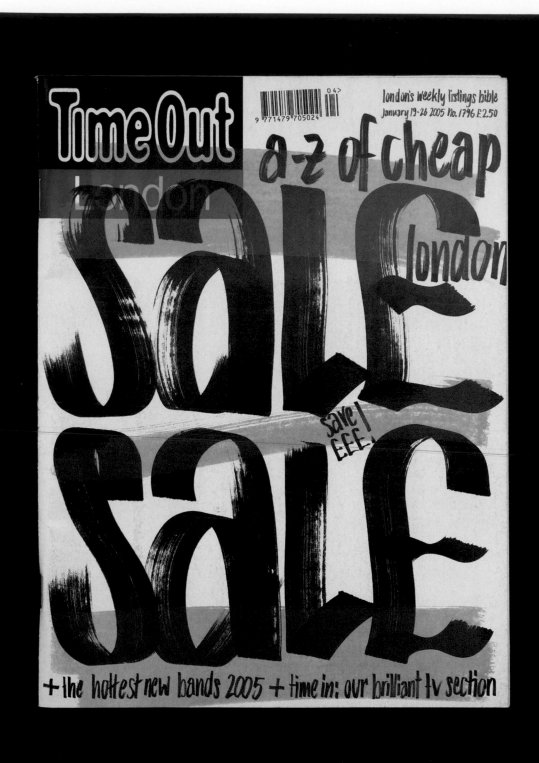

Time Out
London

LONDON'S WEEKLY LISTINGS BIBLE
JULY 13-20 2005
No.1821 £2.50

OUR CITY

LONDON CARRIES ON

dog design

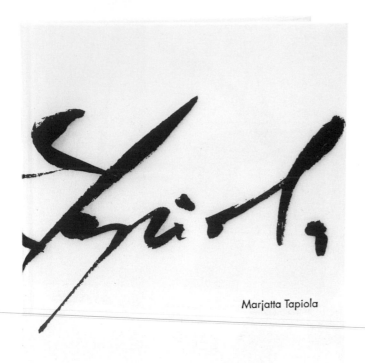

Marjatta Tapiola

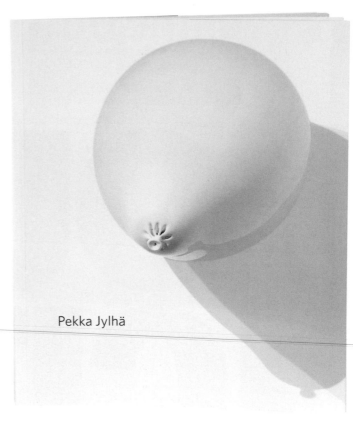

Pekka Jylhä

> *Marjatta Tapiola* > cover > Teos

> *Pekka Jylhä* > cover > Teos

Tallberginkatu 1 c 145
00180 Helsinki
Finland
+358 9 693 2343
dog@dogdesign.fi
www.dogdesign.fi

> The Finnish trio of Ilona Ilottu, Petri Salmela and Eeva Sivula are the creators of Finland's dog design, a design studio that offers a variety of work in graphic design, illustration and art direction. These Helsinki-established designers trained at the same city's University of Art and Design. dog design strives to offer its clients innovative solutions in an informal fashion and without preconceived notions. Their functional expressions demonstrate a pure and subtle contemporary Finnish design. Their clients include large companies and more experimental projects. dog design has received various awards from Finland's Grafia Association of Graphic Designers and the annual award from the Finnish Book Arts Committee. The studio has represented Finnish design in various Finnish and foreign publications. Moving easily between art and design, dog design always finds inspiration.

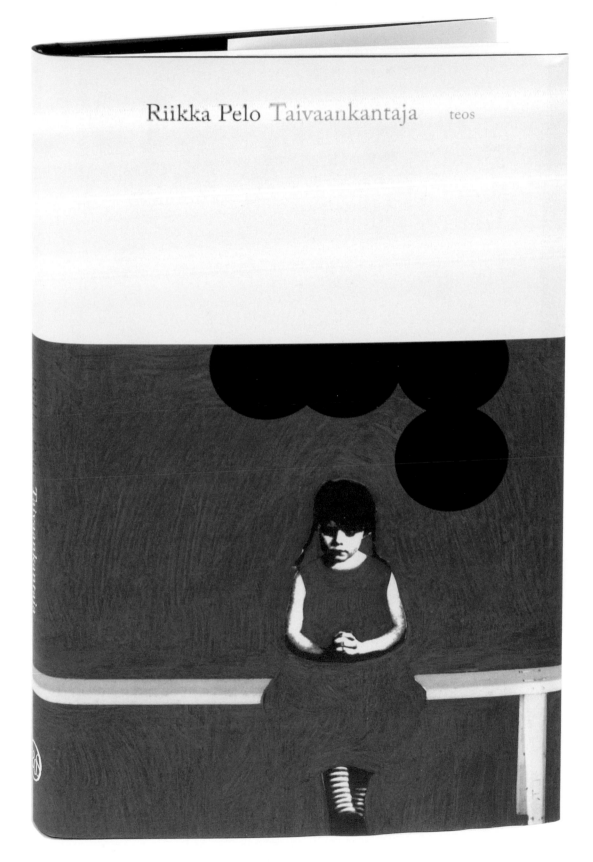

> *Riikka Pelo* > cover > Teos

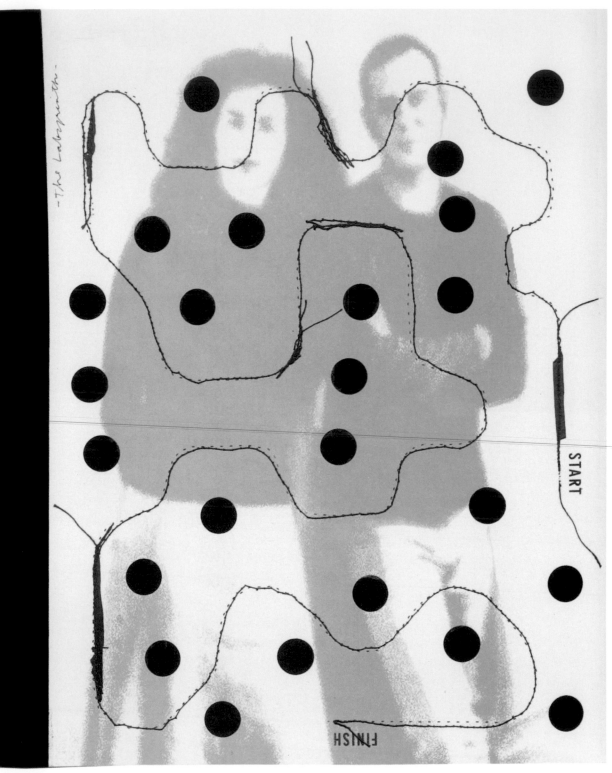

> Illustration by Eeva Sivula > *Anna* magazine

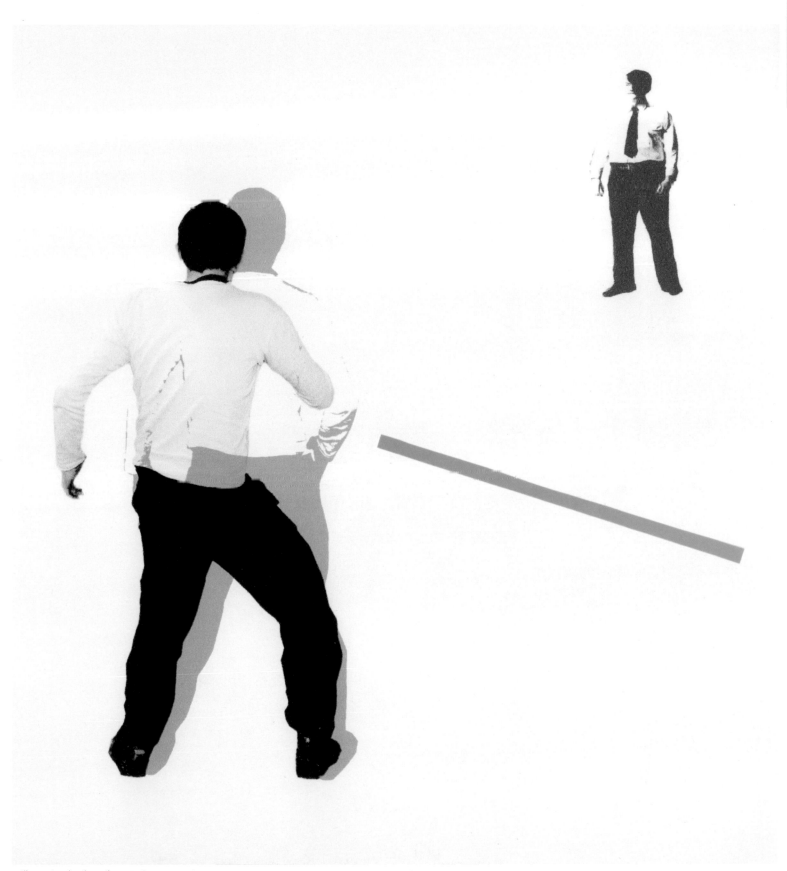

> Illustration by Ilona Ilottu > *Anna* magazine

SEMI-FINAL
AFTER PARTY

OFFICIAL PROGRAM

> Brand identity > ESC

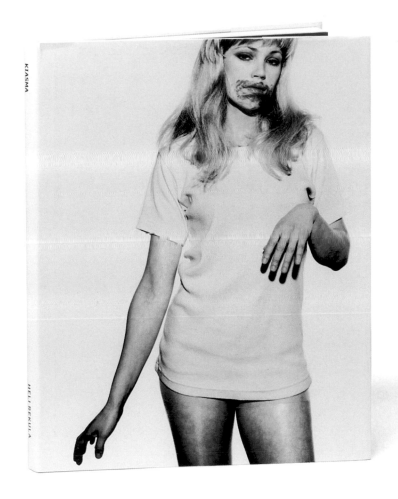

> *Heli Rekula* > catalog > Kiasma Museum of Contemporary Art

> *Helena Kallio* > cover > Teos

> *Leena Krohn Mehiläis-paviljonki* > cover > Teos

> *Edgar Allan Poe* > cover > Teos

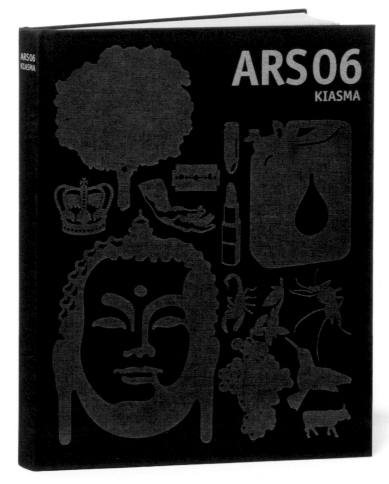

> *ARS 06* > catalog > Kiasma Museum of Contemporary Art

Eduard Cehovin

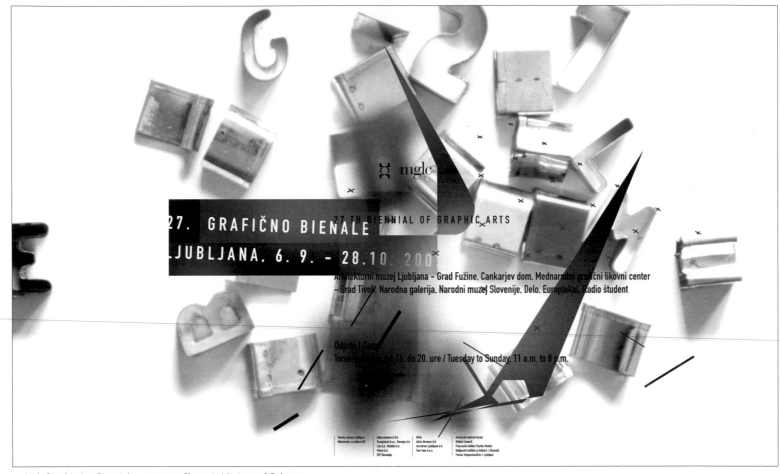

> *27th Graphic Arts Biennial* > posters > Slovenia Ministry of Culture

Knezova 30
1000 Ljubljana
Slovenia
+386 1 519 50 72
eduard.cehovin@siol.net
www.cehovin.com

> As an associate professor, Eduard Cehovin teaches typography in the Design Department of the Academy of Fine Arts at Ljubljana University. He graduated from the Faculty of Applied Arts, Department of Graphic Design, Graphic Communication and Typography in Belgrade. Eduard Cehovin has received many of the most prestigious international awards, like: D&AD UK, the Art Directors Club, and the Good Design Award. His work has been published in most of the international graphic design publica-

tions, such as: *Étapes* (France), *Novum* (Germany), *Linea Grafica* (Italy). His works are included in the permanent collections of the International Trademark Center in Belgium, the Museum of Applied Arts in Croatia, and the contemporary collection at Les Silos—House of the Book and Poster—in Chaumont. Currently, he is a member of the Friends of Icograda (International Council of Graphic Design Association) and is a member of the Type Directors Club of New York.

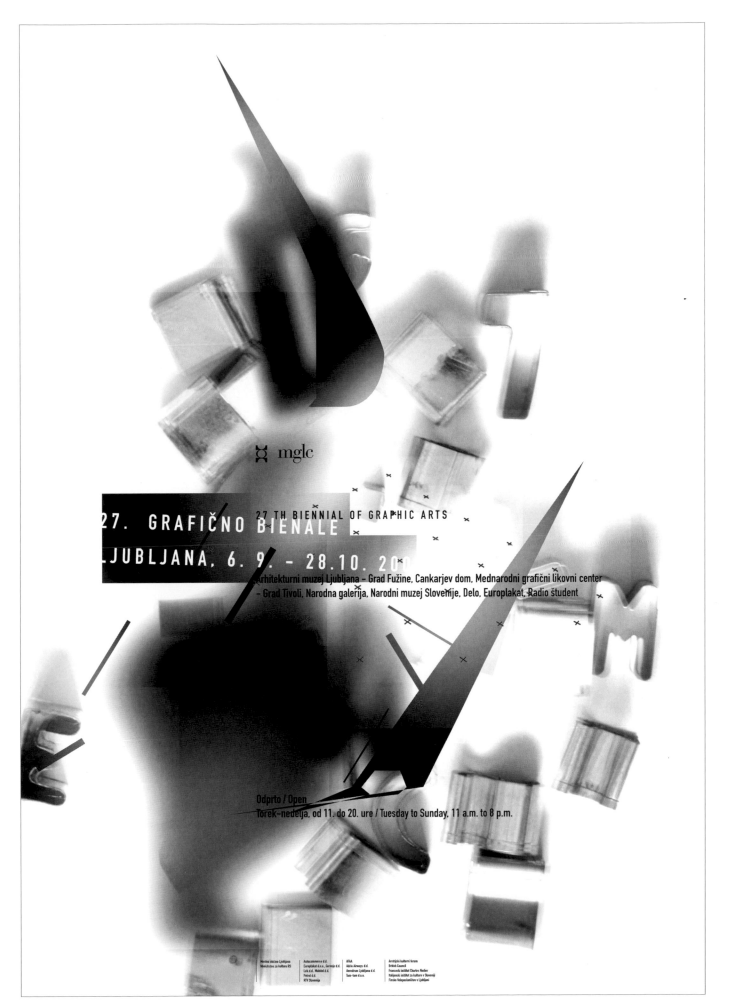

27. GRAFIČNO BIENALE
27 TH BIENNIAL OF GRAPHIC ARTS
LJUBLJANA, 6. 9. – 28.10. 20

mglc

Arhitekturni muzej Ljubljana – Grad Fužine, Cankarjev dom, Mednarodni grafični likovni center
– Grad Tivoli, Narodna galerija, Narodni muzej Slovenije, Delo, Europlakat, Radio študent

Odprto / Open
Torek–nedelja, od 11. do 20. ure / Tuesday to Sunday, 11 a.m. to 8 p.m.

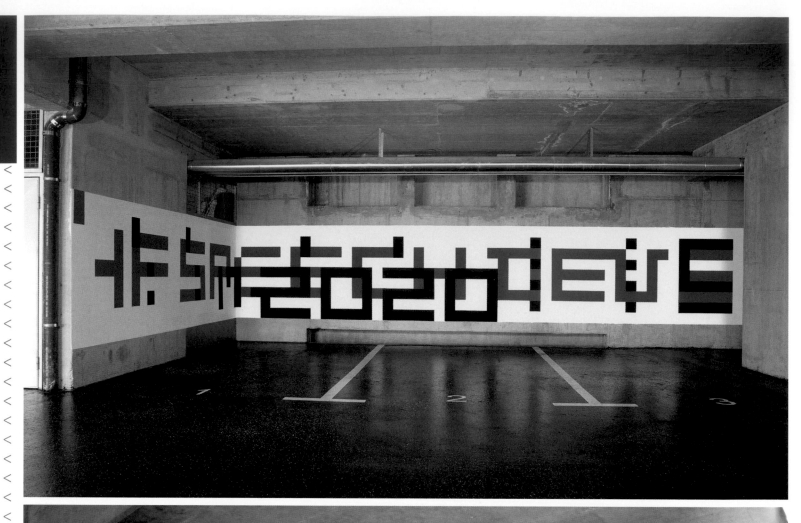

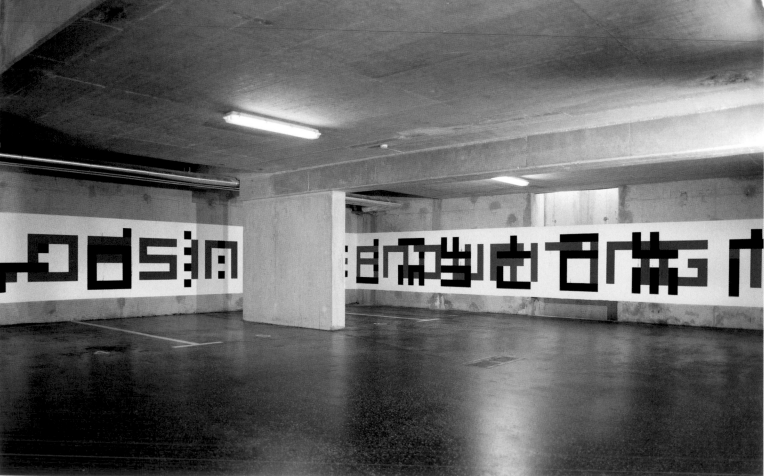

> *Europe 2020* > mural painting > IEDC-Bled School of Management

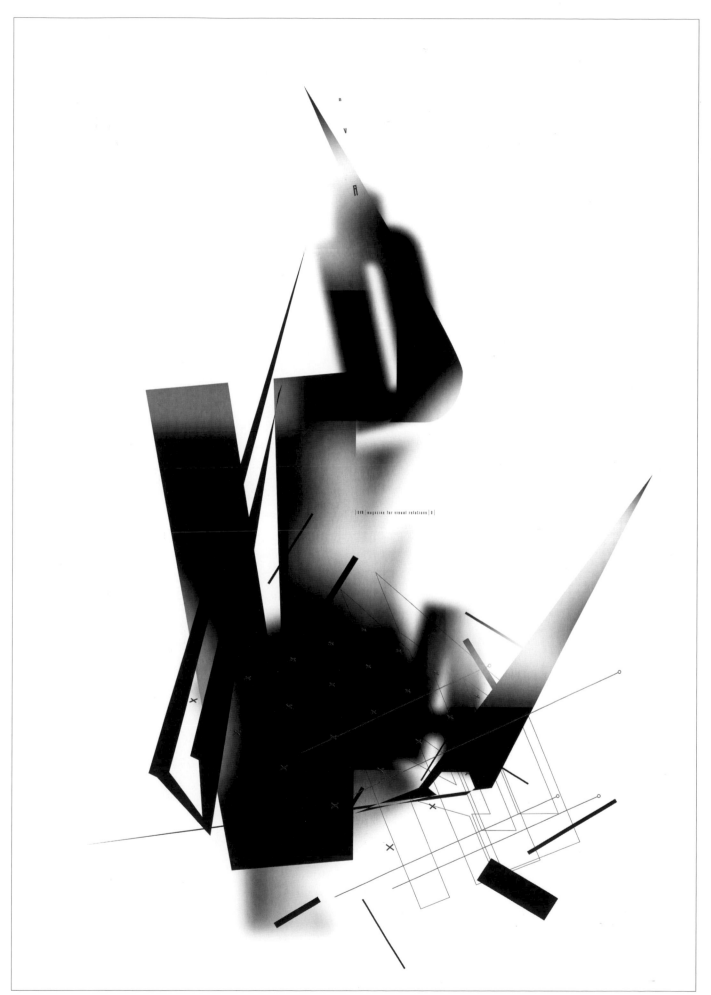

DVA

|DVA|magazine for visual relations|0|

> Cover > *DVA-Magazine for Visual Relations*

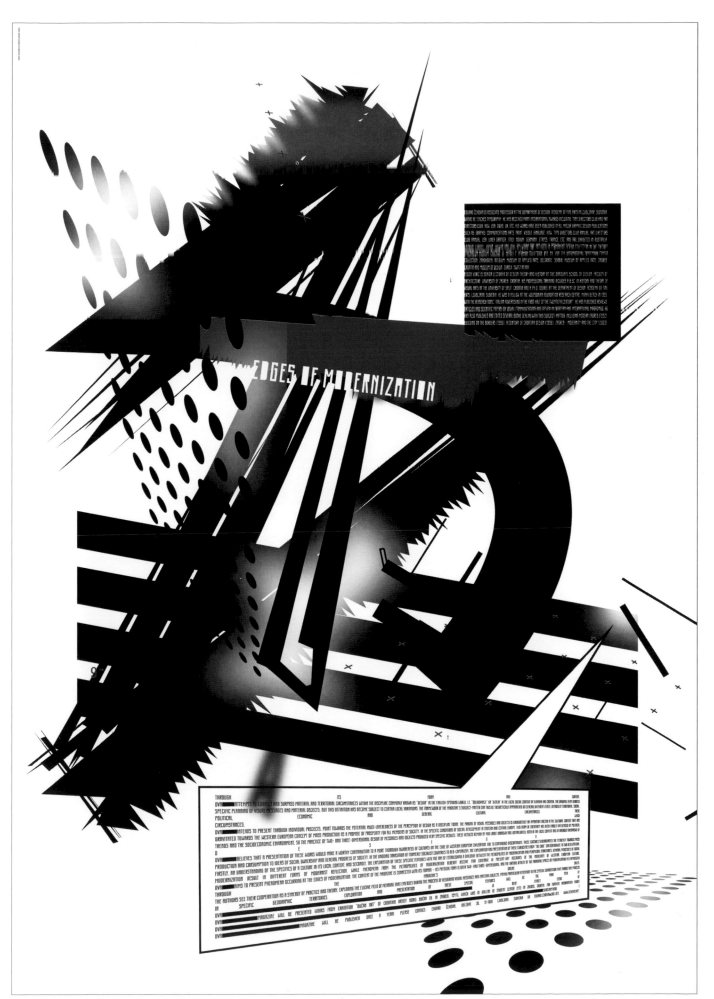

EDGES OF MODERNIZATION

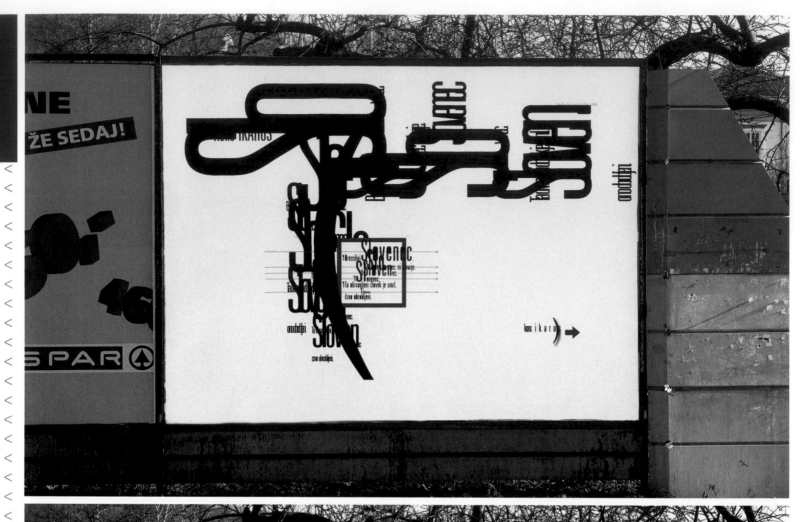

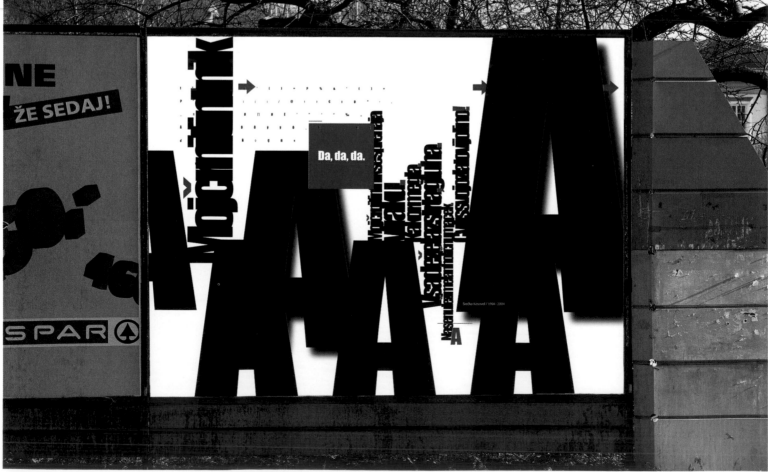

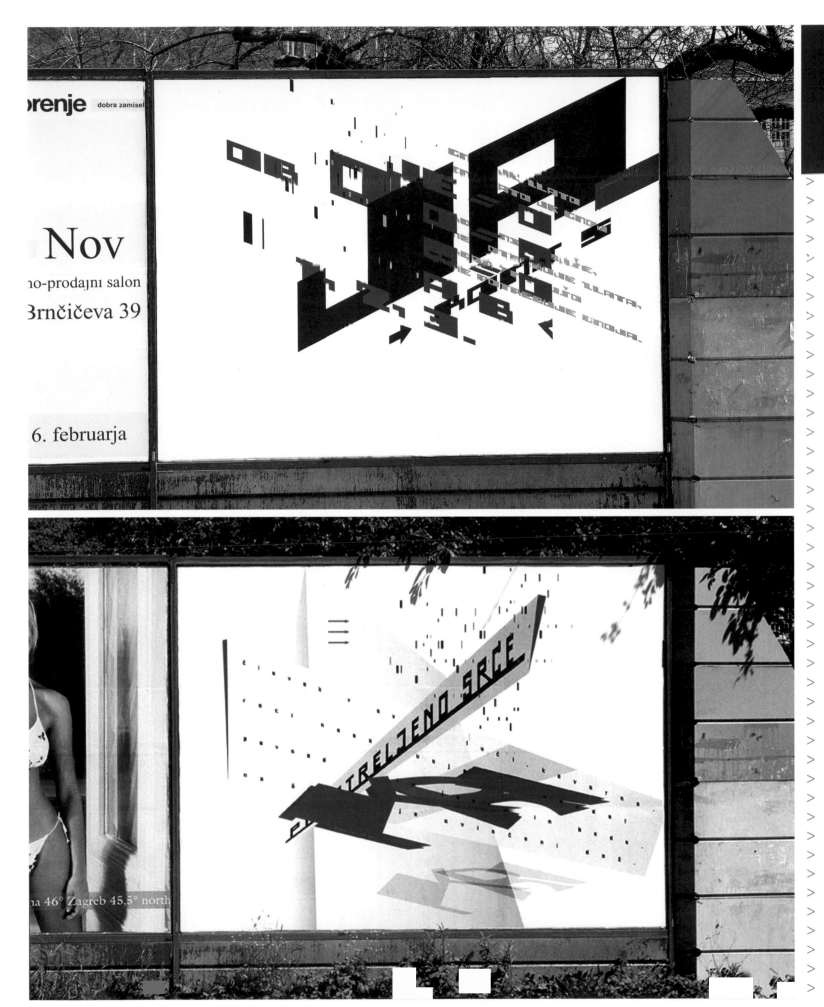

Félix Beltrán

> Poster > Metropolitan Autonomous University of Mexico

> Postcard > International Biennial of Brno

Apartado Postal M-10733
Mexico City 06000
Mexico
+52 55 5752 8634
felixbeltran@att.net.mx

> Now a Mexican citizen, Félix Beltrán was born in La Habana (Cuba) in 1938. Later he travelled to the United States, where he received diplomas from the School of Visual Arts and the American Art School, both in New York. He received scholarships from the New School for Social Research and the Graphic Arts Center-Pratt Institute in New York and from the Council for International Exchange of Scholars in Washington, D.C. At national and international levels, his work has been in 456 collective exhibitions and 66 individual exhibitions. He has received 132 awards in various events and an honorary degree in the arts from the International University Foundation in Delaware. Now he is an associate professor at the Metropolitan Autonomous University of Mexico, a curator at the Galería Artis and the Archive of International Graphic Design, and he is also a member of the International Graphic Alliance in Zurich and the American Institute of Graphic Arts in New York, among other institutions.

> Cover > European Institute of Design

> Cover > Metropolitan Autonomous University of Mexico

DIVADLOSVET

EDUARDO VIGGIANO

EL DISEÑO COMO ACTITUD

NIKLAUS
TROXLER'S
 60TH BIRTHDAY **NIKLAUS**
 TROXLER'S
 NIKLAUS **60TH BIRTHDAY**
 TROXLER'S
 60TH BIRTHDAY
 NIKLAUS
TROXLER'S
 60TH BIRTHDAY **NIKLAUS**
 TROXLER'S
 NIKLAUS **60TH BIRTHDAY**
 TROXLER'S
 60TH BIRTHDAY
 NIKLAUS
TROXLER'S
 60TH BIRTHDAY **NIKLAUS**
 TROXLER'S
 NIKLAUS **60TH BIRTHDAY**
 TROXLER'S
 60TH BIRTHDAY
 NIKLAUS
TROXLER'S
 60TH BIRTHDAY **NIKLAUS**
 TROXLER'S
 NIKLAUS **60TH BIRTHDAY**
 TROXLER'S
 60TH BIRTHDAY

Invitación

Diseño Gráfico de Enric Satué

Barcelona

Lunes
Marzo 12 de 2001
20:00 horas

Galería Artis
Universidad Autónoma Metropolitana
San Pablo 180
Colonia Reynosa Tamaulipas
México DF
México

> Poster > Niklaus Troxler Design

> Invitation > Metropolitan Autonomous University of Mexico

Fons Hickmann m23

 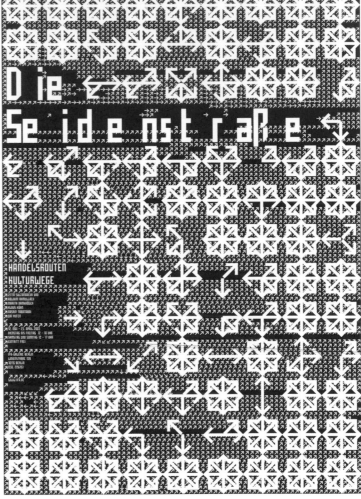

> *The Silk Road* > posters > ifa Gallery > photo: Klaus Kühn

Mariannenplatz 23
10997 Berlin
Germany
+49 30 695 18501
m23@fonshickmann.com
www.fonshickmann.com

> The Berlin studio Fons Hickmann m23 specializes in designing complex systems of communication. This field brings together corporate design, book and poster design, magazine and digital media design. This studio is among the world's most famous design studios, having garnered its fame thanks to its commitment to the social and cultural sphere. Their work is conceptual and analytical while still remaining fun. Fons Hickmann is a professor at the Berlin University of the Arts and a member of the Art Directors Club and Type Directors Club of New York and the International Graphic Alliance. Fons Hickmann m23 consists of a web of designers, musicians and theoreticians; it is directed by Gesine Grotrian-Steinweg, Markus Büsges and Fons Hickmann. Some of their publications include: *Touch Me There* (Die Gestalten Verlag, 2005), and *5 x Berlin* (Pyramid Press, 2006). They have received over 199 international awards like the Red Dot and the Moscow Golden Bee Award.

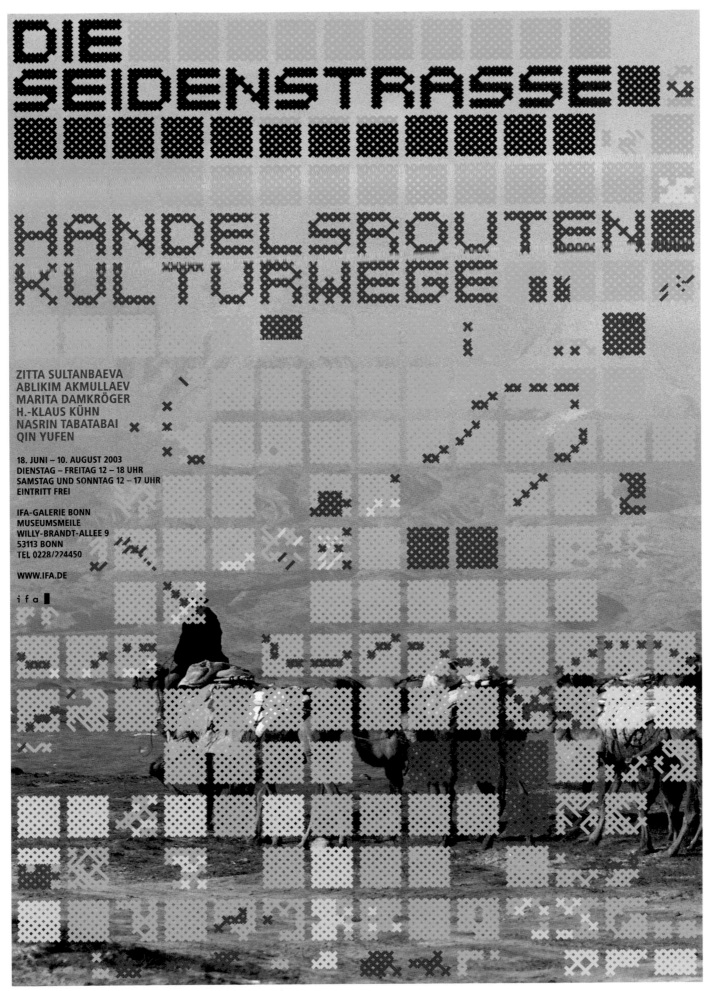

> *11 Designer for Germany* > posters > 2006 World Cup > photo: Simon Gallus

11
Fons Hickmann m23

7
moniteurs

9
Hesse Design

10
nowakteufelknyrim

8
ade hauser lacour

Elf Designer für Deutschland
Offensive für die Fußball WM 2006

Präsentation: elf neue WM Logos
am 15. März 2003, 13 Uhr

Universität der Künste Berlin
Hörsaal 158, Hardenbergstraße 33

Noch ist nichts verloren
www.11designer.de

6
cyan

4
büro uebele

5
Factor Design

3
Die Gestalten

2
Integral Ruedi Baur

1
Uwe Loesch

STUMMFILM-TAGE GRAZ

20.-30.11.96

Als Augen noch sprechen konnten

> *Als Augen noch sprechen konnten* > poster > Silent Movie Festival > photo: Filmmuseum Development

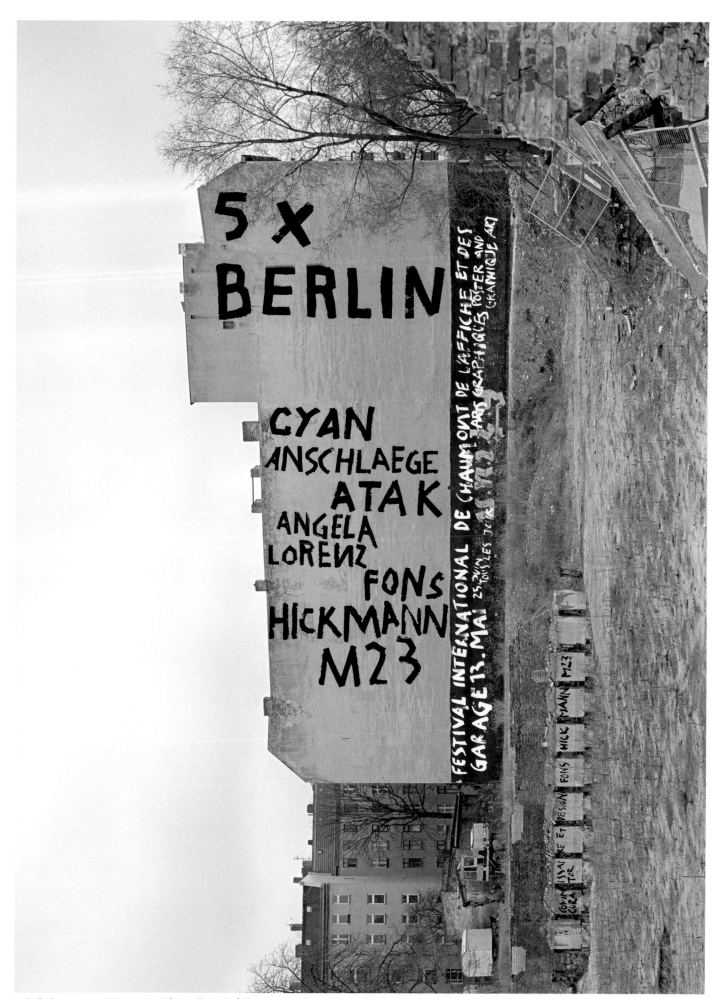

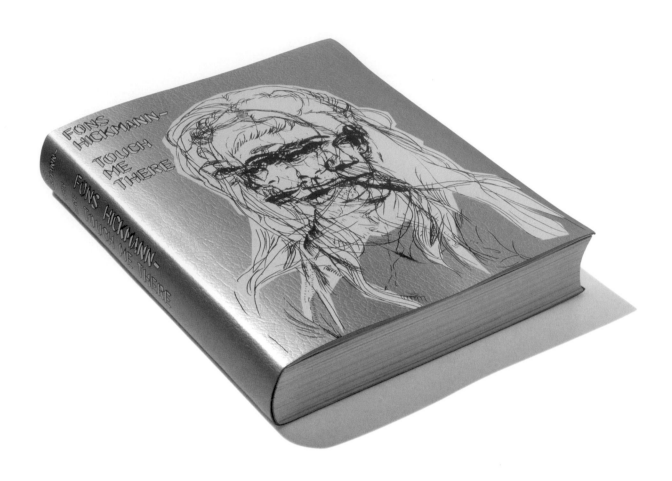

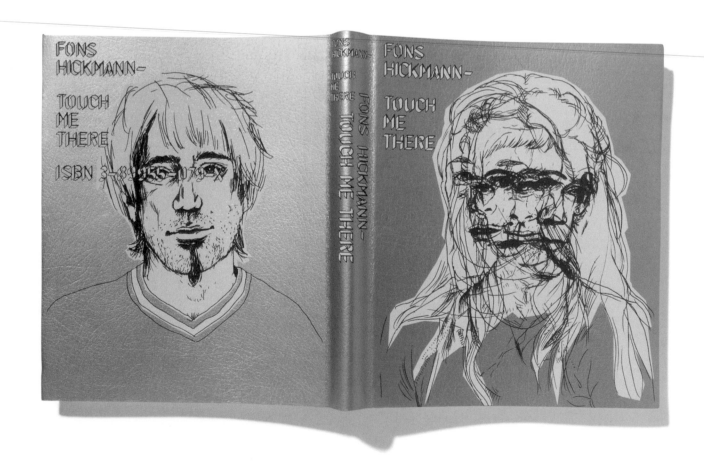

> *Fons Hickmann-Touch Me There* > cover > Fons Hickmann m23 > photo: Simon Gallus

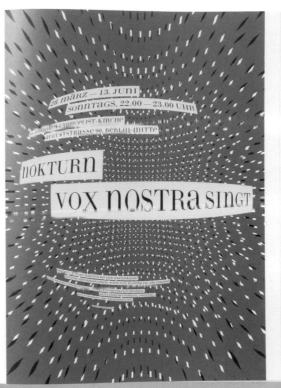

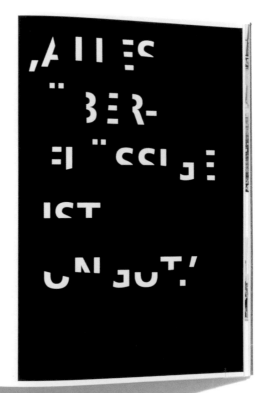

> *Fons Hickmann-Touch Me There* > book > Fons Hickmann m23 > photo: Simon Gallus

ODER DIE VERHINDERUNG
DES REISENS

EDGAR ENDRESS
TANJA OSTOJIC
MARCOS LORA READ
EMEKA UDEMBA

9. APRIL BIS 1. JUNI 2003
DIENSTAG BIS FREITAG 12–18 UHR
SAMSTAG UND SONNTAG 12–17 UHR

IFA-GALERIE BONN
MUSEUMSMEILE
WILLY-BRANDT-ALLEE 9
53113 BONN

TEL 0228 / 22 44 50

EINTRITT FREI

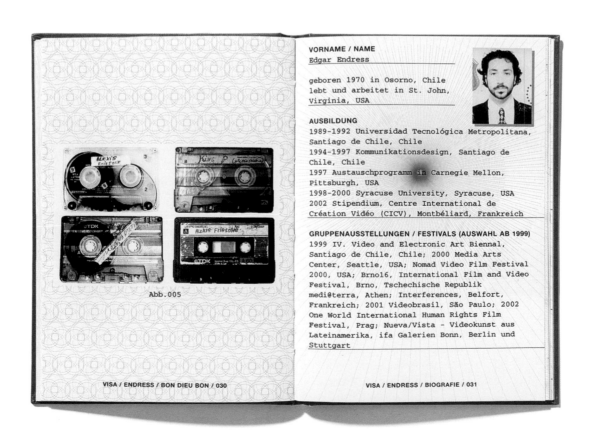

Frost Design

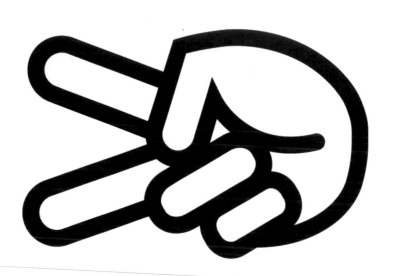

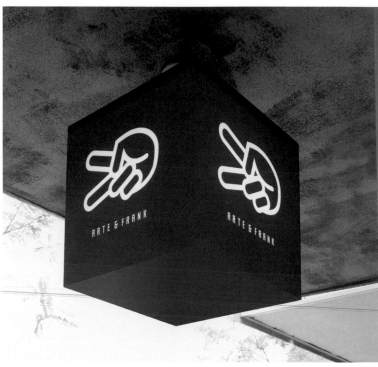

> Logo > Arte & Frank Salon > photo: John Gollings

1st Floor
15 Foster Street
Surry Hills
Sydney NSW 2010
Australia
+61 2 9280 4233
info@frostdesign.com.au
www.frostdesign.com.au

> A member of the CSD, D&AD, ISTD, AGDA and AGI, Vince Frost actively participates in the world design community, giving classes at universities and offering conferences. He started the Frost Design studio in London in 1994 and since then has received many awards. In 2004 he moved to Sydney where he continues to work for clients from the world over and receive international acclaim. The studio boasts a team of 30 people specialized in diverse subjects, from graphic and multimedia designers to architects, from the designing of interiors to corporate identities. While working on a variety of projects, from designing magazines and books to environmental graphics and interactive design, Frost's main focus is to provide exceptional ideas and listen carefully to each client's needs so as to offer tailored designs that make each project the best it can be.

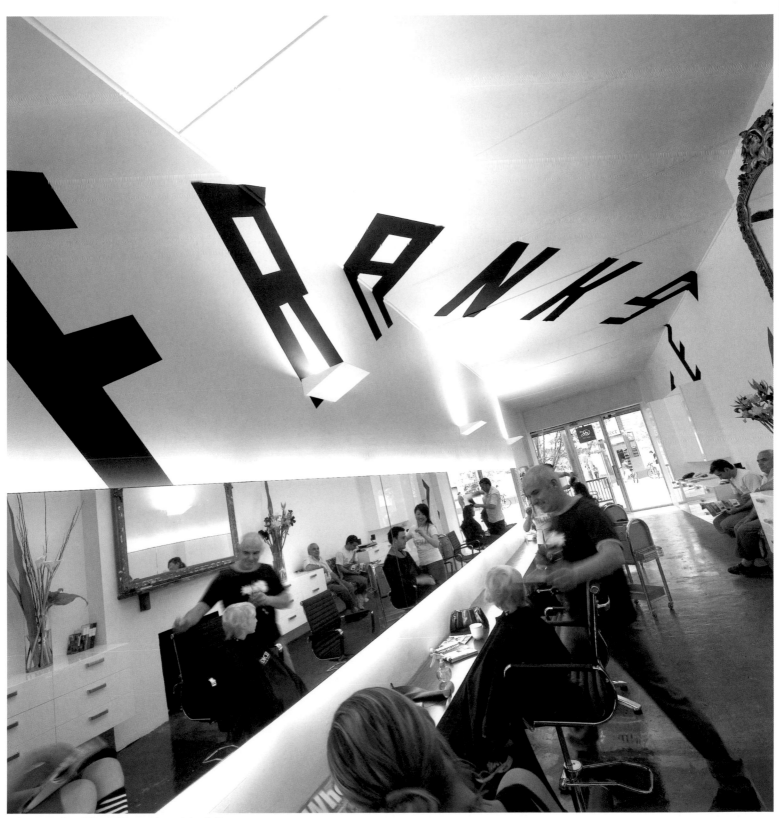

> Interior > Arte & Frank Salon > photo: John Gollings

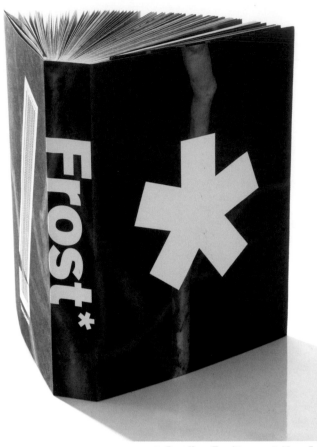

> *Frost (Sorry Trees)* > cover > Vince Frost

When I was at art college, I was encouraged to keep an 'ideas book', a scrapbook of doodles, sketches, anything I found interesting or inspiring. It taught me to open my eyes to everything around me – and to use and trust my intuition. Today, however, our high-tech busy lives mean designers are spending more and more time in front of a computer screen. In this sense, there is very little difference between a bank and a design studio. What used to be a physically creative process has become automated to such a degree that one all-singing, all-dancing plastic box (albeit a damn good looking one) not only delivers our mail and takes our calls, it also does everything else too – all at the click mouse. I would encourage everyone to keep a visual diary – a physical manifestation of your thoughts and ideas – and use it to make those ideas a reality. Work hard and enjoy the process. Collaborate with and enjoy your clients. Bring many flavours to the picture but always be open to new opportunities. This is my 'ideas book'. I hope it will inspire and trigger ideas in you. Vince Frost, Sydney, January 2006.

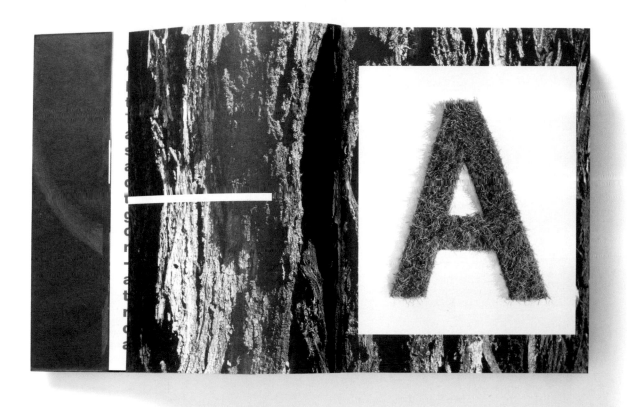

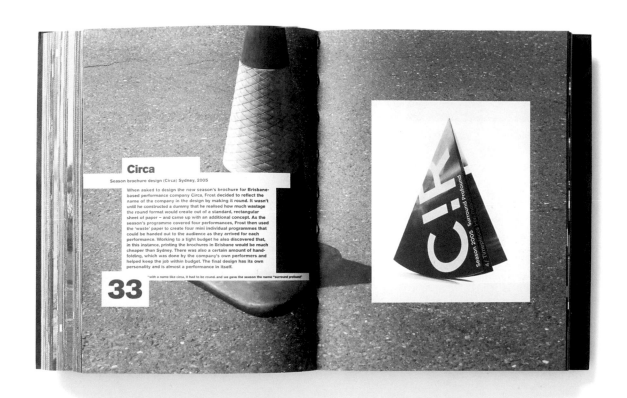

Circa

Season brochure design (Circa) Sydney, 2005

When asked to design the new season's brochure for Brisbane-based performance company Circa, Frost decided to reflect the name of the company in the design by making it round. It wasn't until he constructed a dummy that he realised how much wastage the round format would create out of a standard, rectangular sheet of paper – and came up with an additional concept. As the season's programme covered four performances, Frost then used the 'waste' paper to create four mini individual programmes that could be handed out to the audience as they arrived for each performance. Working to a tight budget he also discovered that, in this instance, printing the brochures in Brisbane would be much cheaper than Sydney. There was also a certain amount of hand-folding, which was done by the company's own performers and helped keep the job within budget. The final design has its own personality and is almost a performance in itself.

33

"with a name like circa, it had to be round, and we gave the season the name "surround profound"

THE LAST MAGA ZINE

by David Renard

> Cover > *The Last Magazine*

COM MUN ITY

The stylepress are created by individuals and small groups for slightly larger social tribes. Their purpose is not fueled by the desire to appeal to all within a category, as in the traditional magazine paradigm. Instead, they are harbingers and mediators of taste and quality for others who play the same role. Advertising revenue flows, when it does, to the stylepress not because of elaborate yet unreliable cpm data, but because of these tribal tastemakers: their attention has a multiplying effect. / / This community focus can take on a wide variety of forms. From Virgin Atlantic's upper-class *CARLOS* and an independent film's *ANNA SANDERS* to *Me*, filling its pages with the featured artist's friends, the pseudo-autobiographical *RE-*, and the mock *Daniel Battams Fan Club*. From the gay, art and culture *They Shoot Homos Don't They?* and *BUTT* and the surf and architecture infused *PROPHECY* to the Middle Eastern, German, and Los Angelino groupuscules of *bidoun*, *ACHTUNG*, and *PUTA*, the young amateur artist-focused *LOOK LOOK*, and the ever-changing creative direction of *Big*.

Why does a magazine have to be programmed to the lowest common denominator?

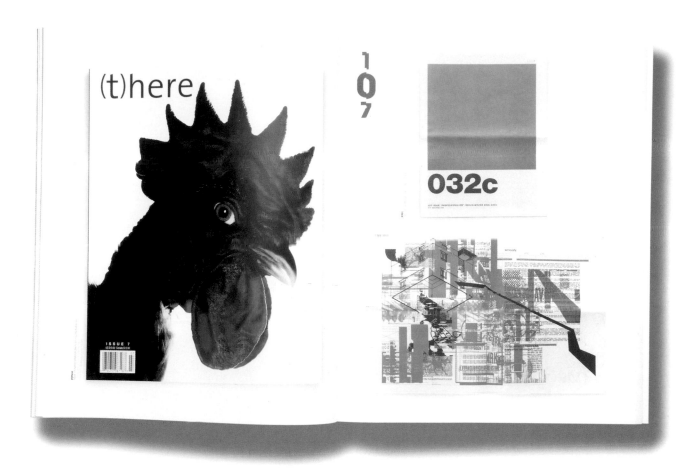

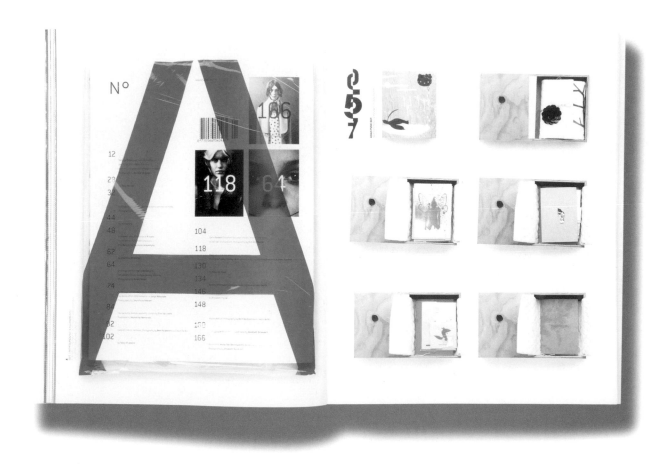

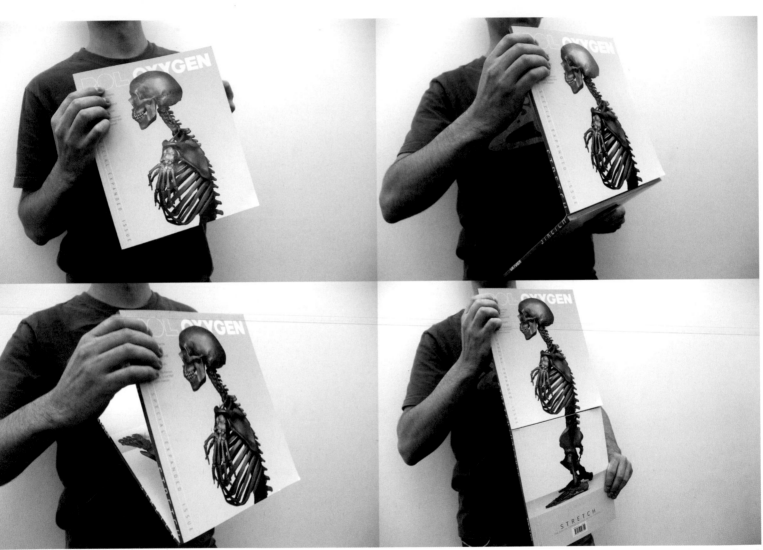

> Magazine > *POL Oxygen-Stretch*

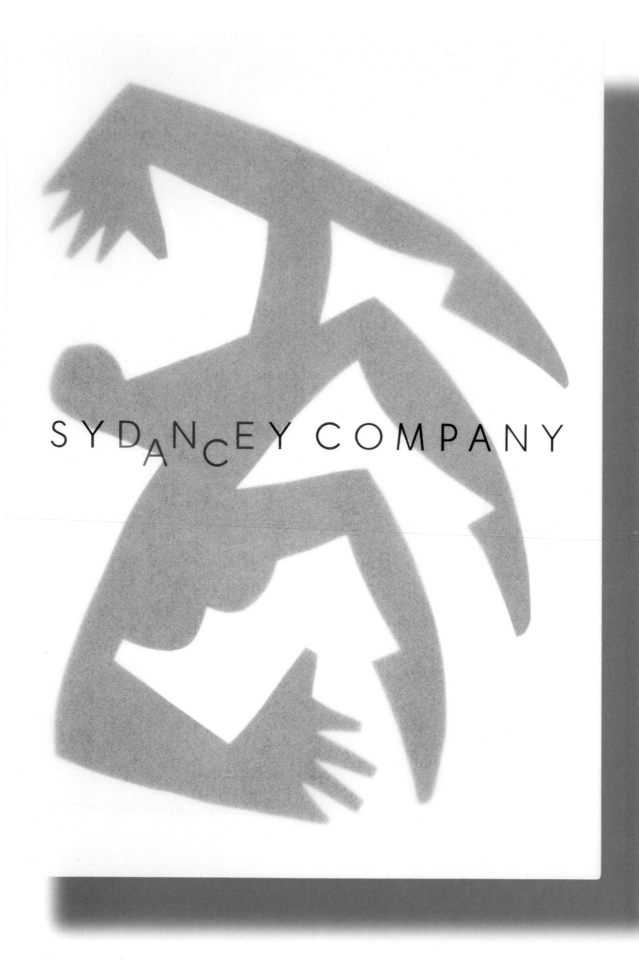

SYD_A_N_CEY COMPANY

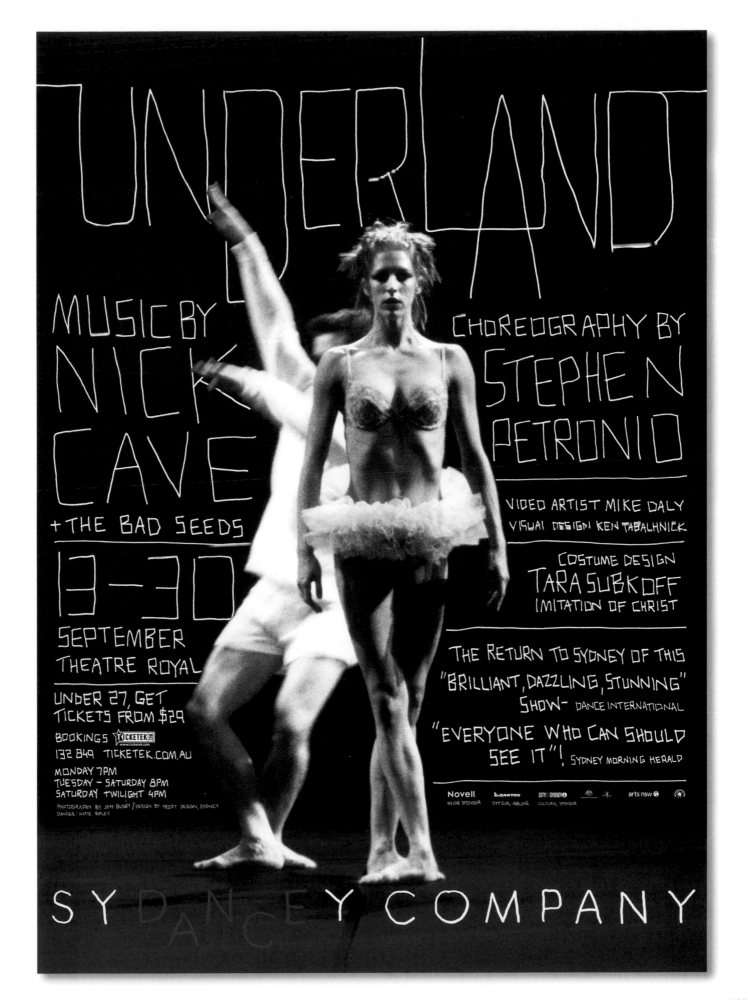

Gabor Palotai

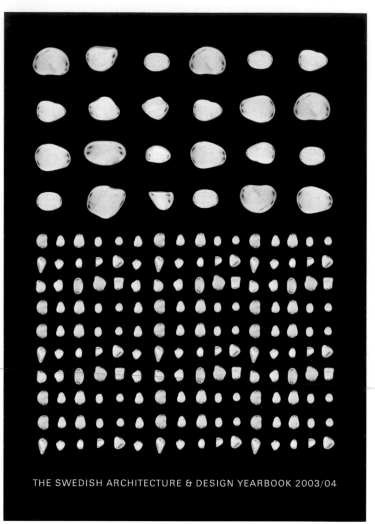

The (un)importance of nationality
Designforum Svensk Form, Skeppsholmen
12 juni – 24 augusti 2003

THE SWEDISH ARCHITECTURE & DESIGN YEARBOOK 2003/04

> *Made in Sweden* > poster > Svensk Form

> *Swedish Architecture Yearbook* > book > Arvinius Förlag, Stockholm

Västerlånggatan 76
111 29 Stockholm
Sweden
+46 8 248 818
design@gaborpalotai.com
www.gaborpalotai.com

> Corporate design, packaging, logotypes, sign-making, exhibition design, web design, animation, book design, illustrations, posters, etc. Gabor Palotai implicates himself into a variety of projects within the field of visual communications. His ideas revolve around knowledge, inspiration, desire, beauty, happiness, surprise, life and death. His formative period was spent in different art schools: the Hungarian Academy of Art and Design, the Royal Swedish Academy of Fine Arts and Beckmans College of Design. Some of the many prizes received include the Red Dot Award 2007 and the Design Prize of the Federal Republic of Germany (nominee). Currently, he is a member of the jury at D&DA London, Art Directors Club of Europe, Swedish Advertising Federations Golden Egg Award, Excellent Swedish Design Award and a member of the International Graphic Alliance.

SCANDINAVIAN DESIGN BEYOND THE MYTH

SCANDINAVIAN DESIGN
HET VERHAAL ACHTER DE MYTHE
DESIGN MUSEUM GENT
VAN 2 JULI TOT 19 SEPTEMBER 2004
VAN 10 TOT 18 UUR; GESLOTEN OP MAANDAG
(BEHALVE OP MAANDAG 19 JULI)

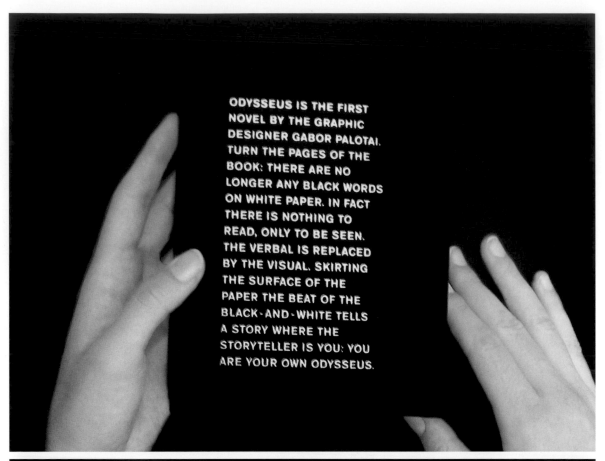

ODYSSEUS IS THE FIRST
NOVEL BY THE GRAPHIC
DESIGNER GABOR PALOTAI.
TURN THE PAGES OF THE
BOOK: THERE ARE NO
LONGER ANY BLACK WORDS
ON WHITE PAPER. IN FACT
THERE IS NOTHING TO
READ, ONLY TO BE SEEN.
THE VERBAL IS REPLACED
BY THE VISUAL. SKIRTING
THE SURFACE OF THE
PAPER THE BEAT OF THE
BLACK-AND-WHITE TELLS
A STORY WHERE THE
STORYTELLER IS YOU: YOU
ARE YOUR OWN ODYSSEUS.

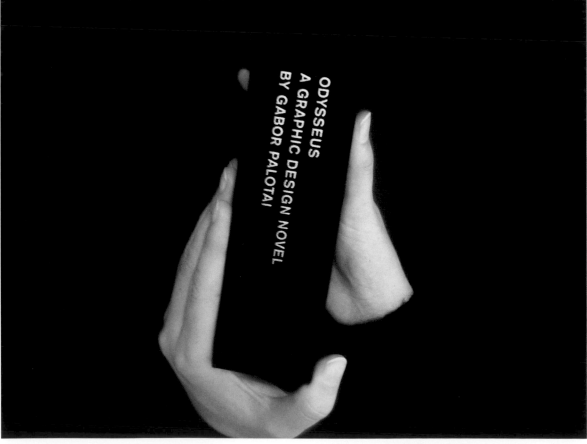

ODYSSEUS
A GRAPHIC DESIGN NOVEL
BY GABOR PALOTAI

> *Odysseus, a Graphic Design Novel* > cover > personal project

> *Odysseus, a Graphic Design Novel* > book > personal project

estonia
estonia
estonia

SJÖHISTORISKA MUSEET **30.04.2005 – 3.09.2006**

GÁBOR PALOTAI DESIGN

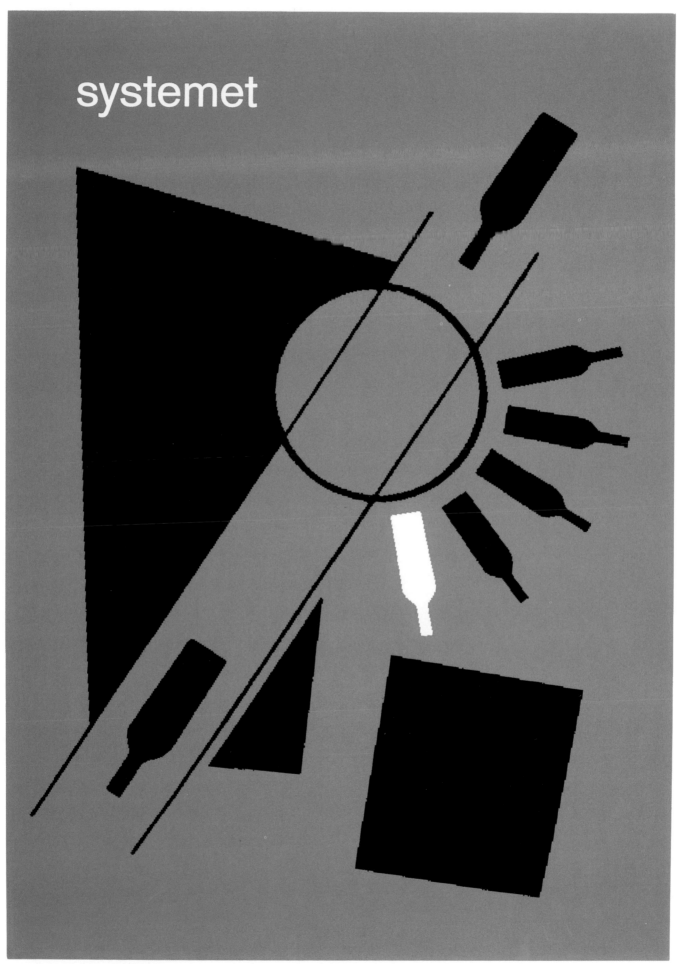

systemet

som9

9 målerielever
från konstfack i museets samlingar

uppsala konstmuseum

12 feb - 10 apr 1994

3 vernissager

12 februari
5 mars
26 mars

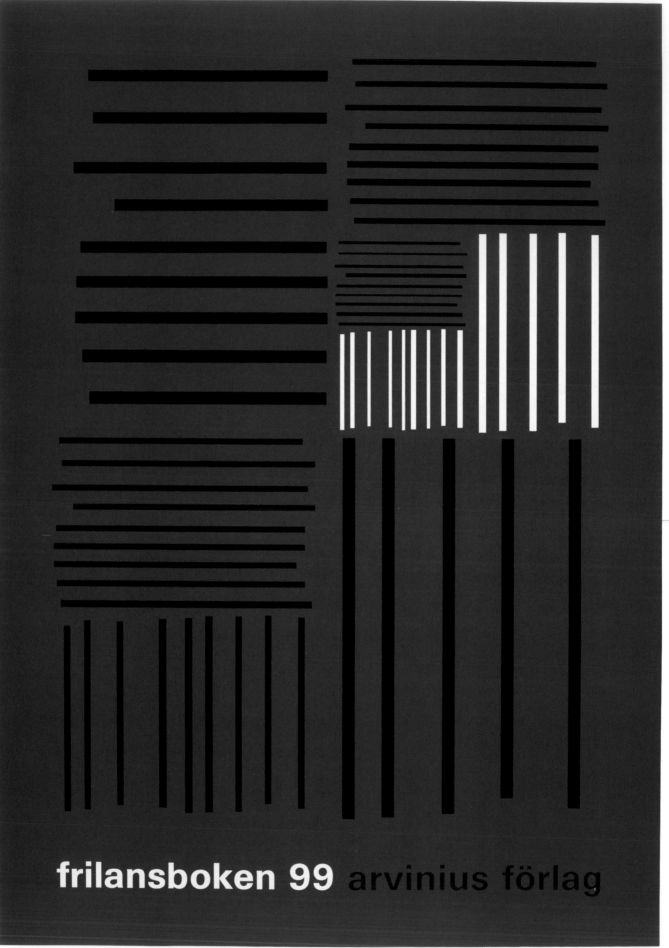

frilansboken 99 arvinius förlag

ERIK VIDEGÅRD

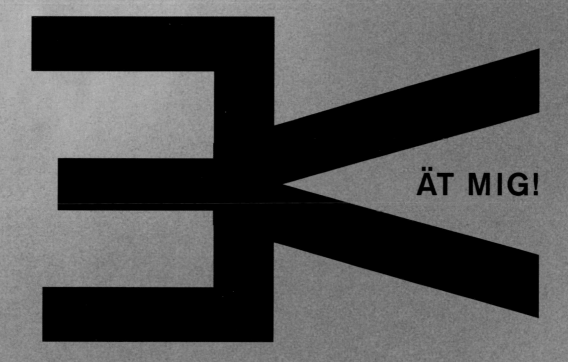

ÄT MIG!

ALBERT BONNIERS FÖRLAG

Garth Walker/Orange Juice Design

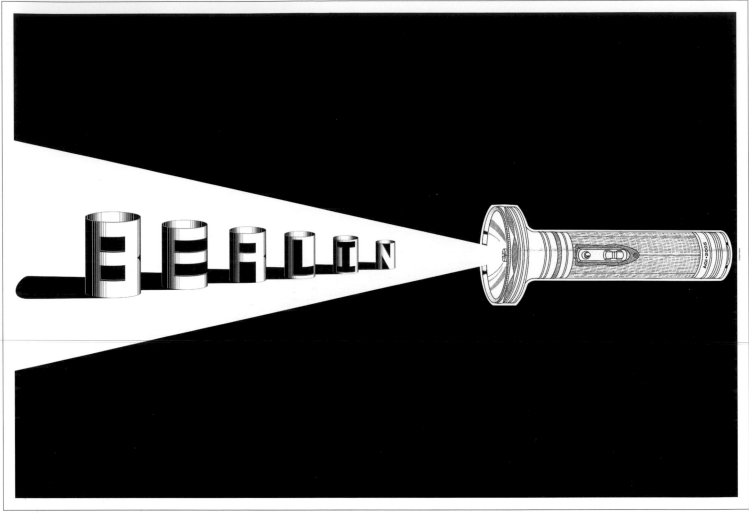

> *Berlin* > poster > Congress of the International Graphic Alliance, Berlin 2005

461 Berea Road
4001 Durban
South Africa
+27 31 277 1860
garth@oj.co.za
www.orangejuicedesign.net

> Garth studied graphic design in the mid-70s and later, in 1995, created the design studio Orange Juice Design in Durban. Orange Juice designs for the majority of South Africa's most high-profile brand names. Nevertheless, Garth is better known for his interests in developing and promoting a language of design that is deeply rooted in the African culture. Since 1995 and after 24 issues, Orange Juice has published the only African magazine of experimental graphic design, *i-jusi*. Garth has been widely recognized with about 100 design awards. His work has been published in 80 magazines and books and his work has shown in 14 countries. He is a member of the International Graphic Alliance, British D&AD, The Type Directors Club and The St. Moritz Design Summit. *i-jusi* magazine can be found in the collections of the National Library of France, at V&A, The Smithsonian, the MoMA and numerous academic libraries across the world.

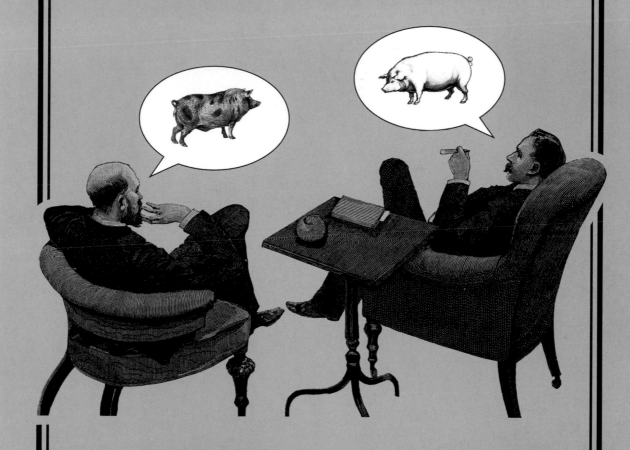

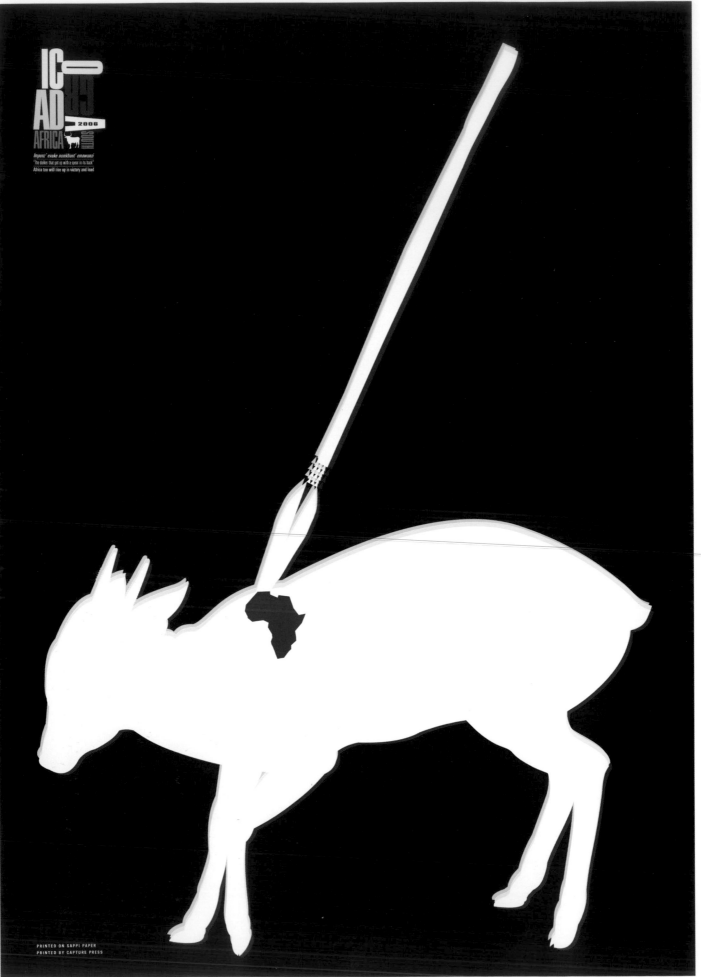

> *The Duiker Who Got Up with a Spear in Its Back* > poster > Icograda, South Africa

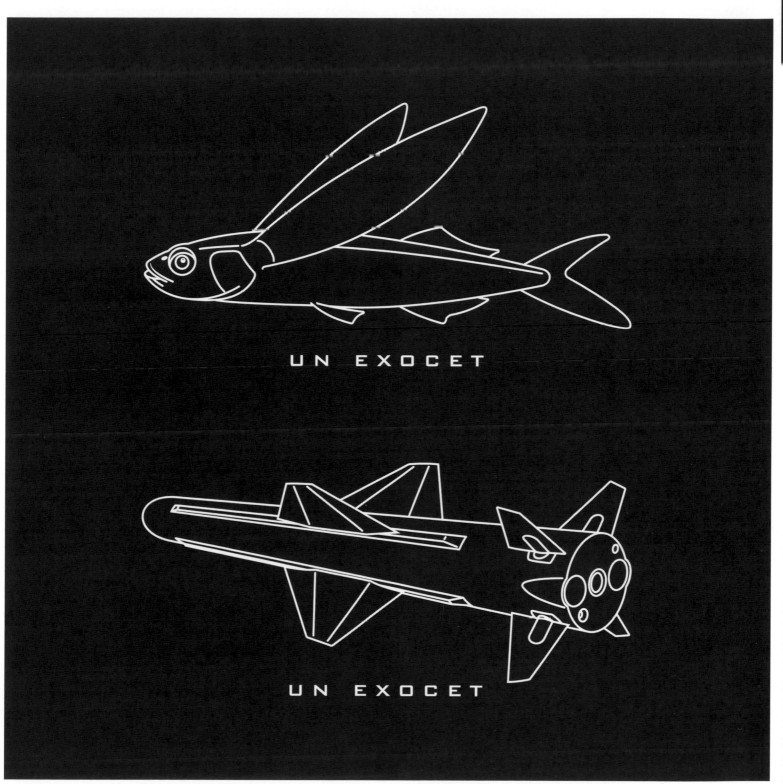

UN EXOCET

UN EXOCET

> *Exocet* > poster > Saint-Étienne Design Biennale 2008, France

zu Gast bei der
Köln International School of Design / KISD
Ubierring 40, 50678 Köln

22. und 23. Juni 2007 in Köln

im Rahmen von RHEINDESIGN

Gemeinsinn
Common Sense
Sens Commun

5. Tagung der DGTF Deutsche Gesellschaft für Designtheorie und -forschung

Gemeinsinn / Common Sense / Sens Commun

Freitag, 22. Juni: Gemeinsinn real

13:00 Registrierung

14:00 Meyer Voggenreiter (Meyer Voggenreiter Projekte, Köln): Begrüßung und gemeinsinnige Einführung

14:15 Michael Erlhoff (Professor für Designtheorie und -geschichte, Köln International School of Design/KISD) und Hans Ulrich Reck (Professor für Kunstgeschichte im medialen Kontext, Kunsthochschule für Medien, Köln): Streifzüge und Wegmarken im "Gemeinen"

15:30 Jörg Huber (Professor für Kulturtheorie/Institut für Theorie der Gestaltung, Zürcher Hochschule der Künste): Zur Einbildung von Gemeinsinn. Fallbeispiele kulturtheoretischer Forschung

16:45 Kaffeepause

17:15 Jakob Berndt (Strategische Planung, Jung von Matt, Hamburg): Deutschlands häufigstes Wohnzimmer

Moderation: Renate Menzi (DGTF-Vorstand, Dozentin Hochschule der Künste Zürich)

18:30 Abendvortrag (in englisch)
Garth Walker (Orange Juice Design, Durban, Südafrika): "If I live in Africa, why would I want to look like I live in New York?"
A Personal Journey towards a New Visual Language 1986-2007

Moderation: Uta Brandes (DGTF-Vorstandsvorsitzende, be design, Köln)

Samstag, 23.Juni: Gemeinsinn virtuell

10:00 Sabine Junginger (Dozentin für Produktdesign und Design Management, Lancaster University, England): Von Menschen für Menschen: Über Gemeinsinn, auf den Menschen bezogene Produktentwicklung und die Rolle des Design im öffentlichen Dienst

11:15 Sandra Buchmüller (User Experience Designerin, Deutsche Telekom Laboratories, Berlin): Common Sense in virtuellen Räumen

12:30 James Auger (Royal College of Art, London, Designstudio Auger-Loizeau): Common Sense and Critical Design (in englisch)

Moderation: Wolfgang Jonas (DGTF-Vorstand, Universität Kassel)

DGTF-Mitglieder: Forschungen zu "Gemeinsinn"

13:45 Robert Schwermer (Diplom Designer, Köln): Schulunterricht über, mit und durch Design

14:15 Johannes Uhlmann (Professor für Technisches Design, TU Dresden) und Christian Wölfel (Wissenschaftlicher Mitarbeiter) Gemeinsame Sache: Ein Ansatz zur Integration von Design- und Konstruktionsprozess bei der Produktentwicklung

Moderation: Lola Güldenberg (DGTF-Vorstand, Agentur für markenorientierte Trend- und Konsumentenforschung, Berlin)

15:00 Snacks & Ende der Tagung

Teilnahmegebühr:
Nicht-Mitglieder der DGTF: €100,- (Studierende: € 50)
DGTF-Mitglieder: € 50 (Studierende: € 30)

Anmeldung und weitere Informationen unter www.dgtf.de und e-mail: info@dgtf.de

T: +49(0)221-251297, F: +49(0)221-252149

Bankverbindung: Kreissparkasse Köln, Kto-Nr. 7728, BLZ 370 502 99

Nach Eingang der Teilnahmegebühr auf das Konto der DGTF erhalten Sie eine Anmeldebestätigung.

Postergestaltung: Garth Walker, Orange Juice Design, Durban

Der Druck wurde realisiert mit freundlicher Unterstützung der Druckerei Joost, Eckernförder Str. 239, 24119 Kronshagen. Für die Unterstützung der Tagung danken wir den Deutschen Telekom Laboratories.

Deutsche Telekom Laboratories · T· · DGTF Deutsche Gesellschaft für Designtheorie und -forschung e.V.

Gemeinsinn / common sense

Kommt heute die Sprache auf den Gemeinsinn, dann entflammen schnell kleine Lagerfeuer des Entzückens an vergangene, vermeintlich gute Zeiten, und romantische Bilder von Politik und Gesellschaft steigen wärmend auf. Es scheint common sense, dass wir gegenwärtig auf diesem Globus nichts mehr entbehren als einen neuen Sinn für den Gemeinsinn. Der Unterschied ist fein und deutlich: als ein Sinn, der als allen gemeinsam vorausgesetzt werden muss, um zu wirken, ist der Gemeinsinn aufs Streitbarste mit der Urteilskraft des Einzelnen verbunden, während der common sense, gemeinhin als gesunder Menschenverstand bekannt, eine gesellschaftliche Übereinkunft postuliert, die in der Zeit ihrer Entstehung eine bürgerliche war und für eine Weile in der Watte des Konsens sich einrichten konnte. Neuerdings wird allerlei Watte woanders billiger produziert, man jammert gerne über deren mangelnde Qualität oder die Bedingungen der Produktion, aber es ist längst nicht mehr der Bürger, der wählt, sondern der Konsument.

Design nun ist in die globale Zirkulation der Watte ebenso verstrickt wie in die Widersprüche des Gemeinsinns. Im kontinuierlichen und auch choc-haften Prozess von Transformation arbeitet Design an der Herstellung von Gemeinsinn. Denn dieser ist nicht, er wird: er will ständig neu gestaltet werden und bringt dafür Objekte ins Spiel, auf die er sich zuvor geeinigt hat. Und dort, wo Transformation ins Stocken gerät und die Verhältnisse nicht mehr genügen wollen, interveniert Design kontrafaktisch und bringt die Transformation wieder in Fluss. Als pragmatischer Einspruch gegen das, was ist (und nicht läuft), steht Design in der Tradition der Skeptiker gegen jedweden Konsens, der über die Dauer seiner eigenen Rede hinausweisen will.

Wenn sich nun in den Zwischenräumen und virtuellen Falten sich selbst entpflichteter Gesellschaften ein neuer Sinn für Gemeinsinn regt, dann könnte es relevant sein, ebendieses Vermögen des Design zum Prozessieren temporärer Vereinbarungen, durch die Nutzen und Nutzung erst realisierbar werden – und je nach Relation durchaus different, aber mit einem hinreichend konsistenten Kern der Verständigung –, also dann könnte es relevant sein, die Produktion von Gemeinsinn, von sens commun und common sense als Voraussetzung, Aufgabe, Herausforderung und Widerspruch von Design neu zu untersuchen.

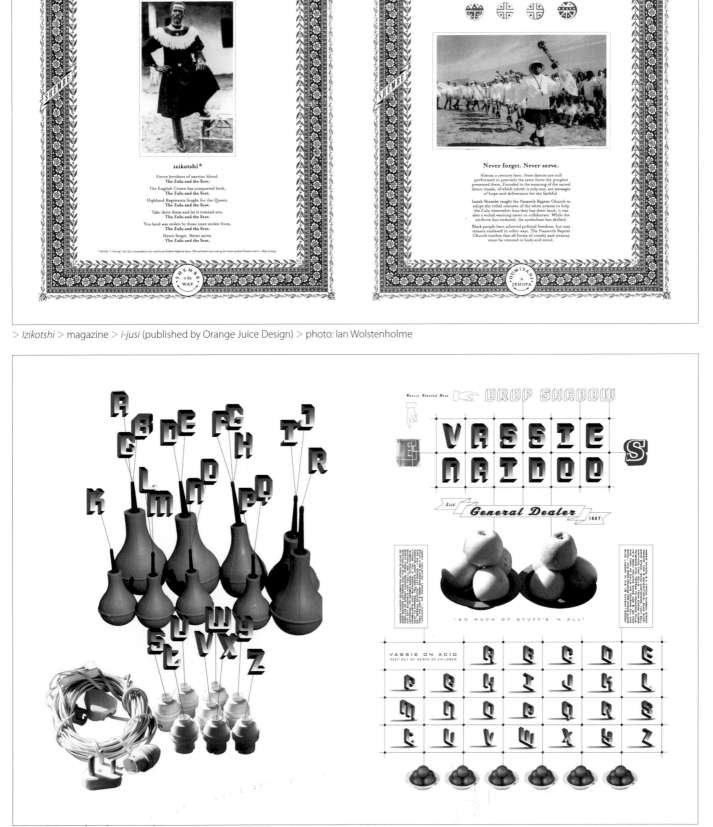

> *Izikotshi* > magazine > *i-jusi* (published by Orange Juice Design) > photo: Ian Wolstenholme

> *Vassie Naidoo Typeface* > magazine > *i-jusi* (published by Orange Juice Design)

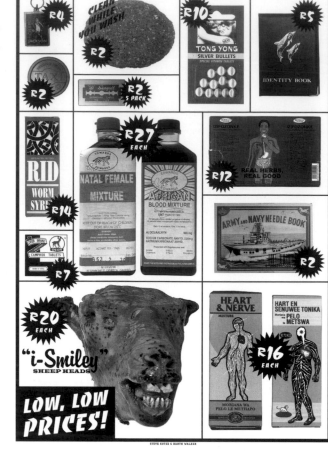

> *Consuming Democracy* > magazine > *i-jusi* (published by Orange Juice Design)

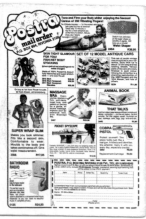
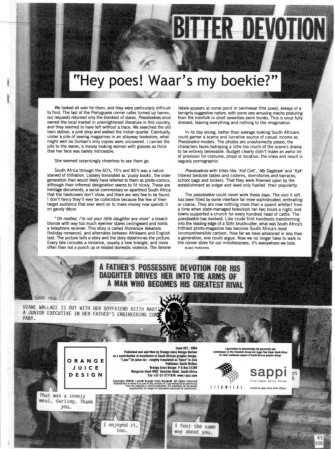

> *Poesboekies* > magazine > *i-jusi* (published by Orange Juice Design)

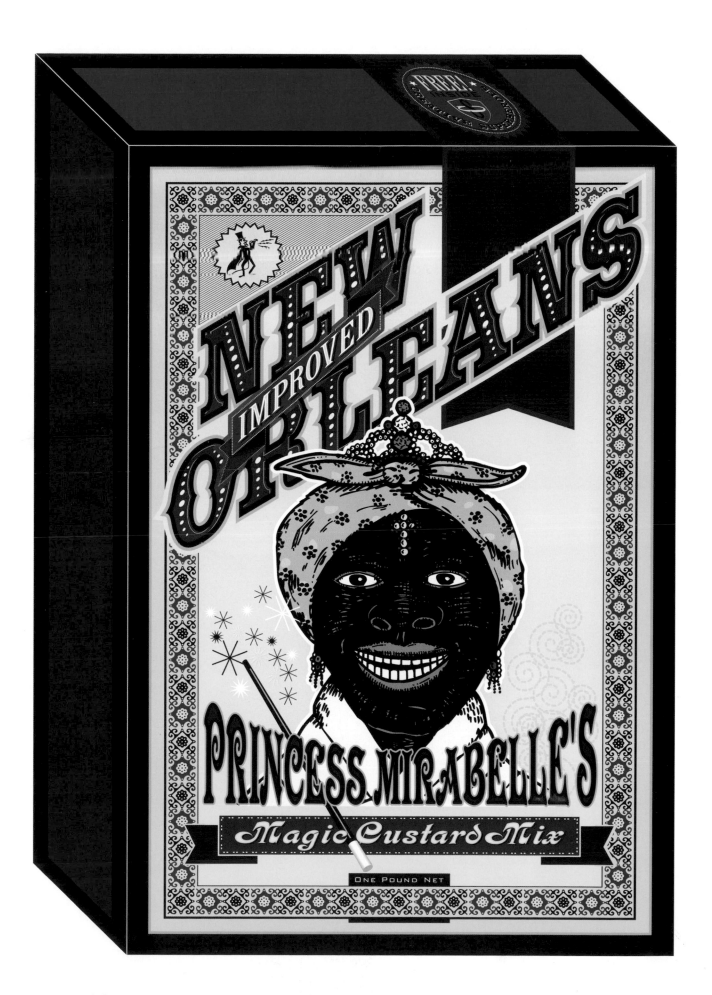

> *Princess Mirabelle's Magic Custard Mix* > cover > Ogilvy Worldwide

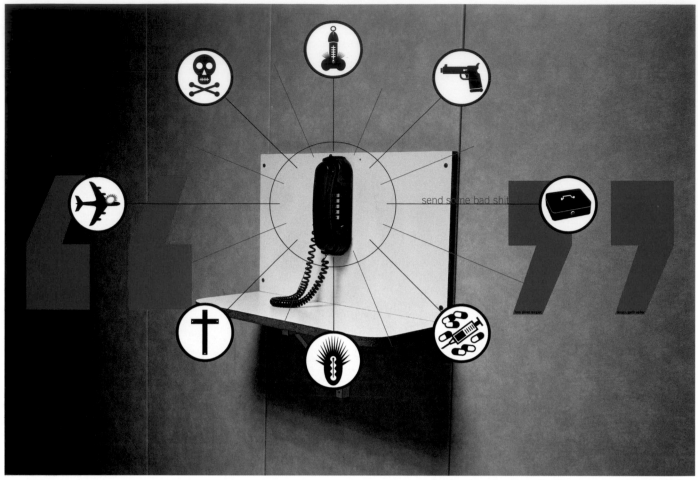

> *Send Some Bad Shit* > poster > Anatome Gallery

> *Don Quixote Visits Africa* > postcard > Argentina

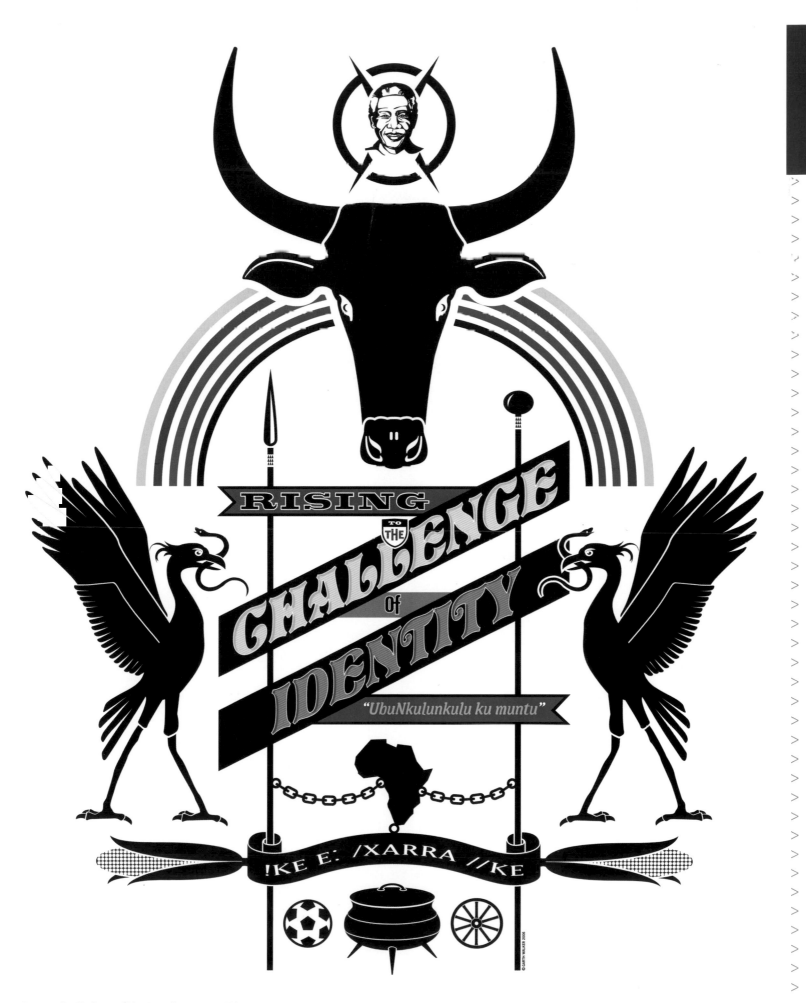

Gerwin Schmidt

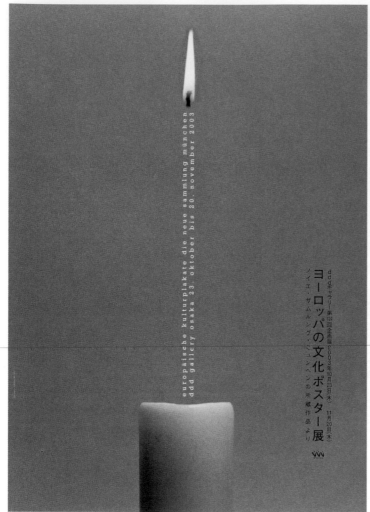

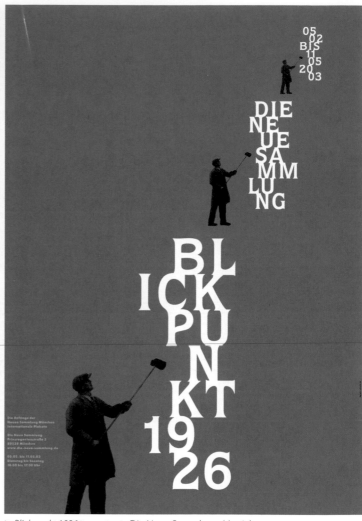

> *Europäische Kulturplakate* > poster > Die Neue Sammlung, Munich, and DDD Gallery, Osaka

> *Blickpunkt 1926* > poster > Die Neue Sammlung, Munich

Zenettistrasse 27
80337 Munich
Germany
+49 89 74 68 94 94
mail@gerwin-schmidt.de
www.gerwin-schmidt.de

> After working in animation, Gerwin Schmidt studied graphic design at the University of Kassel with designer and professor Gunter Rambow. From 1992 to 1997 he studied visual communication at the Karlsruhe University of Arts and Design (HfG) with professors Gunter Rambow, Kurt Weidemann and Werner Jeker. He also studied painting with professor Günther Förg. Between 1993 and 1997 he established himself as a freelance designer in Karlsruhe, Cologne and Munich and, since 1997, directs his own design studio in Munich. His works mainly include books and posters for cultural clients like the Munich Design Center, The New Collection in Munich, the House of Art in Munich, and the National Gallery. Between 1999 and 2003 he was guest lecturer at the Vorarlberg University of Applied Sciences (Austria), in the Intermedia Department. Since 2003 he has taught at the State Academy of Art and Design in Stuttgart, in the Visual Communications Department, and is a member of the International Graphic Alliance.

> *Jeder schweigt von etwas Anderen* > poster > Marc Bauder Film

> *Open Studios-AGI Berlin* > poster > Walden Gallery, Berlin

> *Der Kuss* > poster > Deutsches Hygiene Museum, Dresden

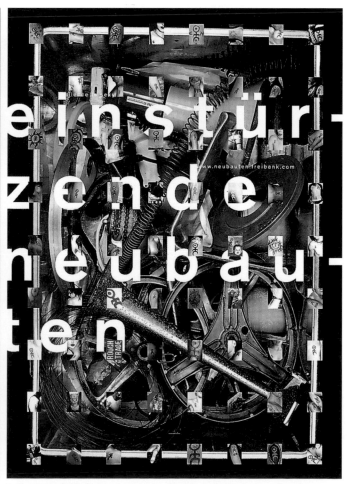

> *Einstürzende Neubauten* > poster > Einstürzende Neubauten, Rough-Trade-Records

WINTERKINDER

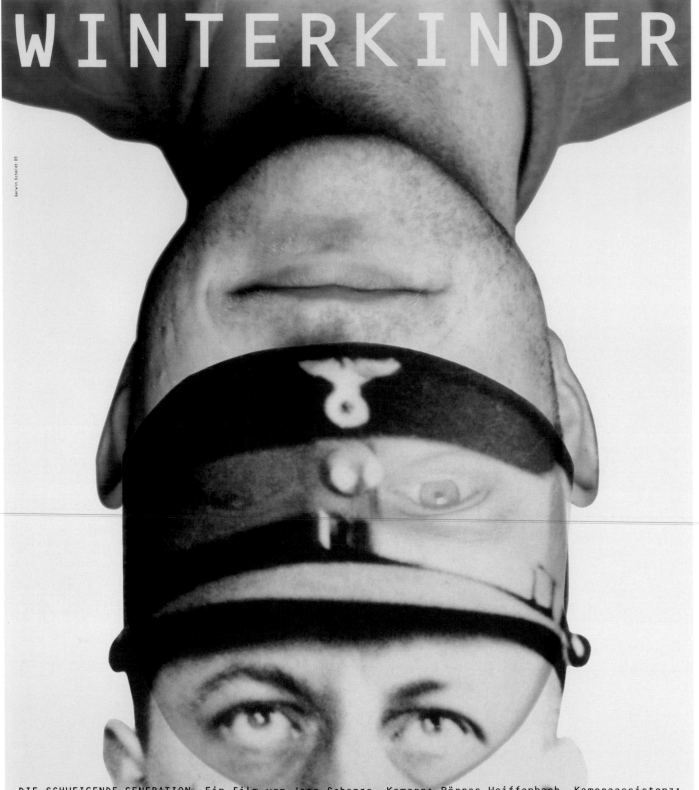

DIE SCHWEIGENDE GENERATION. Ein Film von Jens Schanze. Kamera: Börres Weiffenbach. Kameraassistenz: Helge Haack. Ton: Mauricio Wells, Mario Köhler. Produktion, Buch, Regie, Montage: Jens Schanze. Mischung: Gerhard Auer, Berthold Kröker, Anton Vetter. Herstellungsleitung: Kristina Frieß, Natalie Lambsdorff. Produktionsleitung: Raphaela Bardutzky. Dramaturgische Beratung: Raimund Barthelmes. Musik: Erik Satie. Musikaufnahme: Matthias Funkhauser, Daniel Wehr. Psychologische Beratung: Ulla Roberts. Übersetzung: Adam Lukaszewicz. Redaktion: Benigna von Keyserlingk (BR), Margrit Schreiber (ZDF/3sat). Koproduktion: Bayerischer Rundfunk, ZDF/3sat, Hochschule für Fernsehen und Film München. Gefördert durch: FilmFernsehFonds Bayern, Kulturelle Filmförderung des Bundes BKM. Unterstützt von: BMW Group, Fuji Kine Film, CinePostproduction Bavaria Bild & Ton. © 2005 Jens Schanze Filmproduktion

> *Winterkinder* > poster > Jens Schanze Filmproduktion

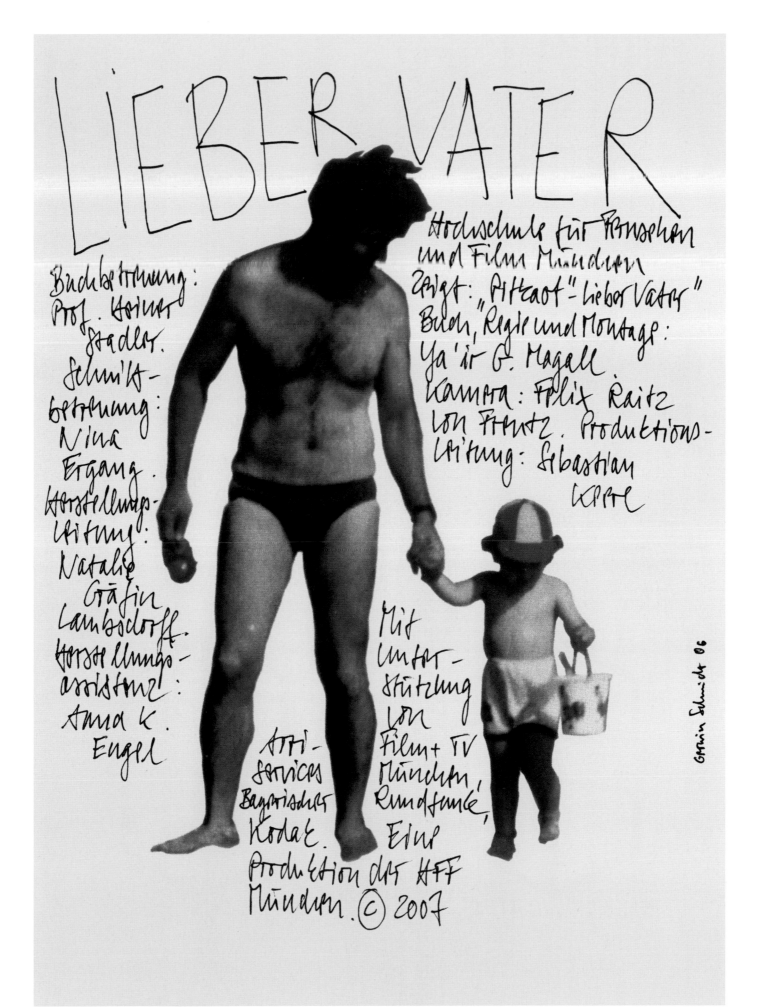

> *Lieber Vater* > poster > Ya'ir G. Magall

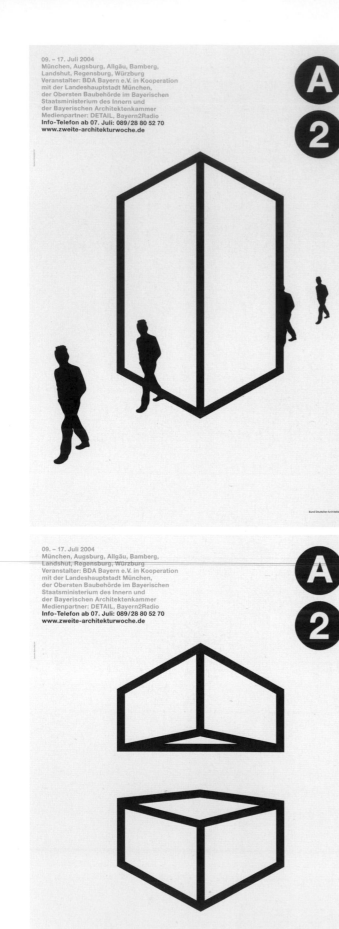

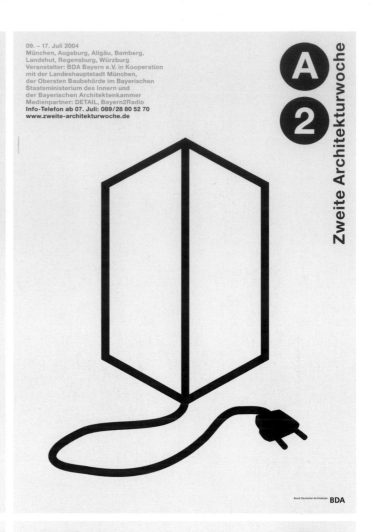

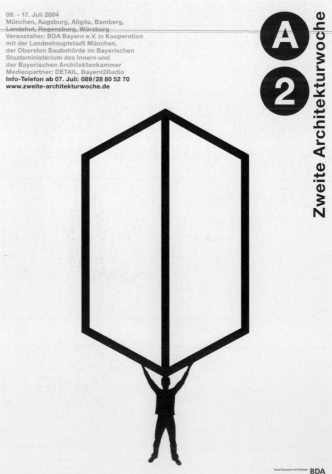

> *Zweite Architekturwoche* > poster > Bund Deutscher Architekten

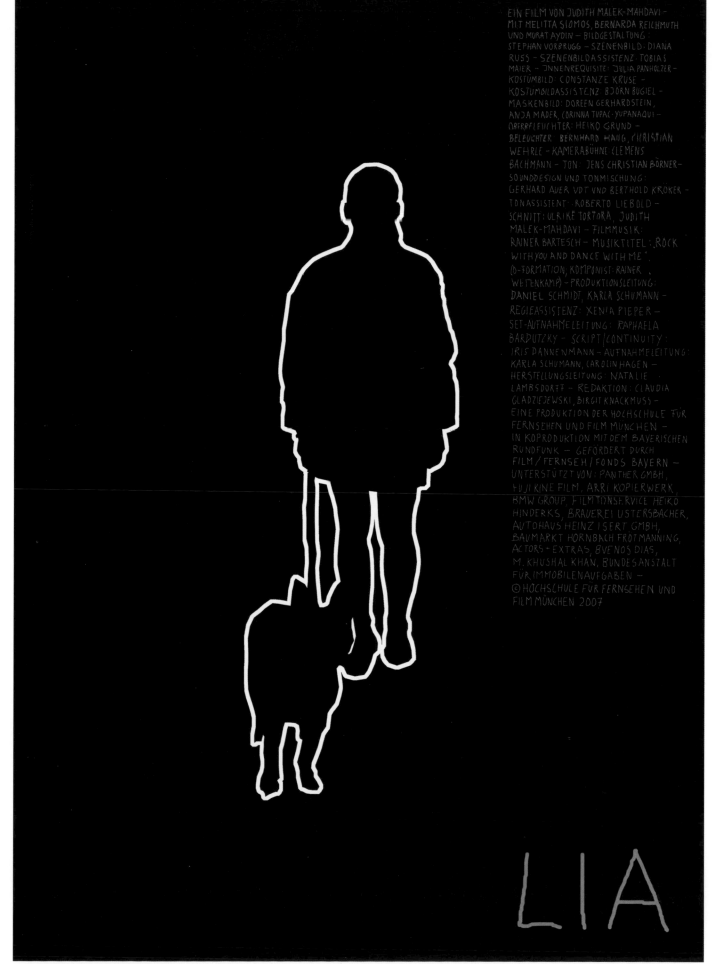

EIN FILM VON JUDITH MALEK-MAHDAVI -
MIT MELITTA SIOMOS, BERNARDA REICHMUTH
UND MURAT AYDIN - BILDGESTALTUNG:
STEPHAN VORBRUGG - SZENENBILD: DIANA
RUSS - SZENENBILDASSISTENZ: TOBIAS
MAIER - INNENREQUISITE: JULIA PANHOLZER -
KOSTÜMBILD: CONSTANZE KRUSE -
KOSTÜMBILDASSISTENZ: BJÖRN BUGIEL -
MASKENBILD: DOREEN GERHARDSTEIN,
ANJA MADER, CORINNA TUPAC-YUPANAQUI -
OBERBELEUCHTER: HEIKO GRUND -
BELEUCHTER: BERNHARD HAUG, CHRISTIAN
WEHRLE - KAMERABÜHNE: CLEMENS
BACHMANN - TON: JENS CHRISTIAN BÖRNER -
SOUNDDESIGN UND TONMISCHUNG:
GERHARD AUER VDT UND BERTHOLD KROKER -
TONASSISTENT: ROBERTO LIEBOLD -
SCHNITT: ULRIKE TORTORA, JUDITH
MALEK-MAHDAVI - FILMMUSIK:
RAINER BARTESCH - MUSIKTITEL: "ROCK
WITH YOU AND DANCE WITH ME".
(D-FORMATION, KOMPONIST: RAINER
WEFENKAMP) - PRODUKTIONSLEITUNG:
DANIEL SCHMIDT, KARLA SCHUMANN -
REGIEASSISTENZ: XENIA PIEPER -
SET-AUFNAHMELEITUNG: RAPHAELA
BARDUTZKY - SCRIPT/CONTINUITY:
IRIS DANNENMANN - AUFNAHMELEITUNG:
KARLA SCHUMANN, CAROLIN HAGEN -
HERSTELLUNGSLEITUNG: NATALIE
LAMBSDORFF - REDAKTION: CLAUDIA
GLADZIEJEWSKI, BIRGIT KNACKMUSS -
EINE PRODUKTION DER HOCHSCHULE FÜR
FERNSEHEN UND FILM MÜNCHEN -
IN KOPRODUKTION MIT DEM BAYERISCHEN
RUNDFUNK - GEFÖRDERT DURCH
FILM/FERNSEH/FONDS BAYERN -
UNTERSTÜTZT VON: PANTHER GMBH,
FUJI KINE FILM, ARRI KOPIERWERK,
BMW GROUP, FILMTONSERVICE HEIKO
HINDERKS, BRAUEREI USTERSBACHER,
AUTOHAUS HEINZ ISERT GMBH,
BAUMARKT HORNBACH FROTMANNING,
ACTORS + EXTRAS, BUENOS DIAS,
M. KHUSHAL KHAN, BUNDESANSTALT
FÜR IMMOBILENAUFGABEN -
© HOCHSCHULE FÜR FERNSEHEN UND
FILM MÜNCHEN 2007

LIA

> Lia > poster > Judith Malek-Mahdavi

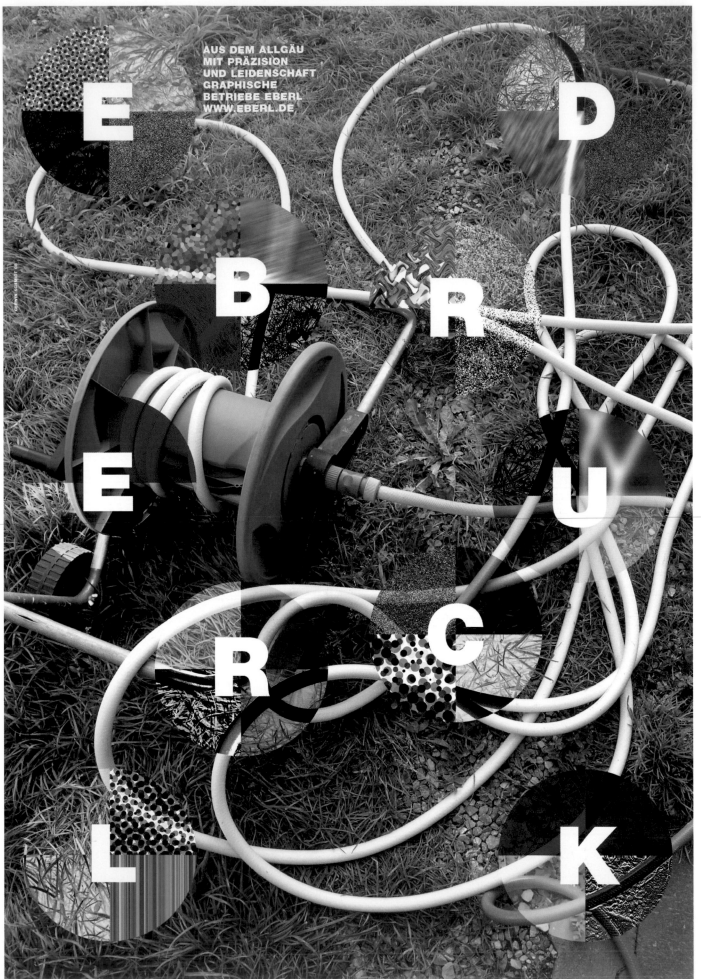

AUS DEM ALLGÄU
MIT PRÄZISION
UND LEIDENSCHAFT
GRAPHISCHE
BETRIEBE EBERL
WWW.EBERL.DE

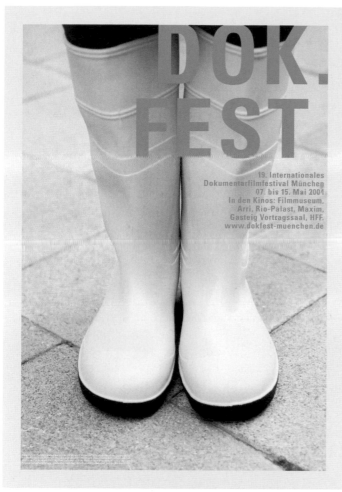

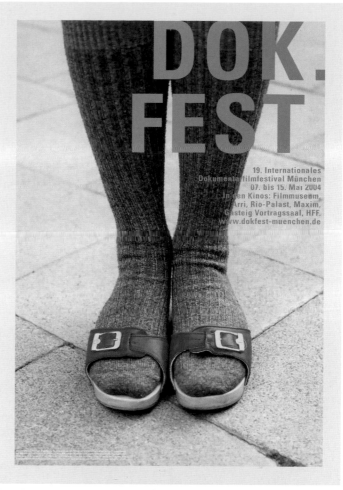

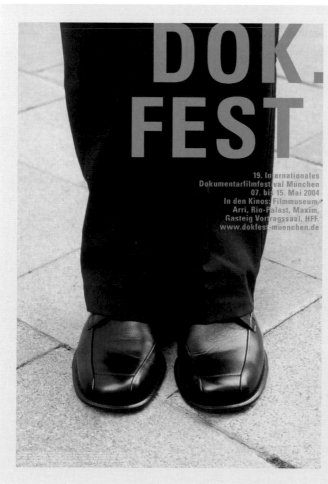

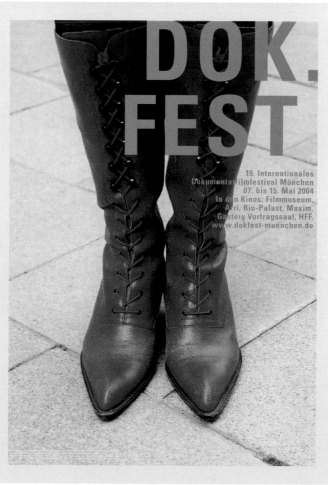

> *Dok. Fest* > posters > Internationales Dokumentarfilmfestival, Munich

journal nomade un film de Simone Fürbringer, Nicolas Humbert et Werner Penzel avec Océane Madelaine et Jocelyn Bonnerave © 2007 Balzli & Fahrer GmbH en association avec ARTE France — La lucarne en coproduction avec Cine Nomad, SimNic Films, Télévision Suisse Romande, Schweizer Fernsehen Caméra: Nicolas Humbert et Werner Penzel — Son: Jean Vapeur — Montage: Simone Fürbringer et Nicolas Humbert — Compagnon spécial & Producteur exécutif: Dieter Fahrer — Sounddesign: Marc Parisotto — Mixage: Michael Hinreiner — Étalonnage et sous-titres: Peter Guyer, Christoph Walther, Aron Nick. Avec le soutien de: Office fédéral de la culture (DFI) Suisse, Pro cinéma Berne, Fachausschuss Audiovision und Multimedia der Kantone Basel-Stadt und Basel-Landschaft, Volkart Stiftung, Succès passages antennes.

LUCIE + MAINTENANT

> *Lucie et maintenant* > poster > Cinenomad

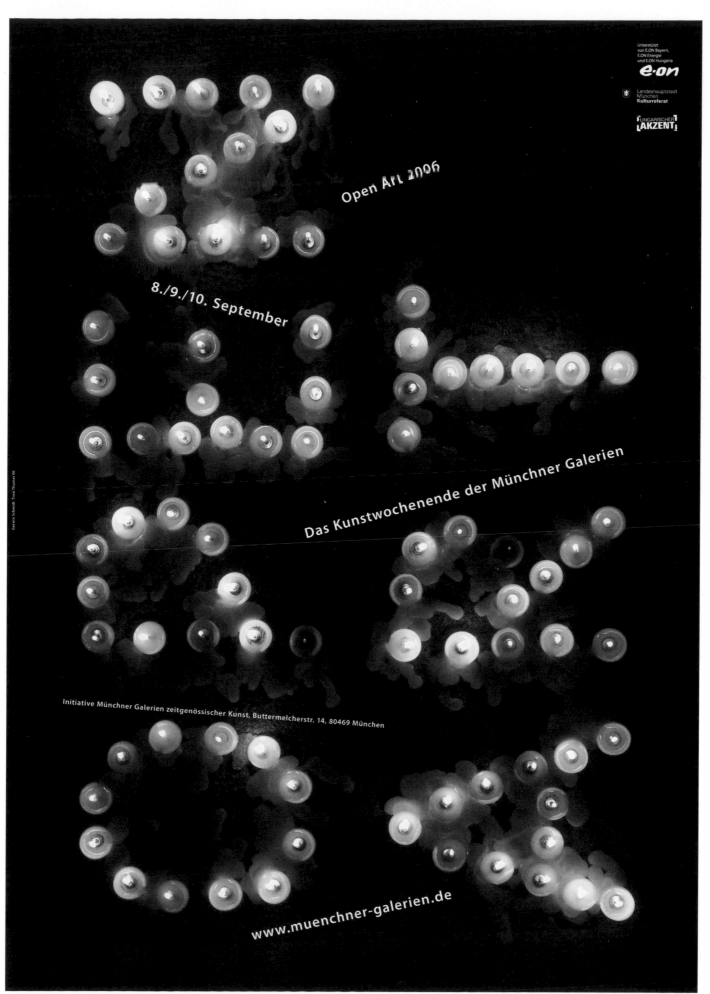

> *Open Art 2006* > poster > Initiative Münchner Galerien, in collaboration with Timo Thurner

Giampietro+Smith

MONEY TALKS

Barbara Kruger

social research
AN INTERNATIONAL QUARTERLY OF THE SOCIAL SCIENCES

errors

CONSEQUENCES OF BIG MISTAKES IN
THE NATURAL AND SOCIAL SCIENCES

VOLUME 72, NO. 1 SPRING 2005

> *Money Talks* > catalog > Skarstedt Fine Art

> *Social Research* > cover > New School University, New York

195 Chrystie Street No. 402-F
New York NY 10002
United States
+1 212 08 7434
info@studio-gs.com
www.studio-gs.com

> The design studio Giampietro+Smith in New York was founded in 2003 by Rob Giampietro and Kevin Smith. Previously, Rob and Kevin used to work at Winterhouse, a studio boasting many design awards and directed by Jessica Helfand and William Drenttel in Falls Village (Connecticut). Their clients normally belong to a great variety of cultural institutions like the Gagosian Gallery, Creative Time, Knoll, the Luhring Augustine Gallery and NYU, as well as internationally renowned artists like Taryn Simon, Ghada Amer and Gregory Crewdson. The studio also collaborates with various not-for-profit world organizations including the United Nations and the Global Fund against AIDS, Tuberculosis and Malaria. Their work has received numerous awards including *i-D* magazine, *Print* magazine, the Type Directors Club and AIGA. Currently, Kevin and Rob are members and co-creative directors of *Topic* magazine.

Knoll

> *Knoll Space* > pamphlet > Knoll

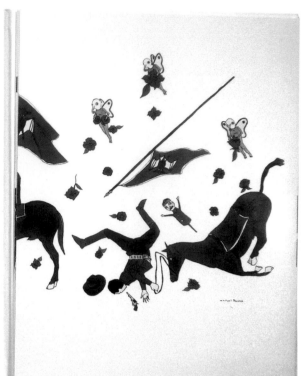

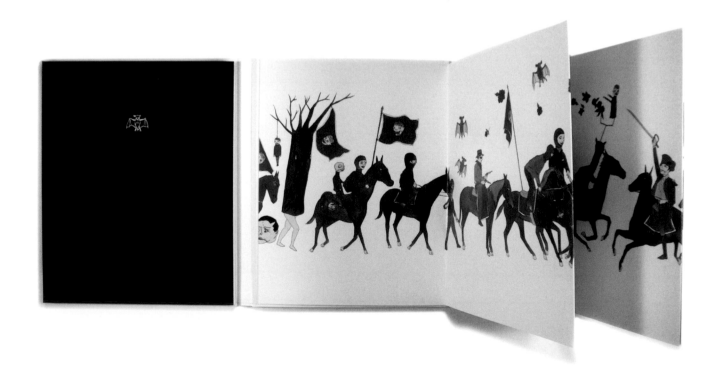

> *Marcel Dzama, the Course of Human History Personified* > catalog > David Zwirner

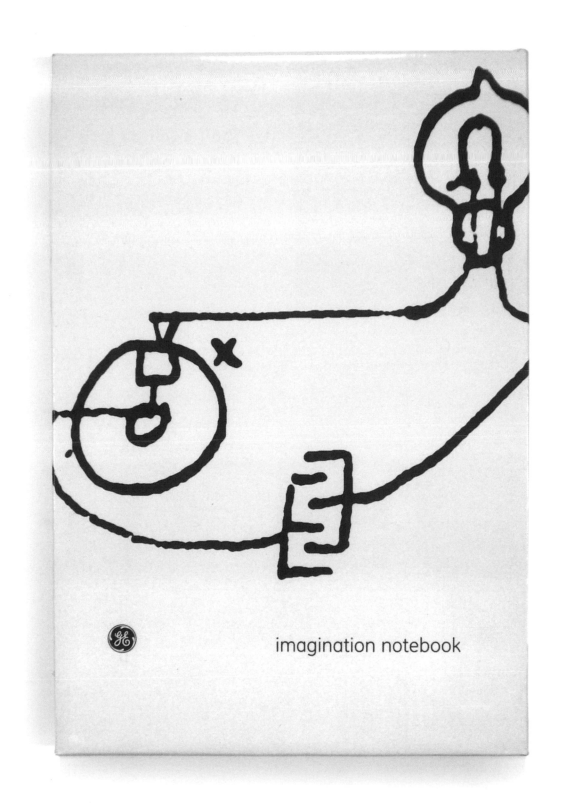

imagination notebook

> *GE, Imagination Notebook* > writing pad > Melcher Media

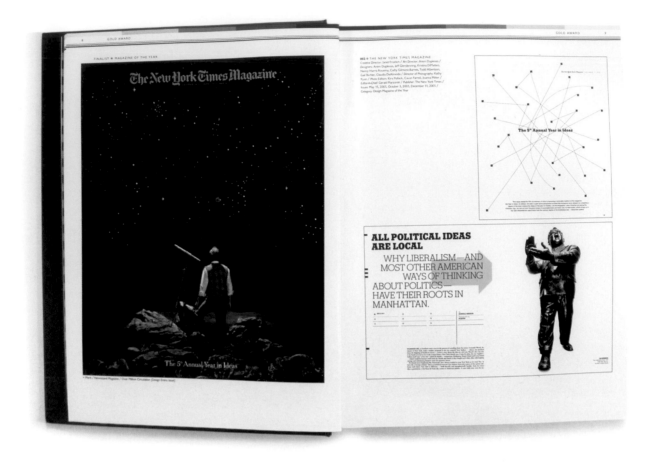

> *Topic 10: Games* > magazine > *Topic*

> *What's Modern?* > catalog > Gagosian Gallery

Jeff Koons

Winter Bears
1988

Polychromed wood
48 x 44 x 15½ inches | 121.9 x 111.8 x 39.4 cm

80

ADVERTISING

Grafiksense

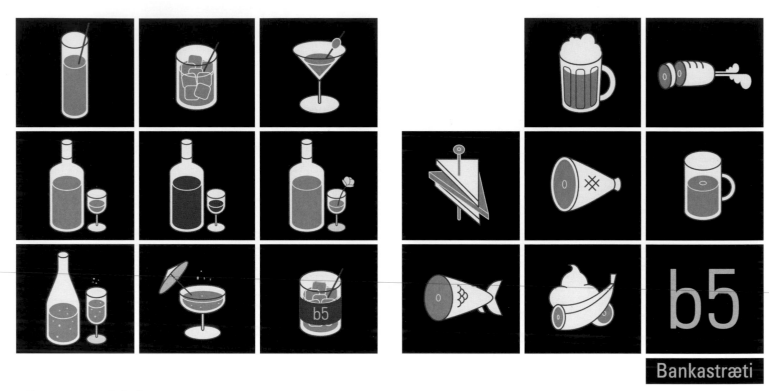

> Menu > restaurant B5 Bankastræti

Stufholt 3
105 Reykjavik
Iceland
+354 694 6501
hello@grafiksense.net
www.grafiksense.net

> With degrees in graphic design from the Iceland Academy of the Arts, Siggi Orri Þórhannesson and Sól Hrafnsdóttir are two Icelandic illustrators and graphic designers. Together they work out of their own design studio, Grafiksense, performing both creative and commercial projects. Sól has specialized in illustration and his interests concern narrative illustrations representing both history and ancient mythologies. Siggi Orri's interests—in relation to creative work— are illustration and animation. In 2003, Siggi Orri received first prize at the Tromsø Nordic Film Festival for his first animated short *Le Mime*. In 2006, Siggi Orri and Sól received first prize from the Icelandic Association of Graphic Designers in the poster category for Nordic Music Days 2006. In 2008, they also received an award from this association, in this case for brand design and environmental design.

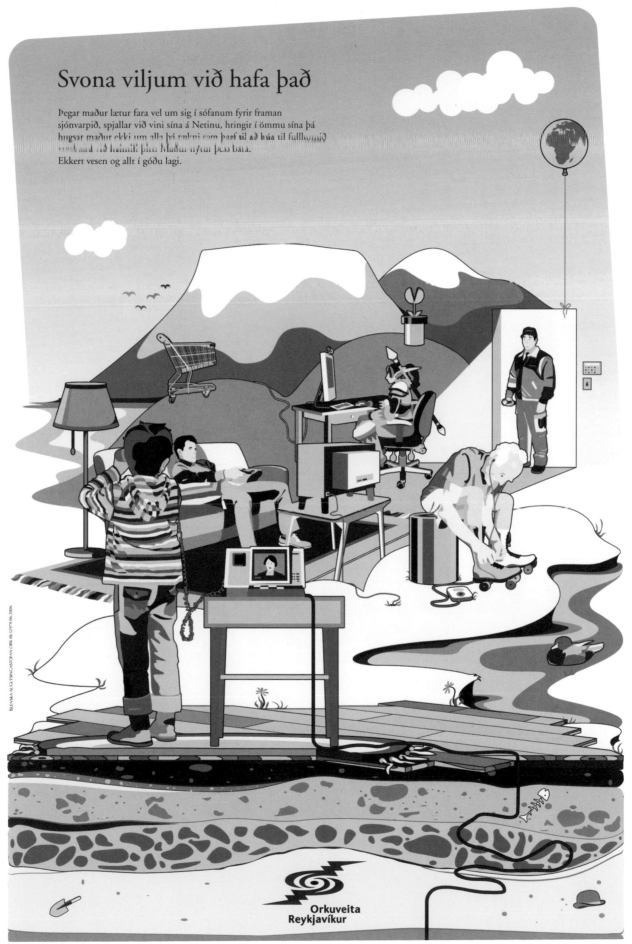

> *Svona viljum við hafa það* > illustration > The Icelandic Advertising Agency

Nordic Music Days Iceland

Festival of
contemporary music
October 5 – 14 2006

More info at
nordicmusicdays.is

NMN
Nordic Music Days Iceland

Festival of
contemporary music
October 5 – 14 2006

More info at
nordicmusicdays.is

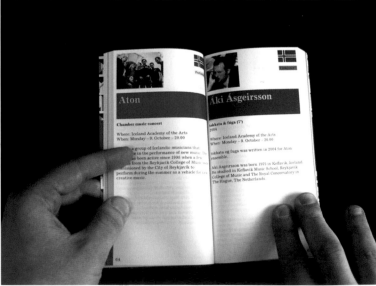

> Branding and promotional material > Nordic Music Days Iceland

Han Jiaying

> Pamphlet > MIUQIU

22F, West Block, Aidi Building
518045 Binhe Road
Futian
Shenzhen
China
+86 755 83551 760
han@hanjiaying.com
www.hanjiaying.com

> Han Jiaying was born in Tianjin in 1961. Between 1982 and 1986 he studied in the Department of Art and Professions at Xian Academy of Fine Arts. Later, between 1986 and 1990, he gave classes in the Fashion Design Department of the West-North Textile College. Han was the creative director of Shenzhen Vanke Mass Medium Co. from 1990 until 1993 and founded the Han Jiaying Design & Associates Ltd. graphic design studio afterwards. He designs posters and covers for the magazine *Frontiers*, along with designing books, logotypes and corporate identity packages for C'estbon, Han Zhou Commercial Bank, Konka Group and Vanke Real Estate Co. Ltd. among others. Han Jiaying has worked for hundreds of clients since 1993, developing a unique style with strong influences from Chinese design. He has received various awards like the Graphic Design Biennial in Brno and the bronze medal at the International Triennial of the Poster in Toyama, among others.

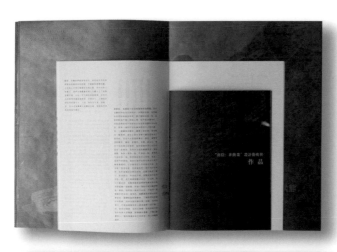

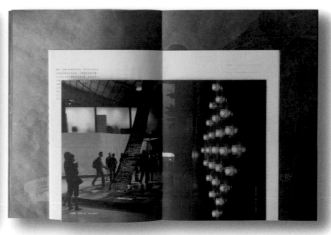

POSTER
DESIGNED
BY HAN
JIAYING

Harry Pearce/Pentagram

> Poster > Lippa Pearce

11 Needham Road
W11 2RP London
United Kingdom
+44 20 7229 3477
email@pentagram.co.uk
www.pentagram.com

> Harry Pearce was born in 1960 and studied at the Canterbury College of Art. He co-founded Lippa Design in 1990. Harry's work covers many disciplines, from spatial and identity design to publishing and packaging design. Some of his clients are: Phaidon, Williams F1, Kangol, Shakespeare's Globe, and Boots, for which he has created designs for 19 years. Some of his more relevant identity work includes Halfords and The Co-operative. Harry is also dedicated to defending human rights. For the last eight years he has provided the necessary designs for Witness, founded by activist and musician Peter Gabriel. He has won various international and national design awards including the D&AD Silver Medal. His work was shown at the 50th anniversary of the International Graphic Alliance, of which he is a member. In 2006, he became a part of the Pentagram design studio in London.

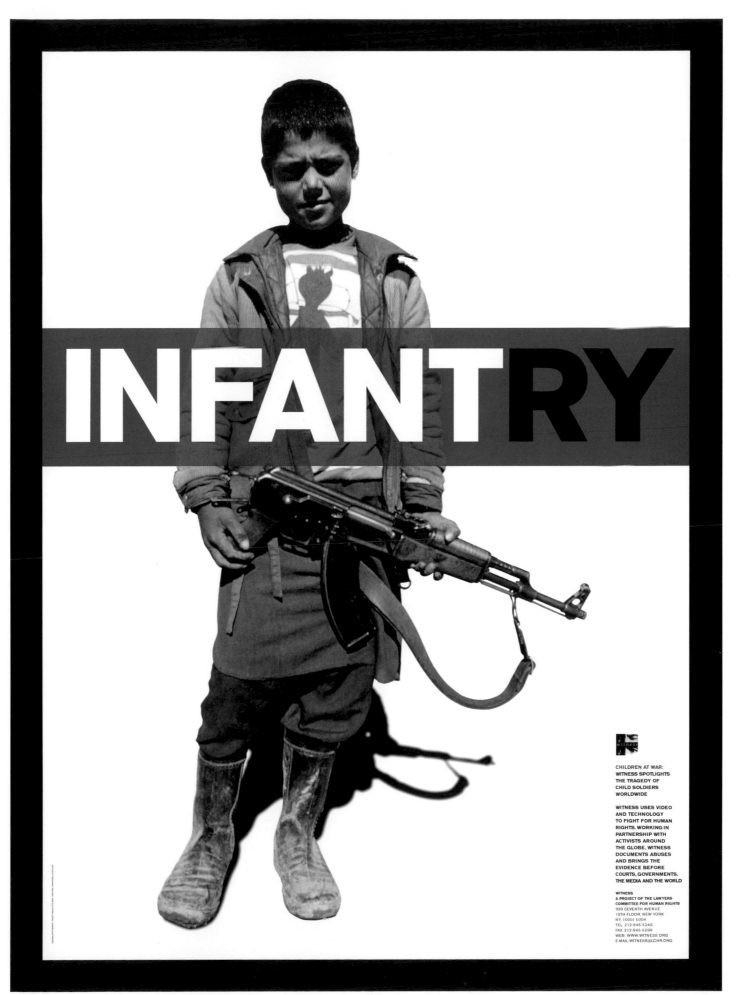

CHILDREN AT WAR:
WITNESS SPOTLIGHTS
THE TRAGEDY OF
CHILD SOLDIERS
WORLDWIDE

WITNESS USES VIDEO
AND TECHNOLOGY
TO FIGHT FOR HUMAN
RIGHTS. WORKING IN
PARTNERSHIP WITH
ACTIVISTS AROUND
THE GLOBE, WITNESS
DOCUMENTS ABUSES
AND BRINGS THE
EVIDENCE BEFORE
COURTS, GOVERNMENTS,
THE MEDIA AND THE WORLD

WITNESS
A PROJECT OF THE LAWYERS
COMMITTEE FOR HUMAN RIGHTS
333 SEVENTH AVENUE
13TH FLOOR, NEW YORK
NY, 10001 5004
TEL. 212-845-5245
FAX. 212-845-5299
WEB: WWW.WITNESS.ORG
E-MAIL WITNESS@LCHR.ORG

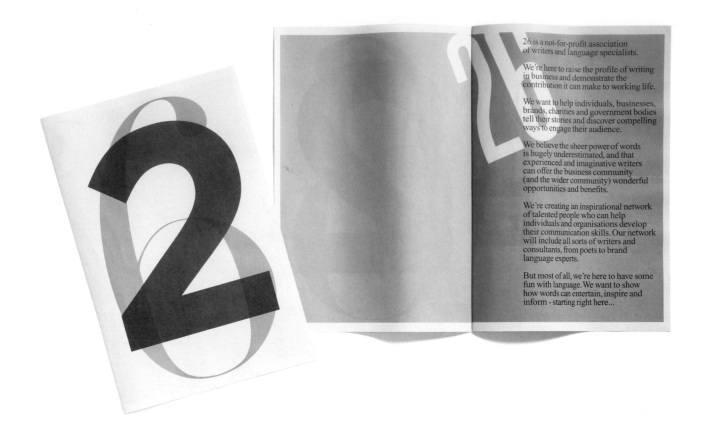

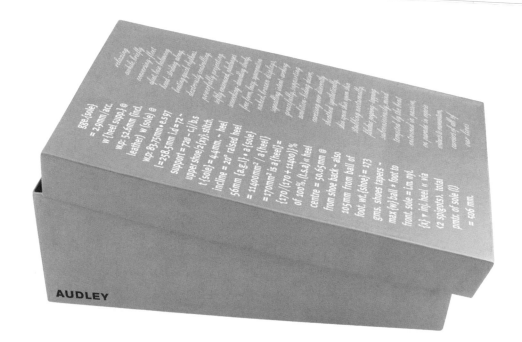

> Advertising > Audley Shoemakers

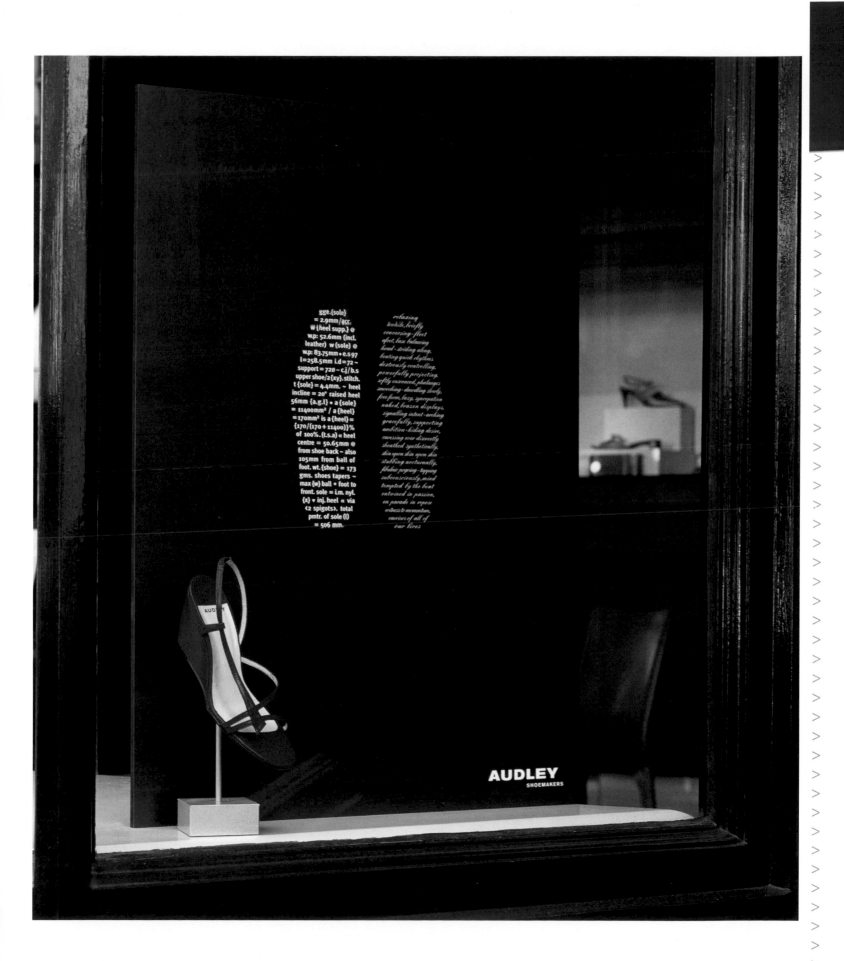

gge.{sole}
= 2.9mm/øcr.
w{heel supp.} @
w.p: 52.6mm (incl.
leather) w(sole) @
w.p: 83.75mm • e.s 97
l=258.5mm i.d = 72 ~
support = 720 ~ c.j/b.s
upper shoe/2{xy}. stitch.
t {sole} = 4.4mn. ~ heel
incline = 20° raised heel
56mm {a.g.l} • a {sole}
= 11400mm² / a {heel}
=170mm² is a{heel} =
{170/(170 + 11400)}%
of 100%. (t.s.a) « heel
centre = 50.65mm @
from shoe back ~ also
105mm from ball of
foot. wt. {shoe} = 173
gms. shoes tapers ~
max {w} ball • foot to
front. sole = i.m. nyl.
{x} ∨ inj. heel « via
‹2 spigots›. total
pmtr. of sole (l)
= 506 mm.

relaxing
awhile, briefly
conversing - fleet
øfeet, base balancing
head - striding along,
beating quick rhythms,
dextrously controlling,
powerfully projecting,
softly entranced, phalanges
smooching - dawdling slowly,
free form, lazy, syncopation
naked, brazen displays,
signalling intent - arching
gracefully, supporting
ambition - hiding desire,
caressing ever discreetly
sheathed synthetically,
skin upon skin upon skin
stubbing nocturnally,
fibular peg-ing - tapping
subconsciously, mind
tempted by the beat
entwined in passion,
on parade in repose
witness to momentum,
carriers of all of
our lives

AUDLEY
SHOEMAKERS

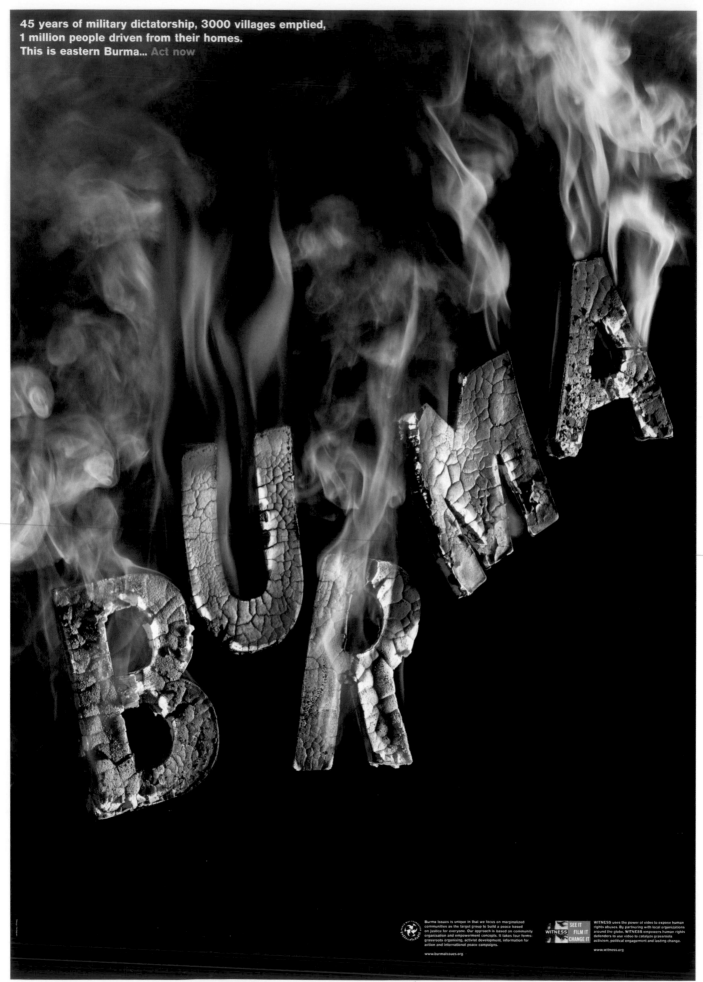

45 years of military dictatorship, 3000 villages emptied,
1 million people driven from their homes.
This is eastern Burma... Act now

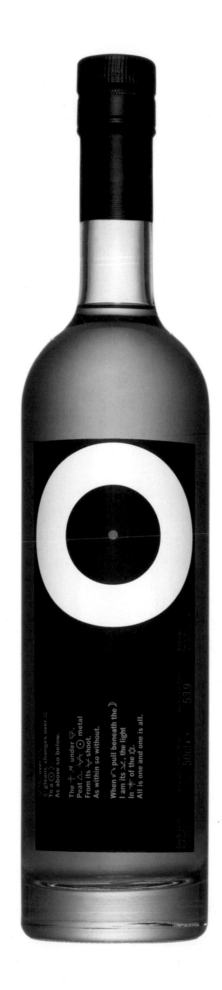

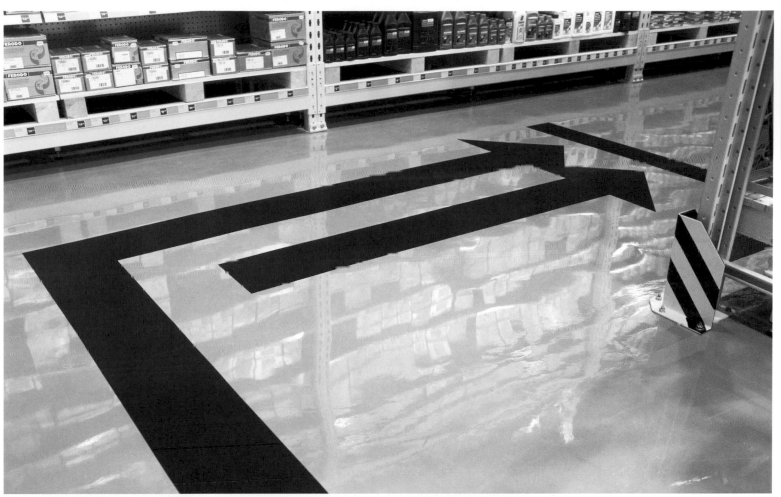

INSTALLATION OF:
ICE
ALARMS
WHEEL & TYRE
COMBINATIONS
TYRES
SUSPENSION
EXHAUSTS

Hesign

> *75th Anniversary of China Academy of Art* > poster > China Academy of Art

Duesseldorfer Strasse 48
10707 Berlin
Germany
+49 30 8867 6915
info@hesign.com
www.hesign.com

> Born in 1973 in Fuyang (China), Jianping He studied graphic design at the China Academy of Art (Hanzhou). He taught classes in poster design at the Berlin University of Arts during 2001 and in the same year won honorable mention at the 13th Lahti International Poster Biennial (Finland) and later, in 2002, special mention from the 81st Art Directors Club of New York. In 2004, he opened his own advertising and design company in Berlin and Shanghai. In 2006, he won the International Prize at Plakatkunst-hof Rüttenscheid in Essen (Germany). The majority of his works can be found in the collections at the Friedrich Ebert Foundation (Germany), at the Museum of the Industrial Arts in Hamburg, the Ogaki Poster Museum, the National Museum of Israel and the National Museum of Munich. He has shown solo in various exhibitions in Germany, China and Malaysia. Presently, he is a member of the Art Directors Club and the International Graphic Alliance.

> Cover > *New Graphic* magazine

> *Backyard* > poster > Yang Fudong

> *Come Back to Asia* > poster > The One Academy, Kuala Lumpur

> *Antalis* > poster > Antalis International Paper Company

> *AGI-New Voice, AGI New Members* > book > Hesign Publishing, Berlin

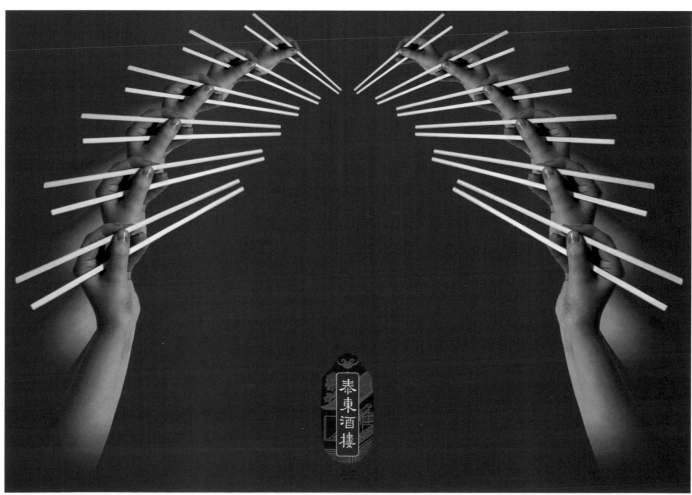

> Poster > Tai-Tung Chinese Restaurant

> Book > Walter Ding

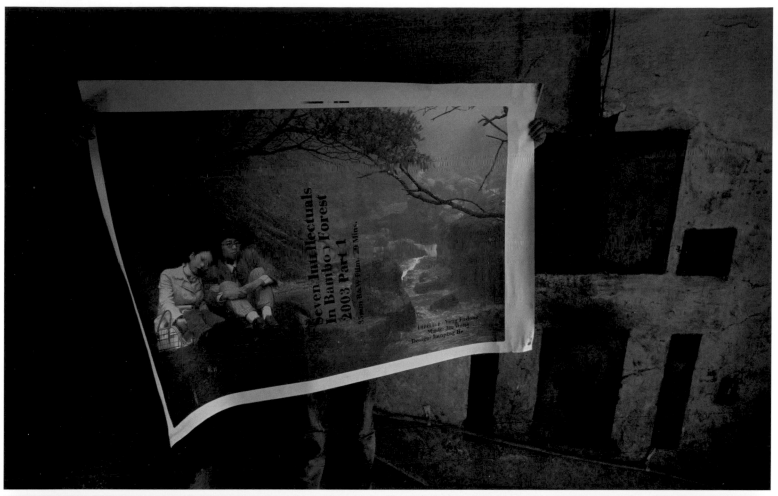

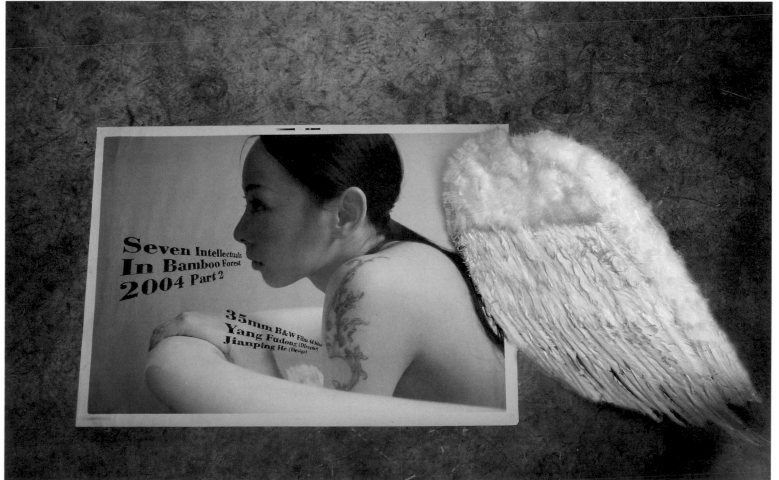

> *Seven Intellectuals in Bamboo Forest* > posters > Yang Fudong

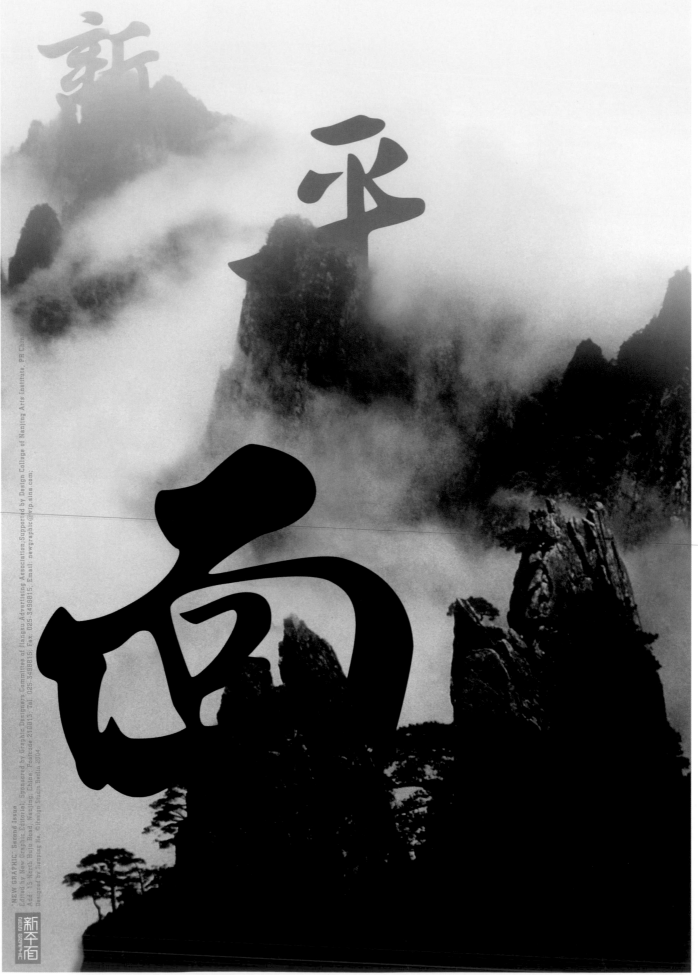

NEW GRAPHIC: Second Issue
Edited by New Graphic Editorial; Sponsored by Graphic Designers Committee of Jiangsu Advertising Association;Supported by Design College of Nanjing Arts Institute, PR China
Add: 15 North Huju Road, Nanjing, China; Postcode 210013; Tel: 025-3498815; Fax: 025-3498815; Email: newgraphic@vip.sina.com;
Designed by Nanjing He. ©Design Studio Berlin 2004.

Hörður Lárusson

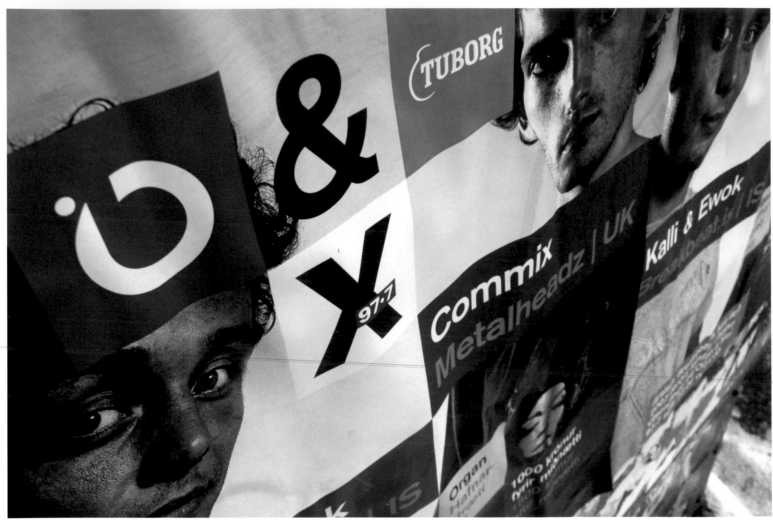

> Poster > Breakbeat.is

Hagamelur 26
107 Reykjavik
Iceland
+354 699 0090
hordur@larusson.com
www.larusson.com

> Reykjavik is Hörður Lárusson's native city and the place where he currently lives and works. After graduating as a graphic designer from the Iceland Academy of the Arts in 2006, he spent time as a freelance designer while studying at the Atli Hilmarsson graphic design studio, a small studio made up of a team of four designers, situated in the center of Reykjavik. Graphic designer, sign designer and sometimes professor, he has a great passion for books and information design. His main interest as a designer lies in finding solutions for information-related problems in maps, signs or exhibitions. Parallel to this interest, he also likes to work on book and poster design. Presently, he gives classes at the Iceland Academy of the Arts, a task he juggles with serving as president of the Icelandic Association of Graphic Designers.

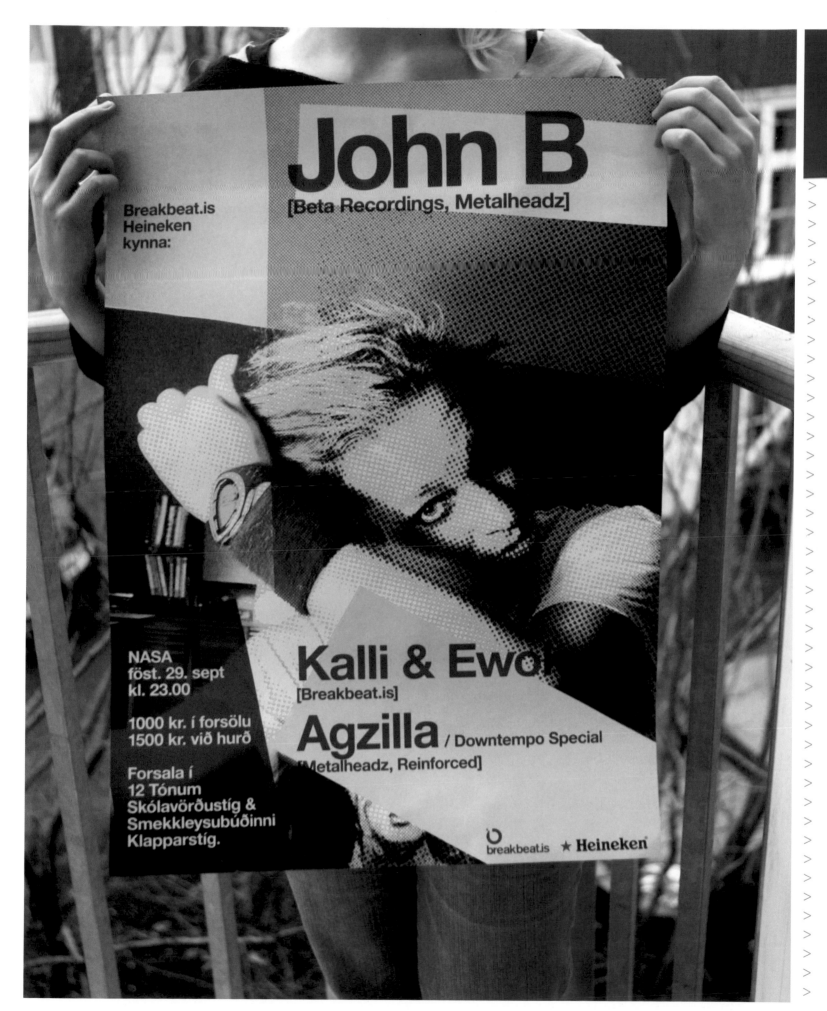

ÍSLENSKI FÁNINN

—

SKÝRSLA

FRÁ

NEFND ÞEIRRI, SEM SKIPUÐ VAR AF RÁÐHERRA ÍSLANDS Þ. 30. DES. 1913 TIL AÐ KOMA FRAM MEÐ TILLÖGUR TIL STJÓRNARINNAR UM GERÐ ÍSLENSKA FÁNANS.

...ÖLUM OG 3 FYLGIRITUM MEÐ 40 LITMYNDUM

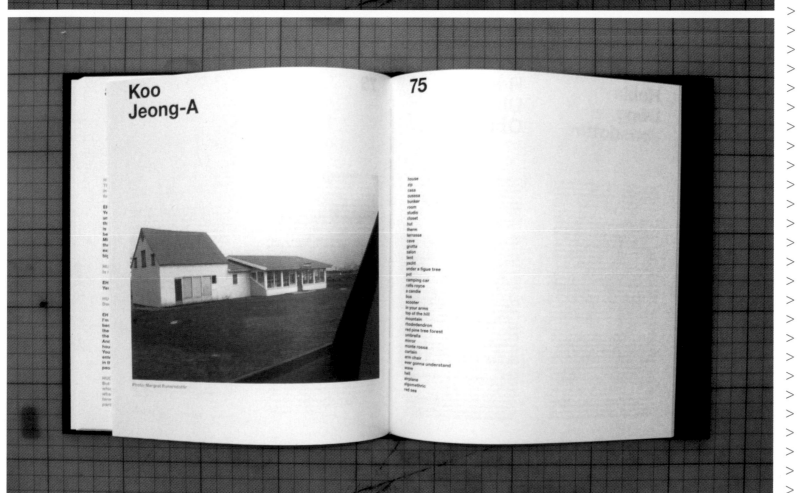

Apple býður þér á VIP
forsýningu á myndinni
Helvetica eftir Gary Hustwit.

Föstudaginn 28. sept.
klukkan 17 í Háskólabíó, S1.

Eftir myndina verða
léttar veitingar í boði.

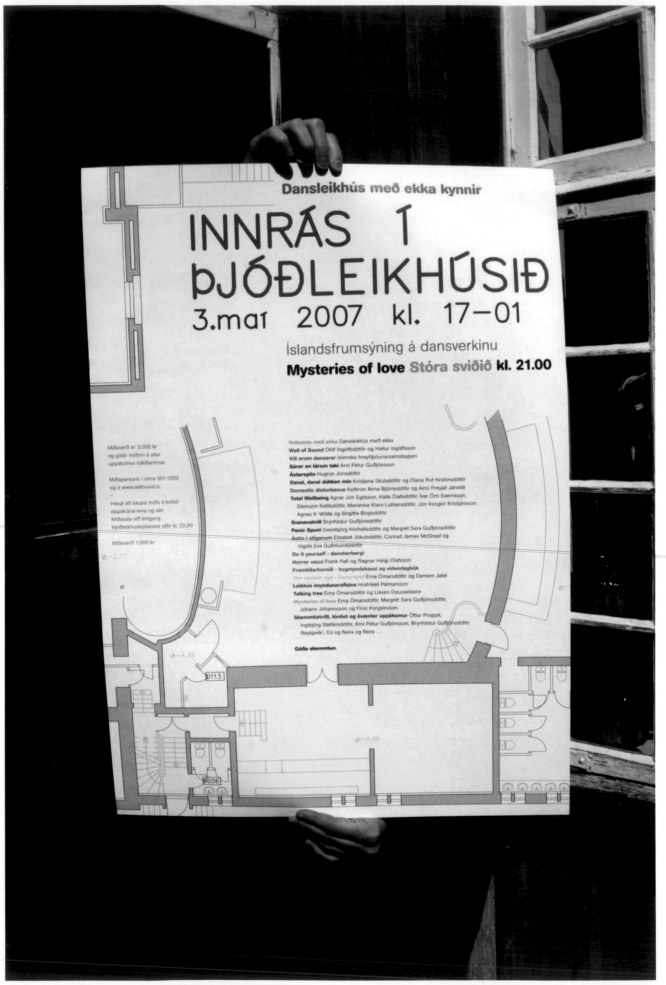

Hybrid Design

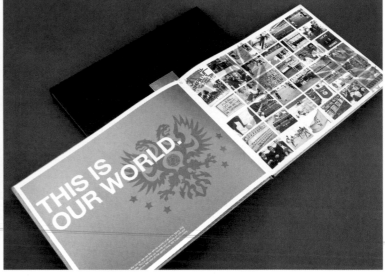

> *Nike World Cup 2006* > book > Greg Hoffman, Heather Amuny-Dey, Julie Freeman

540 Delancey Street
Suite 303
San Francisco CA 94107
United States
+1 415 227 4700
info@hybrid-design.com
www.hybrid-design.com

> Brian Flynn and Dora Drimalas are the creative pair behind Hybrid Design, founded in July of 2001 in San Francisco. For the last six years, Hybrid has been busy working on various projects for Nike, including: the logo for LeBron James, indoor display stands for Brand Jordan, 2004 Olympic Speed, graphics and interior design for the 2003 Manchester United tour and the United States women's soccer team, among other projects. In 2003 Hybrid developed various projects, including: home accessories specially made for W Hotel's meeting rooms during Fashion Week, the designing of sneakers for Converse and various projects for Apple. During this same period, Hybrid started the Super7 brand, which publishes books and magazines, designs clothing and toys and boasts not only a San Francisco store but its own line of home accessories, Hybrid-Home.

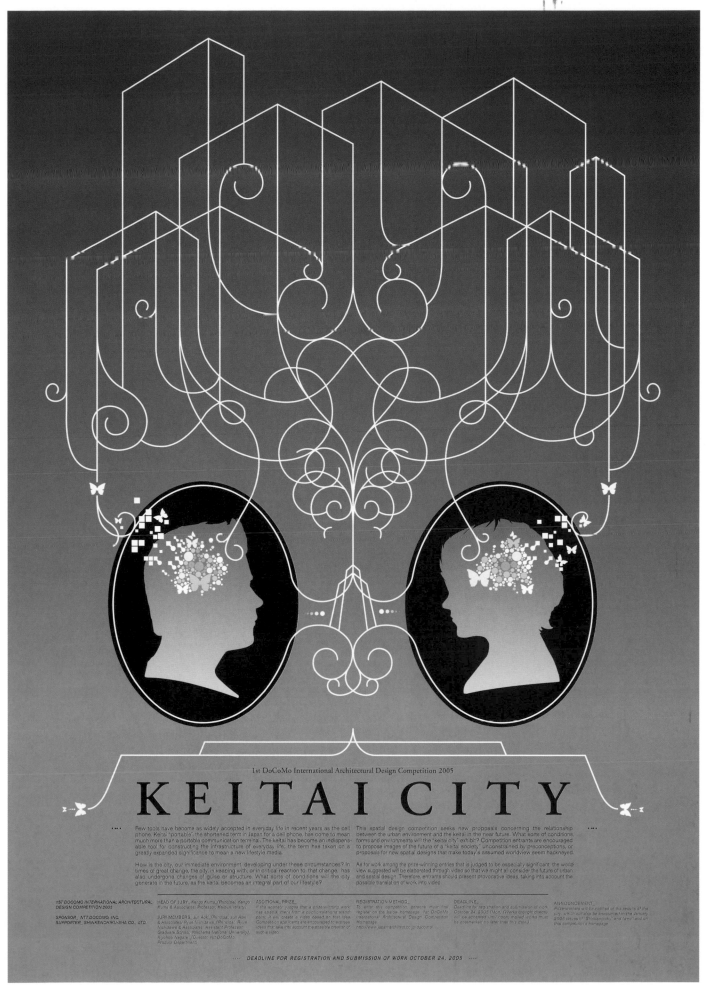

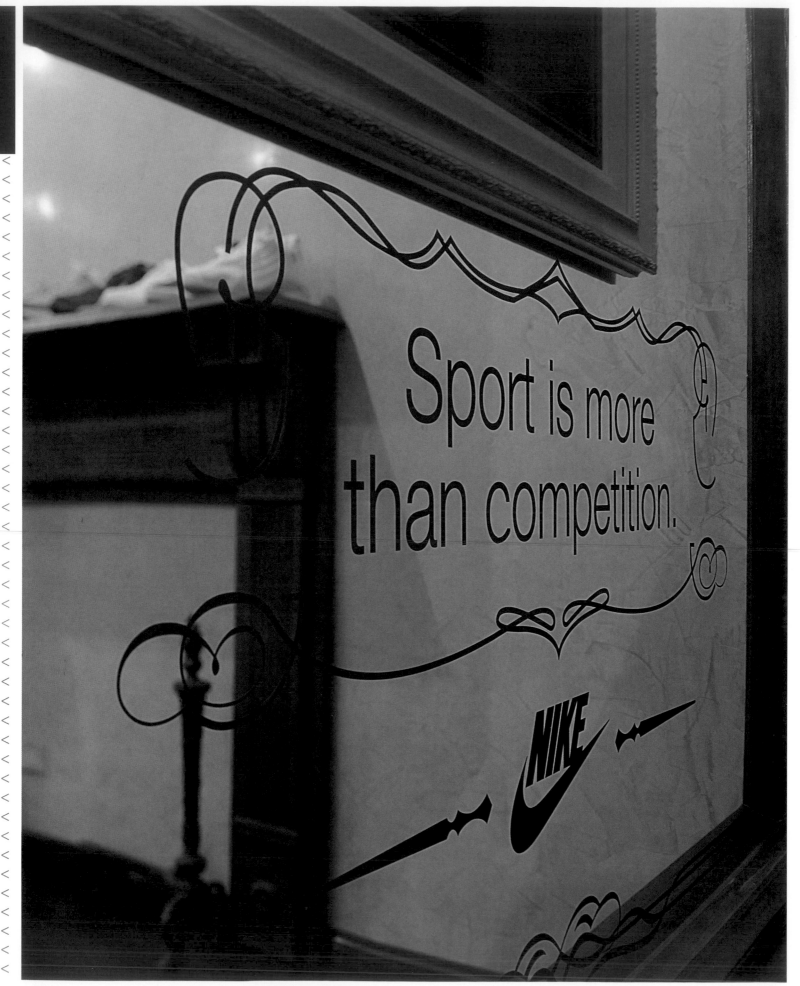

> *Nike Sport Culture Footwear* > store > Heather Amuny-Dey

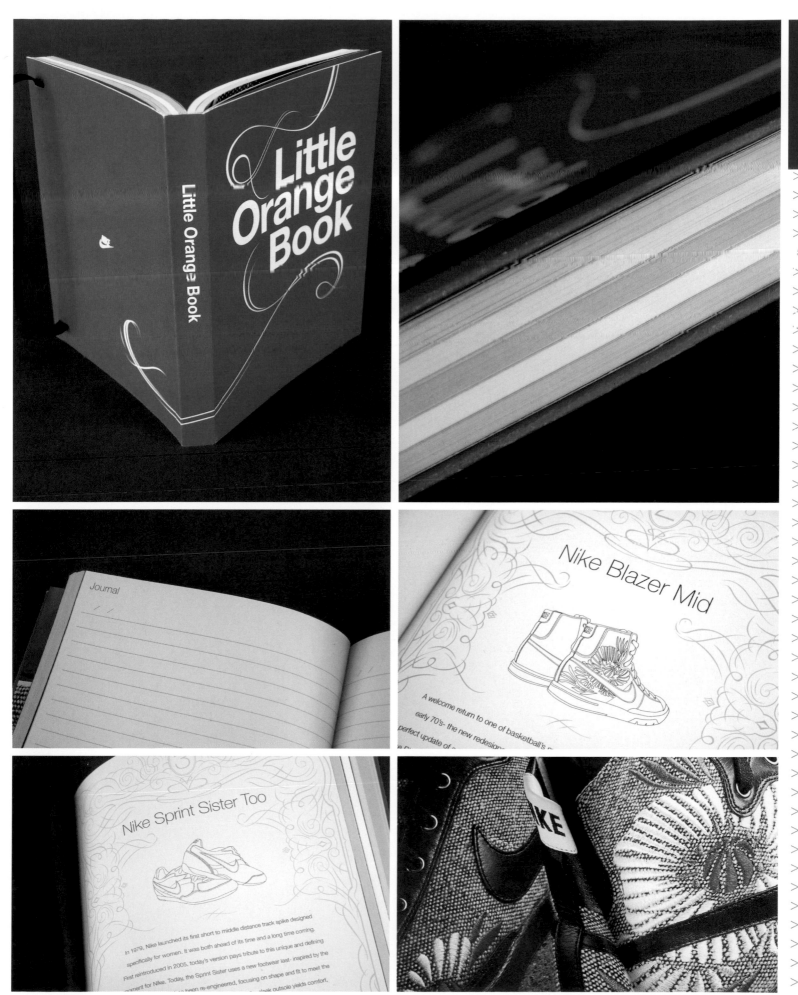

> *Little Orange Book* > book > Nike Sport Metro Women

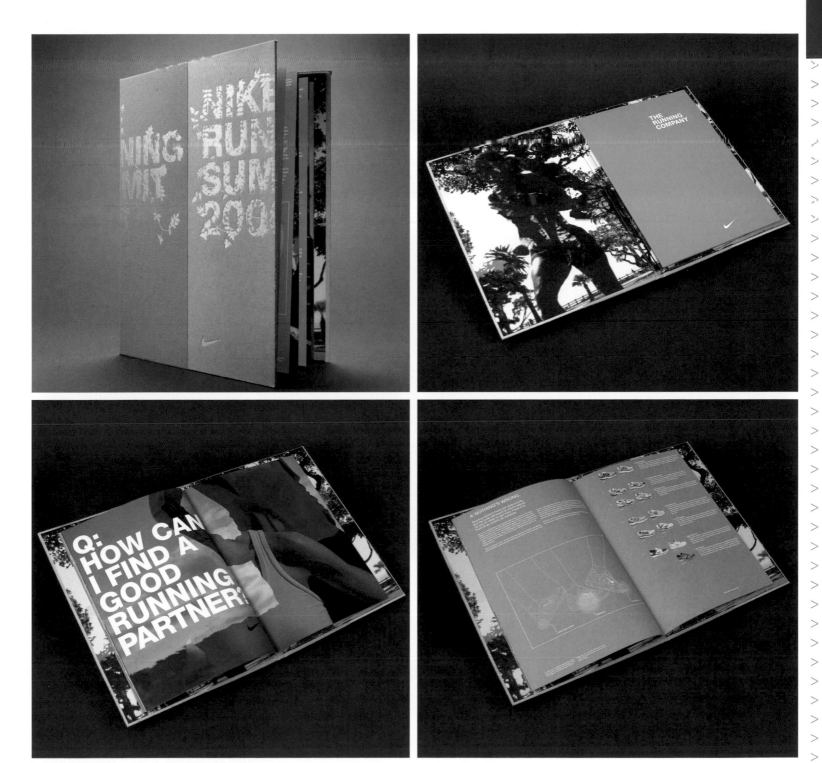

> *Running Summit* > catalog > Nike Natural Running

Isidro Ferrer

No será la muerte por fin
una cocina interminable?

Qué harán tus huesos disgregados,
buscarán otra vez tu forma?

Se fundirá tu destrucción
en otra voz y en otra luz?

Formarán parte tus gusanos
de perros o de mariposas?

XXXVI

> *Libro de las preguntas* > book > Editorial Media Vaca

Plaza de la Justicia, 1, local
22001 Huesca
Spain
+34 974 228 732
isidroferrer@telefonica.net

> With degrees in the dramatic arts and set design, the illustrator and graphic designer Isidro Ferrer was born in Madrid (Spain) and at the age of 14 moved to Zaragoza. He studied dramatic arts and graduated from the Jacques Lecoq International School of Theater in Paris (France). Nevertheless, his acting career came across many obstacles and he finally moved to Barcelona where he developed his skills at the studios of designer Peret. After designing in Barcelona, he moved to Zaragoza and later the small city of Huesca, where he now resides. Isidro Ferrer's work has been shown in individual expositions in Madrid, Gijón, Lisbon, Rouen, Rijeka, Bogota, Quito, Turin, Paris, Mexico and Santiago de Chile. He has received various awards like the National Design Award (2002) and the National Illustration award (2006), both Spanish. Presently, he is a member of the International Graphic Alliance. Isidro has seen over 25 books on his work published in France, Portugal and Spain.

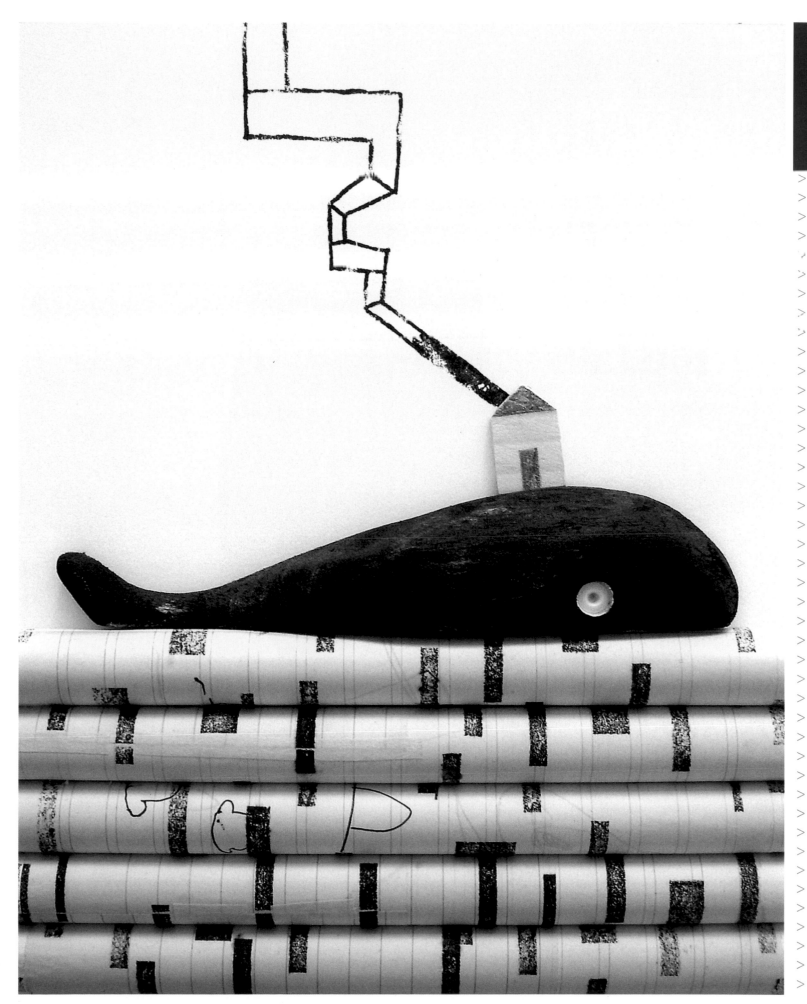

Centro
Dramático
Nacional

MU JERES SO ÑARON CA BALLOS

Texto,
escenografía,
iluminación
y dirección de
Daniel Veronese

**Teatro Valle-Inclán
Sala Francisco Nieva**

**del 12 de abril
al 3 de junio
de 2007**

> *Mujeres soñaron caballos* > poster > National Drama Center, Spain

cine francia

zaragoza en clave de cine

del 11 al 19 de noviembre

> *Cine Francia* > poster > French Film Festival, Zaragoza

LIBRO DE LAS PREGUNTAS

PABLO NERUDA

ISIDRO FERRER

Renau Josep

Nostàlgia de futur /
Homenatge a Renau

> *Nostalgia de futuro* > poster > personal project

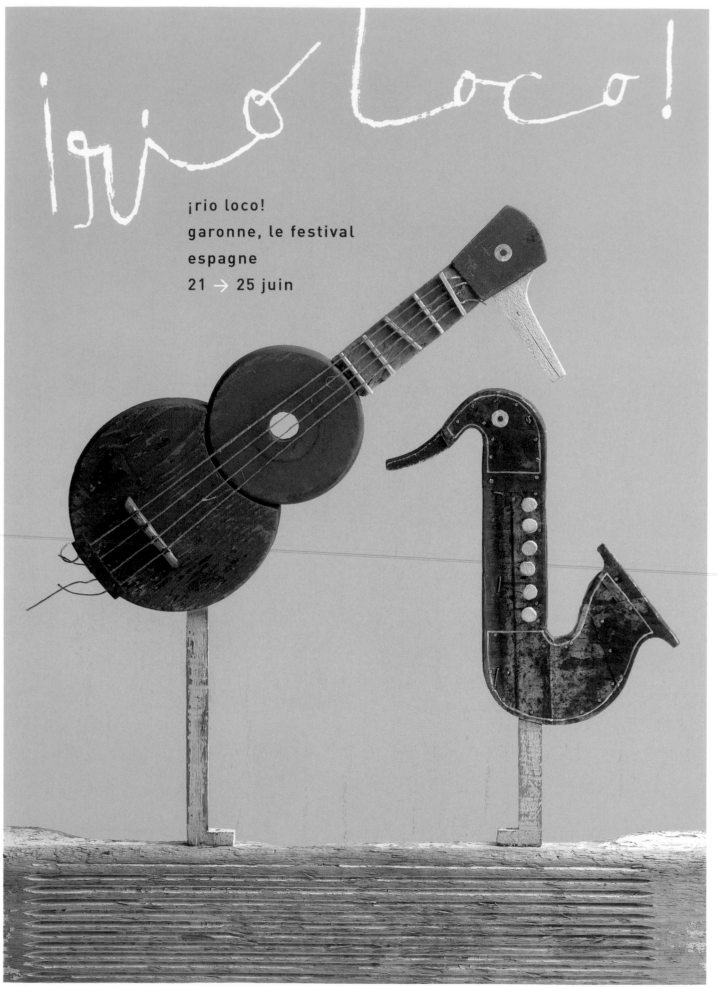

¡rio loco!
garonne, le festival
espagne
21 → 25 juin

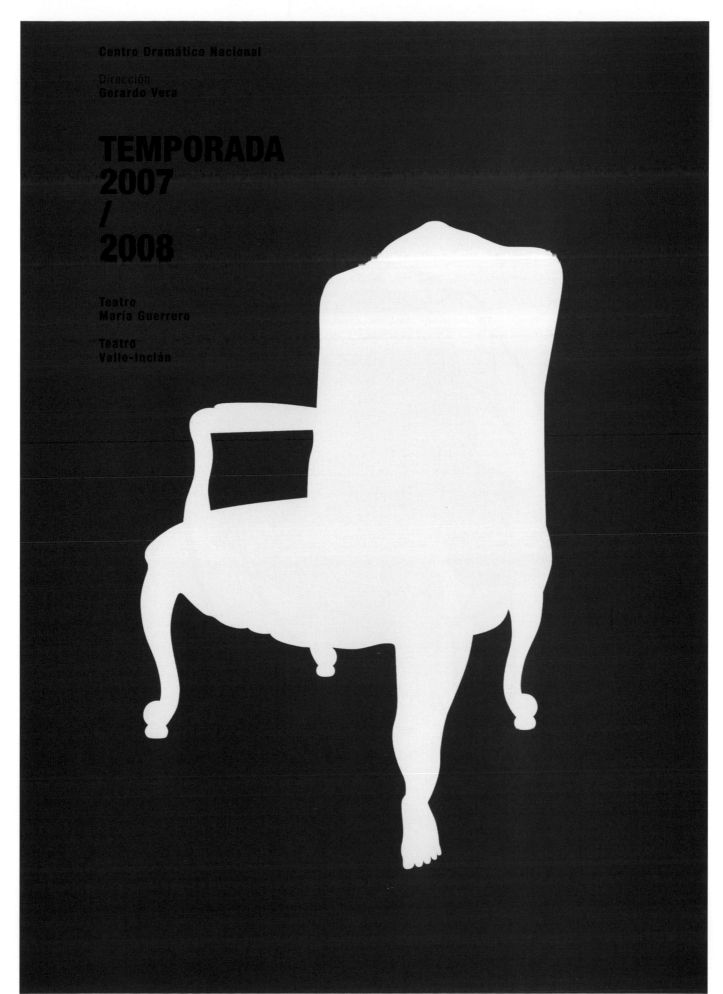

Centro Dramático Nacional

Dirección
Gerardo Vera

TEMPORADA
2007
/
2008

Teatro
María Guerrero

Teatro
Valle-Inclán

TÍO VANIA
de **Anton Chéjov**

Versión
Rodolf Sirera
Dirección
Carles Alfaro

**Centro
Dramático
Nacional**

**Teatro María Guerrero
del 31 de enero
al 16 de marzo
de 2008**

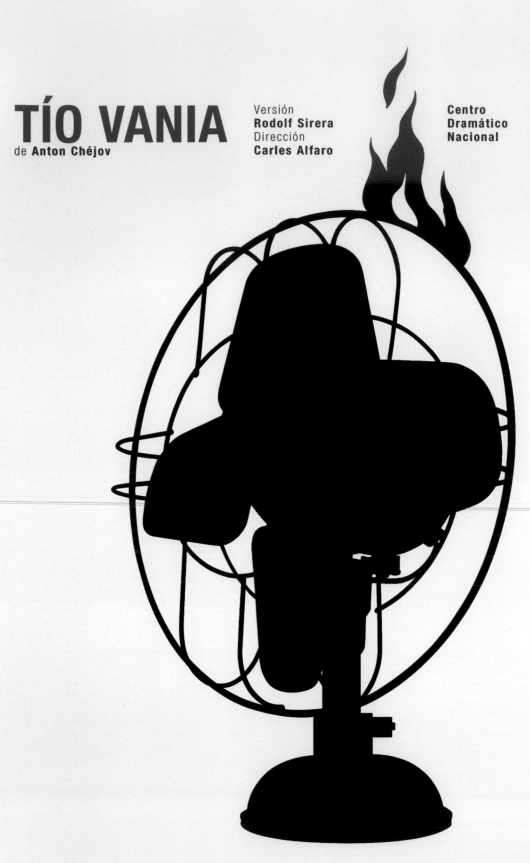

> *Tío Vania* > poster > National Drama Center, Spain

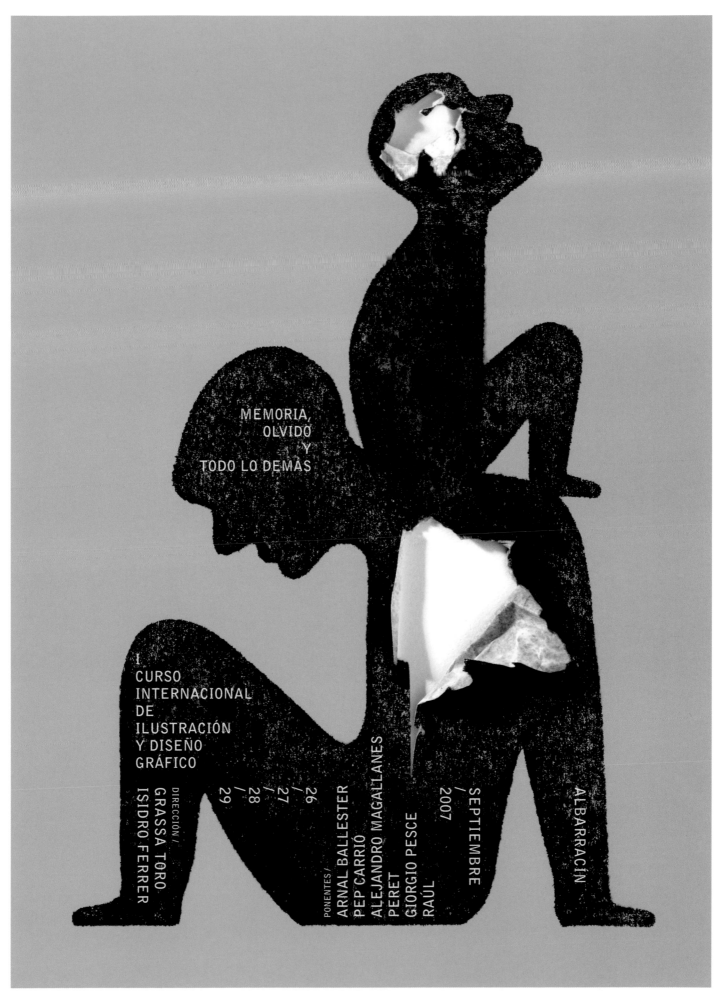

> *Memoria, olvido y todo lo demás* > poster > course in illustration and design in Albarracín

Italo Lupi

> *Tarpaulins* > billboard > Turin Winter Olympics 2006

Via G. Ventura, 3
20134 Milan
Italy
+2269 24099
italolupistudio@tiscali.it
info@italolupistudio.com
www.italolupistudio.com

> A graduate of architecture from the Polytechnic University of Milan in Italy, Lupi dedicated himself to graphic design from the start. Lupi designs images, communication, signs, ephemeral architecture and museum rooms. He was named HonRDI (Honorary Royal Designer for Industry) in London and is an Italian member of the International Graphic Alliance and honorary member of the Milan Art Directors Club, as well as editor-in-chief and art director for *Abitare* magazine. In charge of designing a new image for the Milan Museum of Contemporary Art (Museo del Presente), Lupi has received awards and honorable mention from the Milan Art Directors Club, the Typodomus of Prague, from the 13th Design Biennial of Brno and the Lahti International Poster Biennial. He also received the 1998 Compasso d'Oro Award for Graphic Design and the Pen Club/Fedrigoni Award for the best editorial graphic of 2001. His pieces have been shown in New York, Tokyo, Osaka, Grenoble and Échirolles.

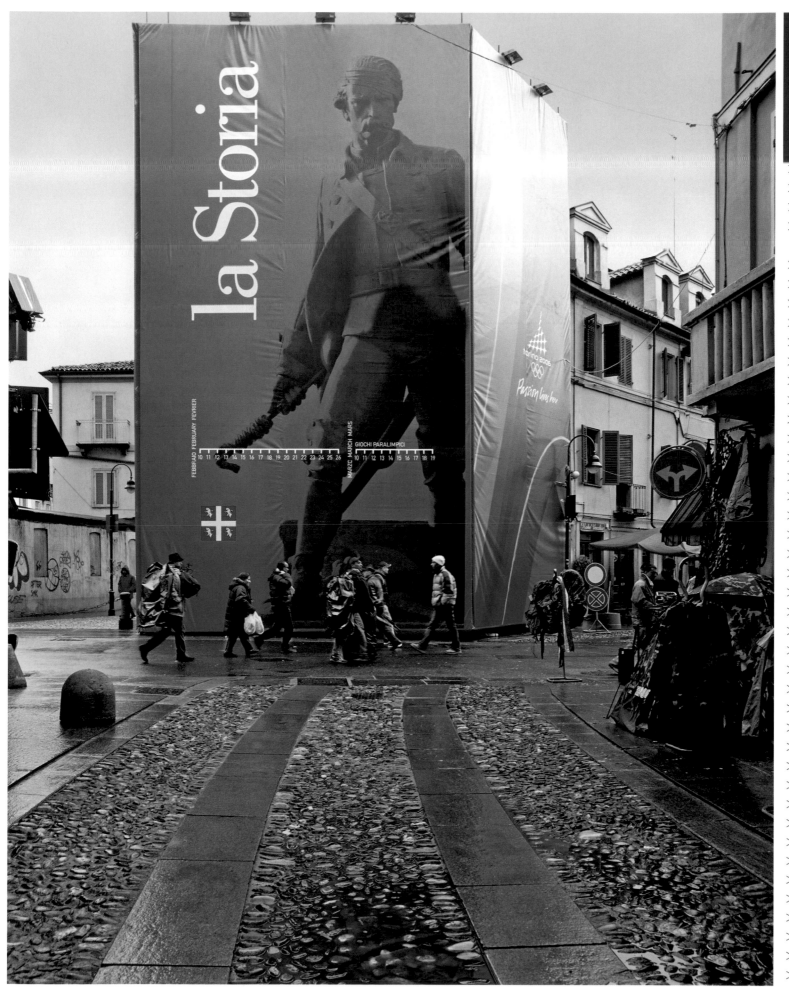

> *Menhir* > billboard > Turin Winter Olympics 2006

GRAFICHE MARIANO

DISEGNATO DA / DESIGNED BY ITALO LUPI

DUEMILAOTTO

TWO THOUSAND EIGHT

> Calendar cover > Grafiche Mariano Typography

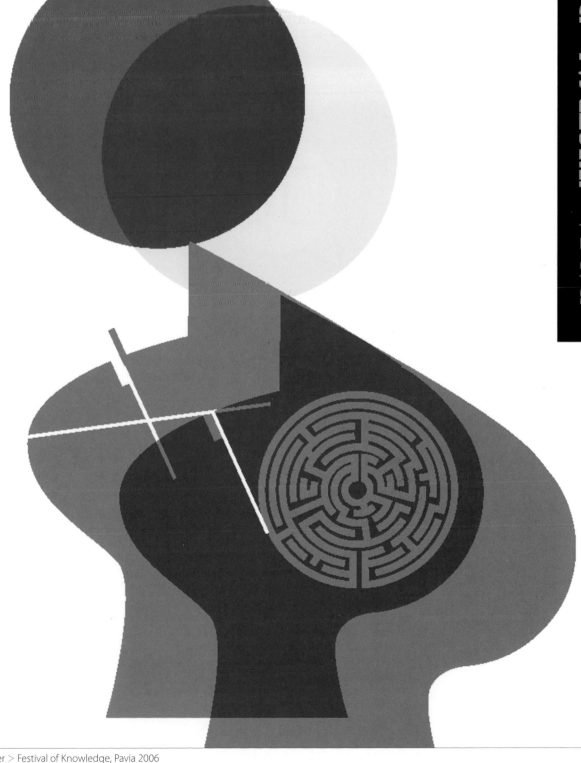

PAVIA FESTIVAL DEI SAPERI

> Pamphlet cover > Festival of Knowledge, Pavia 2006

A.D. ITALO LUPI

GRAFICHE MARIANO

			6	LUNEDI'	MONDAY	13	LUNEDI'	MONDAY	20	LUNEDI'	MONDAY	27	LUNEDI'	MONDAY
			7	MARTEDI'	TUESDAY	14	MARTEDI'	TUESDAY	21	MARTEDI'	TUESDAY	28	MARTEDI'	TUESDAY
1	MERCOLEDI'	WEDNESDAY	8	MERCOLEDI'	WEDNESDAY	15	MERCOLEDI'	WEDNESDAY	22	MERCOLEDI'	WEDNESDAY	29	MERCOLEDI'	WEDNESDAY
2	GIOVEDI'	THURSDAY	9	GIOVEDI'	THURSDAY	16	GIOVEDI'	THURSDAY	23	GIOVEDI'	THURSDAY	30	GIOVEDI'	THURSDAY
3	VENERDI'	FRIDAY	10	VENERDI'	FRIDAY	17	VENERDI'	FRIDAY	24	VENERDI'	FRIDAY	31	VENERDI'	FRIDAY
4	SABATO	SATURDAY	11	SABATO	SATURDAY	18	SABATO	SATURDAY	25	SABATO	SATURDAY			
5	DOMENICA	SUNDAY	12	DOMENICA	SUNDAY	19	DOMENICA	SUNDAY	26	DOMENICA	SUNDAY			

> Calendar, month of October > Grafiche Mariano Typography

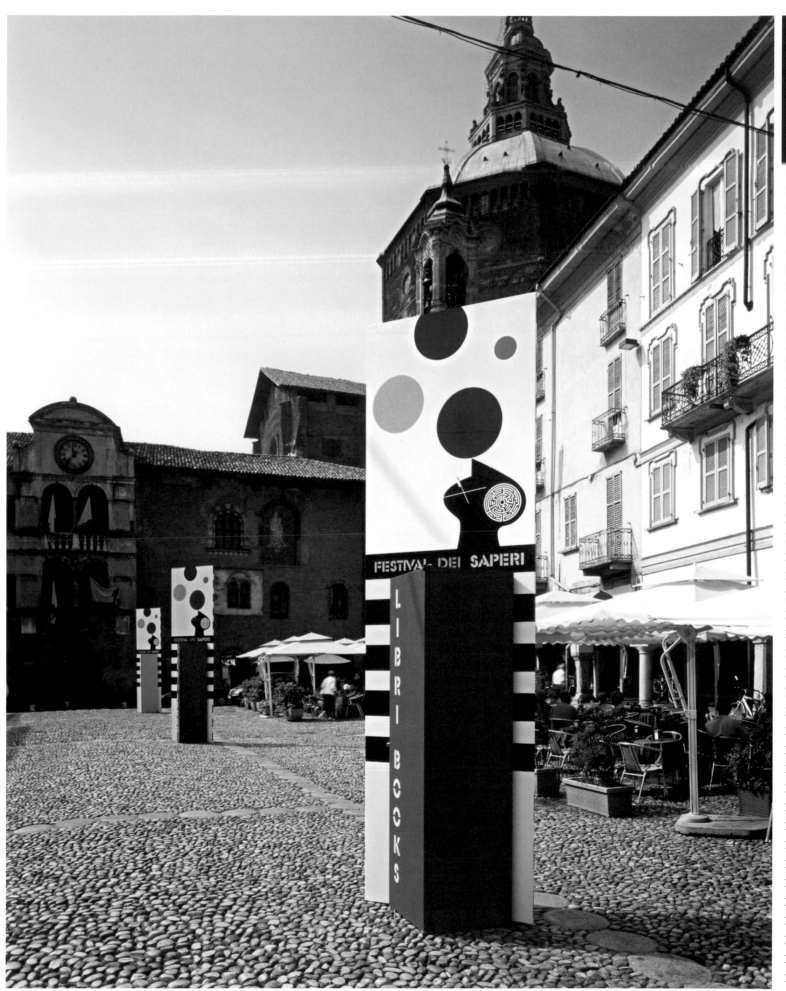

> Book containers > Festival of Knowledge, Pavia 2006

Jukka Veistola/Veistola Oy

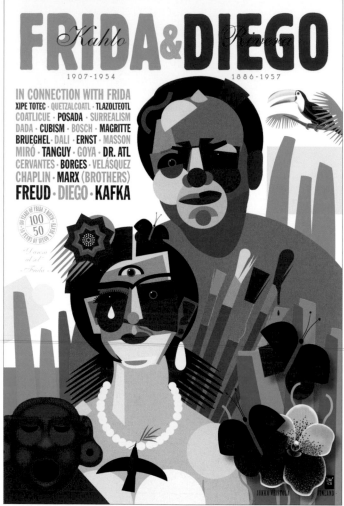

> *Frida & Diego* > poster > personal project

JUKKA VEISTOLA

> *Happy New Year 2008* > poster > personal project

Tehtaankatu 34 D
00150 Helsinki
Finland
+358 9 50 500 4684
jukka.veistola@veistola.fi
www.veistola.fi

> Thanks to the Outdoor Advertising Scholarship 1971 and the State Award for Industrial Art 1971 (both from Helsinki), Jukka Veistola started his career as a graphic designer. He obtained various awards, among them: first place and gold award at the Warsaw International Poster Biennial and the first place prize at the UNICEF/United Children's Fund poster competition. Notable among his individual exhibitions are: a poster exhibition at the Tampere Museum of Modern Art (1975), posters and graphic design at the Kluuvin Gallery (Helsinki, 1977), a poster exhibition at the Art Center Riga (1986). He has also collaborated with such museums as: MoMA, Centre Pompidou, Plakat Museum (Essen), and Stockholm Museum of Modern Art. As a member of the jury he has participated in the International Poster Biennial Helsinki (1994), Top of The Year Graphic Design & Advertising (Finland, 1998) and other contests.

17.8.–7.10.1990

HARTMAN

HELSINGIN KAUPUNGIN TAIDEMUSEO, TAMMINIEMENTIE 6 HELSINGFORS STADS KONSTMUSEUM, EKUDDSVÄGEN 6
KE-SU / ON-SÖ / WED-SUN 11–18.30

> *Hartman* > poster > Helsinki City Art Museum

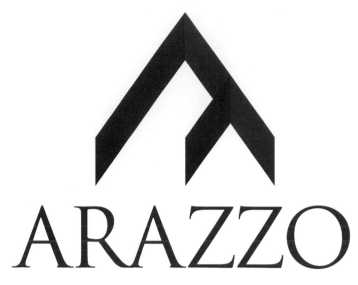

> Logo > Arazzo

> Logo > Kaivopiha shopping mall

> Logo > Fast Eddie

> Logo > Virvo

> Logo > *Blues News Magazine*

> Logo > Fazer Bakeries

> Logo > MH, Metsovaara van Havere

> Logo > Furuvik

Asko
Sarkola
*
Elina
Salo
*
Tom
Wentzel
*
Helena
Kallio

Carl-Kristian
Rundman
*
Peik
Stenberg
*
Sixten
Lundberg

FOREIGNER
- LILLA THEATRE - TEL. 09-394 022 -

RYSK RULETT

::: MUSIKAL AV BENGT AHLFORS :::

I ROLLERNA: JOACHIM WIGELIUS, HENRIKA ANDERSSON,
FRANK SKOG, JONNA JÄRNEFELT, KRISTOFER MÖLLER,
MARGIT LINDEMAN, RIKO EKLUNDH, MATS HOLMQVIST

= VÄRLDSURPREMIÄR 6 SEPTEMBER =

Lilla Jeatern

karlssonwilker inc.

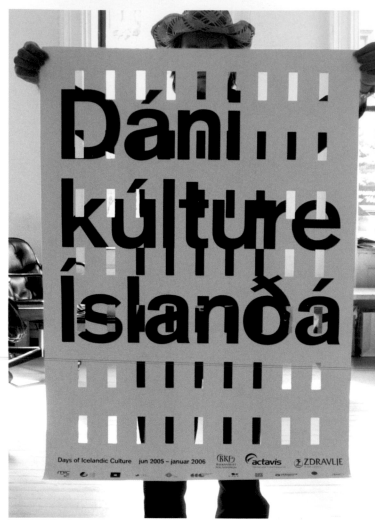

> *Dáni Kúlture Íslanða* > poster > Balkankult

> *Souvenir Poster* > poster > Boym Partners Inc.

536 6th Avenue
New York NY 10011
United States
+1 212 929 8064
tellmewhy@karlssonwilker.com
www.karlssonwilker.com

> karlssonwilker inc. design studio, founded by the Icelandic Hjalti Karlsson and the German Jan Wilker, can be found in the heart of Manhattan. These two designers, plus an intern designer, work on a large variety of projects. Their work has received many awards and been published in many national and international books and magazines for design. The book that covers their studio, *Tellmewhy*, relates their first 24 months at the studio and was published by Princeton Architectural Press in 2003. The book's goal is to dismiss the false idea that living in New York and having more or less "cool" clients meant that they had to live a glamorous and charming life. The book relates the succession of client deceptions and work cancellations that put them in the red. Despite all this, they continue to offer conferences and workshops around the world.

> *Skirl Records CD Series* > CD case > Skirl Records

Alora &
Calzadilla

Bock

Dean

THE HUGO BOSS PRIZE 2006

Ortega

Ruilova

Sehgal

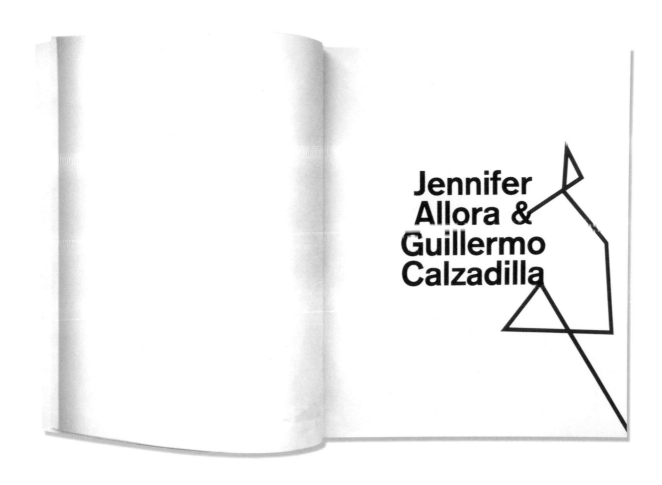

Jennifer Allora & Guillermo Calzadilla

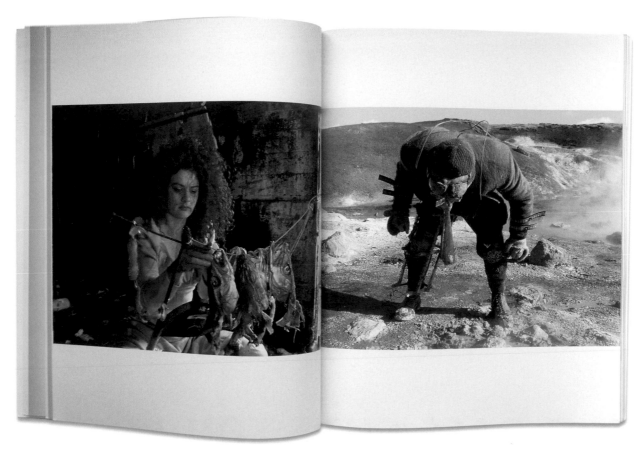

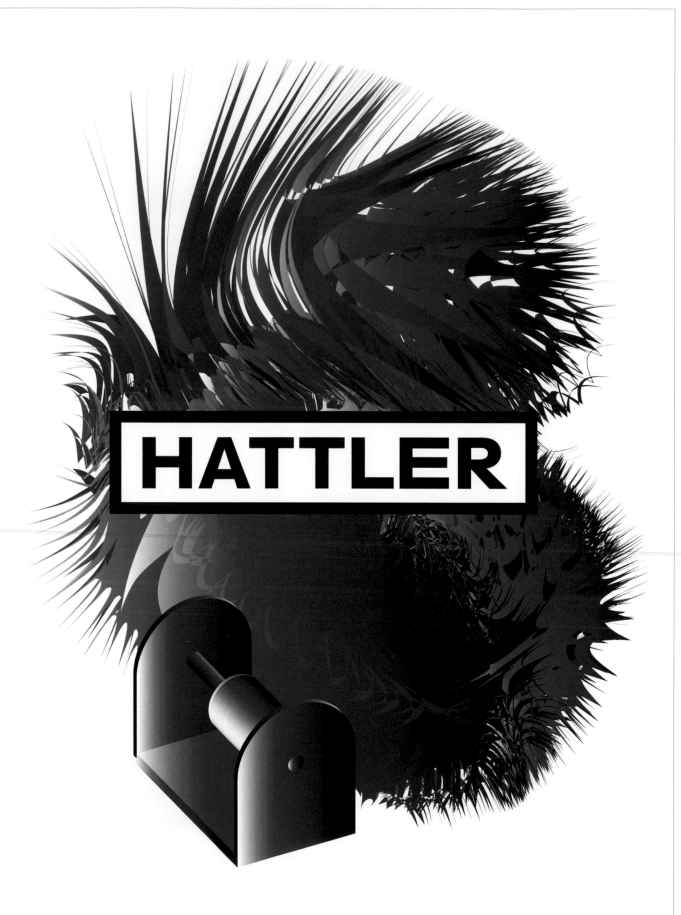

HATTLER

THE BASS CUTS TOUR 2004

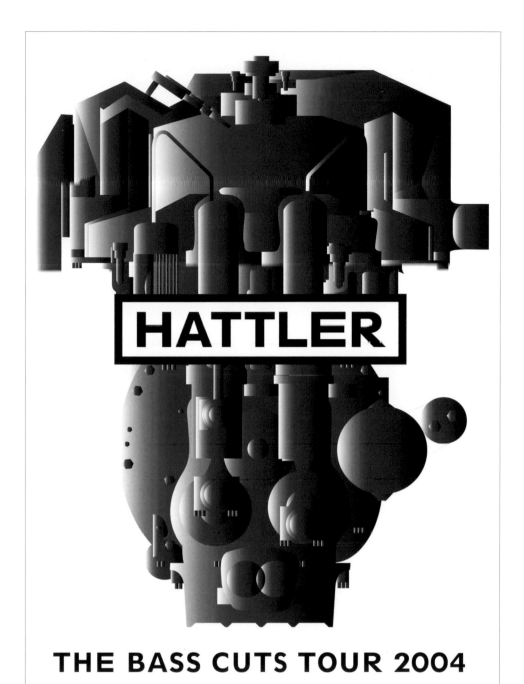

THE BASS CUTS TOUR 2004

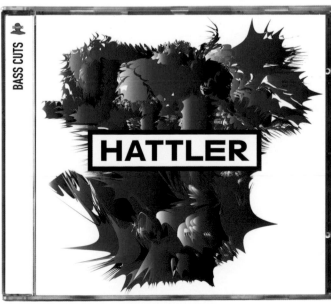

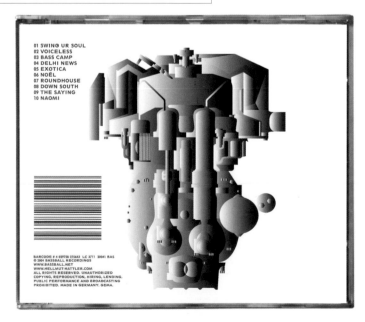

> *Hattler* > CD case > Hattler, Bassball Records

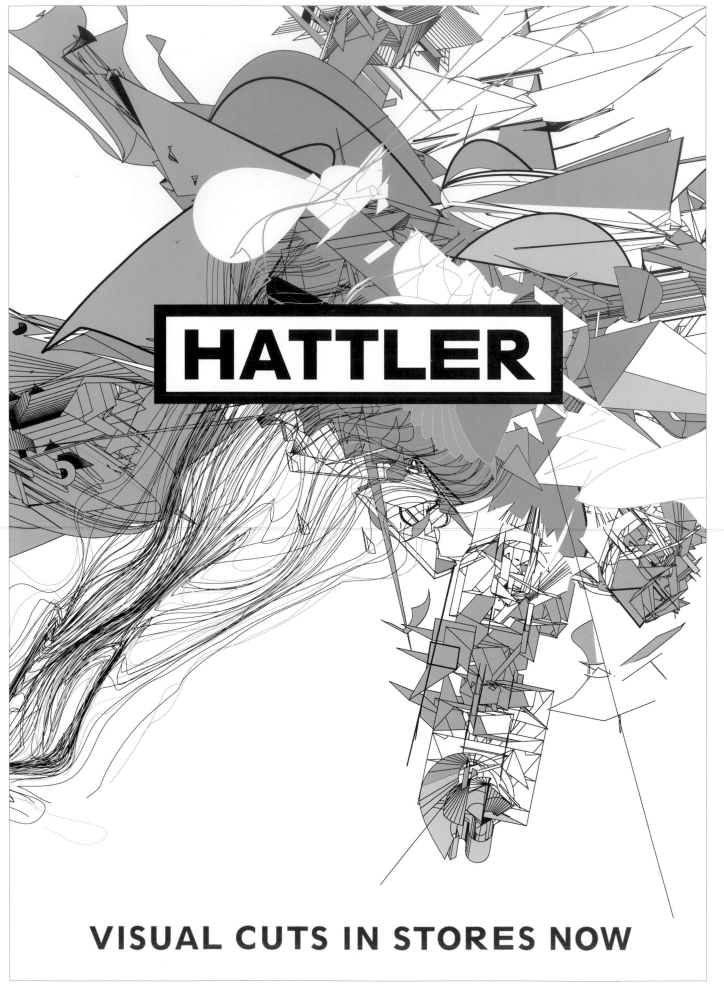

HATTLER

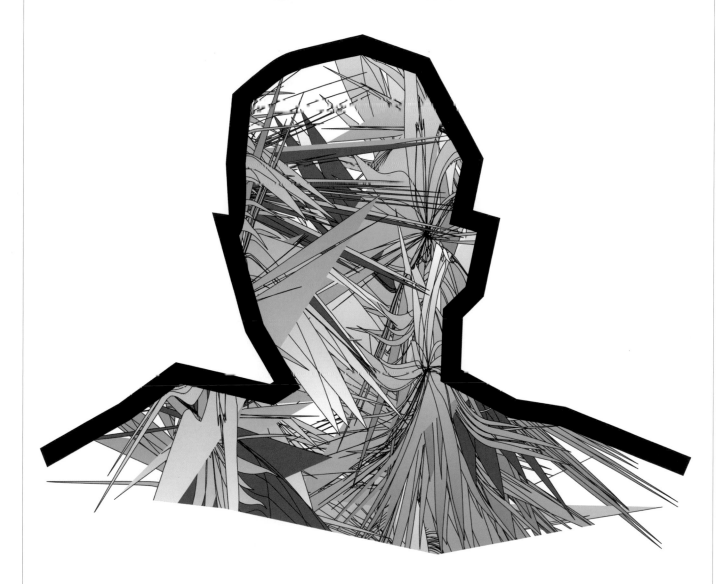

THE BIG FLOW TOUR 2006 **THE BAND IS:**
VOCALS: FOLA DADA GUITARS AND E-SITAR: TORSTEN
DE WINKEL DRUMS AND ELECTRONICS: OLI RUBOW
BASS: HELLMUT HATTLER

Curtis Hasselbring
The New Mellow Edwards

Skirt Records

1 White Sauce Hot Sauce Boss?
2 The Infinite Infiniteness of Infinity
3 ABCs of the Future
4 Plubis Epilogue
5 Double Negative
6 (I'm the annoying guy who always yells) Freebird
7 Insaniterrier (the Radio Dog)
8 Scatology
9 Ana
10 Far-away Planet
11 Mamacita

Special thanks to Chris, Trevor, John, the fine people at Skirt, NME superpals Andy Laster, Brad Jones, Dan Weiss, Anthony Coleman, Roberto Rodriguez, Anthony Burr, Ted Reichman, Andy Taub and all the past Mellow Edwards. A big extra thank you to my family and Alona for all of your positivity and support. Visit Curtis at www.curha.com

Skirt CD 003
©2006 Skirt Records
187 Terrace Pl 2nd floor
Brooklyn NY 11218 USA
www.skirtrecords.com

All compositions by Curtis Hasselbring (Zen Schlubbo Music, BMI) except #9 by Black Francis (Rice & Beans Music) and #11 written by Waller/Kaye (Chappell & Co./Music Sales Corp) This CD packaging was designed by karlssonwilker inc.

Curtis Hasselbring: trombones, Cracklebox, Megamouth, Casios, odd sounds
Chris Speed: clarinet, tenor saxophone, Casio SK1
Trevor Dunn: acoustic bass, bow
John Hollenbeck: drums and percussion, melodica

Recorded at Brooklyn Studios by Andy Taub in August 2004. Mixed by Andy Taub with further recording and mixing by Curtis Hasselbring at the Brooklyn Lyceum of Illicit Musicology and Ted Reichman at Katahadin Mobile. Mastered by Douglas Henderson at Micro-moose

Curtis Hasselbring
The New Mellow Edwards
©2006 Skirt Records www.skirtrecords.com

L2M3
Kommunikationsdesign

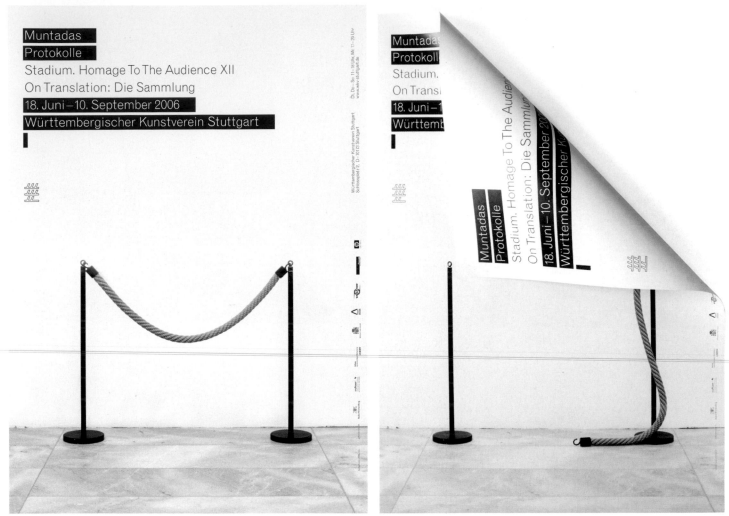

> *Muntadas Protokolle* > poster > Württemberg Art Association, Stuttgart

Hölderlinstrasse 57
70193 Stuttgart
Germany
+49 711 99 33 91 60
info@l2m3.com
l2m3.com

> L2M3 was started in 1999 by Sascha Lobe. Sascha studied visual communication in Pforzheim. Now this design studio boasts a team of designers formed by: Ina Bauer and Jan Maier—both of whom studied visual communication in Stuttgart—and Dirk Wachowiak, who also studied visual communication in Pforzheim. The L2M3 studio generally dedicates its work to the development of orientation systems, museum graphics and other similar projects in the field of spatial graphics. In regards to classic graphic design, L2M3 works for various clients in the worlds of business and industrial culture. Some of their clients are: Adidas, Behr, the Museum of Stuttgart, Mercedes-Benz, and the State of Baden-Württemberg, among others. The works shown here were created for the Pforzheim Jewelry Museum and for the Württemberg Art Association.

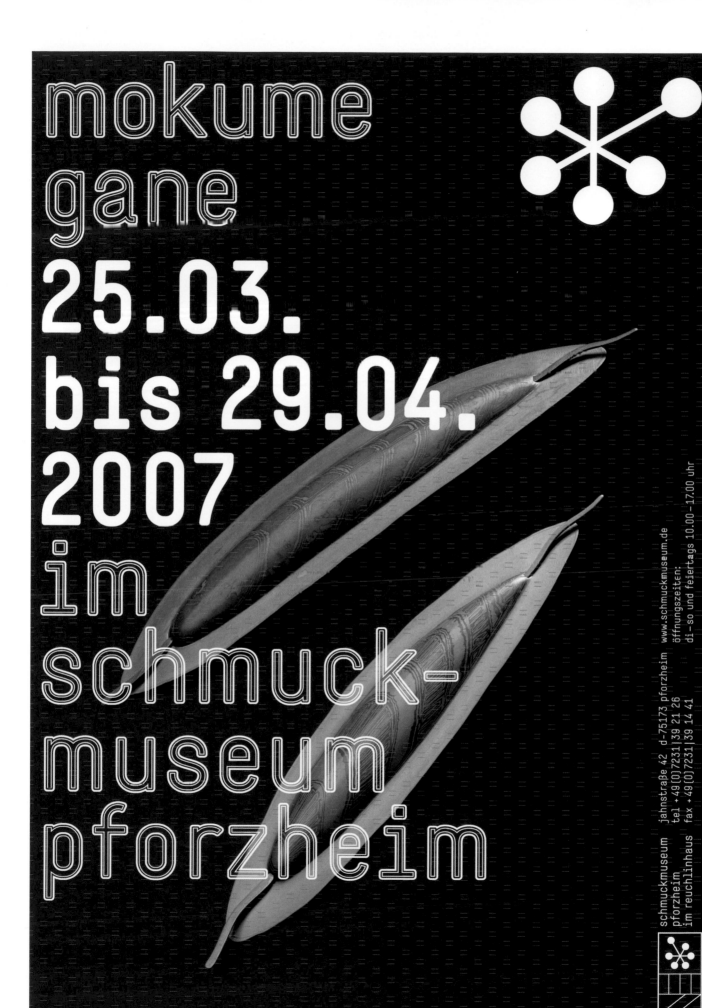

> *Mokume Gane* > poster > Pforzheim Jewelry Museum, Reuchlinhaus

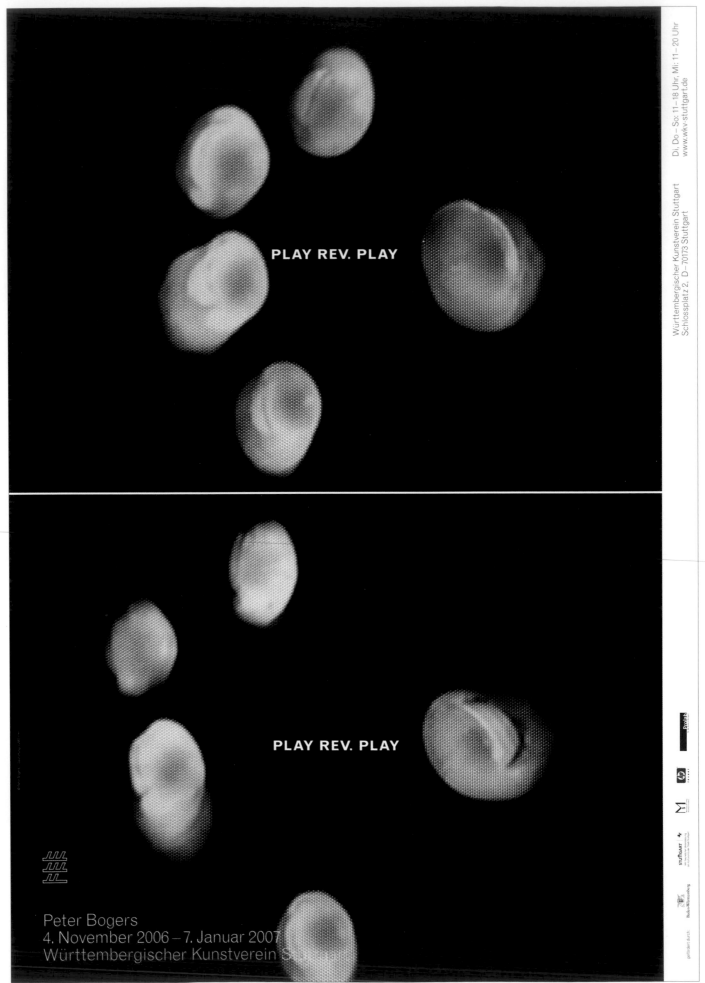

> *Peter Bogers* > poster > Württemberg Art Association, Stuttgart

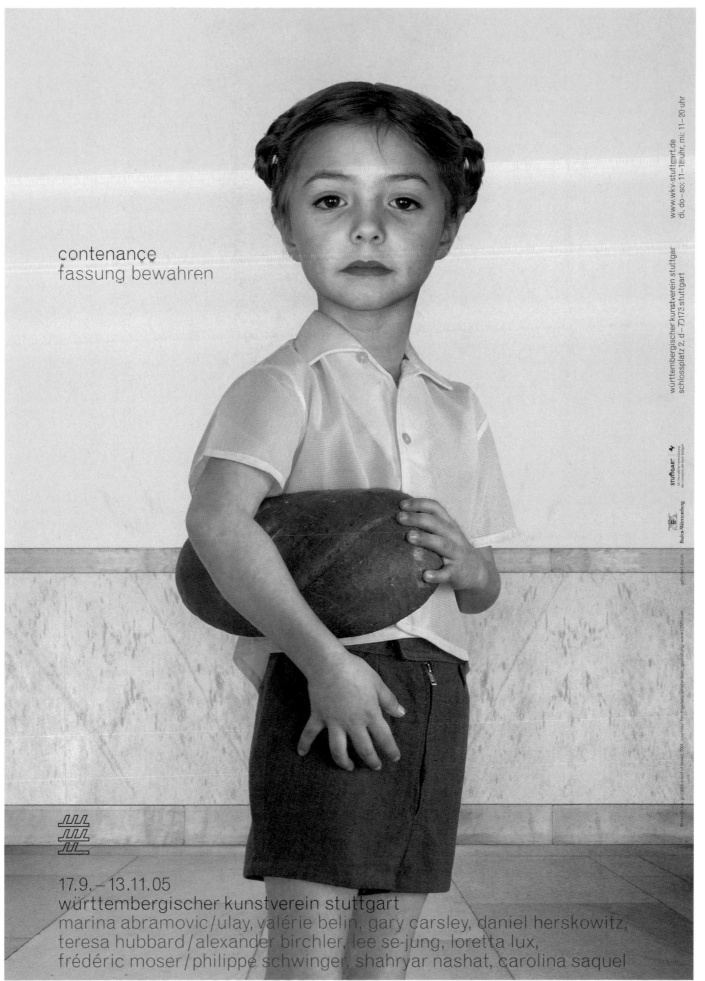

contenance
fassung bewahren

17.9. – 13.11.05
württembergischer kunstverein stuttgart
marina abramovic/ulay, valérie belin, gary carsley, daniel herskowitz,
teresa hubbard/alexander birchler, lee se-jung, loretta lux,
frédéric moser/philippe schwinger, shahryar nashat, carolina saquel

> *Contenance* > poster > Württemberg Art Association, Stuttgart

Staatliche
Akademie der
Bildenden Künste
Stuttgart

new graduate program
conservation of new media
and digital information (m.a.)

application deadline
winter semester
june 30, 2006

L2M3.com

> *Mediakonservation* > poster > State Academy of the Plastic Arts, Stuttgart

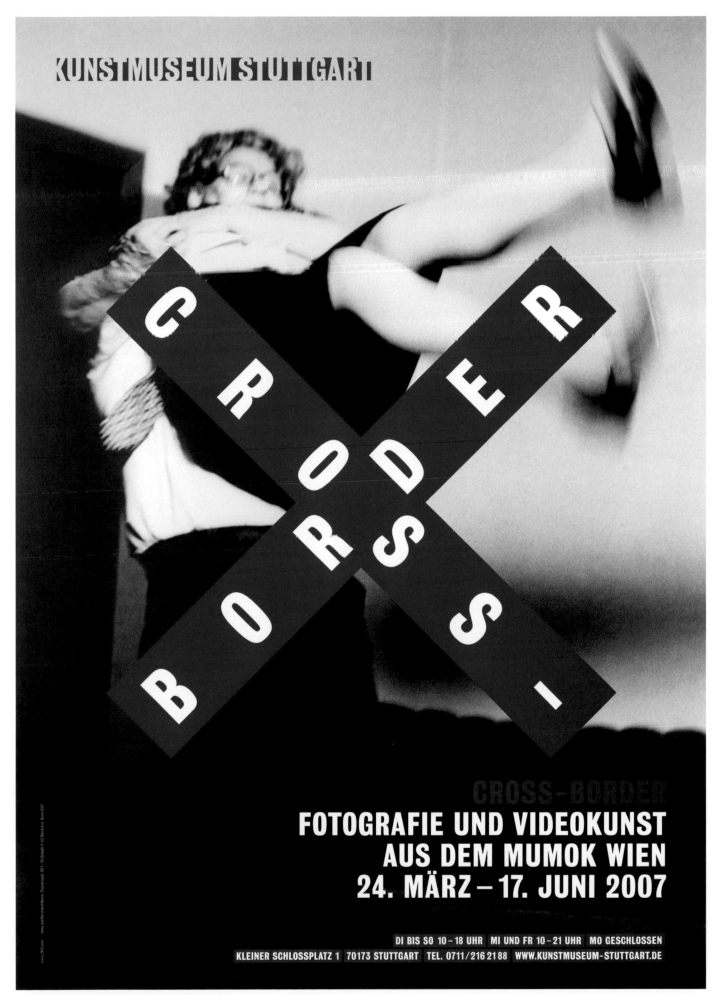

KUNSTMUSEUM STUTTGART

CROSS-BORDER

FOTOGRAFIE UND VIDEOKUNST
AUS DEM MUMOK WIEN
24. MÄRZ – 17. JUNI 2007

DI BIS SO 10 – 18 UHR MI UND FR 10 – 21 UHR MO GESCHLOSSEN
KLEINER SCHLOSSPLATZ 1 70173 STUTTGART TEL. 0711/216 21 88 WWW.KUNSTMUSEUM-STUTTGART.DE

> *Cross-border* > poster > Art Museum, Stuttgart

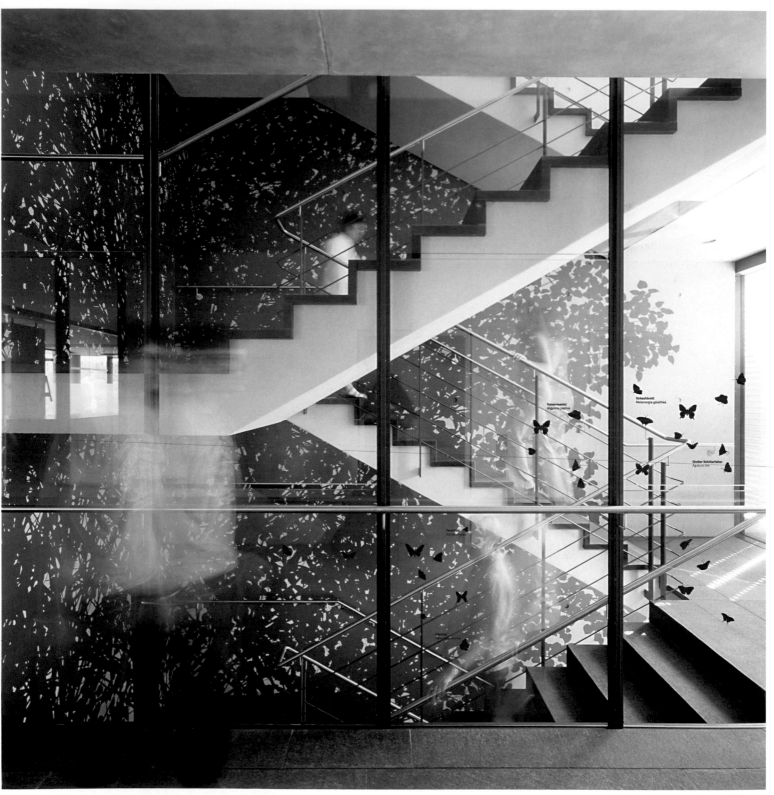

> Mural > Kreissparkasse Tübingen

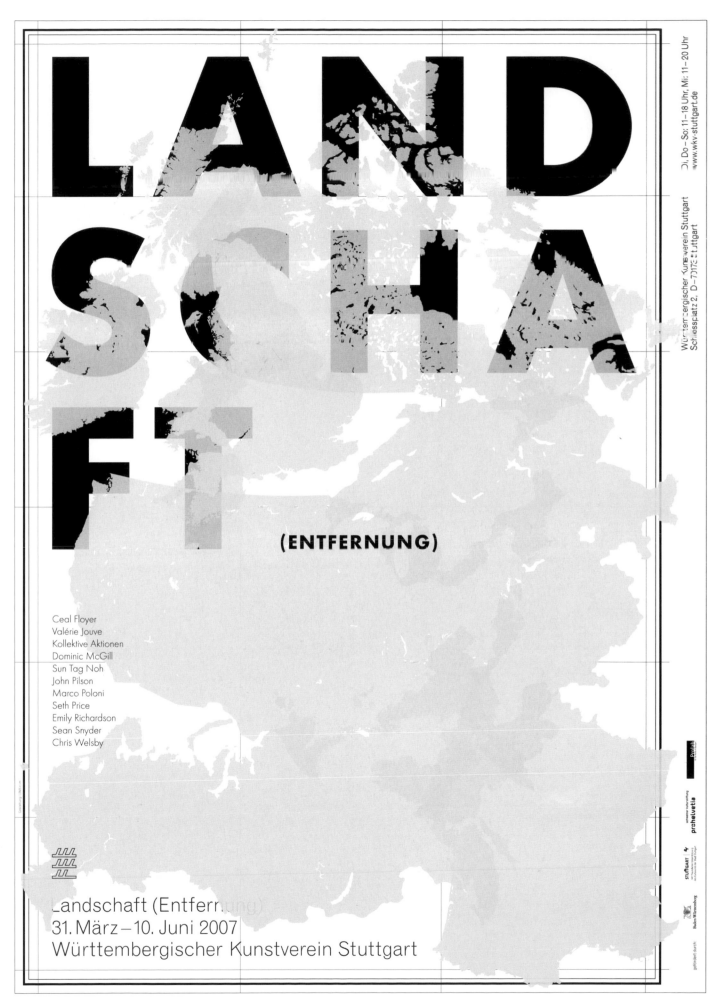

LAND
SCHA
FT
(ENTFERNUNG)

Ceal Floyer
Valérie Jouve
Kollektive Aktionen
Dominic McGill
Sun Tag Noh
John Pilson
Marco Poloni
Seth Price
Emily Richardson
Sean Snyder
Chris Welsby

Landschaft (Entfernung)
31. März – 10. Juni 2007
Württembergischer Kunstverein Stuttgart

Di, Do–So: 11–18 Uhr, Mi: 11–20 Uhr
www.wkv-stuttgart.de
Württembergischer Kunstverein Stuttgart
Schlossplatz 2, D–70173 Stuttgart

Laboratoires CCCP =
Dr. Pêche + M^elle Rose

> *XY Project* > photos > personal project

153 bis, rue d'Ambert
45000 Orleans
France
+33 2 38 84 63 44
peche@laboratoires-cccp.org
www.schizoide.org
www.laboratoires-cccp.org

> After having studied at the Orleans Institute of Fine Arts, Dr. Pêche + M^elle Rose started working as a freelance graphic designer. Between 1990 and 2008, this cryptically named designer collaborated with the National Drama Center in Orleans, a theater directed by Oliver Py. Till now, the annual series of posters produced for this theater is this studio's most representative work. It has also seen its work shown in various collective exhibitions in Bulgaria, Canada, China, Finland, Hong Kong, Iran, Japan, Taiwan, and various individual exhibitions in Bolivia, France, Japan. They've also been published in various books, like: *Laboratoires CCCP = Dr. Pêche + M^elle Rose*, *Area 2*, *Type Image Message*, *All Men Are Brothers* and *Big Ideas*. In 2003, Laboratoires CCCP = Dr. Pêche + M^elle Rose received the Grand Prix and the Yusaku Kamekura International Design Award at the 7th International Poster Biennial of Toyama.

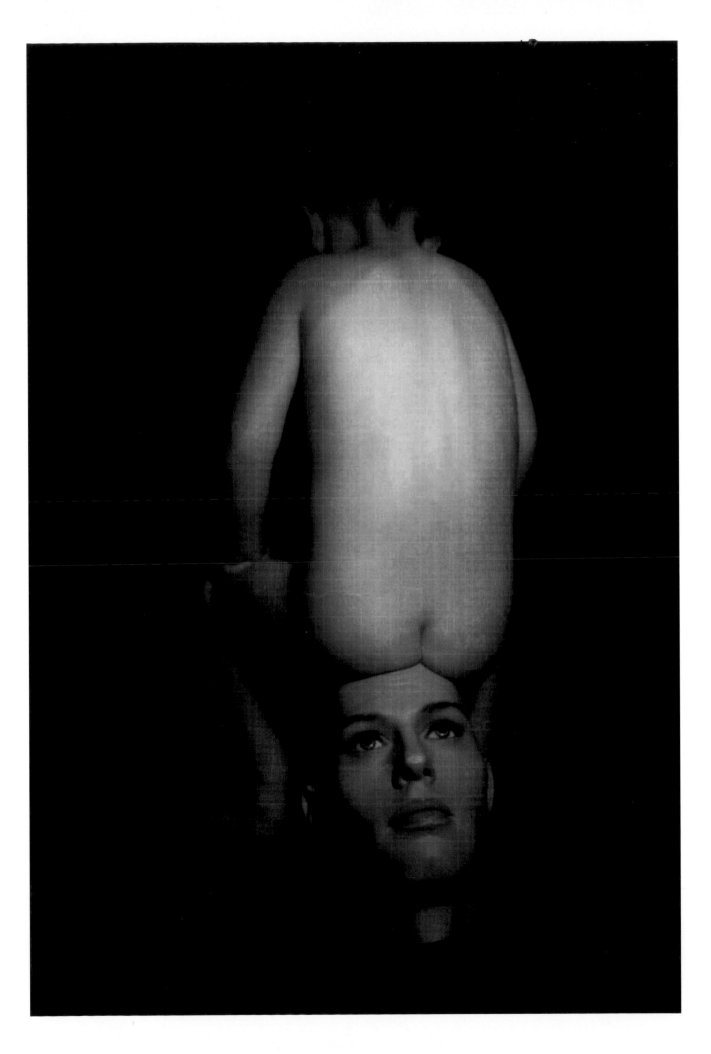

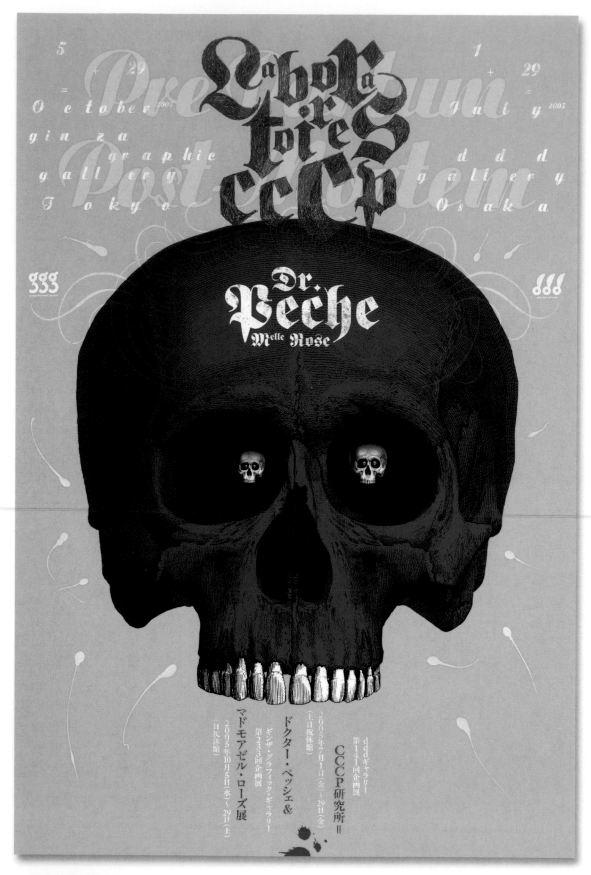

> *Pre-Partum/Post-Mortem* > poster > DDD Gallery, Osaka, and GGG Gallery, Tokyo

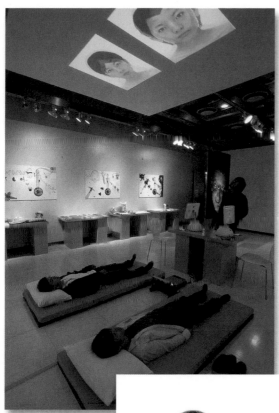

> "Schizoide project" > exhibition > GGG Gallery, Tokyo

> *Schizoide project* > photo > personal project

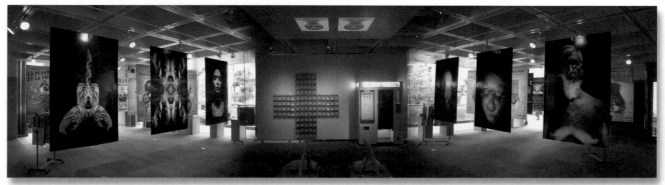

> "Pre-Partum/Post-Mortem" > exhibition > DDD Gallery, Osaka

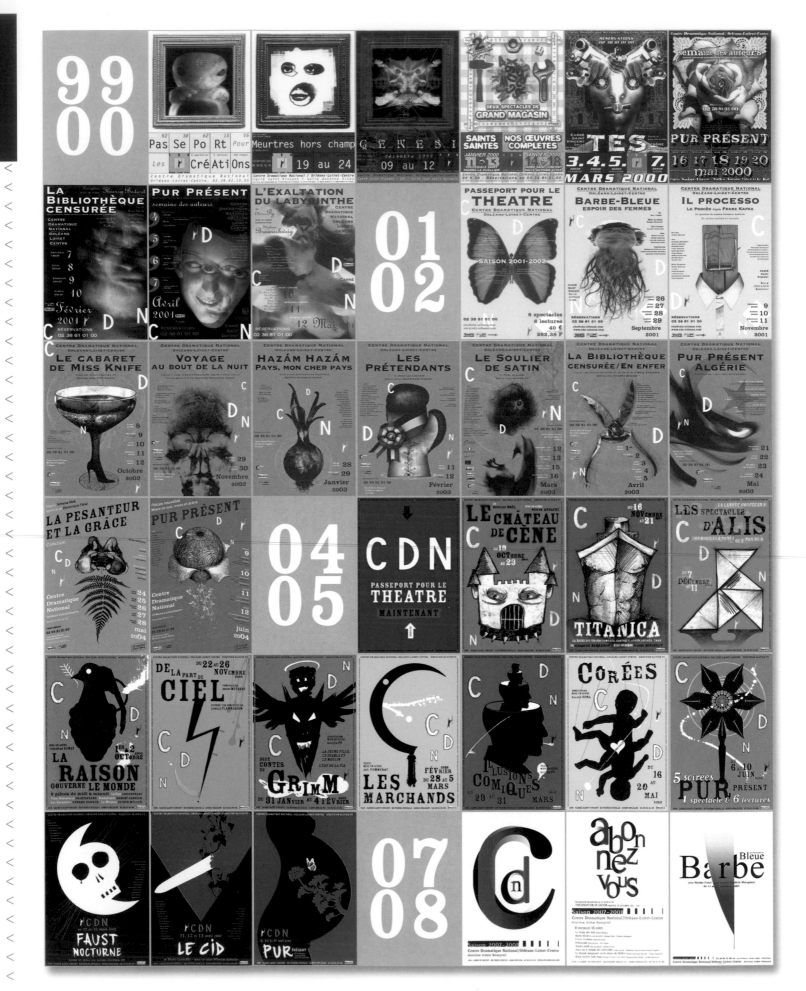

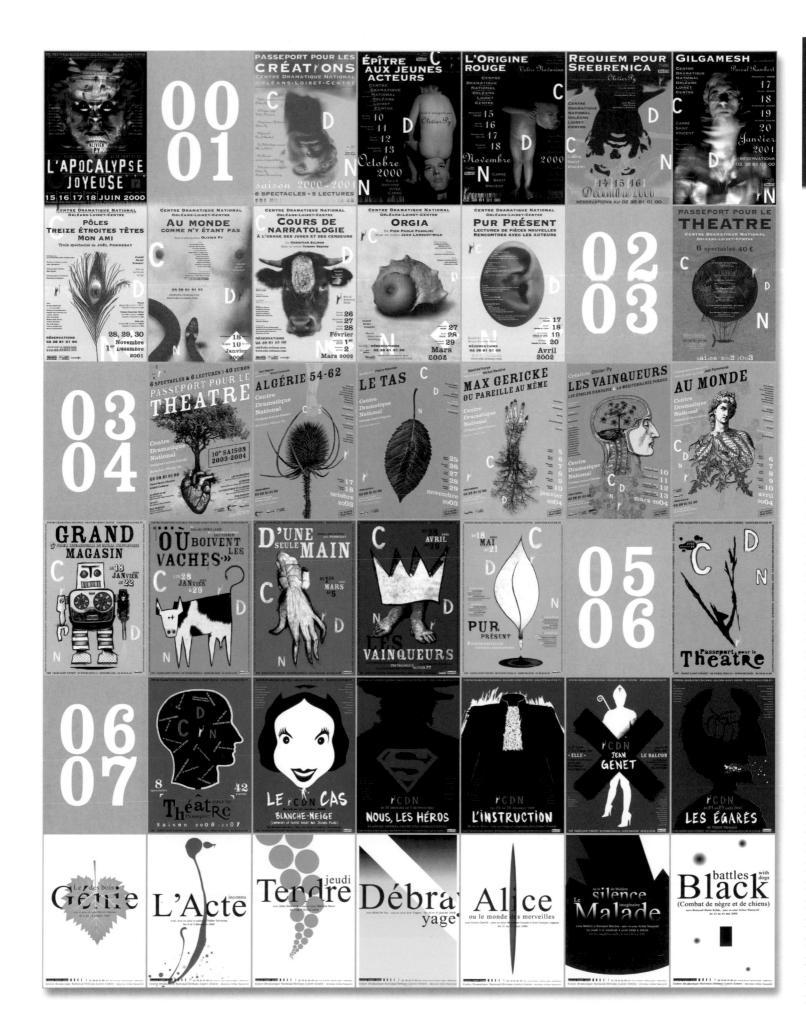

> Poster > personal project

> Cultural Passport for Students > visual identity: logos, poster, pamphlet
> University of Orleans

> Poster > personal project

> Magic House > poster > Maison de la Magie

> *Cultural Passport for Students* > visual identity: logos, poster, pamphlet > University of Orleans

> *Magic House* > poster, logo, postcards, pamphlet > Maison de la Magie

Laboratorium

> 57th Dubrovnik Summer Festival > poster > Dubrovnik Festival

Zeleni trg 1
10000 Zagreb
Croatia
+385 1 606 15 12
lab@laboratorium.hr
www.laboratorium.hr

> Founded in 2001 by Ivana Vučić (designer and photographer) and Orsat Franković (designer), Laboratorium is a studio of design and visual communication. This studio works on a number of projects ranging from graphic design to advertising and photography for a number of different clients like cultural institutions (museums, galleries, theaters, art festivals, book and magazine publishers) and industrial ones (pharmaceutical products, food, cosmetics, fashion). Their manner of attacking each new project consists of finding ways to design better communication between their clients and the public, always keeping in mind the peculiarities of each project (their target audience, the type and dimensions of the communication medium being used, available budget). In terms of compromising between the professional and creative, Laboratorium doesn't differentiate between clients based on importance or budget. They firmly believe that even the smallest project can achieve great importance.

LIGHT

Dom likovnih umjetnika Ivan Meštrović
Galerija Prsten i Galerija PM

26.03. - 10.05.2003.

◉ **hdlu**

DAVOR ANTOLIĆ ANTAS	IVAN FAKTOR	IVANA FRANKE	ANTO JERKOVIĆ	MLADEN GALIĆ
JULIJE KNIFER	IVAN MARUŠIĆ KLIF	ANTUN MOTIKA	MAGDALENA PEDERIN	GORAN PETERCOL
VESNA POKAS	DUBRAVKA RAKOCI	DAMIR SOKIĆ	ALEKSANDAR SRNEC	LJERKA ŠIBENIK
SLAVEN TOLJ	KSENIJA TURČIĆ	MIRJANA VODOPIJA	VLADO ZRNIĆ	SISLEJ XHAFA

SISLEJ XHAFA
/ projekt Galerije PM /
Zagreb Boogie Woogie
svjetlosna site-specific instalacija na fasadi

Pod pokroviteljstvom Ministarstva kulture RH i Gradskog ureda za kulturu Grada Zagreba. Sponzori: UNIQA / IGEPA - Plana papiri / OSRAM / UNIJA Zajednica Albanaca Hrvatske / TEP / HSM

> *Everlasting Adhesive Calendar* > adhesive tape > Laboratorium

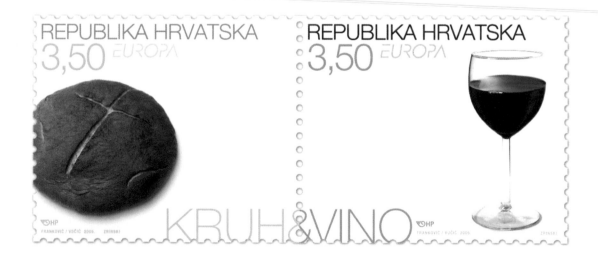

> *Bread & Wine* > postage stamps > Croatian Post

> *HP-Croatian Post* > poster > Croatian Post

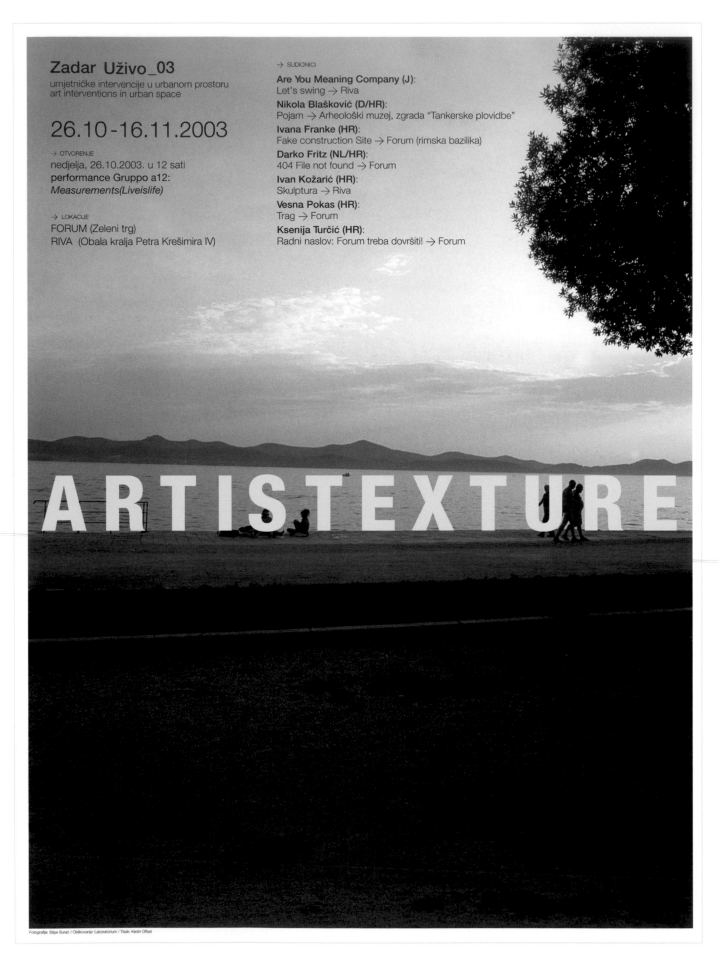

Zadar Uživo_03
umjetničke intervencije u urbanom prostoru
art interventions in urban space

26.10 - 16.11.2003

→ OTVORENJE
nedjelja, 26.10.2003. u 12 sati
performance Gruppo a12:
Measurements(Liveislife)

→ LOKACIJE
FORUM (Zeleni trg)
RIVA (Obala kralja Petra Krešimira IV)

→ SUDIONICI
Are You Meaning Company (J):
Let's swing → Riva
Nikola Blašković (D/HR):
Pojam → Arheološki muzej, zgrada "Tankerske plovidbe"
Ivana Franke (HR):
Fake construction Site → Forum (rimska bazilika)
Darko Fritz (NL/HR):
404 File not found → Forum
Ivan Kožarić (HR):
Skulptura → Riva
Vesna Pokas (HR):
Trag → Forum
Ksenija Turčić (HR):
Radni naslov: Forum treba dovršiti! → Forum

Fotografija: Stipe Surać / Oblikovanje: Laboratorium / Tisak: Kersh Offset

> *Kristian Kožul* > catalog > Museum of Contemporary Art, Zagreb

DU'M

DU'M | DUBROVAČKI MUZEJI
DUBROVNIK MUSEUMS

KNEŽEV DVOR / RECTOR'S PALACE	RUPE	Pomorski muzej	Muzej suvremene povijesti	Arheološki muzej	Dom Marina Držića
Kulturno - povijesni muzej	Etnografski muzej	Maritime Museum	Contemporary History Museum	Arheološki muzej	House of Marin Držić
Cultural - Historic museum	Etnographical Museum			Archeological Museum	

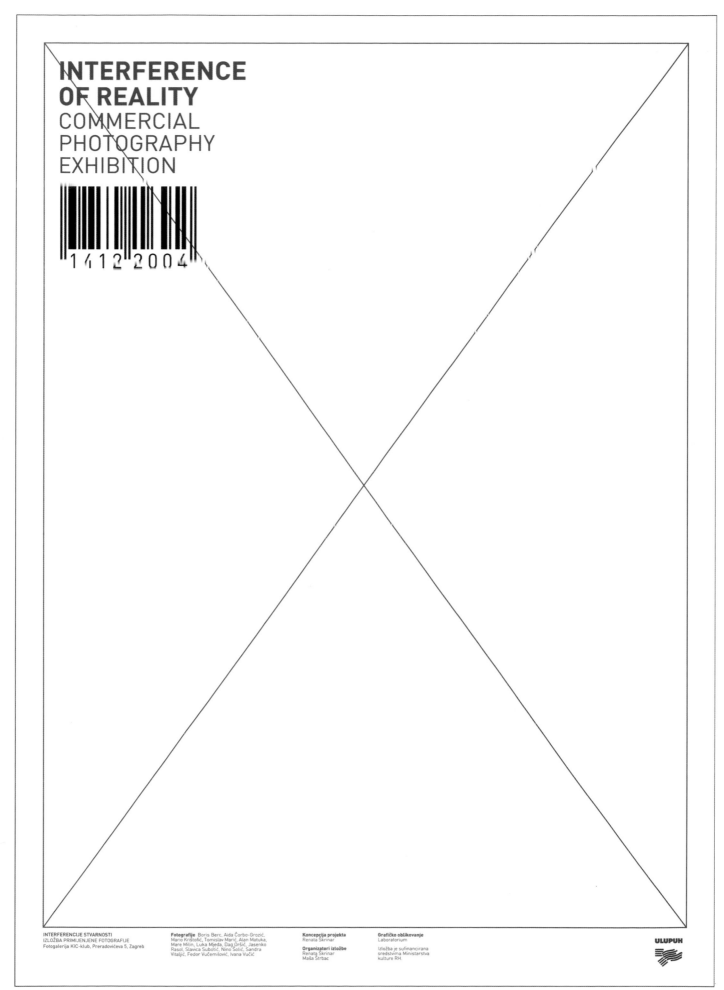

**INTERFERENCE
OF REALITY**
COMMERCIAL
PHOTOGRAPHY
EXHIBITION

1412 2004

INTERFERENCIJE STVARNOSTI
IZLOŽBA PRIMIJENJENE FOTOGRAFIJE
Fotogalerija KIC-klub, Preradovićeva 5, Zagreb

Fotografije Boris Berc, Aida Čorbo-Grozić,
Mario Krištofić, Tomislav Marić, Alan Matuka,
Mare Milin, Luka Mjeda, Dag Oršić, Jasenko
Rasol, Slavica Subotić, Nino Solić, Sandra
Vitaljić, Fedor Vučemilović, Ivana Vučić

Koncepcija projekta
Renata Škrinar

Organizatori izložbe
Renata Škrinar
Maša Štrbac

Grafičko oblikovanje
Laboratorium

Izložba je sufinancirana
sredstvima Ministarstva
kulture RH.

ULUPUH

Léboyé

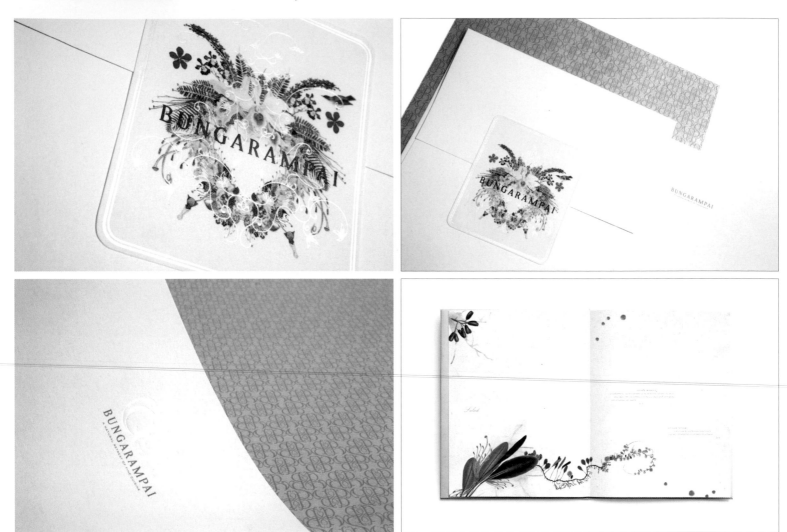

> Menu > Bunga Rampai

Jl Kemang Selatan 99a
Jakarta 12730
Indonesia
+62 217 199 676
info@leboyedesign.com
www.leboyedesign.com

> Born as a graphic design company at the tail end of the 90s Léboyé appeared at a time when the concept of graphic design was still underestimated in Indonesia and computers were rare. Its main idea consists of understanding the necessities of other people and finding the best way to communicate with them clearly, concisely and uniquely. Working on the assumption that no two clients are alike, Léboyé is constantly developing new ideas and distancing itself from conventions and standards.

Currently, it is an interdisciplinary design studio specializing in creating image and branding, identity, packaging and web design. The Léboyé team has received various national and international awards from the Communication Arts and Type Directors Club of New York. A large amount of their work has been published in the Annual Type Directors Club of Tokyo, *Progetto Grafico* magazine, *China Package Design Magazine* and others.

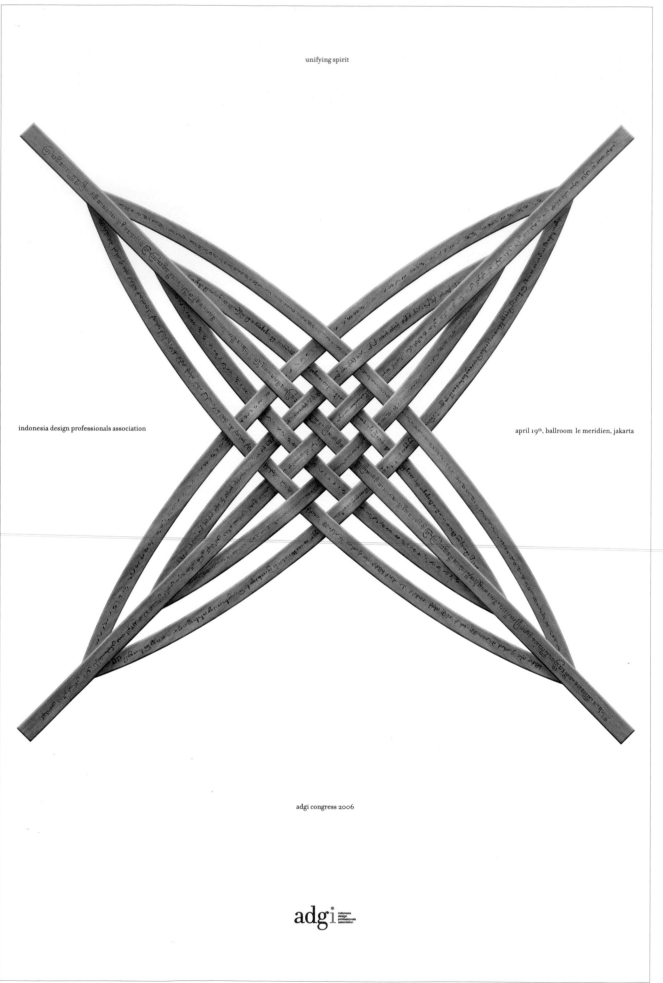

unifying spirit

indonesia design professionals association

april 19th, ballroom le meridien, jakarta

adgi congress 2006

adgi

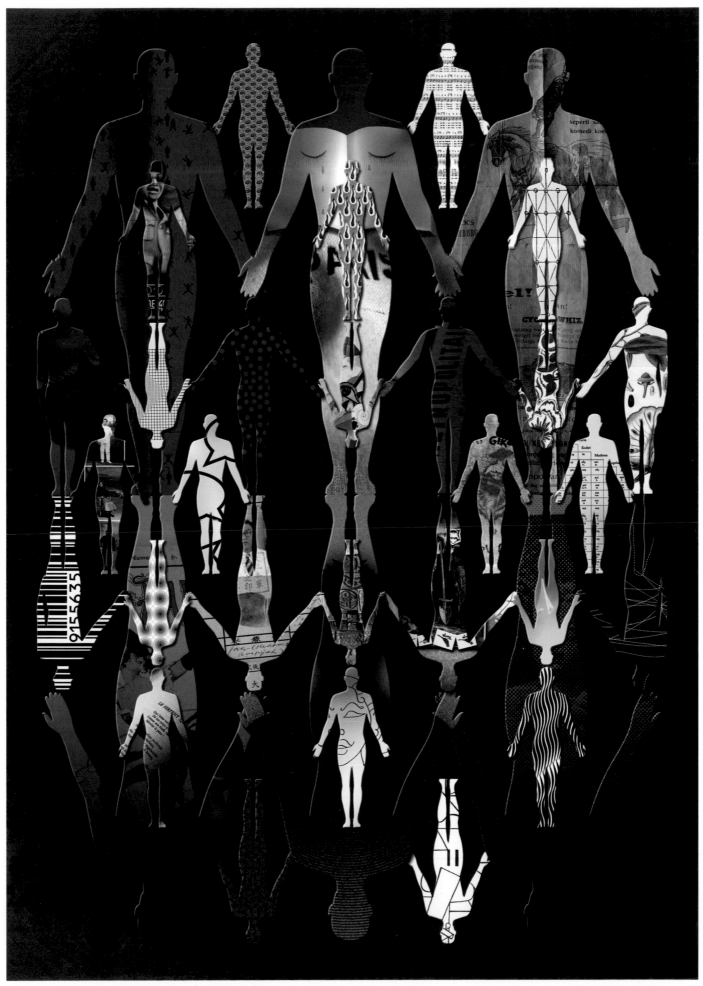

> *Noir sur noir* > poster > National Gallery of Indonesia, Jakarta

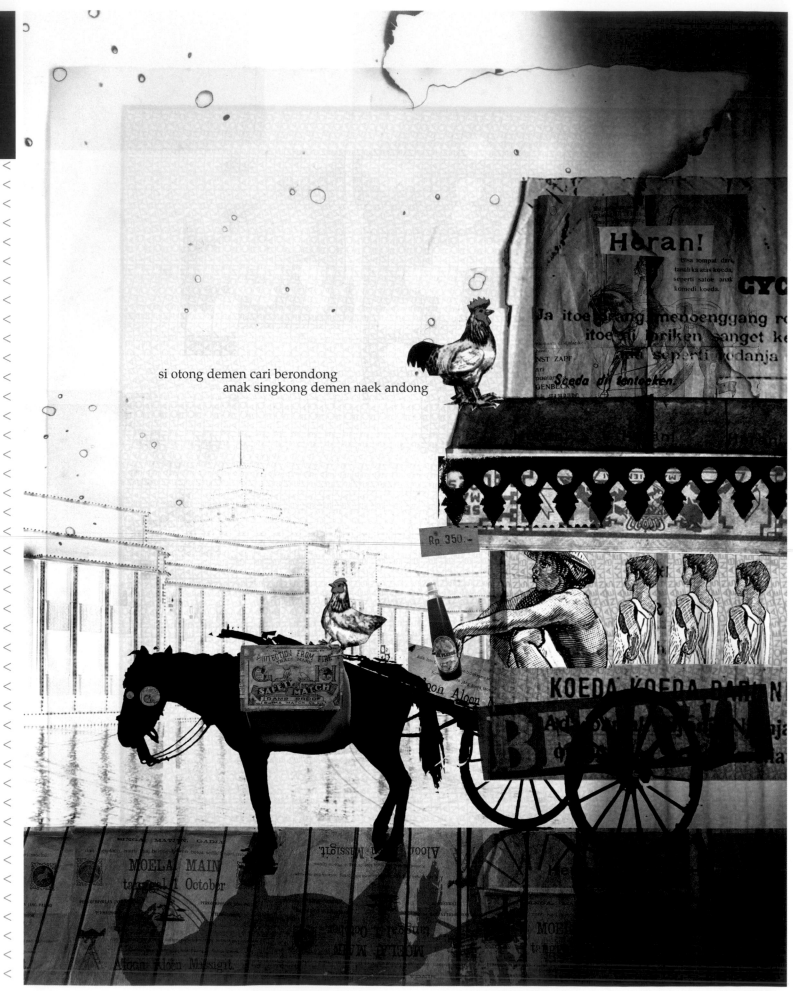

si otong demen cari berondong
anak singkong demen naek andong

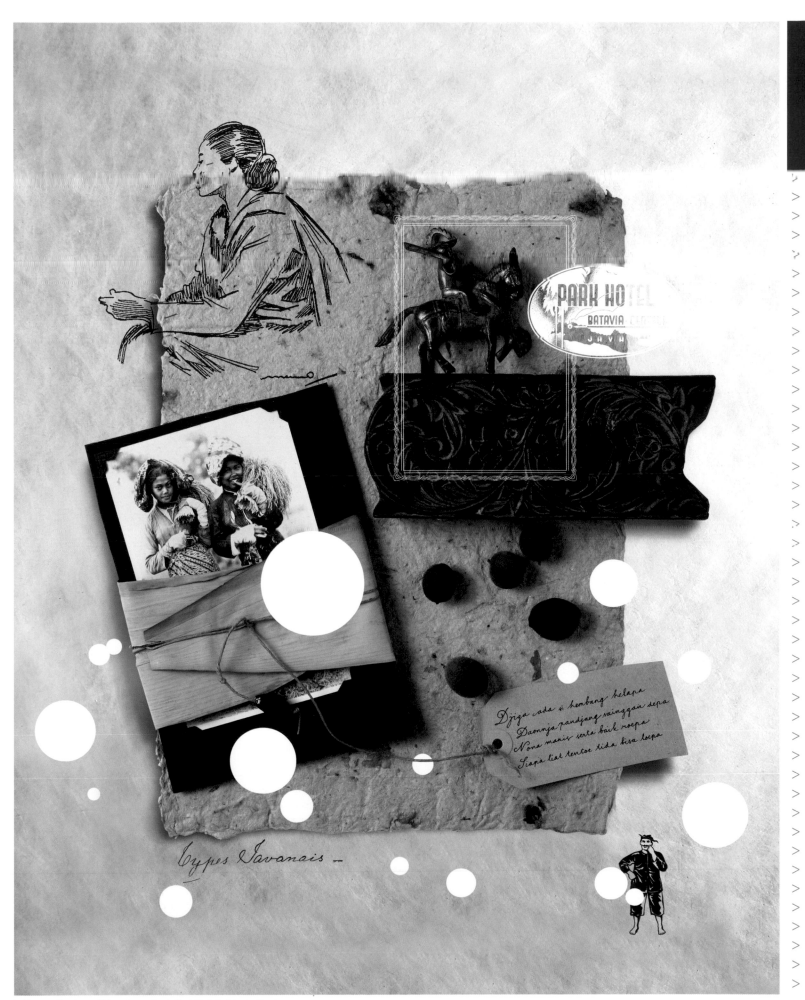

Lonne Wennekendonk

Did Beethoven look like a musician? No, of course she didn't.

Tony Hancock

Give away everything you know, and more will come back to you.

Paul Arden

CONSERVATORIUM VAN AMSTERDAM

KLASSIEKE MUZIEK, JAZZ, POPMUZIEK, OUDE MUZIEK, DOCENT MUZIEK,
VOORTGEZETTE OPLEIDING MUZIEK, JONG TALENT, OPERA

OPEN DAGEN, 10:30 – 16:00 UUR:
ZATERDAG 21 JANUARI 2006 KLASSIEK, JAZZ, OPERA,
OUDE MUZIEK, DOCENT MUZIEK, VOOROPLEIDING EN JONG TALENT
ZATERDAG 28 JANUARI 2006 POPMUZIEK
VAN BAERLESTRAAT 27, AMSTERDAM
WWW.CONSERVATORIUMVANAMSTERDAM.NL

ACADEMIE VOOR BEELDENDE VORMING

OPLEIDING DOCENT BEELDENDE KUNST & VORMGEVING

OPEN DAGEN:
WOENSDAG 30 NOVEMBER 2005 10:00 – 16:00 UUR
DONDERDAG 2 FEBRUARI 2006 15:00 – 21:00 UUR
ZATERDAG 11 MAART 2006 10:00 – 16:00 UUR
DINSDAG 6 JUNI 2006 10:00 – 16:00 UUR
HORTUSPLANTSOEN 2, AMSTERDAM
WWW.ACADEMIEVOORBEELDENDEVORMING.NL

> *Information Days* > pamphlet > Amsterdam School of the Arts

Lloydstraat 17d
3024 EA Rotterdam
The Netherlands
+31 10 244 93 21
info@lonnewennekendonk.nl
www.lonnewennekendonk.nl

> Made up of a team of three graphic designers, the Lonne Wennekendonk studio was created in 1997. Their work consists of getting to the heart of each project in order to communicate a graphic message that is visually convincing, aesthetically rich and intelligent. They feel that character and personality have a lot to do with a design's result. Their main source of inspiration is everyday people. As designers of books, posters, cultural expressions and visual identities they seek to transmit the mentality behind each project. They consider themselves visual communicators, people who interact with other people; in this fashion their work becomes a source of inspiration that helps others to excel. They seek recognition from each of their projects; something they feel should not be confused with seeking fame.

Don't be afraid to work with the best.

Amsterdamse **Hogeschool voor de Kunsten**

opendagen.ahk.nl

AMSTERDAMSE HOGESCHOOL VOOR DE KUNSTEN:
CONSERVATORIUM VAN AMSTERDAM; ACADEMIE VOOR BEELDENDE VORMING;
ACADEMIE VAN BOUWKUNST AMSTERDAM; DE THEATERSCHOOL;
NEDERLANDSE FILM EN TELEVISIE ACADEMIE; REINWARDT ACADEMIE

> *Information Days* > poster > Amsterdam School of the Arts

> *Live Electronics Festival* > poster > Gaudeamus Foundation

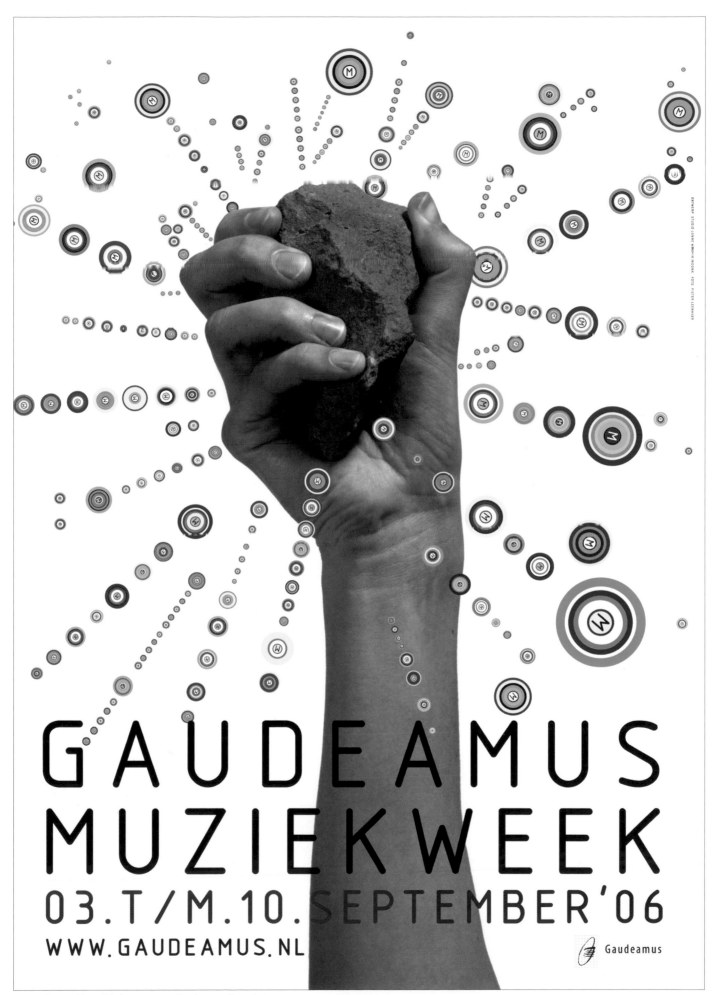

GAUDEAMUS
MUZIEKWEEK
03.T/M.10.SEPTEMBER'06
WWW.GAUDEAMUS.NL

Gaudeamus

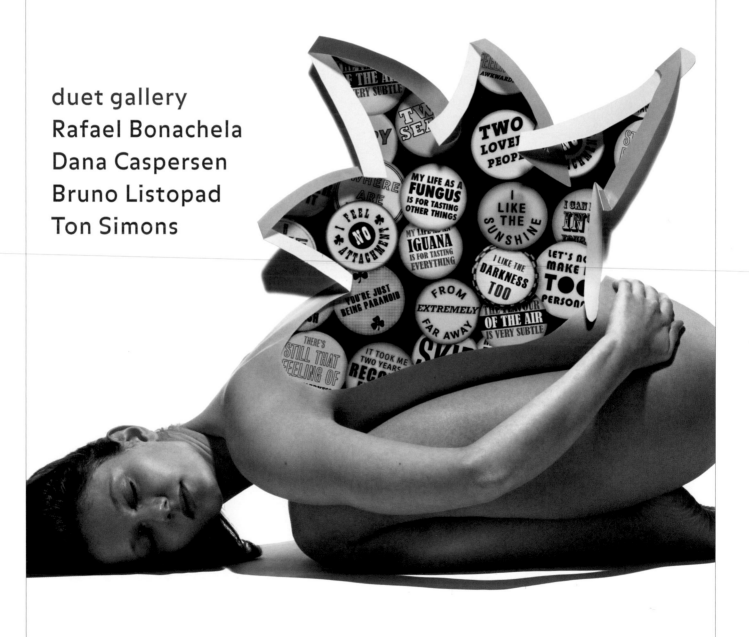

DANCE WORKS
ROTTERDAM
TON SIMONS

duet gallery
Rafael Bonachela
Dana Caspersen
Bruno Listopad
Ton Simons

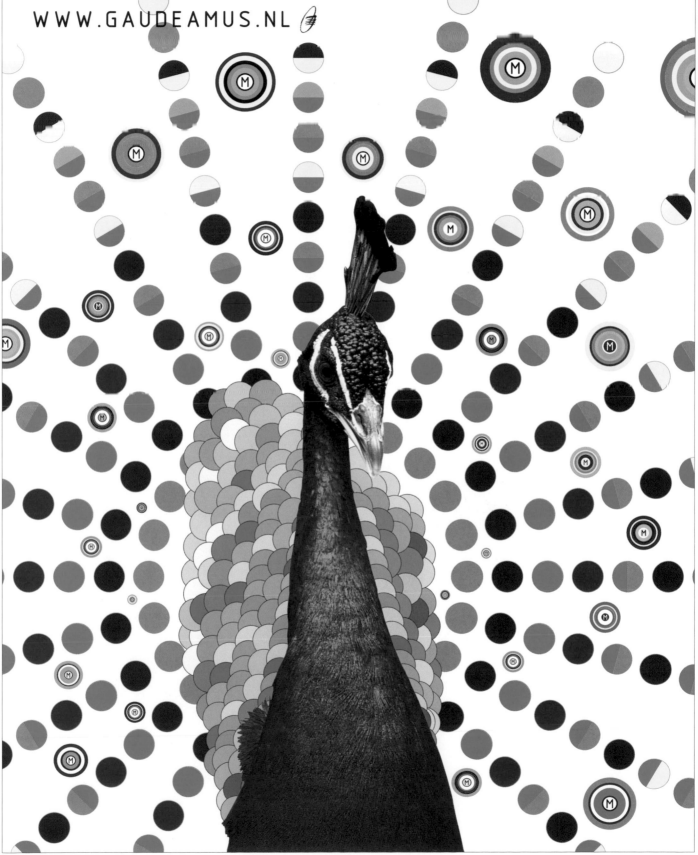

GAUDEAMUS MUZIEKWEEK
04.T/M.11.SEPTEMBER'05
WWW.GAUDEAMUS.NL

> *Gaudeamus Music Week* > poster > Gaudeamus Foundation

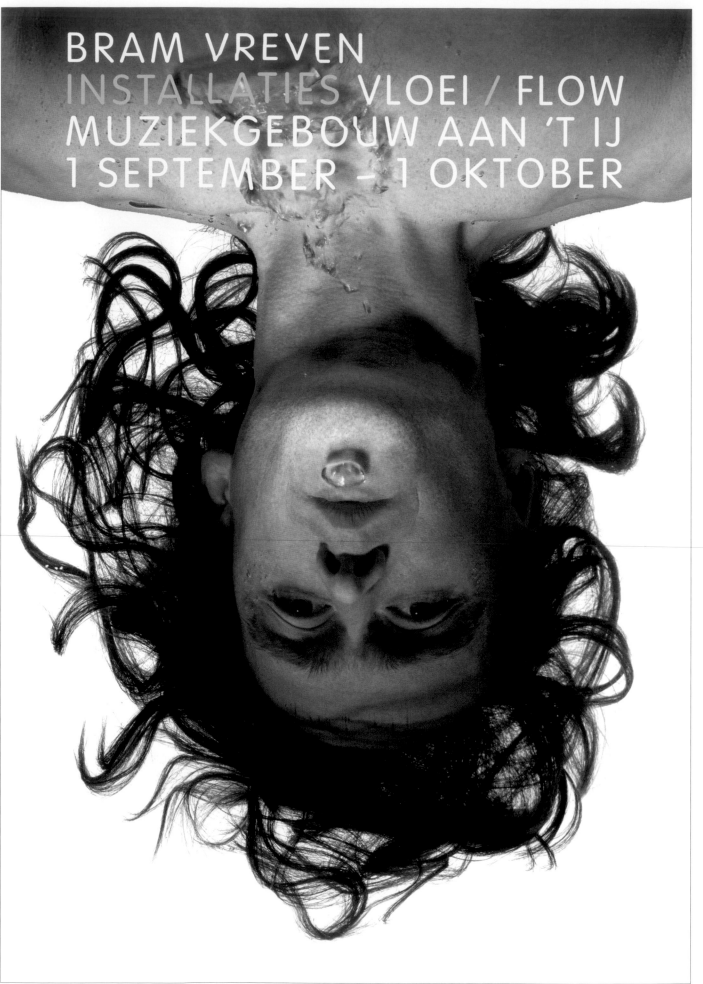

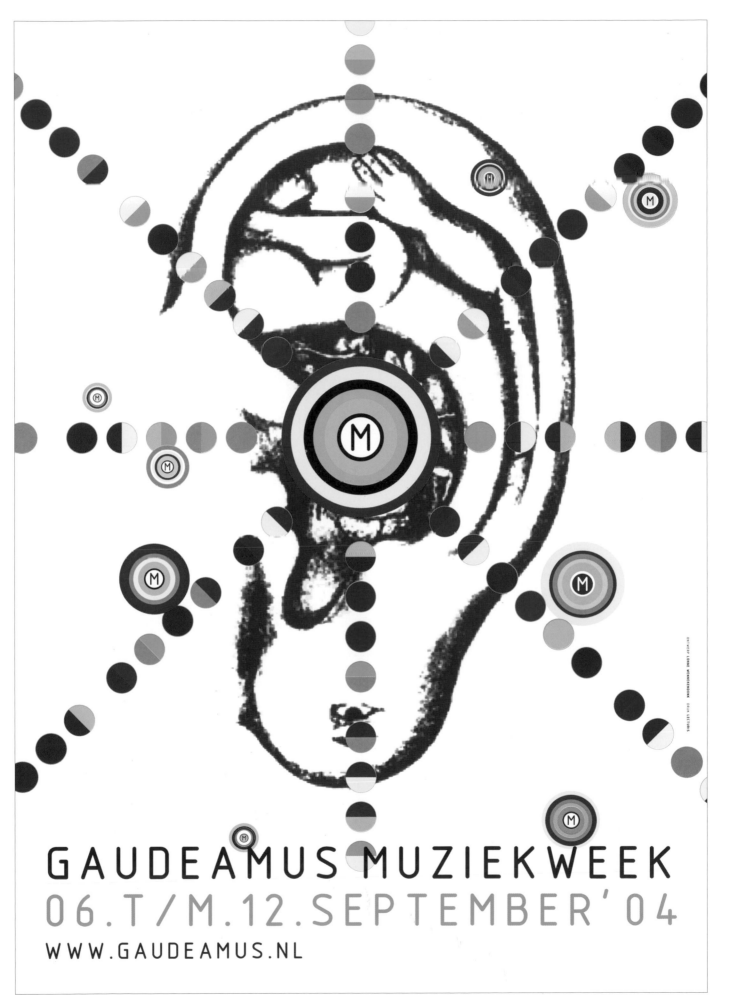

GAUDEAMUS MUZIEKWEEK
06.T/M.12.SEPTEMBER'04
WWW.GAUDEAMUS.NL

Mariscal

Noodles with crayfish
TALLARINES CON CANGREJOS

- 24 live crayfish
- 1 ½ teaspoons sea salt
- 250 g/9 oz fresh noodles
- 250 ml/8 fl oz single cream
- 3 tablespoons chopped fresh parsley
- pepper

- Stock:
- 2 carrots
- 1 onion, peeled
- 6 black peppercorns
- 1 bay leaf
- 1 fresh parsley sprig
- 1 fresh thyme sprig
- 1 tablespoon olive oil
- salt

Serves 4

Put all the ingredients for the stock into a saucepan, pour in 2 litres/3 ½ pints water and bring to the boil over a high heat. Meanwhile, wash the crayfish in plenty of cold water. Pull out the bitter gut, by twisting the central lamina at the end of the tail and then pulling it so that the gut comes out in one piece. When the stock is boiling vigorously, add the crayfish, bring back to the boil and cook for 4–6 minutes, depending on their size. Remove from the pan and shell. (Most of the edible meat is in the tail, but you can crack the claws with a nutcracker and extract the meat too.) Flake the flesh. Pour 3 litres/5 ¼ pints water into a large pan and bring to the boil. Add the salt and noodles, stir with a fork to prevent them from sticking, bring back to the boil and cook for a few minutes, until tender but still firm to the bite. Drain well. Meanwhile, gently heat the cream in another large saucepan, but do not allow it to boil. Stir in the crayfish meat and cook, stirring constantly, for 1 minute, to heat through. Add the noodles and toss over a low heat. Serve immediately, seasoned with pepper and sprinkled with parsley.

Noodles with walnuts and truffles
TALLARINES CON NUECES Y TRUFA

- 1 truffle, about 40 g/1 ½ oz
- 1 egg yolk, lightly beaten
- 150 g/5 oz mascarpone cheese
- 400 g/14 oz fresh noodles
- 12 walnuts, shelled, peeled and chopped
- 25–40 g/1–1 ½ oz Parmesan cheese, grated
- salt and pepper

Serves 4

Clean the truffle with a small brush and a damp cloth. Stir the egg yolk into the mascarpone with a wooden spoon. Season with salt and pepper. Bring a large pan of salted water to the boil. Add the noodles, bring back to the boil and cook for a few minutes, until tender but still firm to the bite. Drain the noodles and toss with the mascarpone mixture, sprinkle with the walnuts and Parmesan cheese to taste and grate a little truffle over the top. Alternatively, sprinkle the noodles with very thinly sliced truffle.

NOTE For a delicious variation, crush the walnuts until they are reduced to a paste, then season with salt and pepper and add a pinch of grated nutmeg and a pinch of ground cinnamon. Stir in a little oil and mix with the noodles.

224 RICE, PULSES, POTATOES AND PASTA

> *1080 Recipes* > book > Phaidon

Pellaires, 30-38
08019 Barcelona
Spain
+34 93 303 69 40
estudio@mariscal.com
www.mariscal.com

> Above all, Javier Mariscal is a creator of images whose work uses all types of supports and disciplines (comics, illustration, graphic, industrial and textile design, sculpture, multimedia, animation and interior design). Born in Valencia, he moved to Barcelona in 1971 and studied graphic design at the Elisava School of Design. Soon after he published his first pieces, of which the character Master of the Toy Horse is notable. Later, in 1979, he designed the Bar Cel Ona sign, which would become a city icon.

In 1988 Cobi was chosen as the mascot for the '92 Barcelona Olympic Games. Javier Mariscal never abandoned the most artistic aspect of his career and his work has been displayed in a considerable amount of shows. In 1999 he received the National Design Award given by the Ministry of Industry and Energy and the BCD Foundation. In 2006 he was sworn in as an honorary member of the Royal Design Industry.

1080 RECiPES

Simone Ortega

PHAIDON

CAMPER

FOR KiDS

acceso clientes Nº de tarjeta 12 últimos dígitos PIN OK Valencia | English ✉ 902 881 000

tubancaja.es todo en internet

HAZTE CLIENTE

bienvenidos | cuentas | tarjetas | hipotecas | depósitos | valores y fondos

hemos imaginado lo mismo que tú

EURIBOR
+
0,35
4,83% TAE

tuhipoteca ligera
La casa de tus sueños
no será tu pesadilla

10% TAE
DURANTE 1 MES

tudepósito más
Tus ahorros crecen en
libertad, sin ataduras.

Quiénes somos | Tarifas y comisiones | Tablón de anuncios | Nota legal | Seguridad | Preguntas frecuentes | Mapa del web

© 2007. Bancaja. Todos los derechos reservados.

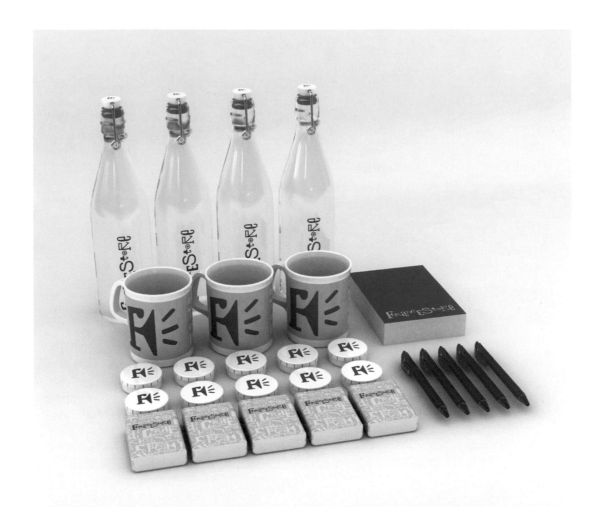

Helen Stanley
Managing Director
COMMERCIALS

FRAMESTORE

9, Noel Street
LONDON W1F 8GH
Tel **+44 (0) 20 7208 2600**
Fax +44 (0) 20 7208 2626
helen.stanley@framestore.com
www.framestore.com

EXTRAORDINARY
TALENT
EXTRAORDINARY
IMAGES

> Calling card, merchandising > Framestore

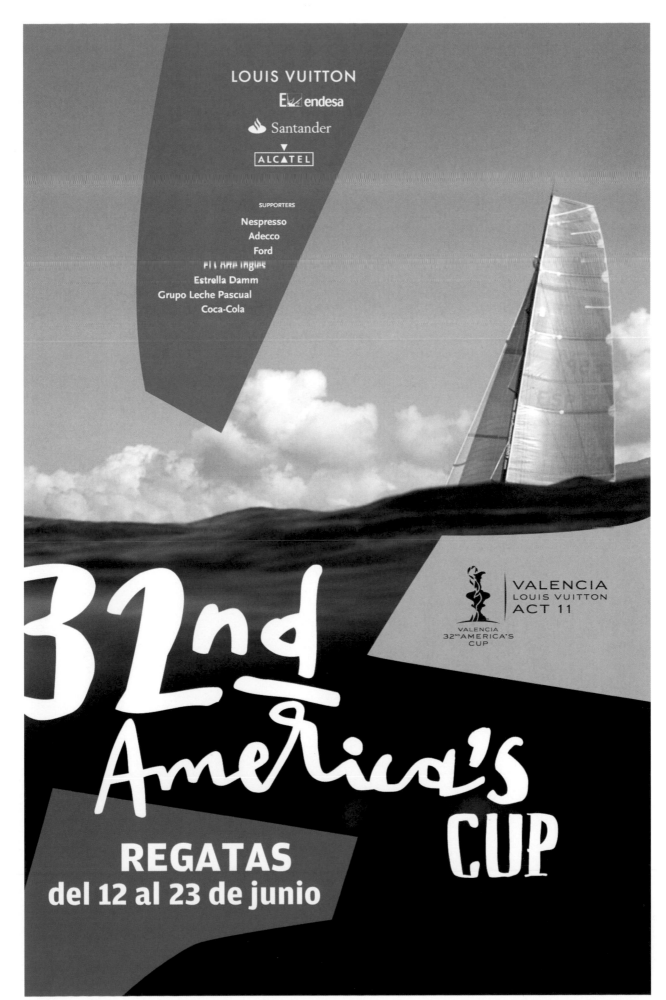

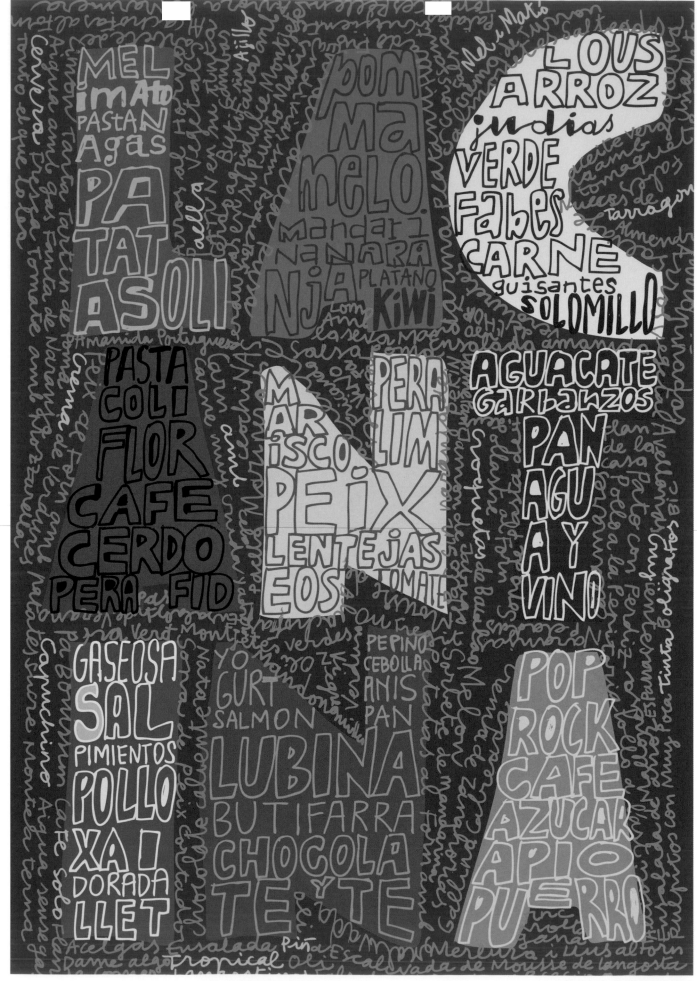

11º FESTIVAL DE MÁLAGA

DEL 4 AL 12 DE ABRIL

organiza

Ayuntamiento
de Málaga

2016.
málaga

patrocina

ANTENA 3

colabora

JUNTA DE ANDALUCÍA
CONSEJERÍA DE CULTURA

> *11th Festival of Malaga* > poster > Malaga City Council

Martin Woodtli

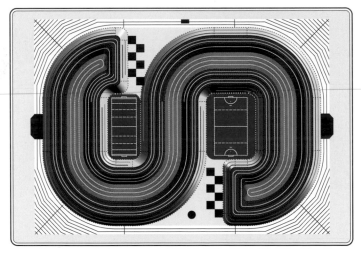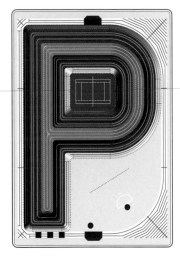

> *Sport Design* > postcard > Museum of Design, Zurich > photo: Martin Woodtli

Schöneggstrasse 5
8004 Zurich
Switzerland
+41 44 291 24 29
martin@woodt.li
www.woodt.li
Portrait: Daniel Sutter

> Having received his first graphic design training in Bern, Martin Woodtli continued his studies and graduated the University of Applied Sciences and Arts in Zurich. He worked in New York for David Carson and Stefan Sagmeister and afterwards founded his own studio in Zurich in 1999. He quickly made a name for himself on the international scene with a series of distinctive visual experiments, for which he received various design awards. He is the author of the book *Woodtli* (Die Gestalten Verlag, 2002). Since 2001, Woodtli has given classes at the Lucerne School of Art and Design and is a guest lecturer at a variety of Swiss and foreign institutions. He received second prize in the contest for designing the new Swiss bank notes. Plugged into the young Swiss design scene, he directs his projects with an emphasis on the passion and happiness of design rather than its more lucrative interests. He has been a member of the International Graphic Alliance since 2000.

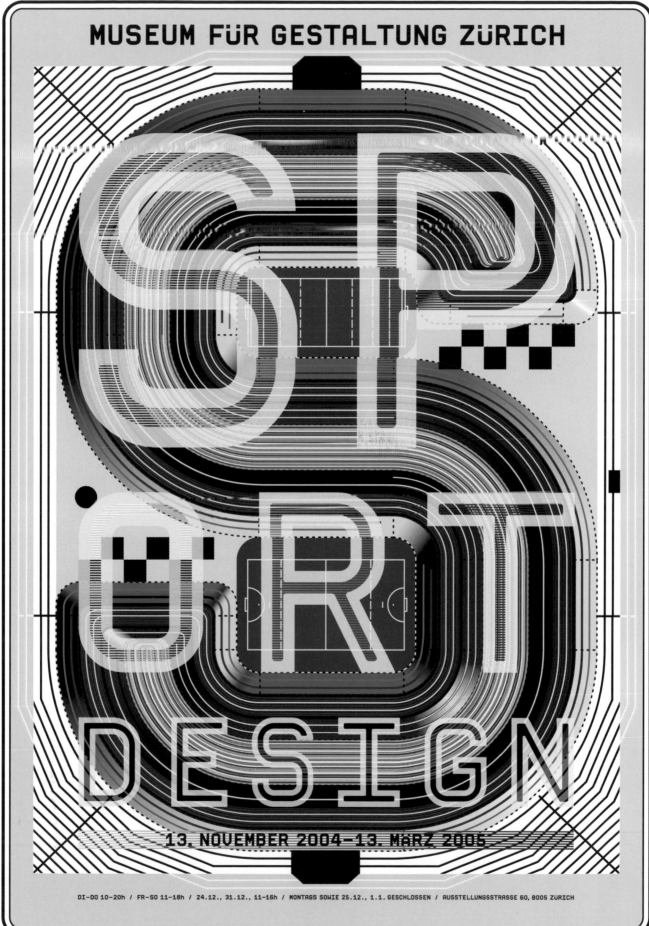

> *Sport Design* > poster> Museum of Design, Zurich > photo: Martin Woodtli

> 9. *Serie Banknoten Entwurf* > legal tender > Swiss National Bank > photo: Martin Woodtli

> *VideoEx* > poster > Patrick Huber, Walcheturm Art Space > photo: Martin Woodtli

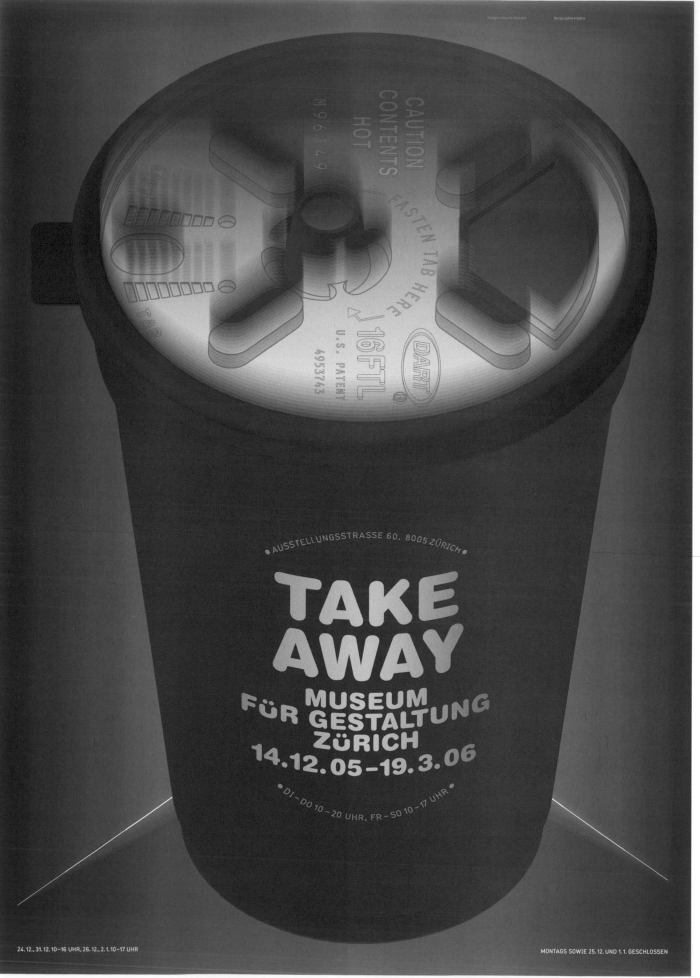

• AUSSTELLUNGSSTRASSE 60, 8005 ZÜRICH •

TAKE
AWAY
MUSEUM
FÜR GESTALTUNG
ZÜRICH
14.12.05–19.3.06

• DI – DO 10 – 20 UHR, FR – SO 10 – 17 UHR •

24. 12., 31. 12. 10–16 UHR, 26. 12., 2. 1. 10–17 UHR

MONTAGS SOWIE 25. 12. UND 1. 1. GESCHLOSSEN

> *Take Away* > posters > Museum of Design, Zurich > photo: Martin Woodtli

TAKE AWAY

DESIGN DER MOBILEN ESSKULTUR
14. DEZEMBER 2005 BIS 19. MÄRZ 2006
MUSEUM FÜR GESTALTUNG ZÜRICH

Take away ist die passende kulinarische Formel zum modernen Lebensstil.
Die Wurzeln der mobilen Verpflegung liegen jedoch im frühen 19. Jahrhundert
und damit am Anfang der Industrialisierung. Sie forderte und förderte
Alternativen zum Essen am Familientisch. Effizienz und Praktikabilität waren
gefragt. Take away und seine engen Verwandten Systemgastronomie und
Convenience Food funktionieren noch heute nach dieser Regel. Weiterentwickelt
hat sich was wir Essen, vor allem aber wie, womit und wo wir es tun. Der
funktionale und ästhetische Anspruch steigt, Toleranzwerte bei den Formqualitäten
sinken. Anything goes. Angesichts der mobilen, lokal und rhythmisch neuen Gestalt
schöner Innovationsgeist bekommt eine neue gesellschaftliche Relevanz.
'Take-away' öffnet mit Charme, Brisanz und Dynamik den Zugang zu diesem
wenig untersuchten Designuniversum. Mit dabei sind Geräte wie Picknick-Koffer
und Pappbecher, sowie Dokumente vom Foto zum Film und kritische Kommentare.
Zusammen präsentieren sie aktuelle Trends im Spiegel ihrer historischen Vorläufer
und projizieren die Zukunft anhand modellhafter Visionen.

PUBLIKATION
Zur Ausstellung erscheint der erste Band in der Reihe
'Design Collection':
Take away - Design der mobilen Esskultur
Hg. von Museum für Gestaltung Zürich,
Designsammlung, Norbert Wild
Mit einem Essay von Walter Loimgruber
avedition Verlag für Architektur und Design
24 x 16.5 cm, 96 Seiten, 120 Farbabbildungen, D / E
ISBN 3-89986-064-0 / Verkaufspreis CHF 39.80

Bitte frankieren

Ich bestelle Ex. **'Take away'** zu CHF 39.80
(exkl. Versandkosten)

Vorname / Name

Strasse

PLZ / Ort

Datum

Unterschrift

MUSEUM FÜR GESTALTUNG ZÜRICH
VERLAG
POSTFACH
CH-8031 ZÜRICH

E-Mail: verlag@museum-gestaltung.ch
Fax: ++41 / 43 / 446 45 67

Vernissage: Dienstag, 13. Dezember 2005, 19 Uhr, Vortragssaal
Begrüssung: Christian Brändle, Direktor Museum für Gestaltung Zürich und
Norbert Wild, Kurator Designsammlung und Ausstellung 'Take away'
Inszenierung Vernissage: Scenographical Design (hgkz)
Ausstellungsarchitektur: Alfredo Häberli, Zürich

BEGLEITPROGRAMM

Dienstag, 13. Dezember 2005, 18 Uhr, Vortragssaal
Architektur des Essens - Rohstoffe Räume Rituale
hgkz RINGVORLESUNG mit
Prof. Dr. Ákos Moravánszky, ETH Zürich

Mittwoch, 4. Januar 2006, 17 Uhr, Vortragssaal
Take away - Essen unterwegs
Präsentation und Diskussion von Projektarbeiten der
Fachklasse für Gestaltung, SfG Basel
Moderation: Eva Molina und Nicole Naas

Dienstag, 24. Januar 2006, 20 Uhr, Vortragssaal
Littering - Design. Abfallproblem im öffentlichen Raum
Diskussion mit Johannes Heeb (Autor der Studie
Littering im Rahmen des Programms Mensch,
Gesellschaft und Umwelt), Andreas Hochstrasser (Grün
Stadt Zürich), Walter Staub (MGB) und dem Grafiker
Jean Jacques Schaffner. Moderation: Gabriela Dietrich

Sonntag, 5. Februar 2006, 12–18 Uhr, Vortragssaal
Kino: Stop and go
Kinofilme rund um das Thema 'Take away'
Kino und Ausstellung: CHF 25.– / CHF 20.–
Das genaue Filmprogramm unter:
www.museum-gestaltung.ch

Dienstag, 7. Februar 2006, 20 Uhr, Vortragssaal
Die Berliner Imbissbude: Design oder Schandfleck?
Vortrag: Jon von Wetzlar (Autor und Kurator, Berlin)
und Christoph Buckstegen (dipl. Designer, Berlin) unter-
suchen am Beispiel der Berliner Imbissbude die
Bedeutung von kleinteiligen Bauten in der Stadtplanung
von heute und morgen.

Dienstag, 7. März 2006, 20 Uhr, Vortragssaal
Heimat in Häppchen, Fastfood in Japan
Christoph Neidhardt (Japan-Korrespondent der NZZ)
spricht über die Bento-Kultur (japanische Lunchboxen)
im Verhältnis von Tradition, Fastfood und Urbanität
im modernen japanischen Alltag.

SONDERFÜHRUNGEN

Dienstag, 10. Januar 2006, 18.30 Uhr, Galerie
Die Erfinder der 'Sigg Bottle'
Führung mit Kurt Zimmerli und Peter Nöthiger

Sonntag, 5. März 2006, 11 Uhr
Exkursion durch die Fast-Food-Gastrolandschaft
des Zürcher Niederdorfs mit Gabriela Dietrich und
anschliessendem Ausstellungsbesuch.
Treffpunkt: Sattlade, Münstergasse 31, 8001 Zürich
Kosten: CHF 25.– / CHF 20.–

ÖFFENTLICHE FÜHRUNGEN
Jeden Dienstag, 18.30 Uhr

Spezialführungen auf Anfrage:
christine.kessler@hgkz.ch oder Tel. ++41 / 43 / 446 67 12

TRENDSCOUTS IM TAKE AWAY
Workshops für Schüler der Berufs- und Mittelschule;
Information und Reservation: Henriette Bon,
Tel. ++41 / 44 / 342 00 10, email: hbongloor@bluewin.ch

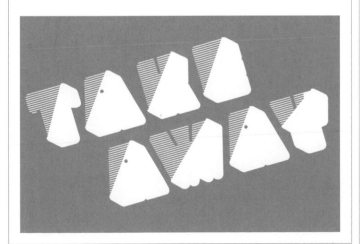

MUSEUM FÜR GESTALTUNG ZÜRICH
Ausstellungsstrasse 60, 8005 Zürich
www.museum-gestaltung.ch, Tel. ++41 / 43 / 446 67 67
Tram 4 und 13, Haltestelle Museum für Gestaltung Zürich

ÖFFNUNGSZEITEN
Dienstag–Donnerstag 10–20 Uhr, Freitag–Sonntag 10–17 Uhr
24. Dezember und 31. Dezember 10–16 Uhr, 26. Dezember, 2. Januar 10–17 Uhr
Montags sowie 25. Dezember und 1. Januar geschlossen

Wir danken für die Unterstützung: Migros-Kulturprozent, Kvadrat® SA, Limmatdruck AG,
Zeiler AG, Tupperware Schweiz AG, McDonald's Suisse Restaurants Sarl,
Eurest Sports & Food GmbH, Candrian Catering AG, Distrimondo AG und allen Leihgebern,
insbesondere dem Museum der Dinge Berlin (Sammlung Karhard)

Hochschule für Gestaltung und Kunst Zürich, Mitglied zfh

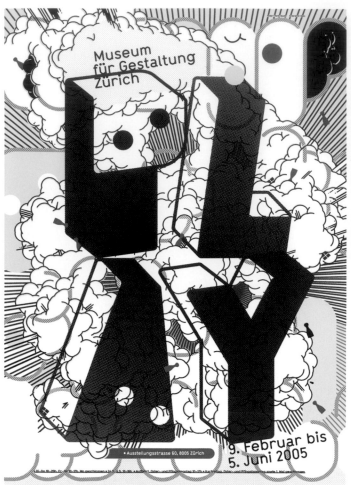

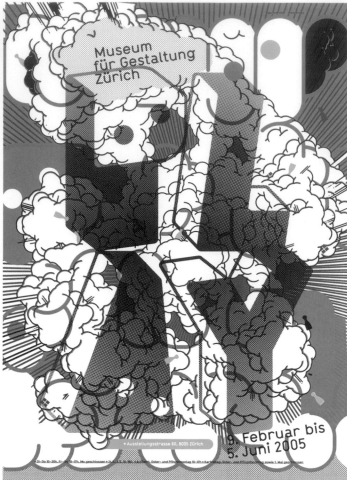

PLAY
Museum für Gestaltung Zürich
9. Februar bis 5. Juni 2005

Spielen als menschliches Bedürfnis und Kulturgut betrifft jede und jeden, unabhängig vom Alter. Die Ausstellung nähert sich dem Thema unter individuellen, sozialen sowie gestalterischen Aspekten. Spielbegeisterte und Wissenschaftler geben Einblick in Spielmotivation und Spielverhalten. Spieldesigner sprechen über den Gestaltungsprozess und stellen ihre Arbeiten vor. Die Ausstellung zeigt Bekanntes wie 'Monopoly', 'Die Siedler von Catan' und Videospiele neben Teddy und 'Bilibo', wirft aber auch einen Blick auf das Spielen in der Zukunft. Ein integriertes Spielfeld bietet allen die Möglichkeit zum selber Spielen.

WIR LADEN SIE HERZLICH EIN ZUR ERÖFFNUNG
AM DIENSTAG, 8. FEBRUAR, 19 UHR, IM FOYER
Begrüssung: Christian Brändle, Direktor Museum für Gestaltung Zürich
Einführung: Cynthia Gavranić, Kuratorin Museum für Gestaltung Zürich
Performance: Marina Belobrovaja, Zürich

BEGLEITPROGRAMM
• Dienstag, 8. März, 19.30 Uhr, Vortrag in der Ausstellung: 'Aus der geheimen Küche eines Spiele-Erfinders: Wie entsteht ein Spiel?', Niek Neuwahl, Spiele-Erfinder, Florenz • Dienstag, 22. März, 20 Uhr, im Vortragssaal, Podium: 'Video killed the Lego Star?-Traditionelles Spielzeug im Zeitalter der Videogames', mit René Küng, Spielmacher Active People, Binningen, Prof. Dr. med. Remo H. Largo, Kinderarzt, Leiter der Abteilung Wachstum und Entwicklung, Kinderspital Zürich, Clemens Wangerin, Game-Entwickler, Sony PlayStation, SCE Liverpool, Moderation: Tom Felber, Spielekritiker und Redaktor 'Neue Zürcher Zeitung', anschliessend Fahr-Bar • Sonntag, 10. April, 14 Uhr, im Vortragssaal: 'Vladimir

Show'- Die einzigartige Talkshow für verbrauchte und vernachlässigte Spielsachen. Kolypan-Projekt von und mit Fabienne Hadorn und Gustavo Nanez. Eintritt: CHF 15.– (zuzüglich Ausstellungseintritt), Kinder bis 12 Jahre gratis. Ticketverkauf ab 10.30 Uhr • Dienstag, 17. Mai, 20 – 24 Uhr, im Foyer: Spieleabend für Erwachsene-Brettspiele & Co., mit Beat Liechti, 'Rien ne va plus' Spieleladen, Zürich, anschliessend FahrBar • Sonntag, 5. Juni, 14 – 17 Uhr, im Foyer: Spielenachmittag für Kinder ab 7 Jahren und Erwachsene-Brettspiele & Co., mit Beat Liechti, 'Rien ne va plus' Spieleladen, Zürich • Auskunft zum Begleitprogramm: 043 446 67 12 oder christine.kessler@hgkz.ch

ÖFFENTLICHE FÜHRUNGEN
• Jeweils Dienstag, 18.30 Uhr • 15.2. Prof. Dr. Marion Strunk, Kulturwissenschaftlerin und Künstlerin, Zürich • 22.2. Caroline Schubiger, Sozialwissenschaftlerin, Zürich • 1.3. Christian Brändle, Direktor Museum für Gestaltung Zürich • 8.3. Laurence Mauderli, Wissenschaftliche Mitarbeiterin Designsammlung Museum für Gestaltung Zürich • 15.3. Beat Liechti, Spieler, Zürich • 22.3. Urs Küenzi, Kulturwissenschaftler, Zürich • 29.3. Cynthia Gavranić, Kuratorin Museum für Gestaltung Zürich • 5.4. Christian Brändle • 12.4. Prof. Dr. Marion Strunk • 19.4. Beat Liechti • 26.4. Urs Küenzi • 3.5. Cecilia Hausheer, Kulturwissenschaftlerin und Ausstellungsmacherin, Zürich • 10.5. Alex Hochstrasser, Spielzeugdesigner, Zürich • 17.5. Alex Hochstrasser • 24.5. Cecilia Hausheer • 31.5. Nicole Urban, Lehrerin für Gestaltung und Kunst, Zürich • Spezialführungen auf Anfrage: 043 446 67 12 oder christine.kessler@hgkz.ch

ÖFFNUNGSZEITEN
• Di – Do 10 – 20 Uhr, Fr – So 10 –17 Uhr • 24.3. (Gründonnerstag) 10 –17 Uhr • 28.3. (Ostermontag) 10 –17 Uhr • 4.5. (Auffahrtsmittwoch) 10 –16 Uhr • 5.5. (Auffahrt) 10 –17 Uhr • 16.5. (Pfingstmontag) 10 –17 Uhr • Montags sowie 25.3. (Karfreitag), 27.3. (Ostersonntag), 1.5., 15.5. (Pfingstsonntag) geschlossen

Museum für Gestaltung Zürich • Ausstellungsstrasse 60 • CH-8005 Zürich • Tel +41 43 446 67 67 • Fax +41 43 446 45 67 • www.museum-gestaltung.ch • Tram 4 und 13, Haltestelle Museum für Gestaltung

Wir danken Sony PlayStation herzlich für die Unterstützung

Hochschule für Gestaltung und Kunst Zürich, Mitglied zfh • Design: Martin Woodtli

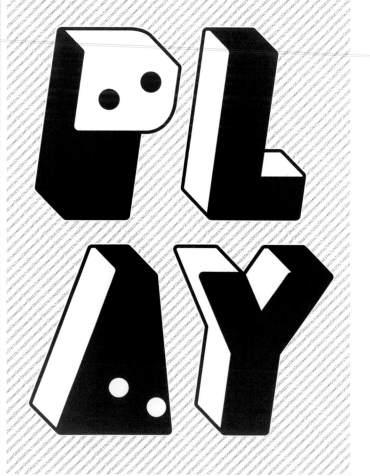

> *Einfach komplex* > poster > Museum of Design, Zurich > Photo: Martin Woodtli

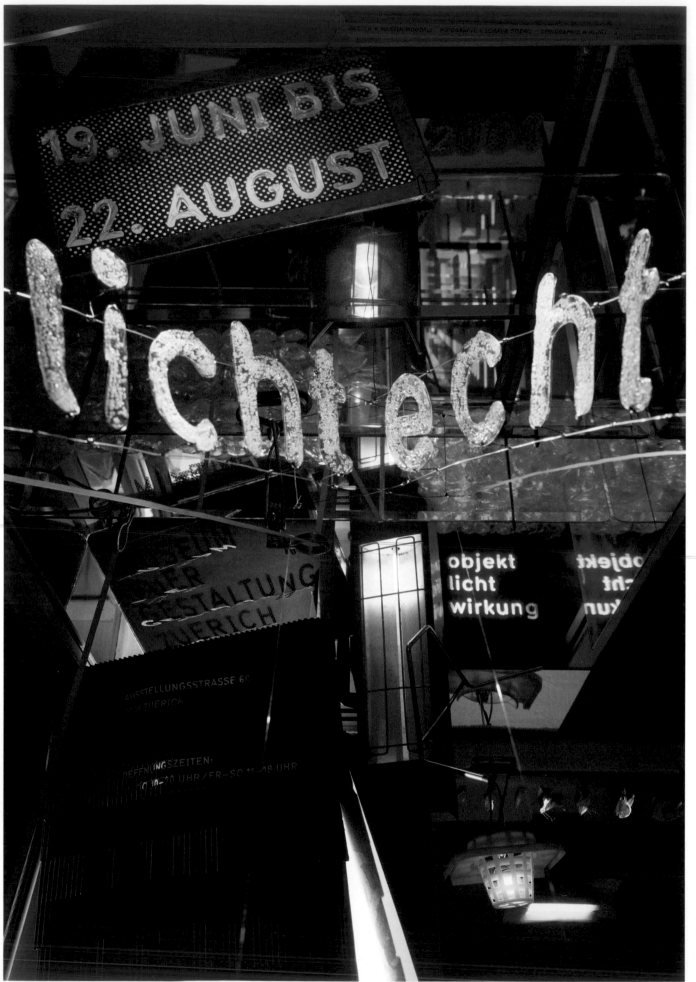

19. JUNI BIS
22. AUGUST

lichtecht

FÜR
DER
GESTALTUNG
ZUERICH

objekt
licht
wirkung

AUSSTELLUNGSSTRASSE 60
ZUERICH

ÖFFNUNGSZEITEN:

> "Lichtecht" > exhibition > Museum of Design, Zurich

Worin liegt die Faszination von Licht im Alltag? Welche Effekte vermag das Licht zu erzeugen, die ohne jeden menschlichen Gestaltungswillen zustande kommen? Wo macht sich die Gestaltung diese natürlichen Lichteffekte zunutze? Diese Fragen bewegen zur Ausstellung, in der es um das Wechselspiel von Licht und Materie geht. Denn Licht wird erst sichtbar, wenn es sich an Materie bricht, und umgekehrt nehmen wir Dinge erst im Licht wahr.

lichtecht
objekt licht wirkung

In Anspielung auf 'Lichtechtheit', dem Grad der (Farb-) Beständigkeit von Material im Licht, liegt der Ausstellungsfokus auf der Wirkung von ausgewählten Objekten im Licht, auf dem Licht als Gestaltungsfaktor und auf dem Erzeugen von Lichteffekten in der Gestaltung. Gezeigt wird dies anhand von ausgewählten Sammlungsstücken des Museums für Gestaltung, wie Beleuchtungskörpern, Fotografien, Glasobjekten, Möbeln oder Plakaten. Die Objekte stammen unter anderem von Françoise Caraco, Hans Finsler, René Lalique, Koichi Sato, Kurt Thut, Andy Warhol und Hannes Wettstein.

VERNISSAGE
Wir laden Sie herzlich ein zur Eröffnung am Freitag

18. JUNI, 19 UHR

Begrüssung und Einführung im Foyer:
Christian Brändle, Direktor MfGZ
Prof. Dr. Hans Peter Schwarz, Rektor HGKZ
Cynthia Gavranić, Kuratorin MfGZ

ÖFFENTLICHE FÜHRUNGEN
jeden Mittwoch, 18.30 Uhr, Halle
23.6. Cynthia Gavranić, Kuratorin MfGZ, mit Hannes Wettstein, Designer
30.6. Christian Brändle, Direktor MfGZ
7.7. Cynthia Gavranić, Kuratorin MfGZ, mit Martin Woodtli, Graphic Designer
14.7. Eva Afuhs, Leiterin Museum Bellerive
21.7. Susanne Schröder, Kunsthistorikerin, S'Art AG
28.7. Peter Stohler, Kunsthistoriker
4.8. Norbert Wild, Kurator Designsammlung MfGZ
11.8. Felix Studinka, Kurator Plakatsammlung MfGZ
18.8. Barbara Junod, Kuratorin Grafiksammlung MfGZ
Spezialführungen auf Anfrage: doris.brem@hgkz.ch oder 043 446 67 12

HOCHSCHULE FÜR GESTALTUNG & KUNST ZÜRICH (MITGLIED ZFH)

MUSEUM FÜR GESTALTUNG ZÜRICH
Ausstellungsstrasse 60, 8005 Zürich, Tel 043 446 67 67, Fax 043 446 45 67, www.museum-gestaltung.ch

BEGLEITPROGRAMM
Mi, 23. Juni, 19.30 Uhr: Kino im Vortragssaal mit 'Touch of Evil', USA 1958, E/d/f, von Orson Welles. Nicht zuletzt wegen seiner Lichtregie ein absoluter Filmklassiker. Anschliessend FahrBar im Foyer
So, 4. Juli, 11 Uhr: Führung durch die Ausstellung mit Cynthia Gavranić. Anschliessend Sonntags Brunch im Foyer. Bitte Anmeldung bis 30. Juni bei doris.brem@hgkz.ch oder 043 446 67 12
Mi, 7. Juli,19.30 Uhr: Gespräch in der Ausstellung: Meret Ernst, Redaktorin Hochparterre, mit Charles Keller, Industrialdesigner, Lichtgestalter, und Hannes Wettstein, Designer
Mi, 18. August, 19.30 Uhr: 'Mehr Licht / Avec les oreilles on ne voit rien / On the duration of formal beauty': Performance in der Ausstellung von Stéphan Meylan und Christoph Lang. Anschliessend FahrBar im Foyer

WIR DANKEN HERZLICH FÜR DIE GROSSZÜGIGE UNTERSTÜTZUNG:
Migros-Kulturprozent, Zumtobel Staff, Elastique, Neue Werkstatt, Jakob Schlaepfer, Hannes Wettstein, Wohnbedarf

PUBLIKATION
lichtecht. 18 Objekte aus den Sammlungen, fotografiert von Franz Xaver Jaggy, kommentiert von Cynthia Gavranić, Peter Stohler, Felix Studinka und Norbert Wild, gestaltet von Martin Woodtli. Museum für Gestaltung Zürich. Postkartenformat, CHF 14
Bestellungen an:
verlag@museum-gestaltung.ch
Fax 043 446 45 67

19. JUNI BIS 22. AUGUST 04

ÖFFNUNGSZEITEN
Di–Do 10–20 Uhr / Fr–So 11–18 Uhr
1. August sowie montags geschlossen

DESIGN ♦ MARTIN WOODTLI FOTOGRAFIE ♦ SCHAUB STIERLI

19. JUNI BIS 22. AUGUST

lichtecht
objekt licht wirkung

MUSEUM FÜR GESTALTUNG ZÜRICH

Melle Hammer

papierpraat.nl

> *Papierpraat* > logo > de raddraaier

Nwe Ulienburgerstraat 3e
1011 LM Amsterdam
The Netherlands
+31 20 623 97 02
xc2me@xs4all.nl
www.mellehammer.nl

> Typographer, designer and professor; Melle Hammer moves between the worlds of art, design and advertising. He started his career as an advertising agency graphic designer at the age of 18, just prior to graduating from the Gerrit Rietveld Academy (Amsterdam, 1981). For a short while, he directed the redesign of the newspaper *Total Design Amsterdam*. In 1983, he returned to advertising as a creative director. Afterwards, in 1988, Hammer left behind his career as advertising design director and returned to the world of independent designer, working as advisor and professor for design studios and advertising agencies. He has designed for opera stages as well as creating furniture and industrial product designs. He was the organizer behind 5x High-T(ypography): a series of presentations and conferences in Arnhem (The Netherlands). As a teacher, Hammer taught typography at the Gerrit Rietveld Academy. Presently, he organizes Drift, an educational event that he founded in Amsterdam.

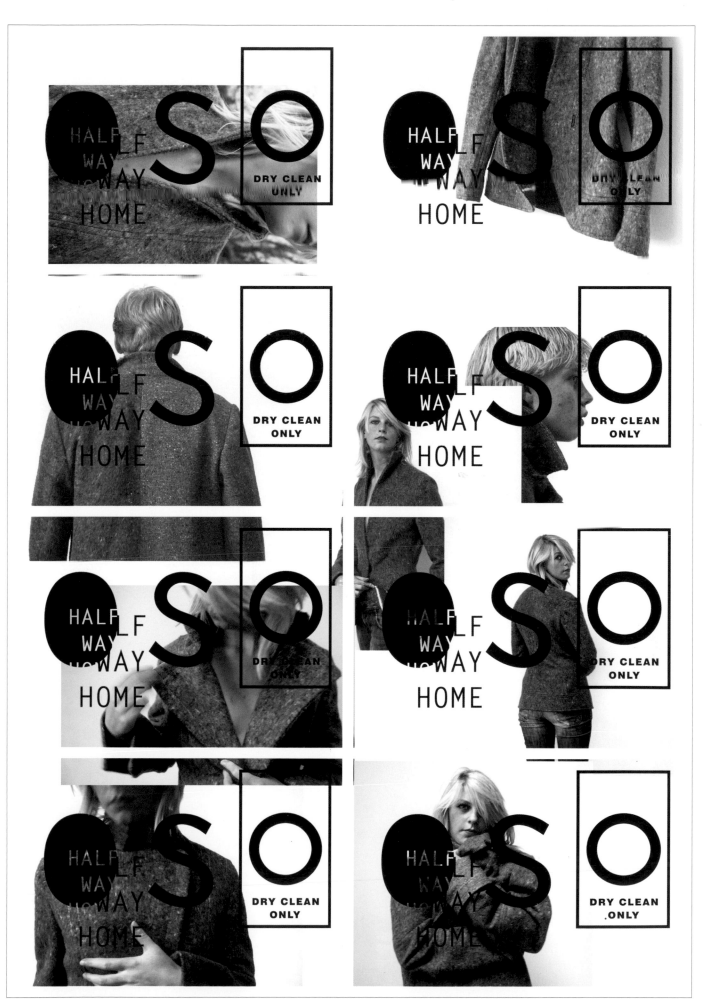

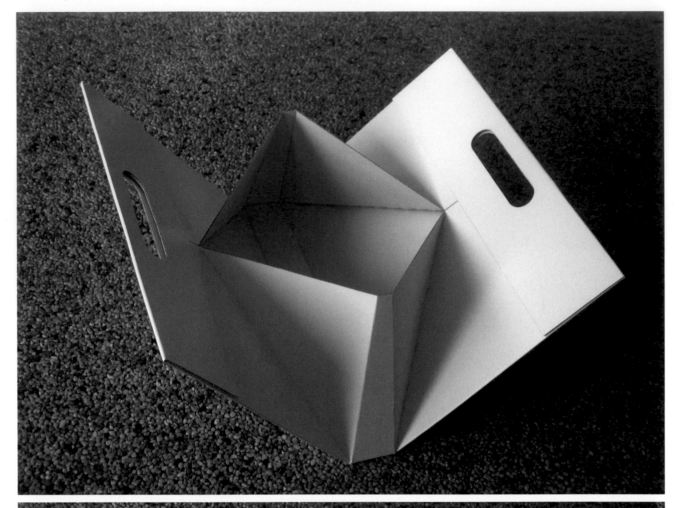

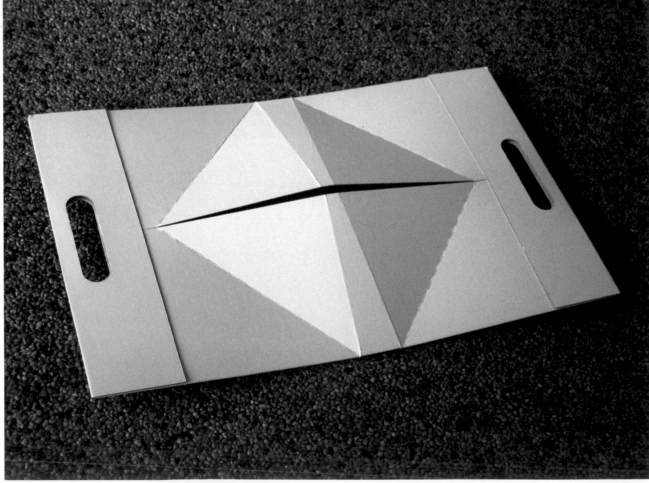

> *Briefcase* > personal project

Liedjes

Nachoem M.Wijnberg

UITGEVERIJ CONTACT

> *Liedjes* > cover > Contact

er is
een spookrijder
gesignaleerd

xavier roelens

UITGEVERIJ CONTACT

Michel Bouvet

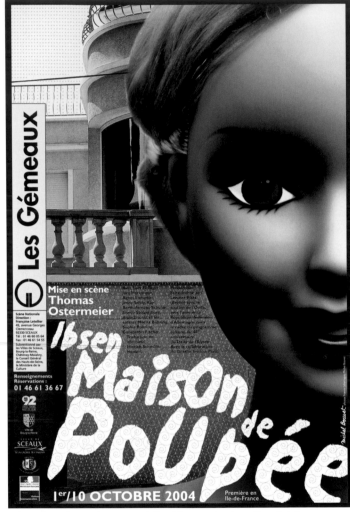

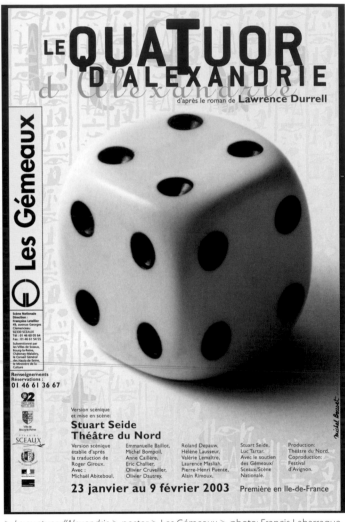

> *La maison de poupée* > poster > Les Gémeaux > photo: Francis Laharrague

> *Le quatuor d'Alexandrie* > poster > Les Gémeaux > photo: Francis Laharrague

36, rue Sedaine
75011 Paris
France
+33 1 48 06 43 44
atelierbouvet@wanadoo.fr

> A graduate of the Superior National School of the Decorative Arts in Paris, Michel Bouvet lives and works in Paris. His design studio tends to work for public institutions like theaters, operas, museums, festivals and dance companies. He has participated as a poster designer and member of the jury for the International Biennials of Helsinki, Mexico, Chaumont, Sofia, Zagreb, and the Art Directors Club of New York. He has had solo exhibitions in cities such as: Bucharest, Zagreb, Vienna, Graz, Lisbon, Mexico and Osaka. His most notable awards include: The Cultural Poster Grand Prize (the National Library of France) and the International Poster Biennial first prize (Fort Collins, Colorado). His work has seen publication in *Affiche*, *Étapes*, and *Graphis Poster*. Now he is a professor at ESAG/Penninghen (Superior School of Graphic Arts in Paris).

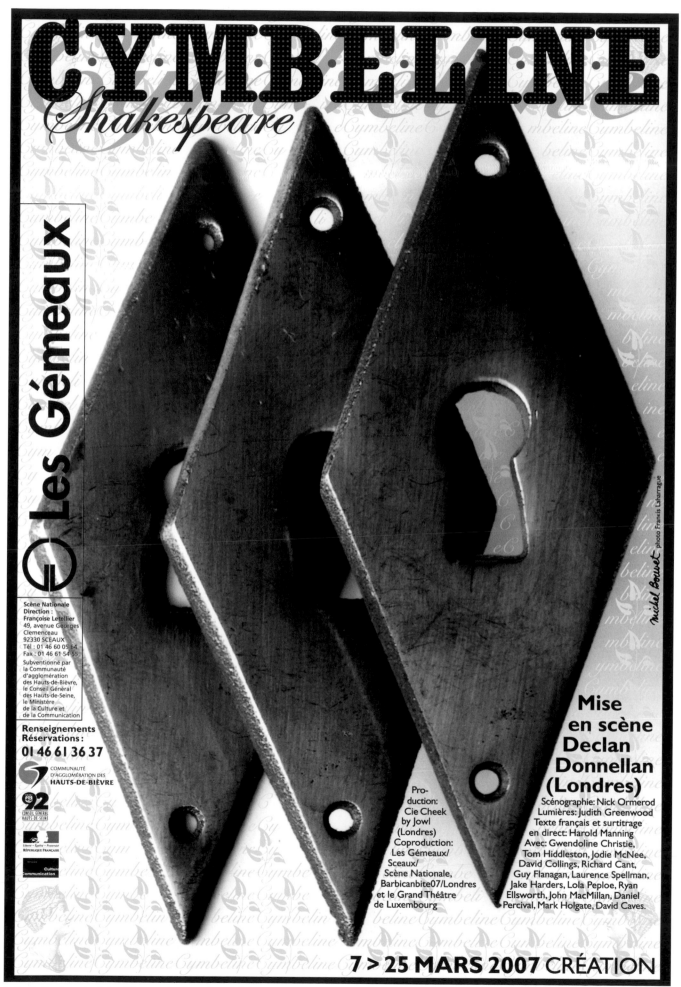

CYMBELINE

Shakespeare

Les Gémeaux

Scène Nationale
Direction :
Françoise Letellier
49, avenue Georges
Clemenceau
92330 SCEAUX
Tél : 01 46 60 05 64
Fax : 01 46 61 54 55
Subventionné par
la Communauté
d'agglomération
des Hauts-de-Bièvre,
le Conseil Général
des Hauts-de-Seine,
le Ministère
de la Culture et
de la Communication

**Renseignements
Réservations :
01 46 61 36 37**

COMMUNAUTÉ
D'AGGLOMÉRATION DES
HAUTS-DE-BIÈVRE

92
CONSEIL GÉNÉRAL
HAUTS DE SEINE

Liberté · Égalité · Fraternité
RÉPUBLIQUE FRANÇAISE

Culture
Communication

Michel Bouvet · photo Francis Laharrague

**Mise
en scène
Declan
Donnellan
(Londres)**

Scénographie: Nick Ormerod
Lumières: Judith Greenwood
Texte français et surtitrage
en direct: Harold Manning
Avec: Gwendoline Christie,
Tom Hiddleston, Jodie McNee,
David Collings, Richard Cant,
Guy Flanagan, Laurence Spellman,
Jake Harders, Lola Peploe, Ryan
Ellsworth, John MacMillan, Daniel
Percival, Mark Holgate, David Caves.

Pro-
duction:
Cie Cheek
by Jowl
(Londres)
Coproduction:
Les Gémeaux/
Sceaux/
Scène Nationale,
Barbicanbite07/Londres
et le Grand Théâtre
de Luxembourg

7 > 25 MARS 2007 CRÉATION

> *Cymbeline* > poster > Les Gémeaux > photo: Francis Laharrague

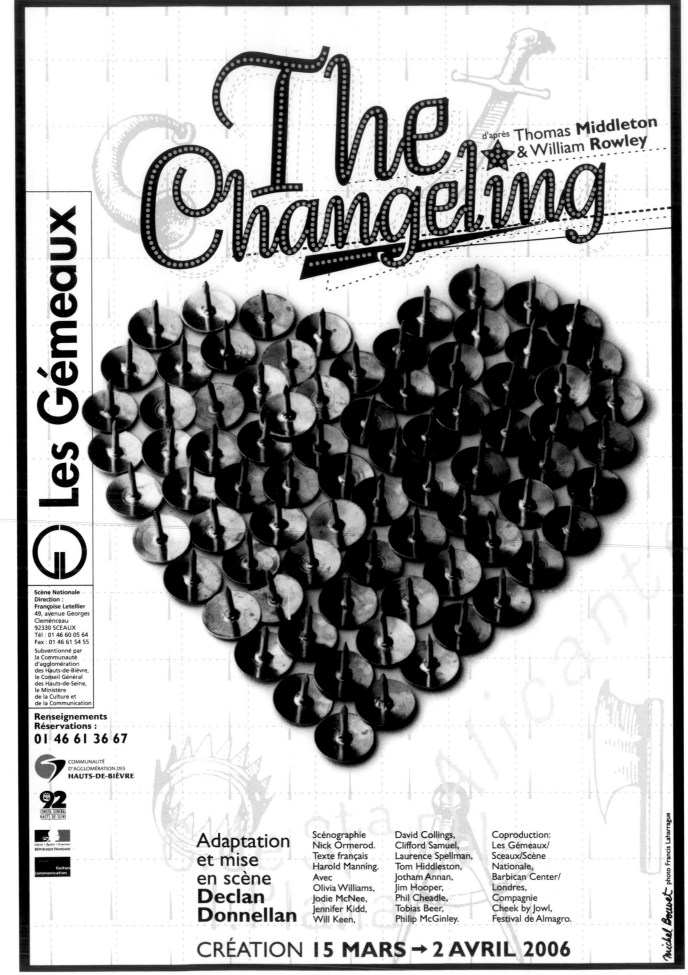

The Changeling

d'après **Thomas Middleton** & William **Rowley**

Les Gémeaux

Scène Nationale
Direction :
Françoise Letellier
49, avenue Georges
Clemenceau
92330 SCEAUX
Tél : 01 46 60 05 64
Fax : 01 46 61 54 55
Subventionné par
la Communauté
d'agglomération
des Hauts-de-Bièvre,
le Conseil Général
des Hauts-de-Seine,
le Ministère
de la Culture et
de la Communication

**Renseignements
Réservations :**
01 46 61 36 67

COMMUNAUTÉ
D'AGGLOMÉRATION DES
HAUTS-DE-BIÈVRE

92
CONSEIL GÉNÉRAL
HAUTS-DE-SEINE

Liberté · Égalité · Fraternité
RÉPUBLIQUE FRANÇAISE

Culture
Communication

**Adaptation
et mise
en scène
Declan
Donnellan**

Scénographie
Nick Ormerod.
Texte français
Harold Manning.
Avec
Olivia Williams,
Jodie McNee,
Jennifer Kidd,
Will Keen,

David Collings,
Clifford Samuel,
Laurence Spellman,
Tom Hiddleston,
Jotham Annan,
Jim Hooper,
Phil Cheadle,
Tobias Beer,
Philip McGinley.

Coproduction:
Les Gémeaux/
Sceaux/Scène
Nationale,
Barbican Center/
Londres,
Compagnie
Cheek by Jowl,
Festival de Almagro.

Michel Bouvet photo Francis Laharrague

CRÉATION 15 MARS → 2 AVRIL 2006

> *The Changeling* > poster > Les Gémeaux > photo: Francis Laharrague

> *Boris Godounov/Lady Macbeth de Mzensk* > poster > Opéra de Massy

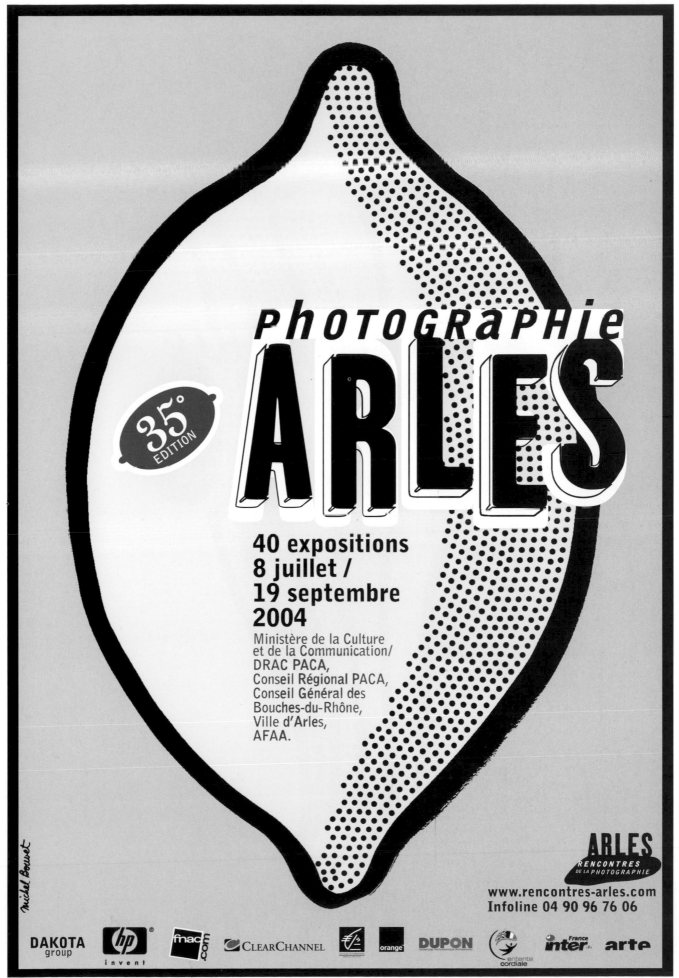

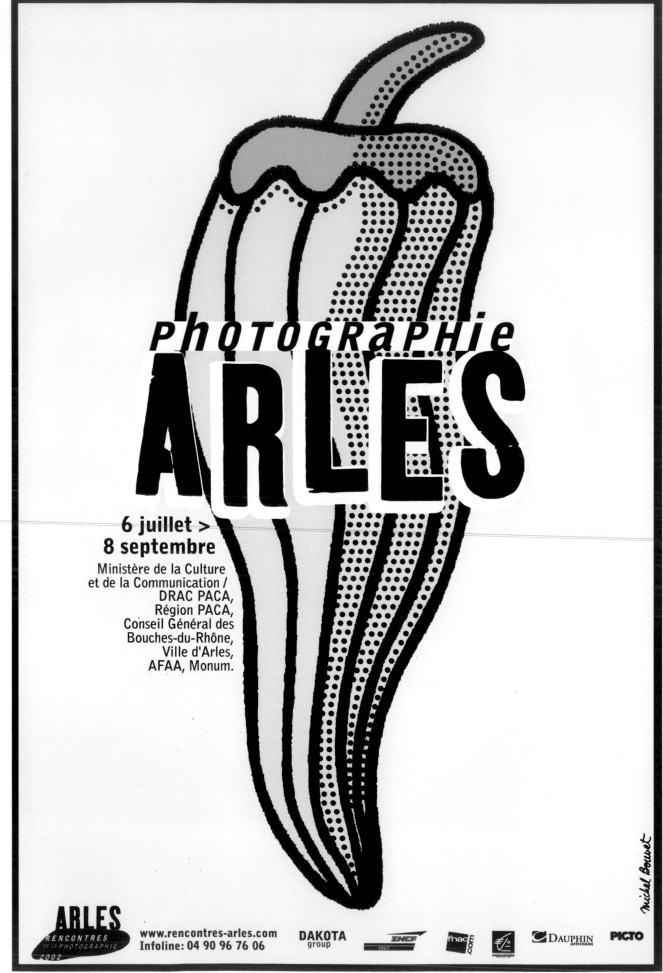

PHOTOGRAPHIE
ARLES

6 juillet >
8 septembre

Ministère de la Culture
et de la Communication /
DRAC PACA,
Région PACA,
Conseil Général des
Bouches-du-Rhône,
Ville d'Arles,
AFAA, Monum.

ARLES
RENCONTRES
DE LA PHOTOGRAPHIE
2002

www.rencontres-arles.com
Infoline: 04 90 96 76 06

DAKOTA
group

SNCF
FRET

fnac
COQ

DAUPHIN
AFFICHAGE

PICTO

Michel Bouvet

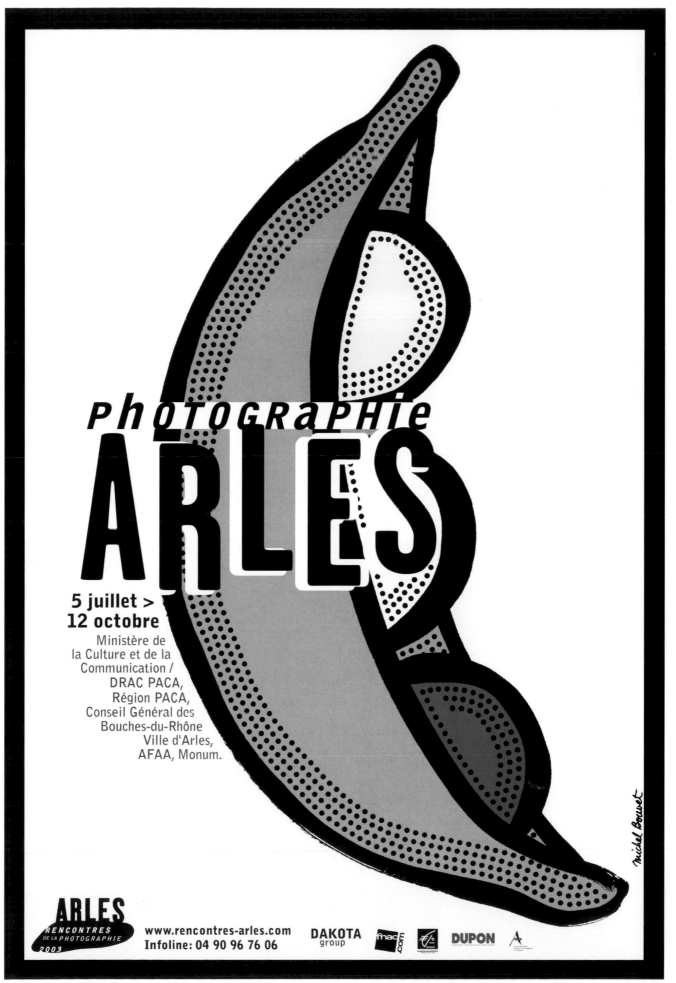

Milkxhake

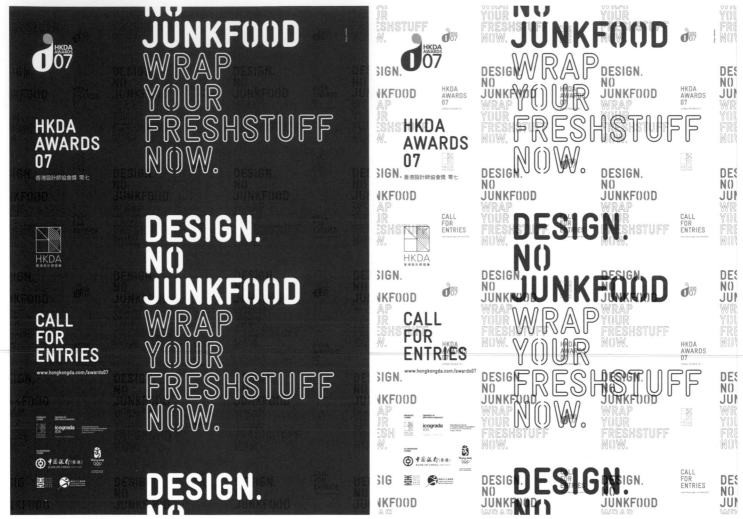

> *Hong Kong Designers Association Awards 07* > posters > Hong Kong Designers Association

3/F, B Lam Shan Building
113-119 Belcher's Street
Kennedy Town
Hong Kong
+852 6336 9740
mix@milkxhake.org
www.milkxhake.org

> Javin Mo (graphic designer) and Wilson Tang (interactive designer), are the cofounders of Milkxhake design studio in Hong Kong. The letter "x" in the word Milkxhake alludes to a continual idea of mixing and multiplying. They believe that true design, mixed with the essence of good ideas, can provoke change in our environments and perceptions of life. Their motto is *Mix it a Better World*. In 2004, Javin Mo of Milkxhake was invited to form part of the Fabrica Department of Visual Comunication in Italy. He was involved with projects like the quarterly publication of the Fabrica magazine *FAB*. In 2005, Javin restarted Milkxhake with Wilson Tang as one of Hong Kong's most energetic design collectives. They received 10 awards at the 2005 Hong Kong Designers Association Awards, including a gold medal and a bronze.

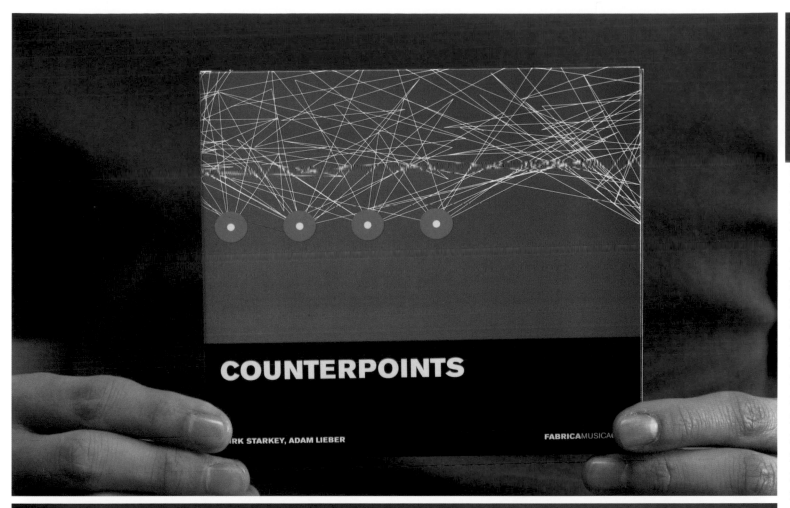

COUNTERPOINTS

...RK STARKEY, ADAM LIEBER

FABRICAMUSICA...

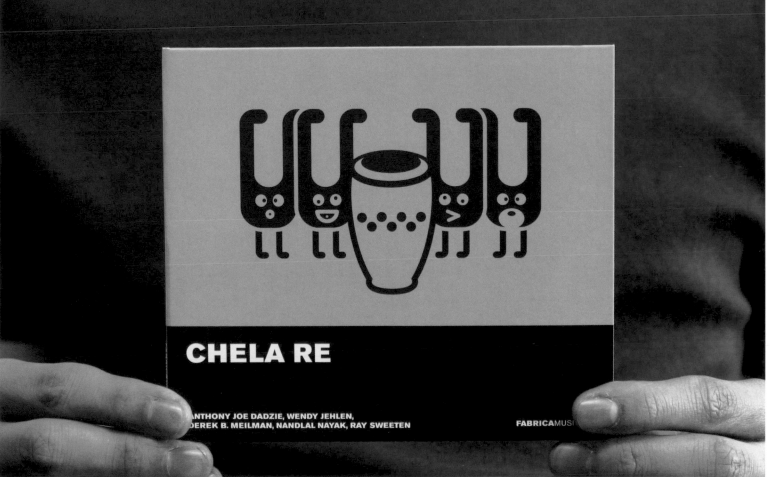

CHELA RE

...ANTHONY JOE DADZIE, WENDY JEHLEN,
...DEREK B. MEILMAN, NANDLAL NAYAK, RAY SWEETEN

FABRICAMUSI...

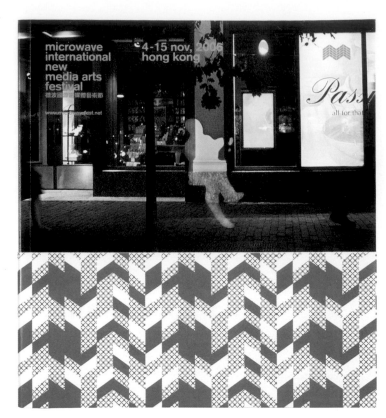

> *Microwave International New Media Arts Festival 2006* > pamphlet > Microwave

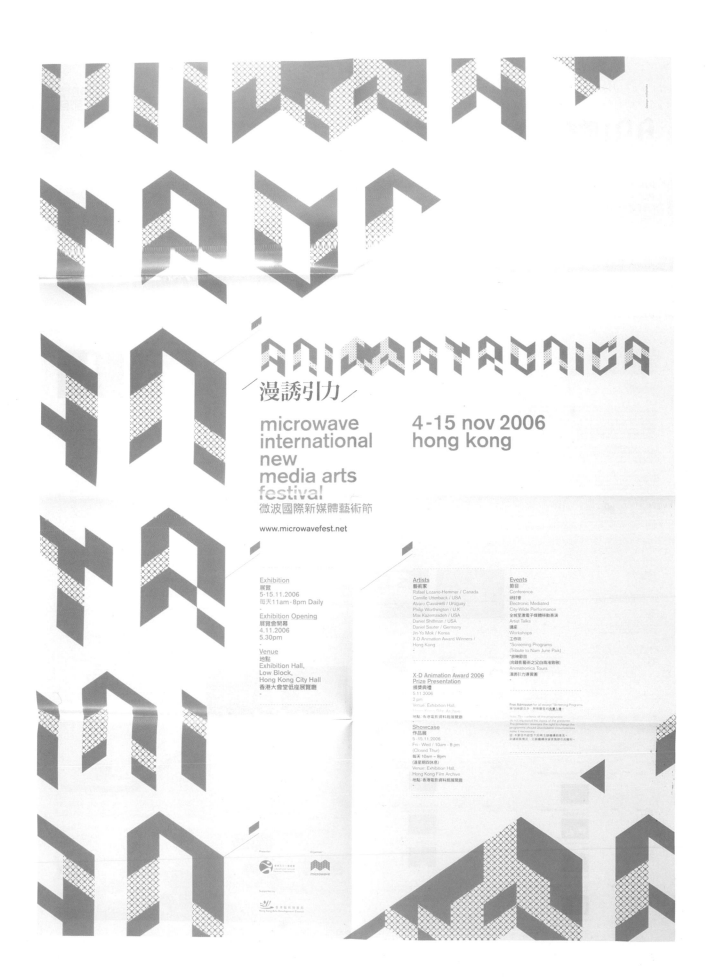

ANIMATRONICA
/漫誘引力/

microwave
international
new
media arts
festival
微波國際新媒體藝術節

4-15 nov 2006
hong kong

www.microwavefest.net

Exhibition
展覽
5-15.11.2006
每天11am - 8pm Daily

Exhibition Opening
展覽會開幕
4.11.2006
5.30pm

Venue
地點
Exhibition Hall,
Low Block,
Hong Kong City Hall
香港大會堂低座展覽廳

Artists
藝術家
Rafael Lozano-Hemmer / Canada
Camille Utterback / USA
Alvaro Cassinelli / Uruguay
Philip Worthington / U.K
Max Kazemzadeh / USA
Daniel Shiffman / USA
Daniel Sauter / Germany
Jin Yo Mok / Korea
X-D Animation Award Winners /
Hong Kong

X-D Animation Award 2006
Prize Presentation
頒獎典禮
5.11.2006
2 pm
Venue: Exhibition Hall,
Hong Kong Film Archive
地點: 香港電影資料館展覽廳

Showcase
作品展
5-15.11.2006
Fri - Wed / 10am - 8 pm
(Closed Thur)
每天 10am - 8pm
(逢星期四休息)
Venue: Exhibition Hall,
Hong Kong Film Archive
地點: 香港電影資料館展覽廳

Events
節目
Conference
研討會
Electronic Mediated
City-Wide Performance
全城電激電子媒體移動表演
Artist Talks
講座
Workshops
工作坊
"Screening Programs
[Tribute to Nam June Paik] .
*放映節目
(向錄影藝術之父白南准致敬)
Animatronica Tours
漫誘引力導賞團

Free Admission for all except "Screening Programs
除*放映節目外、所有節目均免費入場。

note: To - unless of the programmes
do not represent the views of the presenter.
The presenter reserves the right to change the
programme should unavoidable circumstances
make it necessary.
註: 本節目內容並不代表主辦機構的意見。
如遇到無可避免的情況、主辦機構保留更改節目的權利。

THE
STUDIO
By ProWolfMaster

T_+39 0421 33 66 91
F_+39 0421 18 40 02 8
E_RUGGERO.BALDASSO@RBA.IT
H_WWW.RBA.IT

VIA VITTORIO VENETO 114
30027 S. DONA' DI PIAVE/VE/ITALY

studio_rba
ruggero_baldasso_architects

RUGGERO BALDASSO
DIRECTOR

T_+39 0421 33 66 91
F_+39 0421 18 40 02 8
E_RUGGERO.BALDASSO@RBA.IT
H_WWW.RBA.IT

VIA VITTORIO VENETO 114
30027 S. DONA' DI PIAVE/VE/ITALY

studio_rba
ruggero_baldasso_architects

> *RBA Identity* > promotional material > Ruggero Baldasso Architects (RBA)

VIA VITTORIO VENETO 114
30027 S. DONA' DI PIAVE / VE / ITALY

RBa

studio_rba
ruggero_baldasso_architects

Mirko Ilić

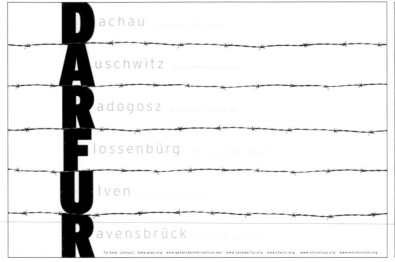

> *Darfur* > poster > public awareness for Darfur

> *MIJ Logo* > logo > Serbian Museum of Yugoslavian History

207 East 32
New York NY 10016
United States
+1 212 481 9737
studio@mirkoilic.com
www.mirkoilic.com

> Born in Bosnia-Herzegovina, Mirko Ilić worked in Europe as illustrator and designer of posters, record covers and comics. In 1986 he moved to the United States and continued his career as designer. He has illustrated for some of the biggest magazines and newspapers in the United States. His work as art director includes the international edition of *Time* and the op-ed page of the *The New York Times*. In 1995, he started Mirko Ilić Corp., a graphic design, 3D computer graphics and motion picture titling studio. He has received awards from the Society of Illustrators, the Society of Publication Designers and the Art Directors Club. He was vice-president of the New York chapter of AIGA between 1994 and 1995 and a professor of design at Cooper Union. He has co-authored various books, such as *100 Icons of Graphic Design* and *Handwritten: Expressive Lettering in the Digital Age*. He now teaches the masters degree in illustration at the New York School of Visual Arts.

TIHANY DESIGN
135 West 27th Street
New York, NY 10001
tel: 212 366 5544
fax: 212 366 4302
mail@tihanydesign.com
www.tihanydesign.com

> *Tihany Design Brochure & Stationery* > promotional material > Tihany Design

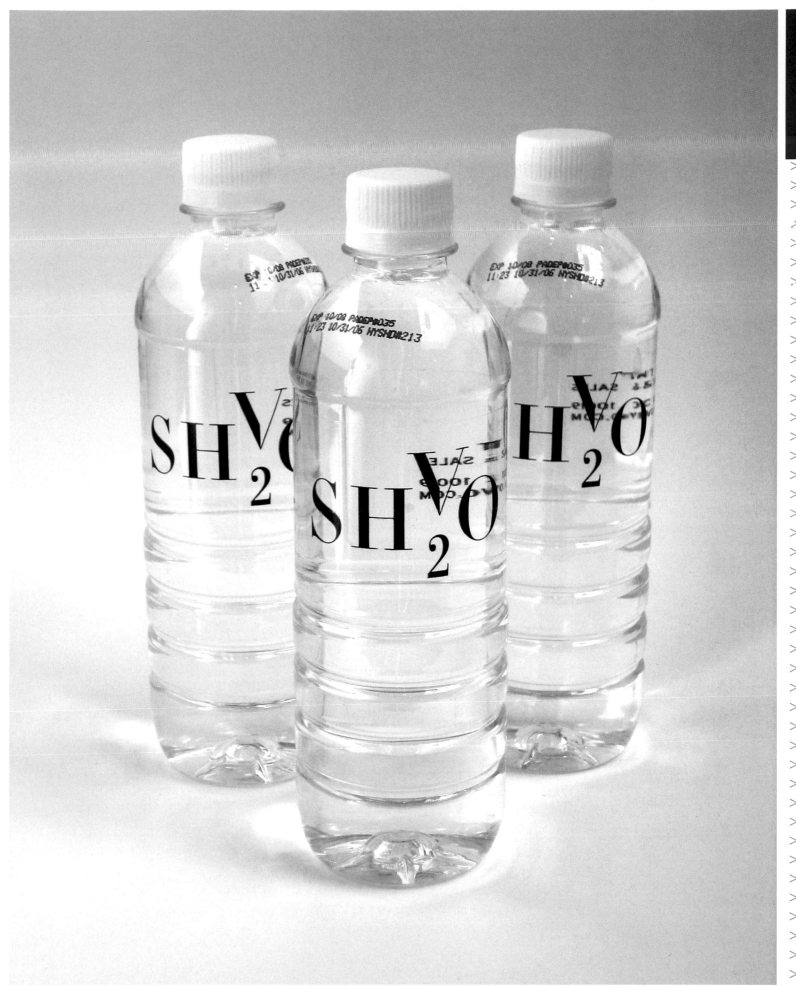

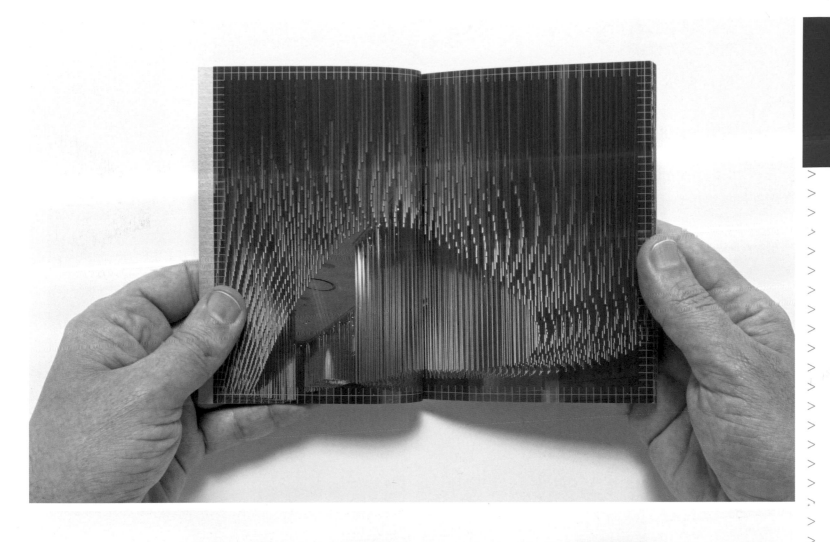

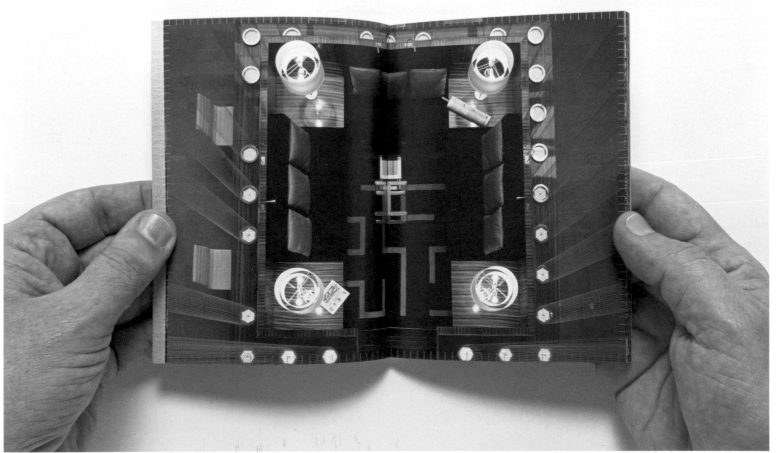

Niklaus Troxler

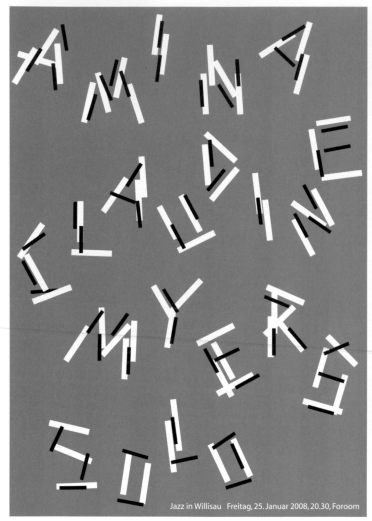

Jazz in Willisau Freitag, 25. Januar 2008, 20.30, Foroom

> *Amina Claudine Myers* > poster > Jazz in Willisau

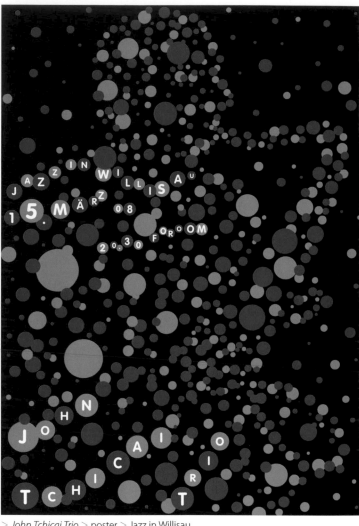

> *John Tchicai Trio* > poster > Jazz in Willisau

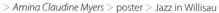

Postfach
6130 Willisau
Switzerland
+41 41 970 27 31
troxler@troxlerart.ch
www.troxlerart.ch
Portrait: Paula Troxler

> Of Swiss origin, Niklaus Troxler has had a long career as a designer by offering a variety of high quality styles. The large number of works produced till now demonstrate his characteristic simple style, even while his personal aesthetic has changed with the years and fashions. Since 1973 he has directed his own graphic design studio in Willisau and currently—parallel to his work as organizer of the Willisau Jazz Concerts—he is a lecturer at the State Academy of Art and Design in Stuttgart. He has received many prizes from both the New York and European Art Directors Clubs and the Type Directors Club of Tokyo. He has participated in various poster and design contests, including the Poster Biennial of Warsaw, the Brno Biennial of Design and the Poster Biennial of Mexico. His works can be found in the poster collections of MoMA, the Essen Museum of the Poster and in the poster collections of Basel and Zurich.

Ein buntes Neues Jahr wünscht Bösch Siebdruck AG, Postfach, CH-6371 Stans

> New Year Poster Silkscreen Printing Boesch > poster > Bösch Siebdruck

24. Mai 2008

12. Internationaler
Rollstuhlmarathon
Schenkon

4. Einzelzeitfahren
Handbike

> *Rollstuhlmarathon Schenkon* > poster > International Wheelchair Marathon, Schenkon

> 4x Troxler > poster > Design Festival, Hangzhou

Niklaus Troxler en Cuba : Carteles de Jazz
Galería de la Biblioteca Publica Ruben Martinez Villena

Plaza de Armas, Habana Vieja / Desde el 23 octubre al 23 noviembre 2007
Horario de la galería: de lunes a domingo. 9:00 am a 5:00 p.m.

> *Niklaus Troxler en Cuba* > poster > Gallery at Rubén Martínez Villena Public Library

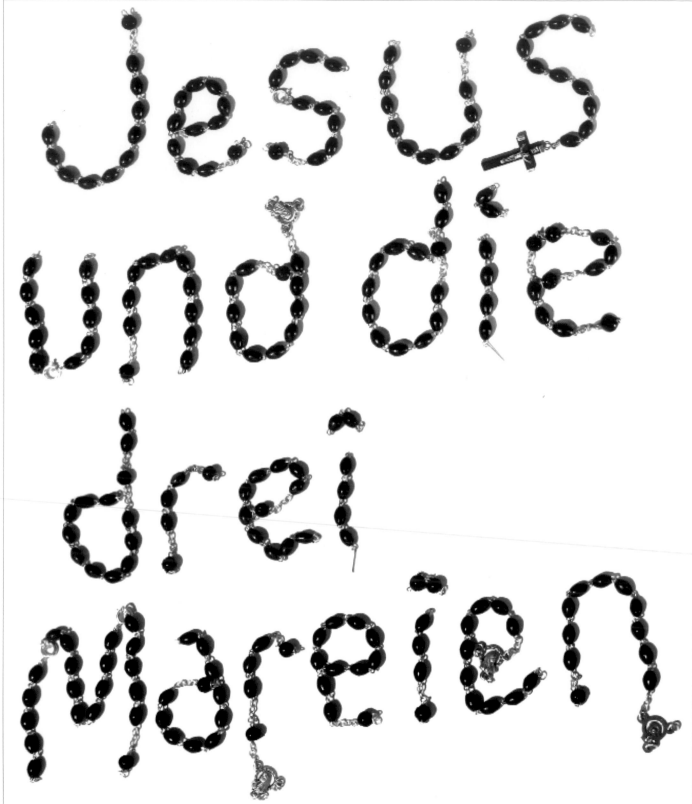

Theaterstück in
Schweizerdeutsch

Nach den vier Evangelien

Von Hansjörg Schneider

Uraufführung

Ab 8. Dezember 2007
in der Mariahilf Kirche
Luzern

Regie:
Louis Naef

Musik und Geräusche:
Koch-Schütz-Studer

Raum und Objekte:
Barbara Jäggi

Kostüme:
Ems Troxler und
Kathrin Troxler

Eintritt: Fr. 48.-

Vorverkauf ab November
und weitere
Informationen:
www.theater-jesus.ch

Unterstützt von Stadt und
Kanton Luzern

Produziert vom
Verein Autorentheater

If you cover Helvetica it looks quite nice

HELVETICA 50 YEARS. Designed by NIKLAUS TROXLER, Willisau
on the occasion of the celebration of «Helvetica, 50 Years» and the European Premiere of «Helvetica, A Documentary Film by Gary Hustwit» in Zürich, on March 24, 2007.
An initiative by Lars Müller in collaboration with the Museum of Design Zürich, sponsored by the Swiss Federal Office of Culture.

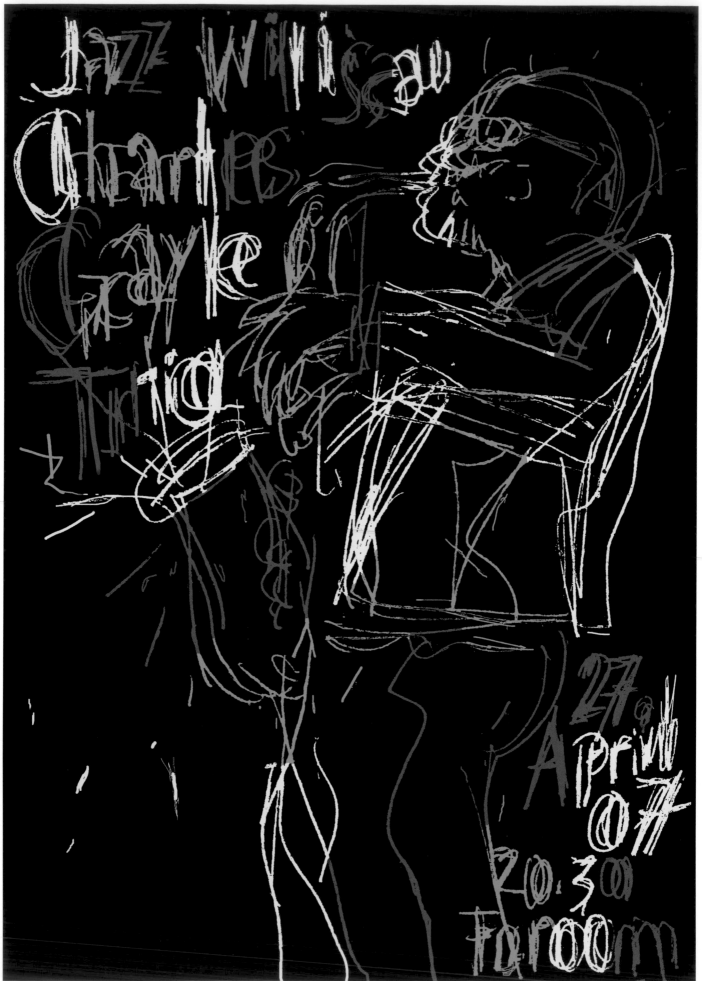

> *Charles Gayle Trio* > poster > Jazz in Willisau

Zentralschweizer Literaturtage Willisau
9.-11. März 2007

Stadtmühle Willisau

Samstag 10. März
10.00-11.30:
Thomas Hürlimann
im Gespräch mit
Andreas Iten

Freitag 9. März
19.30-21.00:
Osy Zimmermann
„Der silbergraue
Zeppelin"

Sonntag 11. März
10.00-11.30:
Lyrik Matinée

Samstag 10. März
14.00-18.00:
Neun Lesungen

Freitag 9. März
22.00-24.00:
Poetry Slam

Sonntag 11. März
12.00-13.30:
Vier beste Bücher

Samstag 10. März
19.30-22.00:
Rathausbühne
Hörspiele frisch
aus der Werkstatt

www.stadtmuehle.ch

STADTMÜHLE
KULTUR REGION WILLISAU

Oded Ezer Typography

> *Typosperma* > poster > personal project

35a Gordon Street
Givatayim 53229
Israel
+972 54 2288 042
oded@odedezer.com
www.odedezer.com

> Alongside his exclusive dedication to advertising typography and type design, Oded Ezer is also a university professor and a typographic experimentalist. He graduated in visual communication design at the Bezalel Academy of Arts and Design in Jerusalem. Later, he started his own independent studio, Oded Ezer Typography in Givatayim. He also co-founded Ha'Gilda ("The Guild"), the first cooperative of Israeli font designers. Now, he is a member of the Israel Community of Designers and teaches both typography and graphic design at the Shenkar College of Engineering and Design in Ramat Gan and the Wizo Academy of Design in Haifa. His work has won local awards and international praise, including the Gold Prize in the design competition of the International Nagoya Design Center in Japan, the certificate of excellence at the fourth annual competition of the New York Type Directors Club and the certificate of excellence from Bukva:raz!, a type design competition in Moscow (Russia).

> *Muzik* > logo > Tel Aviv School of Music

> *Ccafe* > logo > Bezalel Gallery

> Logo > Larin

a non profit item #8__typographic hommage to the music of the Israeli composer anja shepira__design by **oded ezer**__printed in Israel 2001__היא היא

> *The Message* > poster > personal project > photo: Oded Ezer

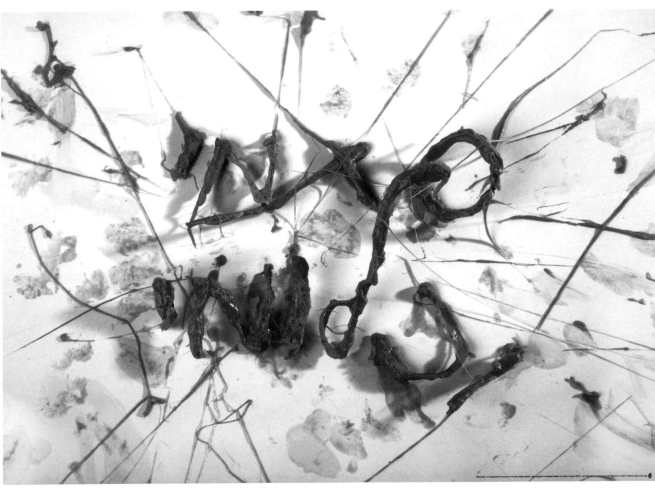

> *Stami Veklumi* > poster > personal project > photo: Shaxaf Haber

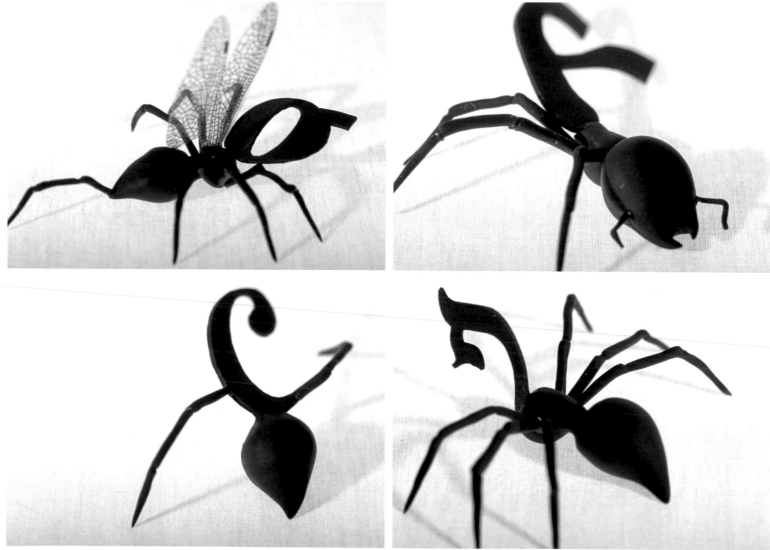

> *Biotypography* > poster > personal project > photo: Idan Gil

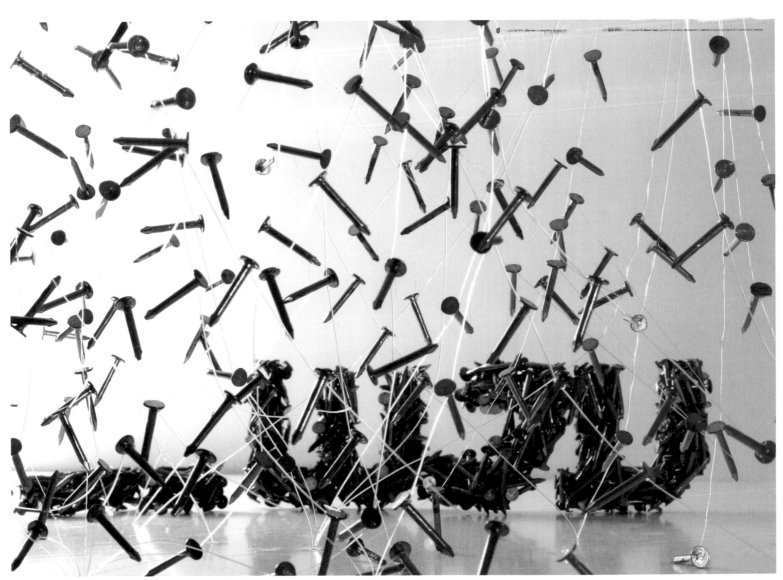

> *Now* > poster > personal project > photo: Shaxaf Haber

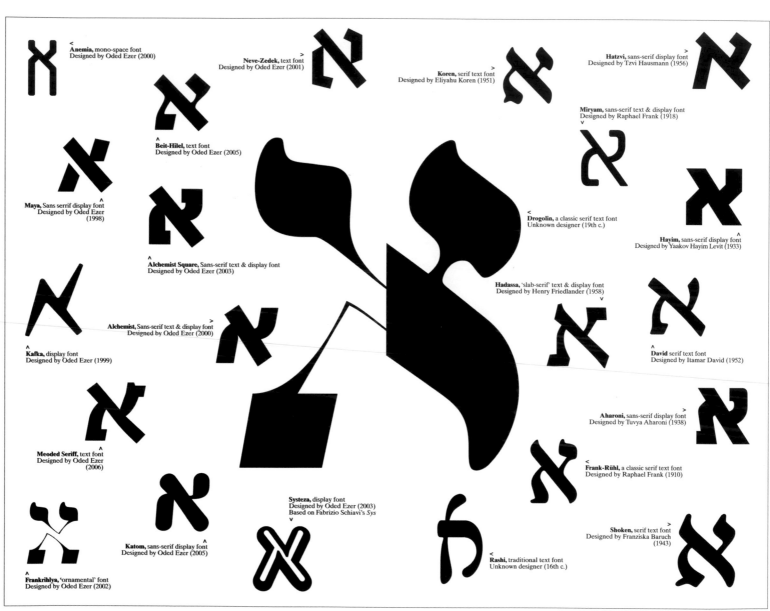

Anemia, mono-space font
Designed by Oded Ezer (2000)

Neve-Zedek, text font
Designed by Oded Ezer (2001)

Koren, serif text font
Designed by Eliyahu Koren (1951)

Hatzvi, sans-serif display font
Designed by Tzvi Hausmann (1956)

Miryam, sans-serif text & display font
Designed by Raphael Frank (1918)

Beit-Hilel, text font
Designed by Oded Ezer (2005)

Maya, Sans serrif display font
Designed by Oded Ezer
(1998)

Drogolin, a classic serif text font
Unknown designer (19th c.)

Hayim, sans-serif display font
Designed by Yaakov Hayim Levit (1933)

Alchemist Square, Sans-serif text & display font
Designed by Oded Ezer (2003)

Hadassa, 'slab-serif' text & display font
Designed by Henry Friedlander (1958)

Alchemist, Sans-serif text & display font
Designed by Oded Ezer (2000)

Kafka, display font
Designed by Oded Ezer (1999)

David serif text font
Designed by Itamar David (1952)

Meoded Seriff, text font
Designed by Oded Ezer
(2006)

Aharoni, sans-serif display font
Designed by Tuvya Aharoni (1938)

Frank-Rühl, a classic serif text font
Designed by Raphael Frank (1910)

Systeza, display font
Designed by Oded Ezer (2003)
Based on Fabrizio Schiavi's *Sys*

Katom, sans-serif display font
Designed by Oded Ezer (2005)

Shoken, serif text font
Designed by Franziska Baruch
(1943)

Rashi, traditional text font
Unknown designer (16th c.)

Frankrihlya, 'ornamental' font
Designed by Oded Ezer (2002)

> *Hebrew Fonts Fan Catalogue* > poster > personal project

> **420**

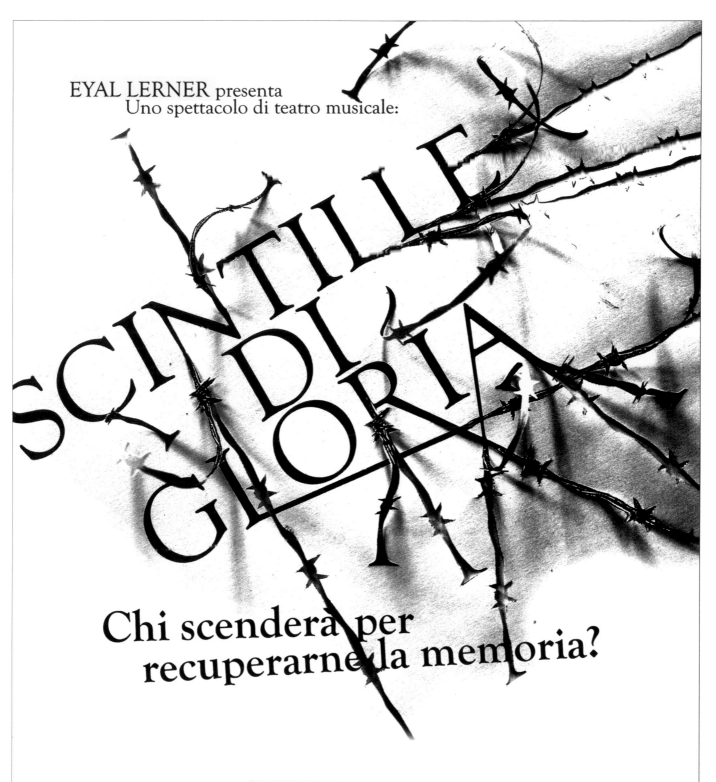

EYAL LERNER presenta
Uno spettacolo di teatro musicale:

SCINTILLE DI GLORIA

Chi scenderà per recuperarne la memoria?

Cura dell'allestimento Eyal Lerner

Musiche di Weill, Stravinskij, Ullman, Zosi, Pärt, Schoenfield

Testi Dalfino, Brecht, Ramuz, Kien, Prager

Interpreti Eyal Lerner (narrazione, canto), Laura Dalfino (soprano)
Marco Ortolani (clarinetto), Alberto Bologni (violino),
Andrea Noferini (violoncello), Giuseppe Bruno (pianoforte)

Ostengruppe

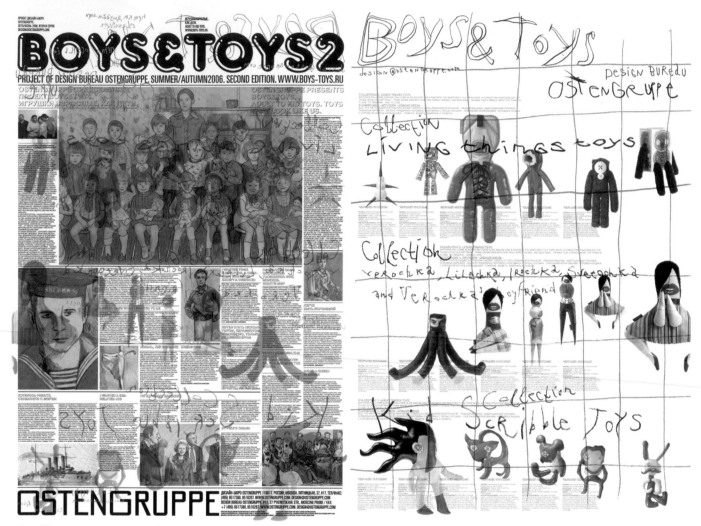

> *Boys&Toys* newspaper > personal project > design: Dmitry Kavko

#17, 37 Pyatnitskaya
Moscow
Russia
+7 95 17380 9518207
design@ostengruppe.com
www.ostengruppe.com

> Much more than a design studio, Ostengruppe is a creative laboratory. It is a small company, which means they are more flexible and adaptable to a client's needs. Their motto: "We do what we like and we do it well!" Each of their projects maintains a healthy balance between its goals and their abilities. Their objective is to perform a job well done, enjoy themselves and obtain quality results that reflect their enthusiasm and talents. They define themselves as proactive and try to find a solution for every situation. They encourage constructive criticism because it helps them to find answers and keep an open dialogue. They do what they can to ensure that the team is comfortable with its workspace. To make them feel comfortable and free to express their creativity, an entire universe of possibilities is open to them; new technologies and new tools that expand the limits of their imagination.

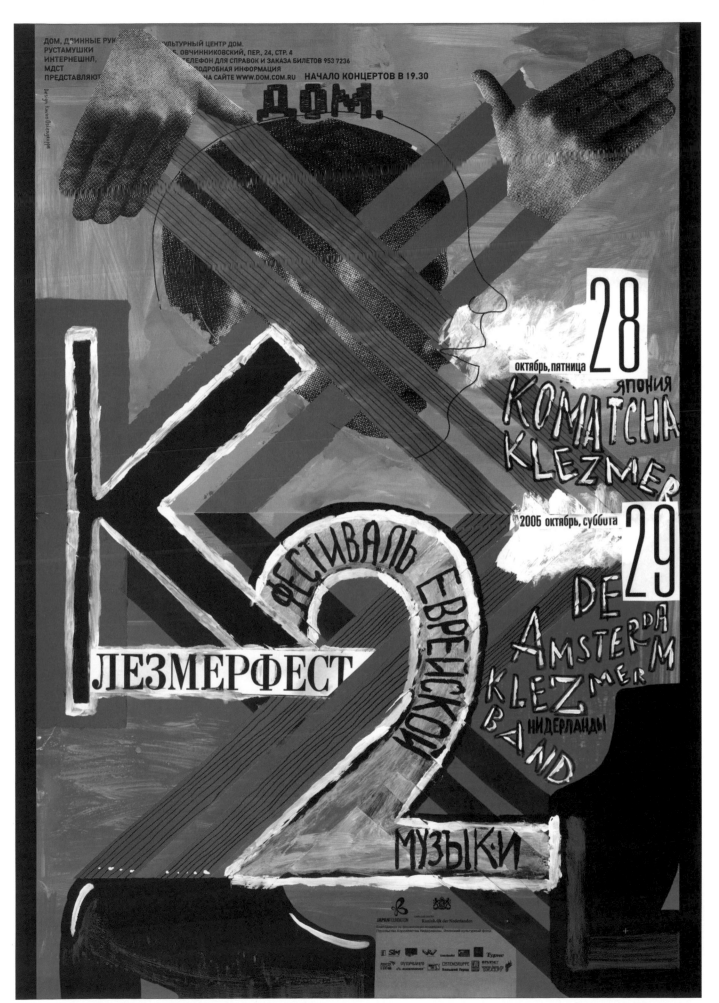

> *Klezmerfest* > poster > DOM cultural center > design: Dmitry Kavko

> Krzysztof Kieslowski's Retrospective > poster > Film Museum > design: Dmitry Kavko

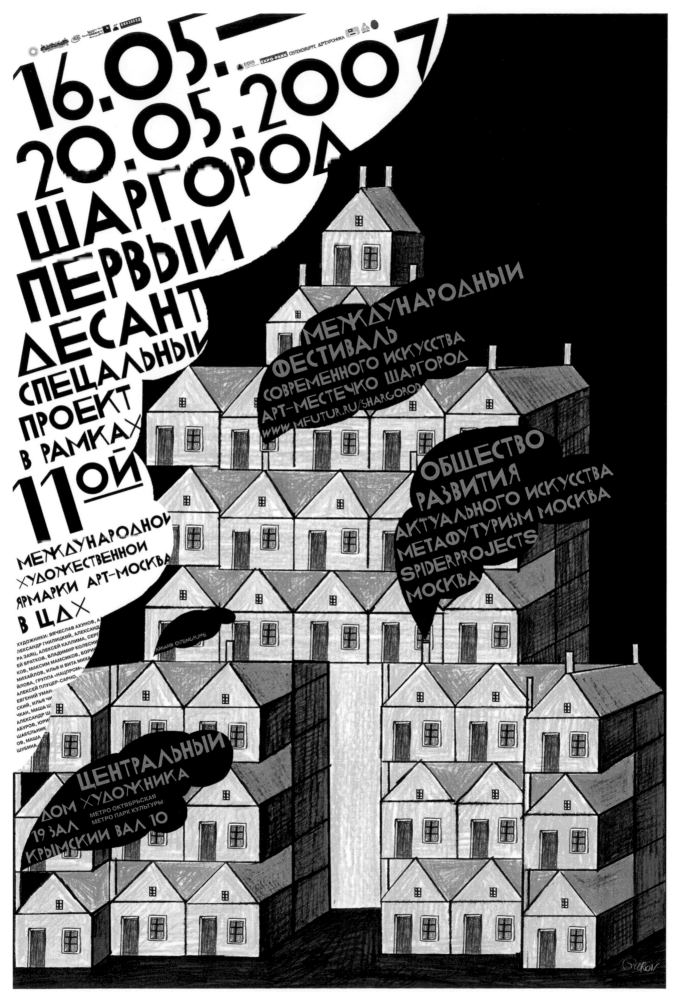

> *Shargorod* > poster > modern art exhibition > design: Igor Gurovich

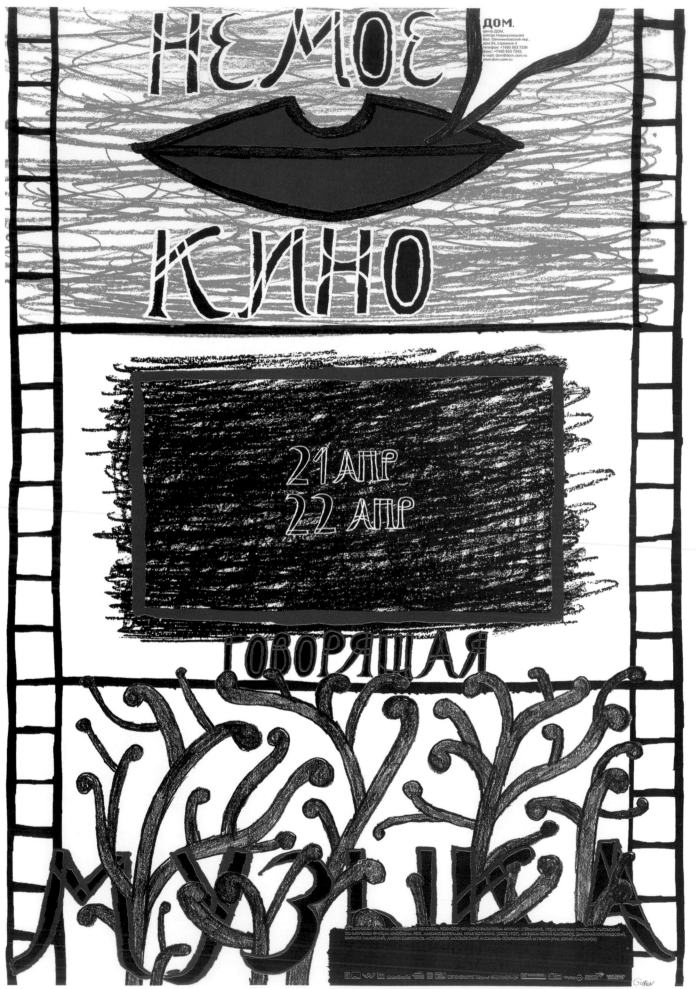

> *Silent Films-Talkative Music* > poster > DOM cultural center > design: Igor Gurovich

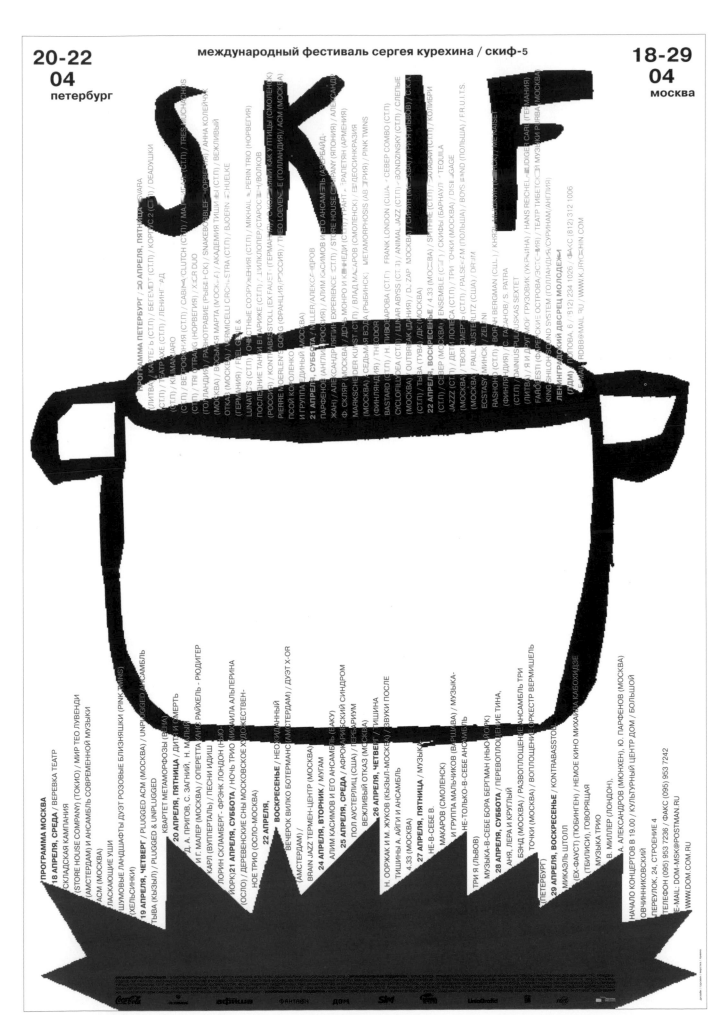

> Sergey Kuryokhin International Festival > poster > DOM cultural center > design: Igor Gurovich

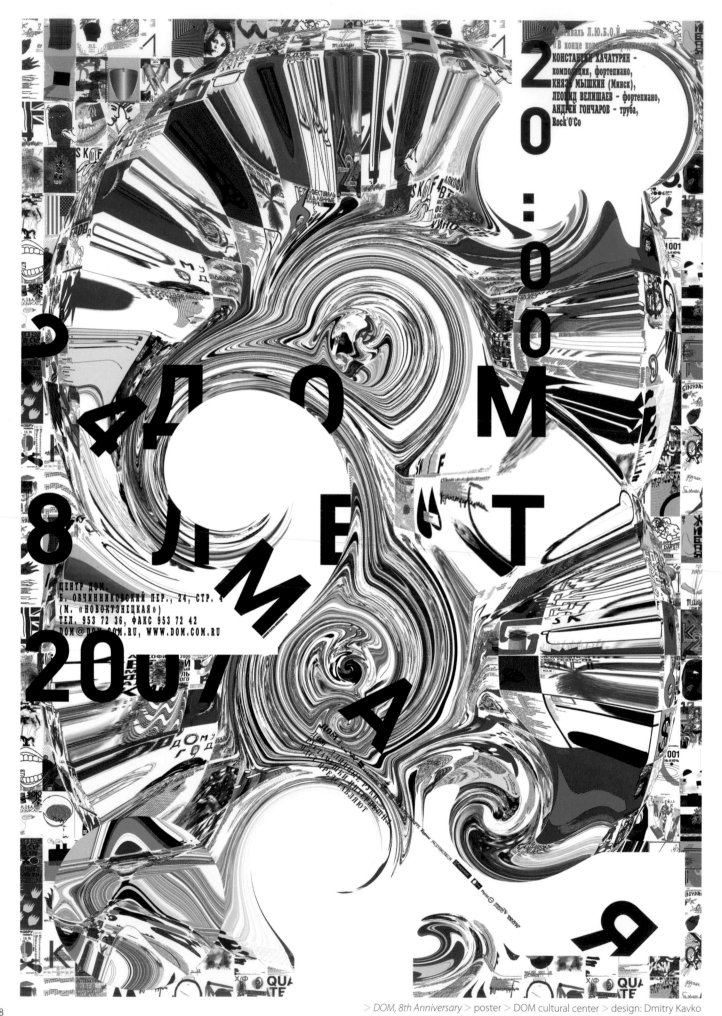

> DOM, 8th Anniversary > poster > DOM cultural center > design: Dmitry Kavko

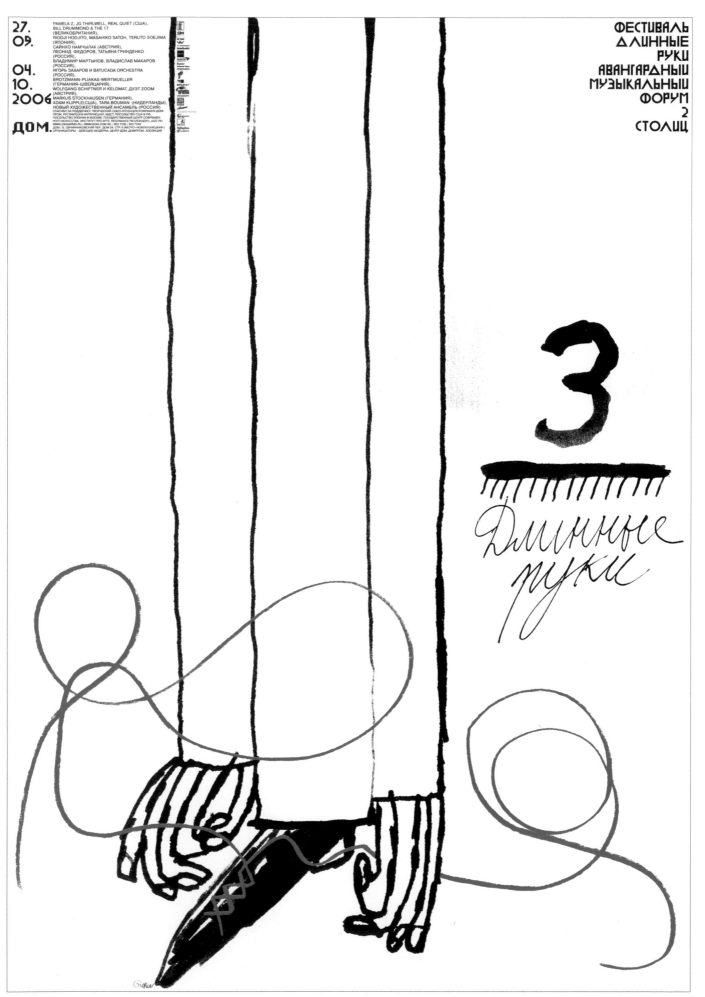

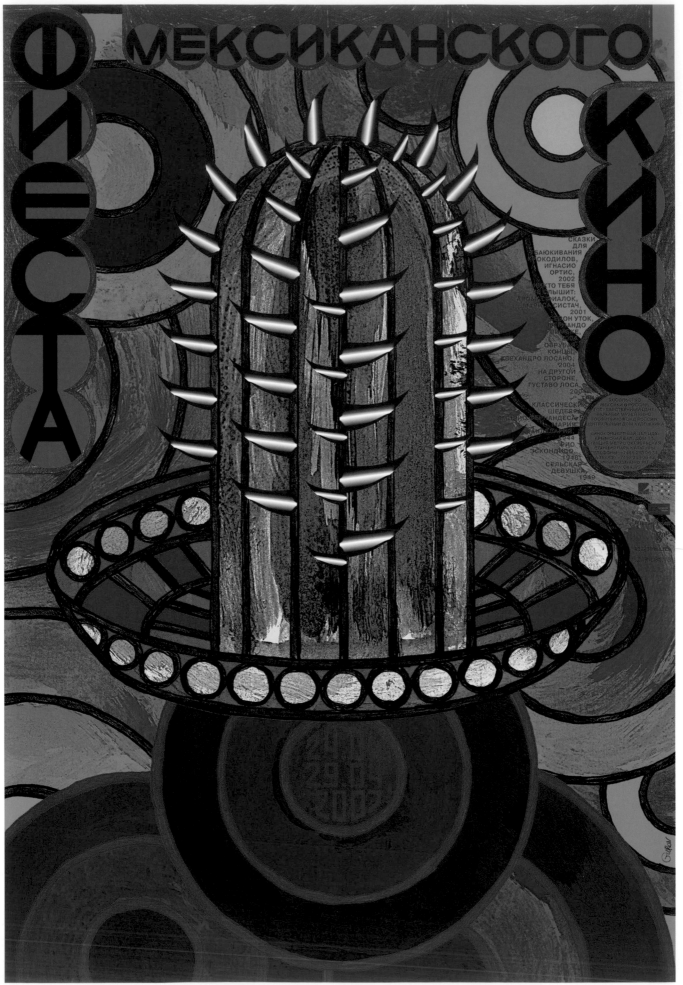

> *Mexican Cinema Festival* > poster > Cinema Museum > design: Igor Gurovich

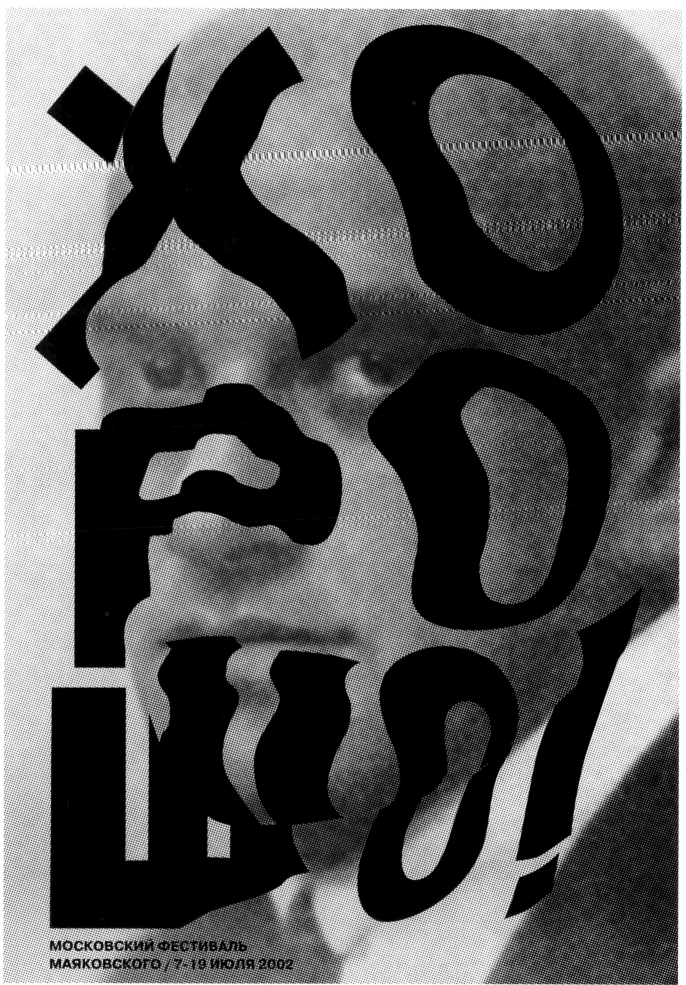

МОСКОВСКИЙ ФЕСТИВАЛЬ
МАЯКОВСКОГО / 7-19 ИЮЛЯ 2002

> *Good* > poster > DOM cultural center > design: Eric Belooussov

Paprika

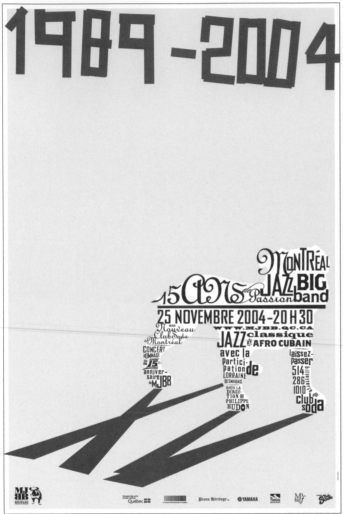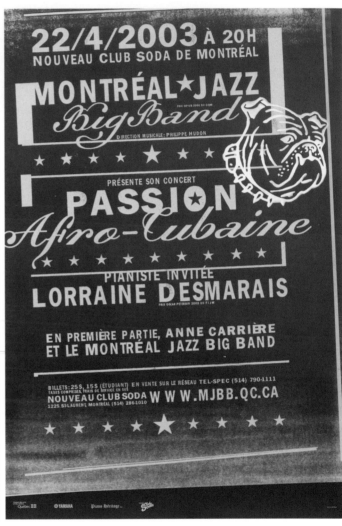

> *Big Band* > poster > Montreal Jazz Big Band

400, Laurier Ouest
Suite 610
Montreal
QC H2V 2K7 Canada
+1 514 276 6000
info@paprika.com
www.paprika.com

> Joanne Lefebvre and Louis Gagnon started the Paprika design studio in 1991 by uniting their efforts towards one common goal: to offer new ways of taking the creative process beyond the conventional standards of today. Thanks to its team of highly creative designers, Paprika continues to share its unique style while keeping its message in mind and maximizing the impact of the image. It is a graphic design team that offers specialized services in all stages of communication: branding, corporate image, packaging, environmental design, catalogs, posters, signs and images. Over the years, Paprika has dealt with a large quantity of clients and, as a result of these associations, reaped a great number of national and international awards. Almost a total of 400 awards have been given them by such prestigious organizations as AIGA, Art Directors Club and Type Directors Club of New York, among others.

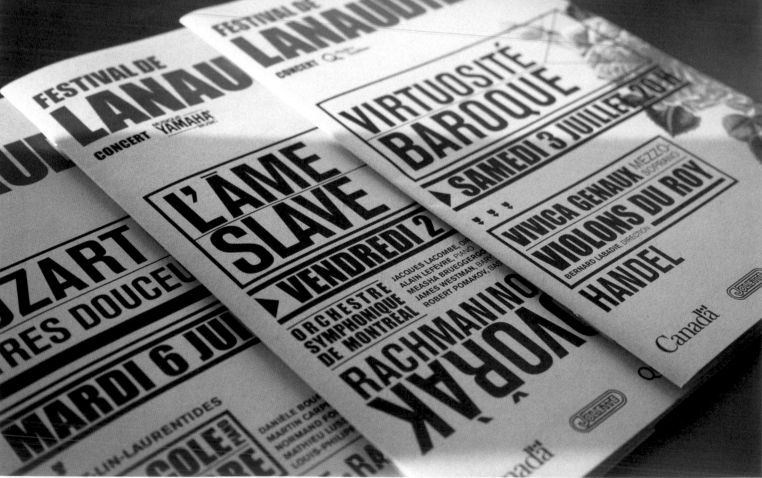

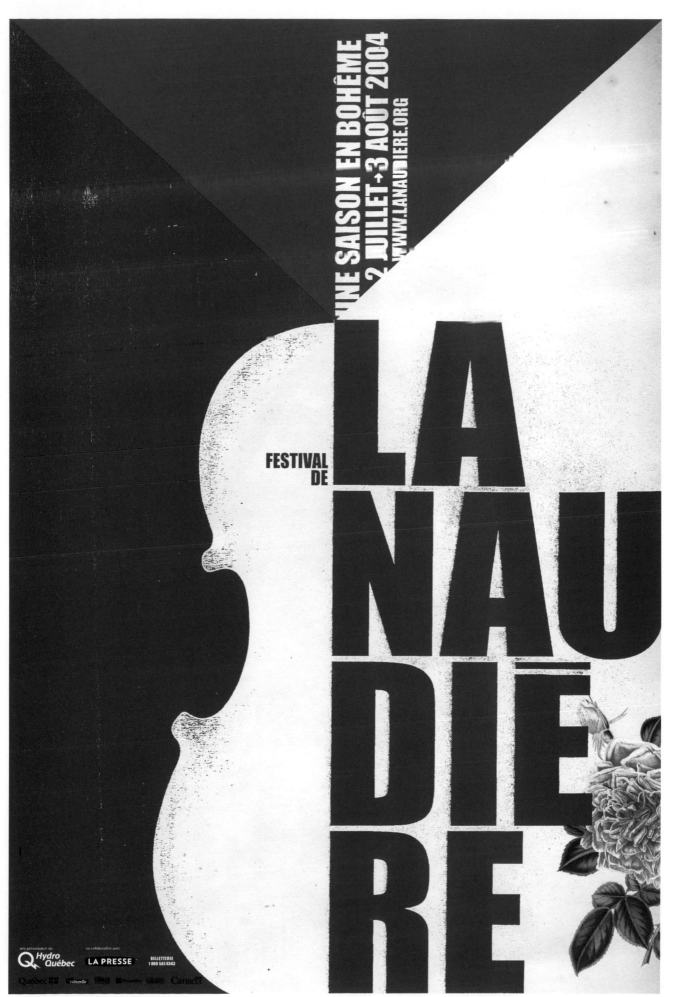

> Poster > Lanaudière Festival

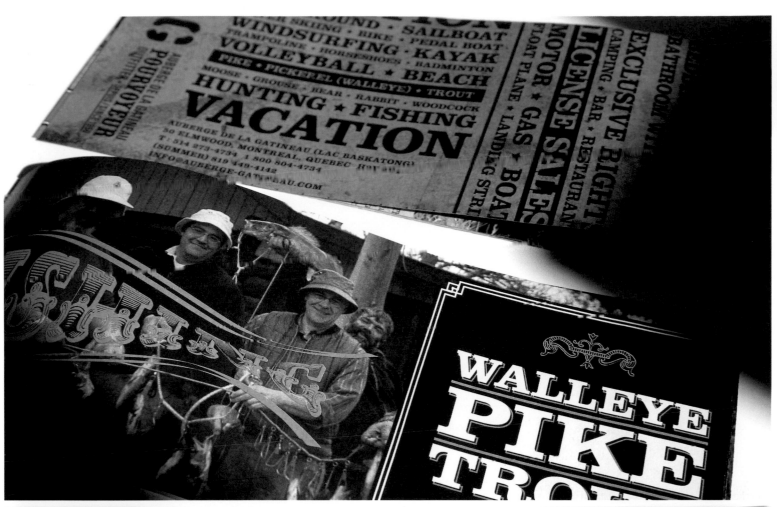

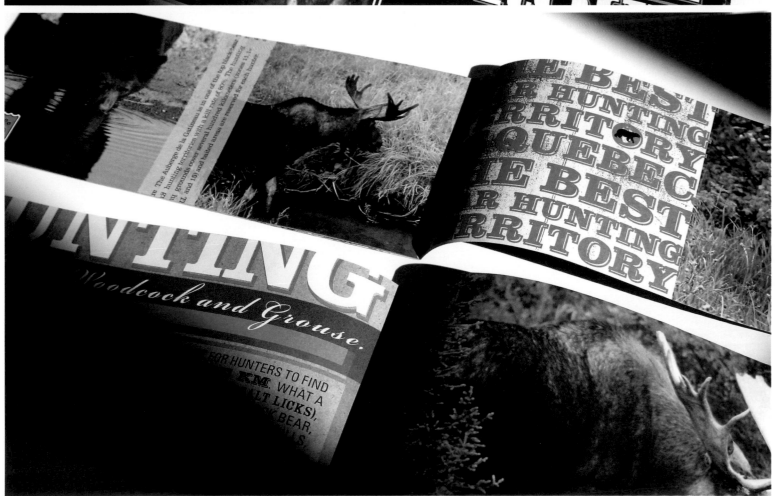

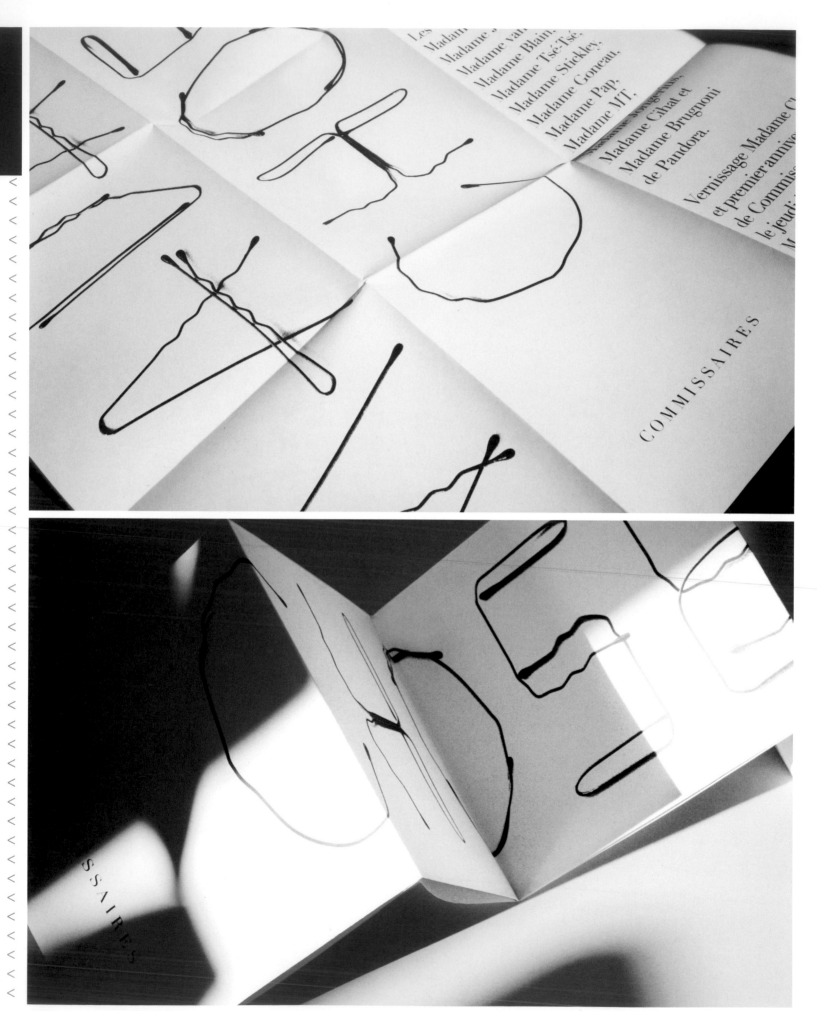

Les
Madame ...
Madame van ...
Madame Blain...
Madame Tsé-Tsé...
Madame Stickley,
Madame Goneau.
Madame Pap.
Madame MT.

Madame Cihat et
Madame Brugnoni
de Pandora.

Vernissage Madame ...
et premier anniv...
de Commis...
le jeudi...

COMMISSAIRES

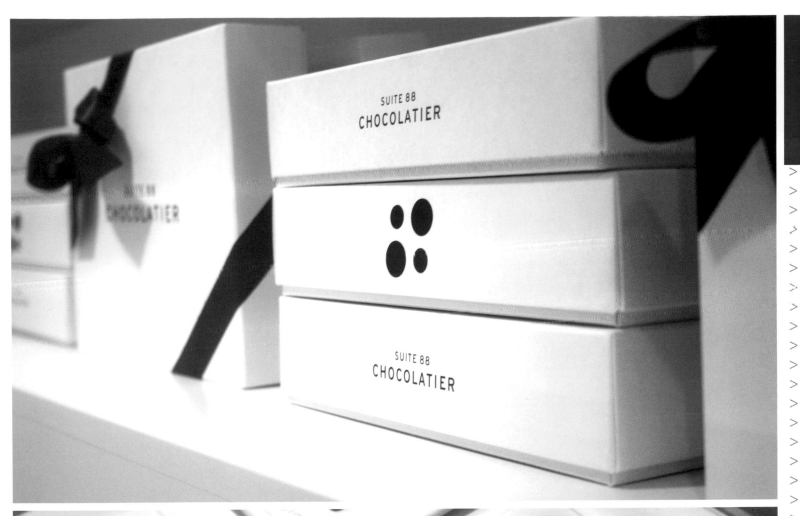

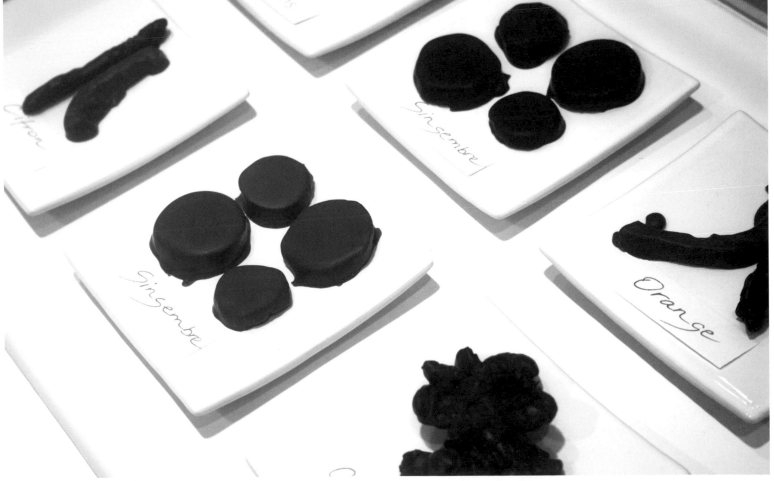

Parallax Design

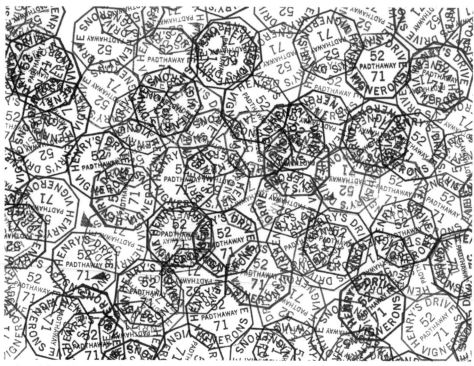

> *Henry's Drive Vignerons* > logo > Mark and Kim Longbottom

447 Pulteney Street
Adelaide SA 5000
Australia
+8 8232 8066
hello@parallaxdesign.com.au
www.parallaxdesign.com.au

> A consultancy for design and creator of ideas, Parallax Design was started in 2001. This design studio works for industrial sectors, specializing in corporate identity and packaging. Parallax provides real solutions to real problems in the most convincing and inspired way possible. Creative talent and general director Matthew Remphrey was born in Adelaide in 1970. In 1991, he obtained his degree in visual communication, specializing in illustration at the University of South Australia. Matthew's work has won both national and international awards. Some of the more notable ones are the Gold Chair (Best of Show) from the Adelaide Advertising and Design Awards 2006 and Best of Show at the 2000 Australian Packaging Awards. Currently, Matthew is chair of the Advisory Committee to the School of Art and Design at the University of South Australia.

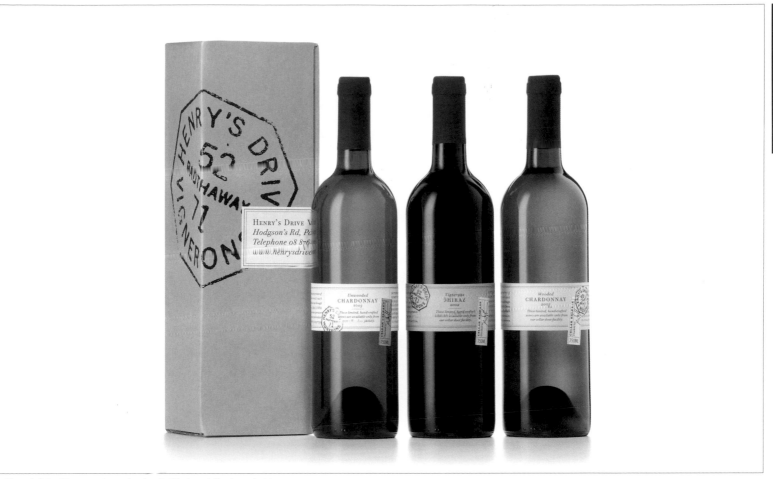

> *Henry's Drive Vignerons* > packaging > Mark and Kim Longbottom

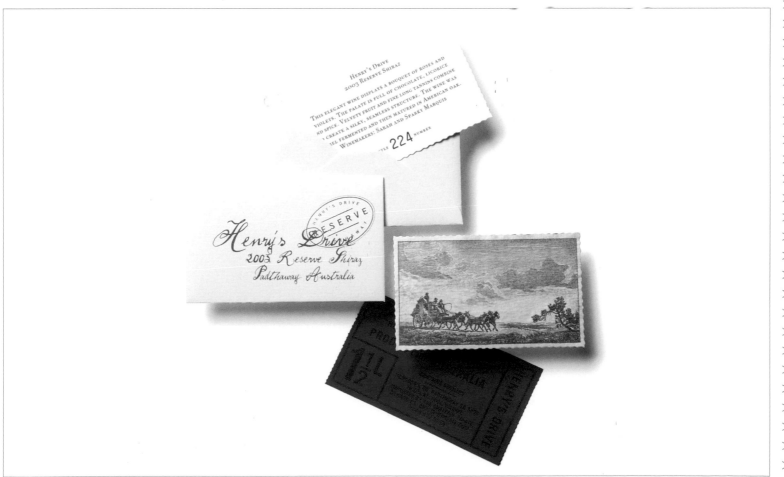

> *Henry's Drive Vignerons* > promotional material > Mark and Kim Longbottom

> *Henry's Drive Vignerons* > postcards > Mark and Kim Longbottom

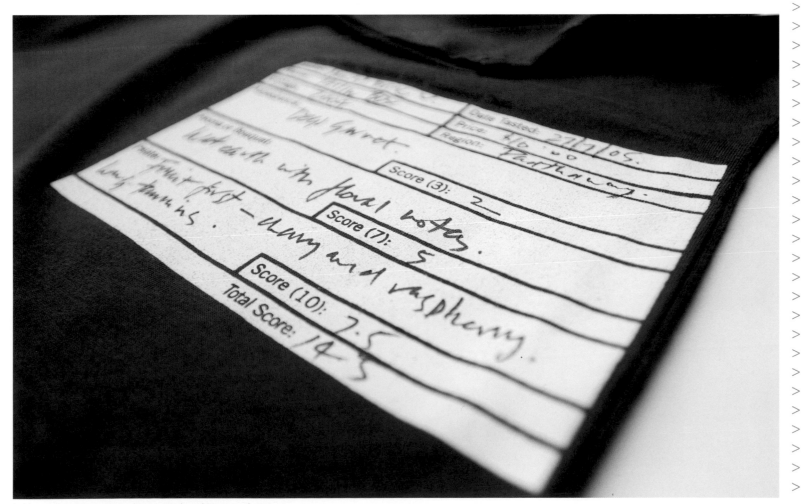

> *Henry's Drive Vignerons* > shirts > Mark and Kim Longbottom

> Logo and card > Umbo

The Southpaw Vineyard is a special patch of dirt in McLaren Vale, growing only Shiraz grapes. Our wine-making philosophy is simple—let the vineyard speak for itself. This approach

> *Southpaw Vineyard* > packaging > Henry Rymill

Perndl+Co

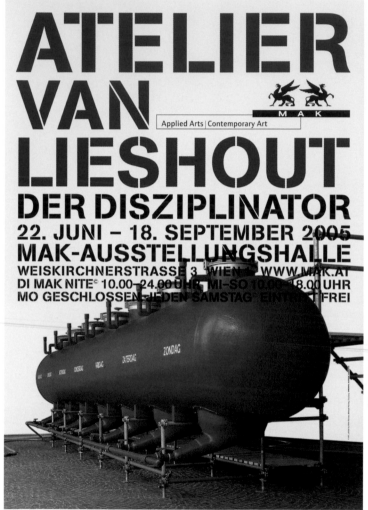

> Atelier van Lieshout > poster > MAK

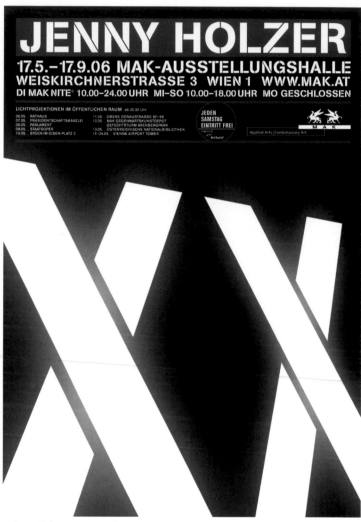

> Jenny Holzer > poster > MAK

Nelkengasse 4/4
1060 Vienna
Austria
+43 1 581 65 45
office@perndl.at
www.perndl.at

> Good graphic design requires an understanding of the people and motivations that exist behind every project. The Perndl studio adapts this work ethic and applies it to a variety of specialties: fine arts, film, architecture, design, music and theater. Perndl is comprised of Josef Perndl (1965) and Gerhard Bauer (1964)—both of whom studied at the University of Applied Arts in Vienna—and by Regula Widmer (1965), who studied at the School of Art and Design in Zurich. The majority of their clients are institutions or businesses in the cultural sector. They believe that enjoying work is an important motivational factor. The way they experience this pleasure is when they are able to surprise their clients, the public and themselves. For them, conceptual precision, good work and a pleasant and inspirational workspace are factors of maximum importance.

GNADENL
OSFRANZ
WESTMER
CILESS

21. 11. 2001 – 17. 02. 2002
MAK-AUSSTELLUNGSHALLE
WEISKIRCHNERSTRASSE 3 WIEN 1
DI (MAK NITE) 10.00 – 24.00 UHR
MI – SO 10.00 – 18.00 UHR
MO GESCHLOSSEN

Applied Arts | Contemporary Art

MAK

> *West* > poster > MAK

die welt
von charles
und ray eames

eames

MAK-AUSSTELLUNGSHALLE

WEISKIRCHNERSTRASSE 3, WIEN 1

27. JUNI – 30. SEPTEMBER 2001

DI (MAK NITE) 10.00 – 24.00 UHR

MI – SO 10.00 – 18.00 UHR

MO GESCHLOSSEN

Eine Ausstellung der Library of Congress, Washington, USA, in Zusammenarbeit mit dem Vitra Design Museum, Weil am Rhein, Deutschland.
Die europäische Tournee wird vom Vitra Design Museum organisiert. Die Ausstellung wurde durch die großzügige Unterstützung von
International Business Cooperation (IBM), Hermann Miller Inc. und Vitra ermöglicht. Weitere Unterstützung kam von CCI, Inc.

M A K

Applied Arts | Contemporary Art

MAK, Stubenring 5, Wien 1
Tel. (+43-1) 711 36-0
Fax (+43-1) 713 10 26
E-Mail: office@MAK.at
www.MAK.at

> *Jannis Kounellis* > poster > MAK

Vorträge nonstop im RadioKulturhaus in Wien. Samstag, 4. März 2006. Von 13.00 bis 22.00 Uhr.

Architektur Festival

Turn on

Martin Feiersinger
HOLZ BOX TIROL
Helmut Richter
Elsa Prochazka
Architekten Krischanitz & Frank
Ernst Linsberger
PPAG Popelka Poduschka
Angonese, Boday, Köberl
INNOCAD
Caramel
Dietrich | Untertrifaller
Hermann Czech
Jean Nouvel
Beneder / Fischer
Klaus Stattmann

„Turn On Partner"
Freitag, 3. März 2006
15.30 – 18.00 Uhr

Moderation: Michael Kerbler,
Barbara Rett, Margit Ulama
www.nextroom.at/turn-on/
Konzeption: Margit Ulama
Veranstalter: Universität
für angewandte Kunst Wien
Tel 01 / 711 33 - 2160

RadioKulturhaus, 1040 Wien
Argentinierstraße 30a
Eintritt frei

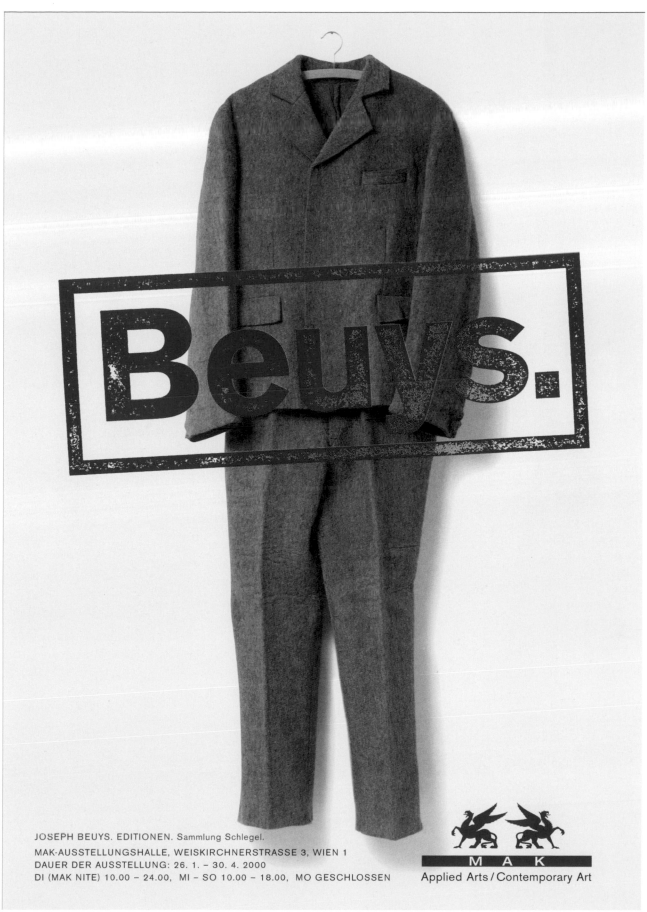

JOSEPH BEUYS. EDITIONEN. Sammlung Schlegel.

MAK-AUSSTELLUNGSHALLE, WEISKIRCHNERSTRASSE 3, WIEN 1
DAUER DER AUSSTELLUNG: 26. 1. – 30. 4. 2000
DI (MAK NITE) 10.00 – 24.00, MI – SO 10.00 – 18.00, MO GESCHLOSSEN

MAK
Applied Arts / Contemporary Art

> *Beuys* > poster > MAK

R2

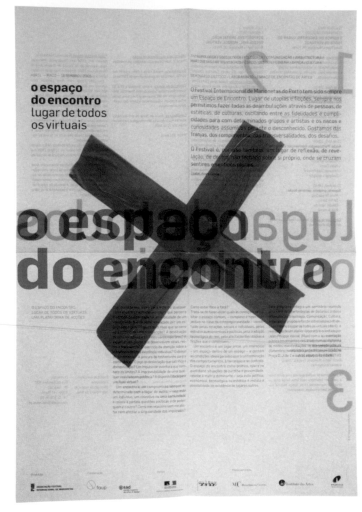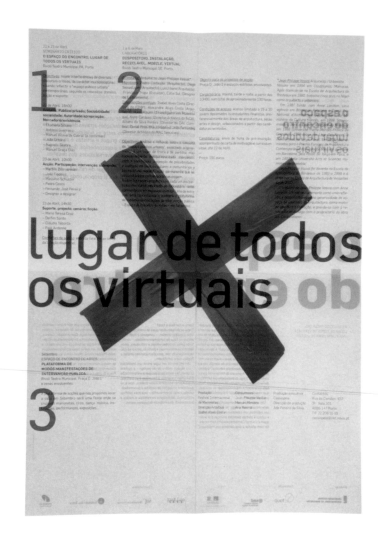

> *O espaço do encontro, lugar de todos os virtuais* > poster > FIM/Cassiopeia

Rua de Meinedo, 112
4100-337 Porto
Portugal
+351 22 938 68 65
info@r2design.pt
www.r2design.pt

> Lizá Defossez Ramalho and Artur Rebelo started the design studio R2 in Porto while they studied at the Faculty of Fine Arts at the University of Porto. Both hold a DEA in design research from the Barcelona Fine Art University. R2 works for a wide variety of cultural organizations, contemporary artists and architects, including the Serralves Museum of Contemporary Art in Porto, the Chiado Museum in Lisbon, the House of Music, the Berardo Museum, the School of Architecture and the Calouste Gulbenkian Foundation. His work covers corporate identity and poster, book and exhibition design. These have been exhibited internationally and published in various design magazines and books. R2 has received many awards, like: the International Biennial of Graphic Design Brno (2006) and the Certificate of Excellence in Typography from the Type Directors Club of New York (2005, 2006 and 2007).

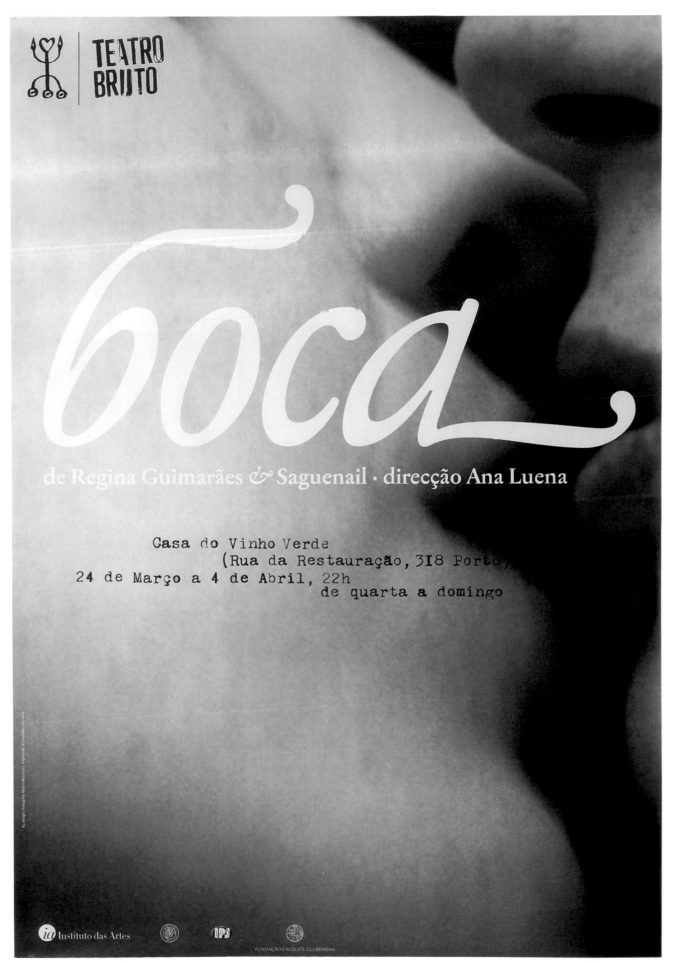

> *Boca* > poster > Bruto Theater

Museu dos Transportes e Comunicações Alfândega, Porto
30 Mar — 21 Maio 2006

Reunião de Obra — Norte → #002 Tema: Habitação Unifamiliar

Atelier:
José Paulo dos Santos
Projectos:

Casa Carlota / Porto
1998 — 2004

Casa Laranjeira / Miramar
1998 — 2004

1.1

1.7 1.8

Como se faz a coordenação
das especialidades?

O que é um mapa
de acabamentos?

Para que serve o
projecto de execução?

Como se cota
um projecto?

planta p1

A que correspondem os custos
de um projecto?

Até onde vai
o trabalho do
arquitecto?

Quais os tempos
de um projecto?

Qual é a vantagem
de ter um arquitecto
até ao final da obra?

REUNIÃO DE OBRA – NORTE / #002

COMISSARIADO: FILIPA GUERREIRO, LUÍS TAVARES PEREIRA E TERESA NOVAIS

PRODUÇÃO: PELOURO DA CULTURA: ANA MAIO E CARLOS FAUSTINO [cultura@oasrn.org / T 22 20 74 250]
+ ASSOCIAÇÃO PARA O MUSEU DOS TRANSPORTES E COMUNICAÇÕES – DRª SUZANA FARO
museu@amtc.pt / 222 074 250

DESIGN GRÁFICO: R2 DESIGN [www.r2els.com] / IMPRESSÃO: V.COUTINHO

MECENAS EXCLUSIVO

PROGRAMA:

Inauguração e Conferência
com a presença da equipa projectista e outros
intervenientes na obra
5ª Feira, 30 de Mar, 21:30h

APOIOS

OSVALDO MATOS, LDA.

HORÁRIO:

Visita Guiada às Obras: 3ª a 6ª
Arq. José Paulo dos Santos 10–12h e 14–18h

•Casa Carlota Sábado e Domingo
Sábado, 01 de Abr, 15h 15–19h
•Casa Laranjeira
Sábado, 15 de Abr, 10h
[Inscrição Obrigatória]

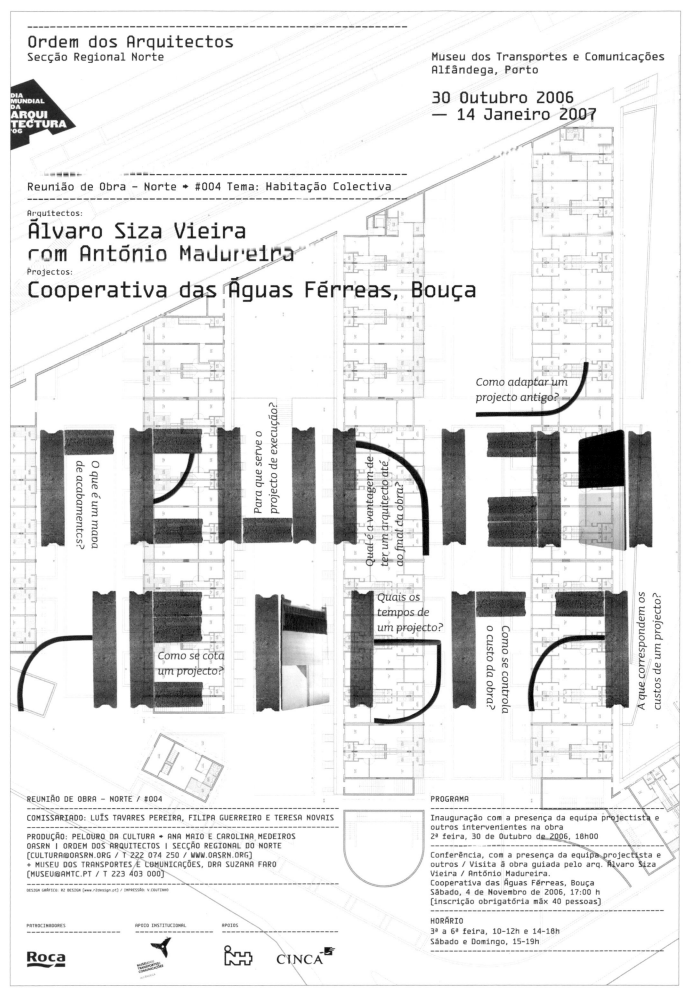

Ordem dos Arquitectos
Secção Regional Norte

Museu dos Transportes e Comunicações
Alfândega, Porto

30 Outubro 2006
— 14 Janeiro 2007

Reunião de Obra - Norte ◆ #004 Tema: Habitação Colectiva

Arquitectos:
Álvaro Siza Vieira
com António Madureira
Projectos:
Cooperativa das Águas Férreas, Bouça

Como adaptar um projecto antigo?

O que é um mapa de acabamentos?

Para que serve o projecto de execução?

Qual é a vantagem de ter um arquitecto até ao final da obra?

Quais os tempos de um projecto?

Como se controla o custo da obra?

A que correspondem os custos de um projecto?

Como se cota um projecto?

REUNIÃO DE OBRA - NORTE / #004

COMISSARIADO: LUÍS TAVARES PEREIRA, FILIPA GUERREIRO E TERESA NOVAIS

PRODUÇÃO: PELOURO DA CULTURA ◆ ANA MAIO E CAROLINA MEDEIROS
OASRN | ORDEM DOS ARQUITECTOS | SECÇÃO REGIONAL DO NORTE
[CULTURA@OASRN.ORG / T 222 074 250 / WWW.OASRN.ORG]
+ MUSEU DOS TRANSPORTES E COMUNICAÇÕES, DRA SUZANA FARO
[MUSEU@AMTC.PT / T 223 403 000]

DESIGN GRÁFICO: R2 DESIGN [www.r2design.pt] / IMPRESSÃO: V.COUTINHO

PATROCINADORES APOIO INSTITUCIONAL APOIOS

Roca CINCA

PROGRAMA

Inauguração com a presença da equipa projectista e
outros intervenientes na obra
2ª feira, 30 de Outubro de 2006, 18h00

Conferência, com a presença da equipa projectista e
outros / Visita à obra guiada pelo arq. Álvaro Siza
Vieira / António Madureira.
Cooperativa das Águas Férreas, Bouça
Sábado, 4 de Novembro de 2006, 17:00 h
[inscrição obrigatória máx 40 pessoas]

HORÁRIO
3ª a 6ª feira, 10-12h e 14-18h
Sábado e Domingo, 15-19h

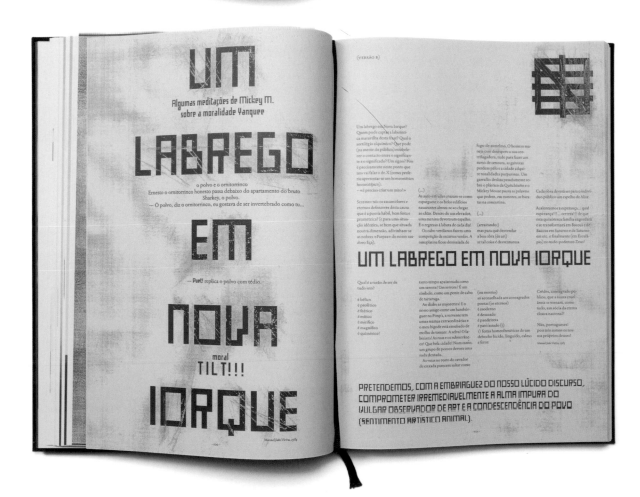

1. Prémio Fernando Távora
Apresentação / 20 Novembro
Salão Nobre da Faculdade de
Ciências, UP / 21:30

2. Obra Pedagógica
Ciclo de conferências e vídeo +
projecção de desenhos e fotografias de
viagens lectivas 1980–1993
Salão Nobre e átrio da Faculdade de
Ciências (Praça dos Leões), 21:30

Ciclo de Conferências
4ª feiras · 21:30

23 Nov: "A Viagem"
Alexandre Alves Costa,
Joaquim Vieira

30 Nov: "Viajar / Coleccionar"
Eduardo Souto Moura

**07 Dez: "Fernando Távora – Eu sou a
Arquitectura Portuguesa"**
Manuel Mendes

Ciclo de Vídeo
Reposição das "Aulas de Teoria Geral da
Organização do Espaço, Fernando Távora,
FAUP, 92/93" introduzidas por
arquitectos e historiadores que
com ele partilharam a docência
Domingos · 21:30

20 Nov: "A Aula"
Álvaro Siza Vieira

27 Nov
António Lousa

04 Dez
Manuel Graça Dias

11 Dez
Rui Lobo

15 Jan
Nuno Tasso de Sousa

08 Jan
João Mendes Ribeiro

22 Jan
Rui Tavares

29 Jan
Carlos Machado

05 Fev
Paulo Varela Gomes
(a confirmar)

3. Reunião de Obra - Exposição
Palácio do Freixo, Porto (1996–03)
Local Museus dos Transportes,
Alfândega do Porto /15 Dezembro

4. Obra Aberta
Visitas guiadas a obras de arquitectura
de Fernando Távora,
5 de Fev — 6 Maio (Sábados)

Mercado Municipal de Santa
Maria da Feira /11 Fevereiro

Casa da Covilhã, Guimarães
25 de Fevereiro

Casa de Férias no Pinhal de Ofir
11 de Março

Pousada de Stª Marinha,
Guimarães / 25 de Março

Centro Histórico de Guimarães
8 de Abril

Quinta da Conceição e Quinta de
Santiago, Leça da Palmeira
6 de Maio

Casa dos 24, Porto / 22 de Abril

5. A Festa
I Love Távora
Quinta da Conceição,
Leça da Palmeira
06 de Maio, 22 horas

**✱ { Entrada livre
em todos os eventos!**

Comissariado:
Luís Tavares Pereira
Teresa Novais
Filipa Guerreiro

Beatriz Madureira (Ciclo de vídeo)
José Gigante (Festa)

Produção:
Ana Maio
Carlos Alberto Faustino

**Comemorações do
dia Mundial da Arquitectura**

**Ordem dos Arquitectos
Secção Regional do Norte**
OASRN

**I love
Távora**

**20 Nov — 06 Maio
2005/06**

OASRN
Secção Regional Norte da Ordem
dos Arquitectos
www.oasrn.org

Rua de D. Hugo, 5–7
4050-305 Porto – Portugal
F 222 074 250 · F 222 074 259
cultura@oasrn.org

Apoio institucional:
 faup PORTO
Patrocinadores:
 TUPAI
Apoio:
Miele weber

em torno do espaço público

seminário no âmbito do projecto em torno quadros de dança 2006 /

Biblioteca Municipal Almeida Garrett / Porto

22 Abril

Organização
nEC

Neo financiado por:
MC Ministério da Cultura

Instituto das Artes

Silvia Bächli
Studio

MUSEU**SERRALVES**
MUSEU DE ARTE CONTEMPORÂNEA

> *Silvia Bächli* > poster > Serralves Museum

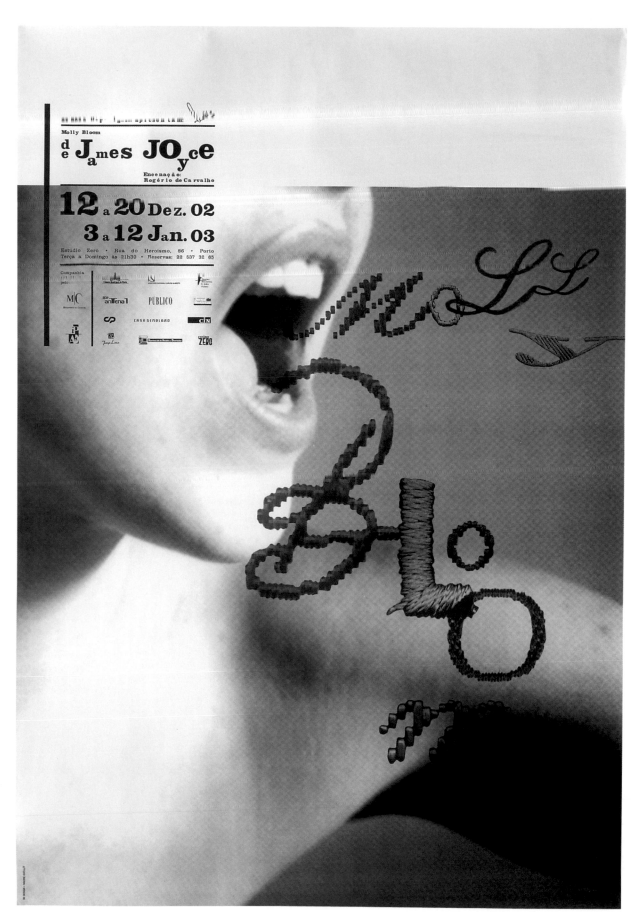

> *Molly Bloom* > poster > Bruto Theater

Reza Abedini Studio

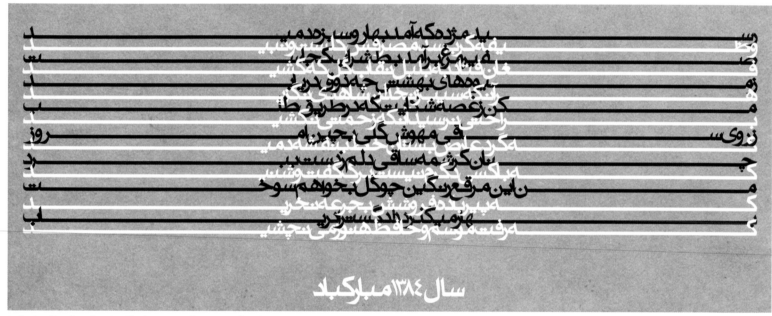

> *Persian New Year Greeting Card* > postcard > personal project

No.19, 3rd St., Arabali Street
Khorramshahr Street
Tehran 15338 64868
Iran
+98 21 88 51 37 88
info@rezaabedini.com
www.rezaabedini.com

> Born in 1967 in Tehran, Reza Abedini is a cele-brated Iranian designer and professor of graphic design and visual culture at Tehran University. Abedini is one of Iran's most famous graphic de-signers thanks to his modern version of Persian typography, which demonstrates a unique style thanks to the combination of traditional and mod-ern elements. He has received many national and international design awards, among them: the Principal Prince Claus Award (2006) in recognition of the personal creativity he employs in producing special graphic designs and the personal way he applies and redefines the knowledge and achieve-ments of Iran's artistic patrimony. The award is also based on the diversities of Iranian history and modern culture while recognizing graphic design's impact as an internationally influential method of communication. Abedini is a member of the Inter-national Graphic Alliance since 2001.

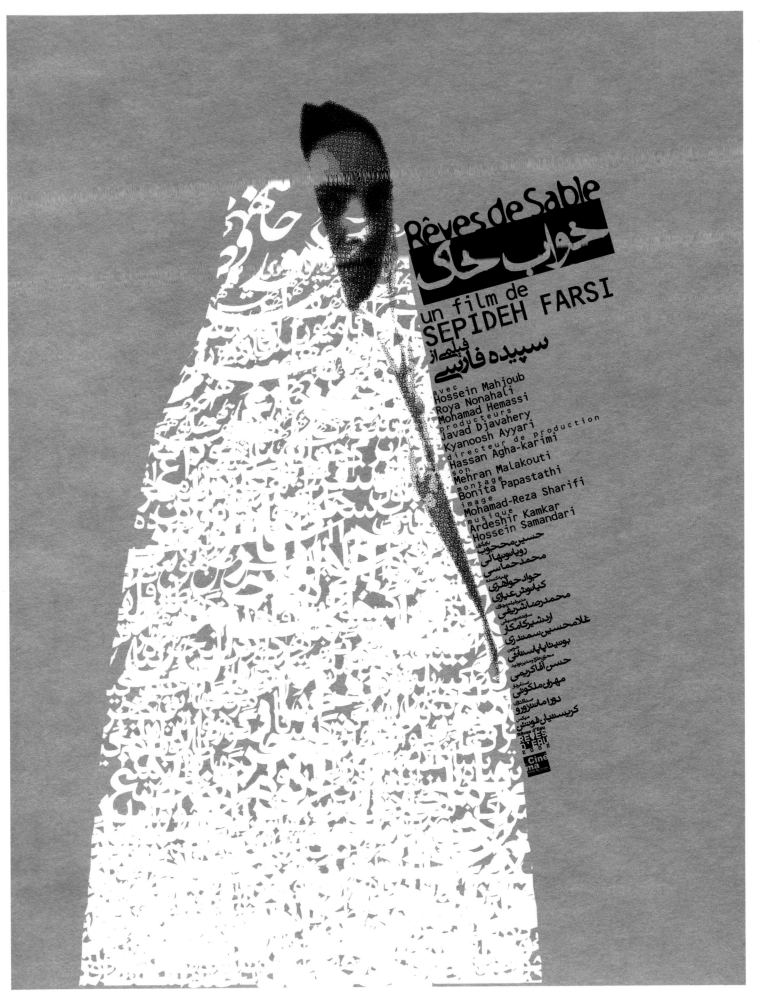

Rêves de Sable

un film de
SEPIDEH FARSI

avec
Hossein Mahjoub
Roya Nonahali
Mohamad Hemassi
producteurs
Javad Djavahery
Kyanoosh Ayyari
directeur de production
Hassan Agha-karimi
son
Mehran Malakouti
montage
Bonita Papastathi
image
Mohamad-Reza Sharifi
musique
Ardeshir Kamkar
Hossein Samandari

> Logo > *Tandis* magazine

> Logo > Tiva Tahrir

> Logo > *Khat* magazine

> Logo > Laleh Art Gallery

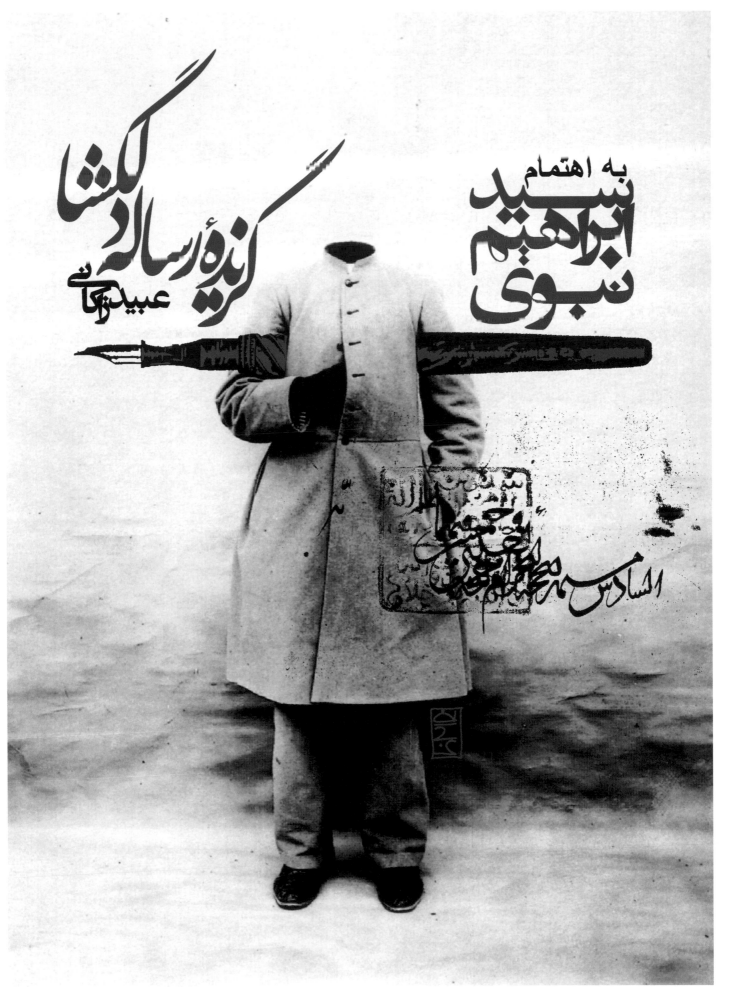

به اهتمام
سید
ابراهیم
نبوی

گزیدهٔ رساله‌گشا
عبیدزاکانی

> *S.E. Nabavi* > cover > Rowzaneh Publications

467 <

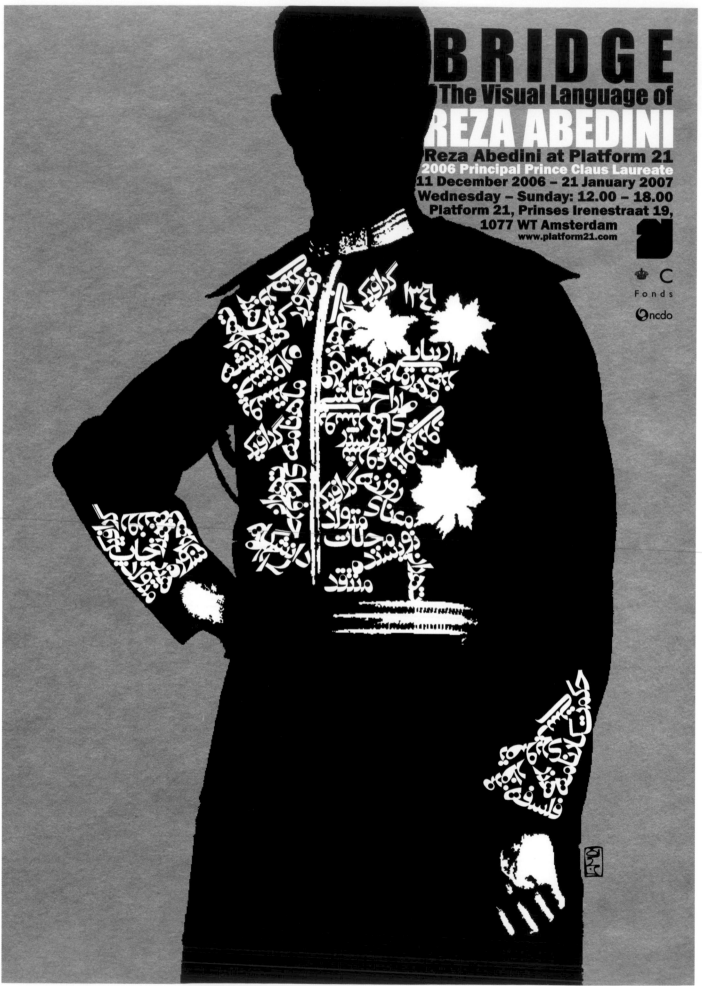

> *Bridge: The Visual Language of Reza Abedini* > poster > Platform 21

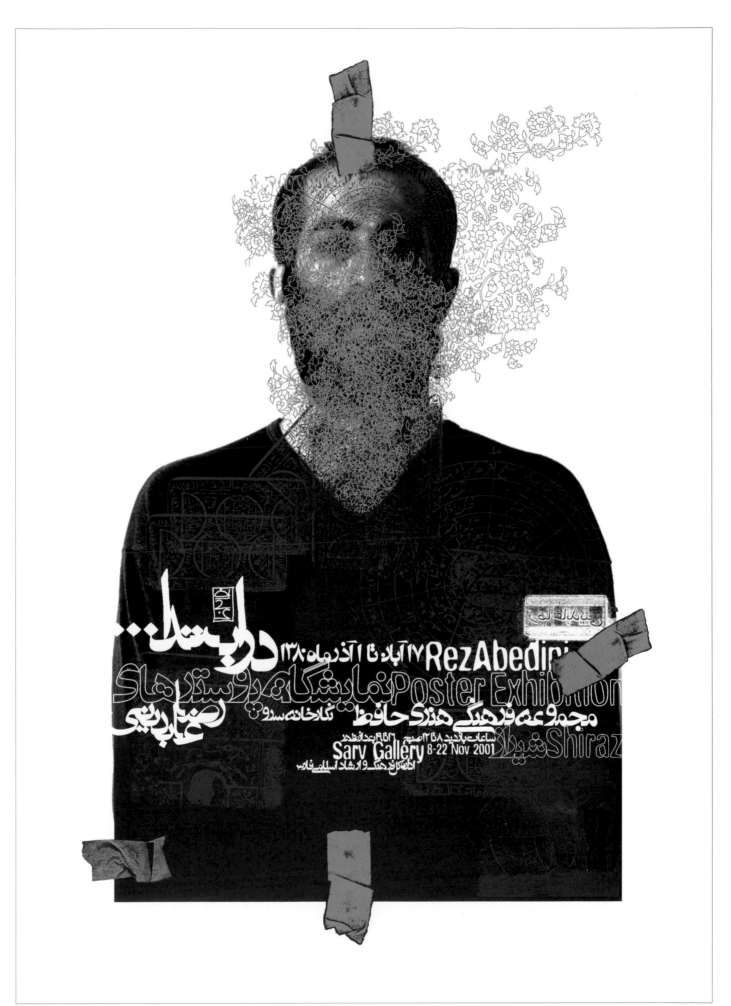

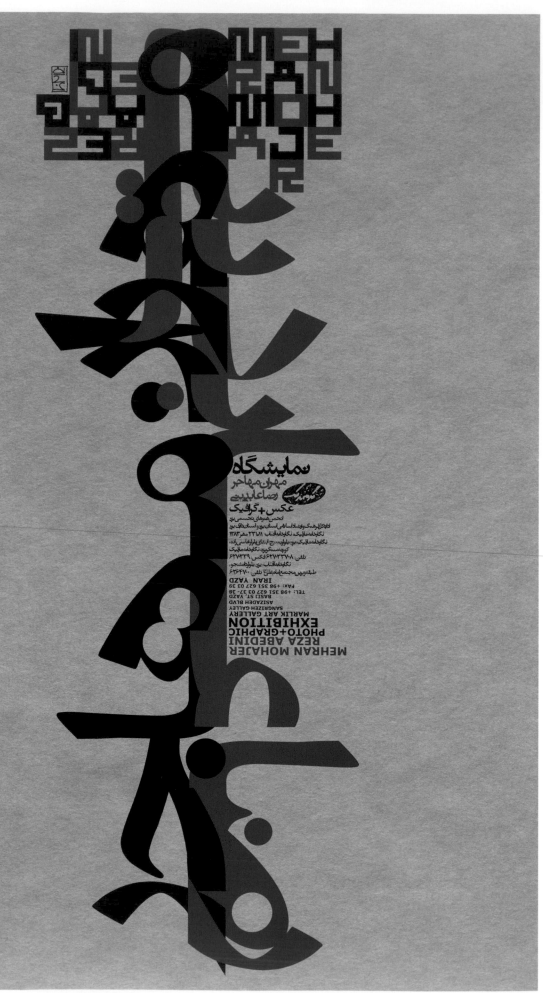

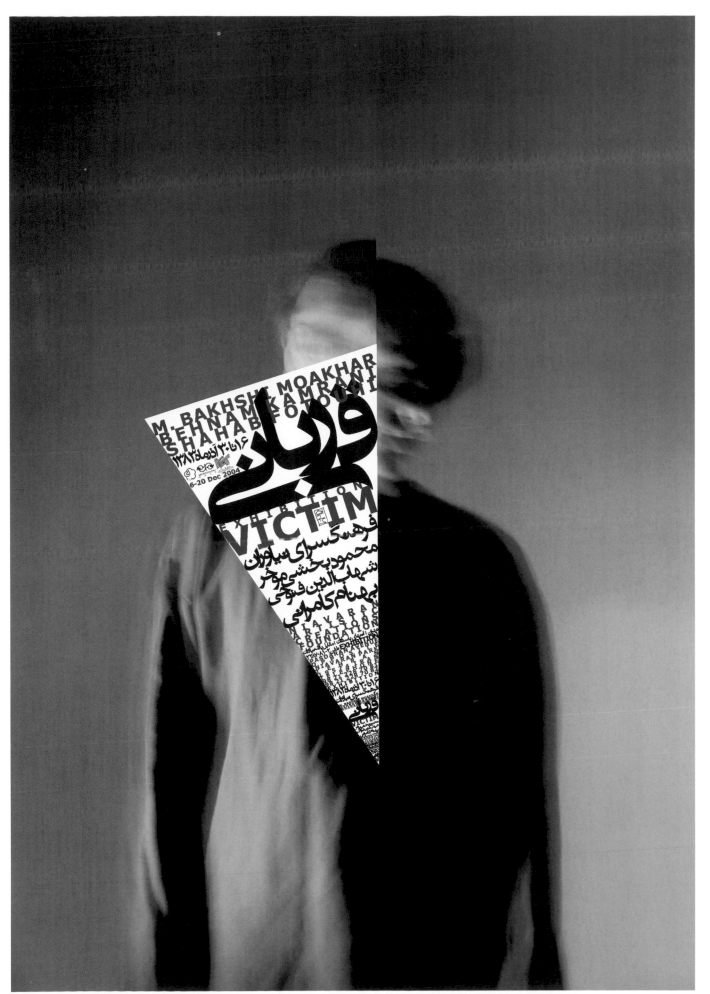

> *Victim* > poster > Niavaran Artistic Creations Foundation

Richard B. Doubleday

> *Posters* > poster > Ibero-American University

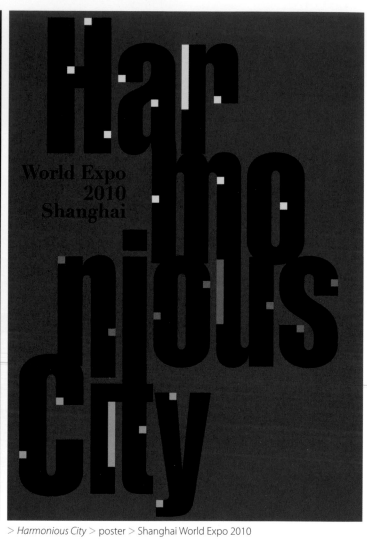

> *Harmonious City* > poster > Shanghai World Expo 2010

42 Rockview Street
Unit 6
Boston MA 02130-2116
United States
+1 617 817 3710
richard@richarddoubleday.com
www.richarddoubleday.com

> Based on the synthesis between content and form and the interrelations between them, the work of Richard B. Doubleday consists of knowledge of visual sensitivity, personal vision and typographic principles to attack each new problem by providing an appropriate solution. Richard B. Doubleday is a graphic designer, author and an assistant professor of Art in the Graphic Design Department of the Boston University of Fine Arts. He has been awarded various prizes, such as the Marion and Jasper Whiting Foundation Fellowship and a visiting fellowship from the Chelsea College of Art and Design, University of the Arts London. Recently, he exhibited at the 7th International Poster Triennial in Toyama (Japan), the Galería Artis at the Metropolitan Autonomous University (Mexico) and the Suzhou Art and Design Technology Institute (China). Richard was invited to become part of the jury at the annual design contest held by the Art Directors Club of Tokyo in 2008.

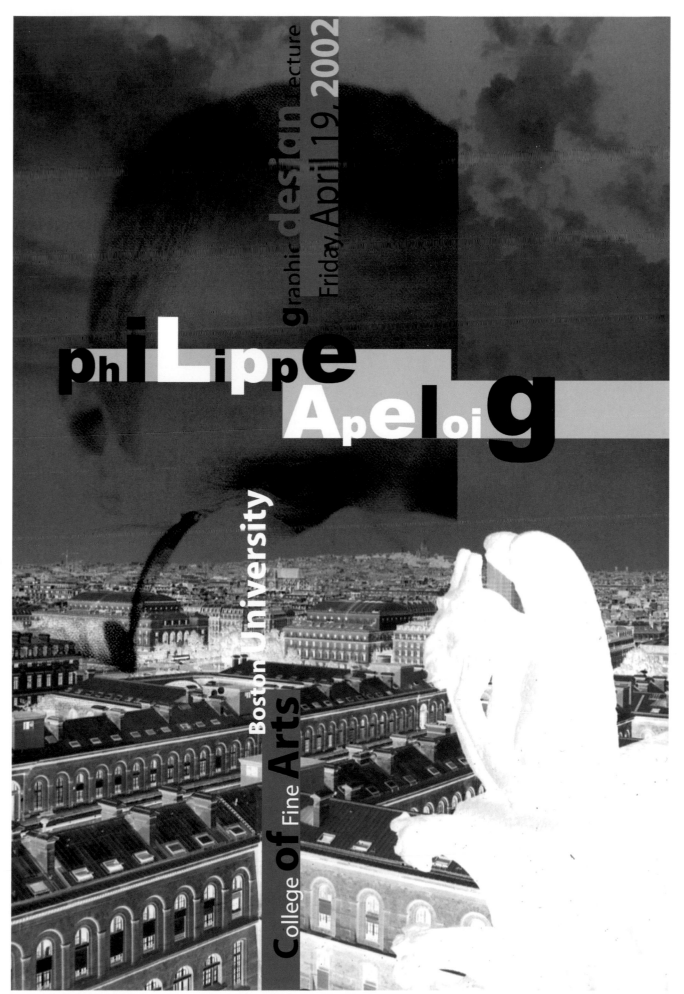

> *Philippe Apeloig Lecture Poster* > poster > Jan Koniarek Gallery

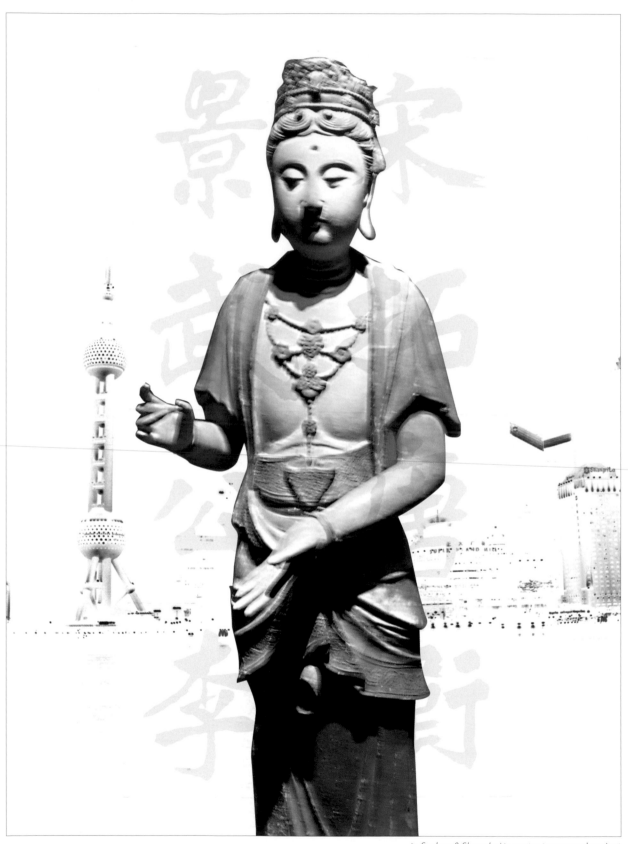

> *Suzhou & Shanghai* > poster > personal project

> *Sport, Sunshine, Health* > poster > Taiwan International Design Poster Award

international poster exhibition

chinese character

空氣郵件

> *The Chinese Character International Poster Exhibition* > poster > National Kaohsiung Normal University

> *The Chinese Character International Poster Exhibition* > poster > National Kaohsiung Normal University

GRAPHISME DANS LA RUE

16e

FONTENAY-SOUS-BOIS

> *16ᵉ Graphisme dans la rue-Fontenay-sous-Bois* > poster > International Poster and Graphic Design Festival of Chaumont

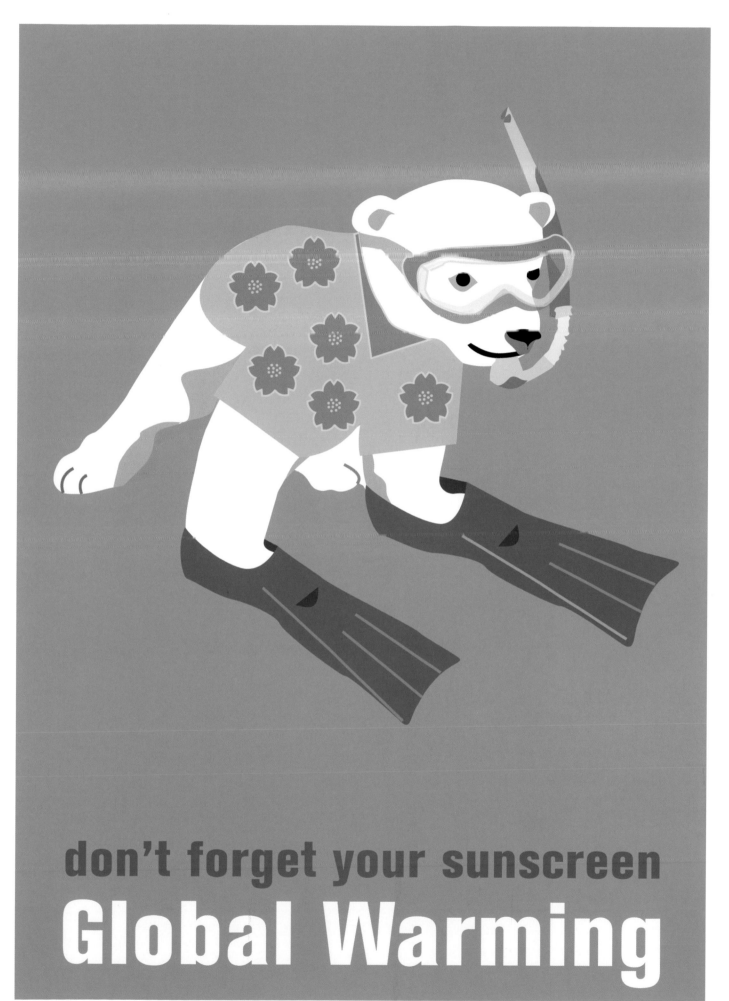

> *Global Warming: Don't Forget Your Sunscreen* > poster > Good 50 x 70

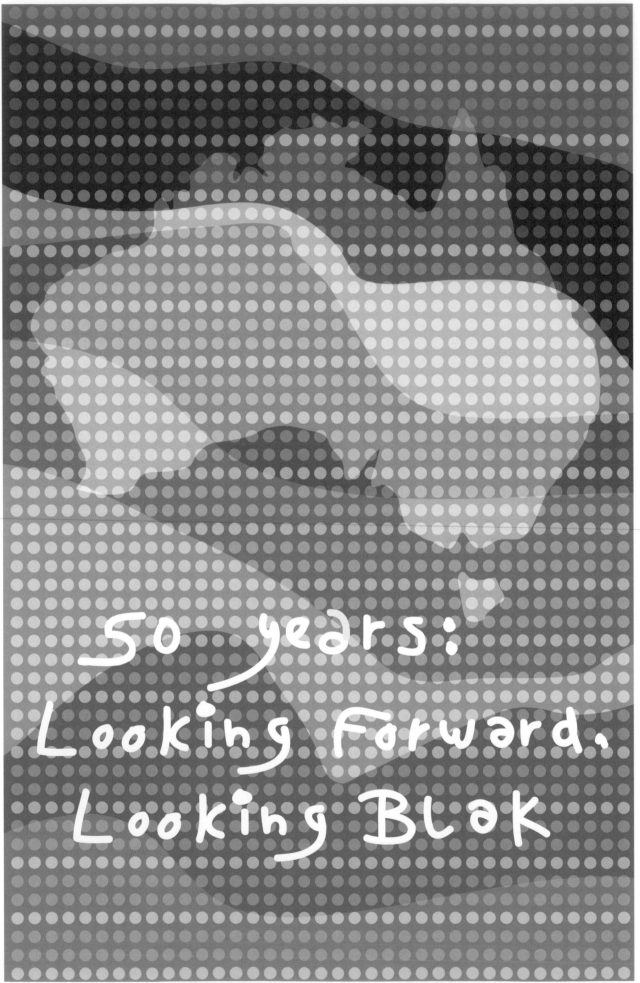

50 years:
Looking Forward,
Looking Blak

> *Celebrating 50 years of NAIDOC: Looking Forward, Looking Blak* > poster > NAIDOC Poster Competition

BASS FESTIVAL
THE MIDLANDS
JUNE 2008
www.bassfestival.co.uk

BBOYING
DJING
MCING
GRAFFITI
THE FOUR ELEMENTS OF HIP HOP

Rico Lins

> *Entre nós* > book > Língua Geral

Rua Campevas
617 Perdizes
05016-010 São Paulo
Brazil
+55 11 3675 3507
studio@ricolins.com
www.ricolins.com

> A designer and art director, Rico Lins has been working for the last 25 years in Paris, London, New York, Rio and São Pablo. He is considered one of Brazil's most influential graphic designers. His training includes a graduate masters degree from the Royal Academy of Art in London. Some of his projects have been made for CBS Records, Time Warner, *The New York Times*, *Newsweek*, *Libération*, MTV Networks, The New York Public Theater, Centre Pompidou, Goethe Institute, TV Globo, Editorial Abril, Soomp, and Natura. His work has been published internationally in the most popular specialized books and magazines. He has received, amongst other awards, gold medals from the Art Directors Club of New York and the Society of Publication Designers, along with the Editorial Abril Award. Former professor of the School of Visual Arts in New York, he now coordinates the graphic design masters program at the European Institute of Design in São Paulo and is a member of the International Graphic Alliance.

> *Brasil em cartaz* > poster > Brazilian poster exhibition in Chaumont

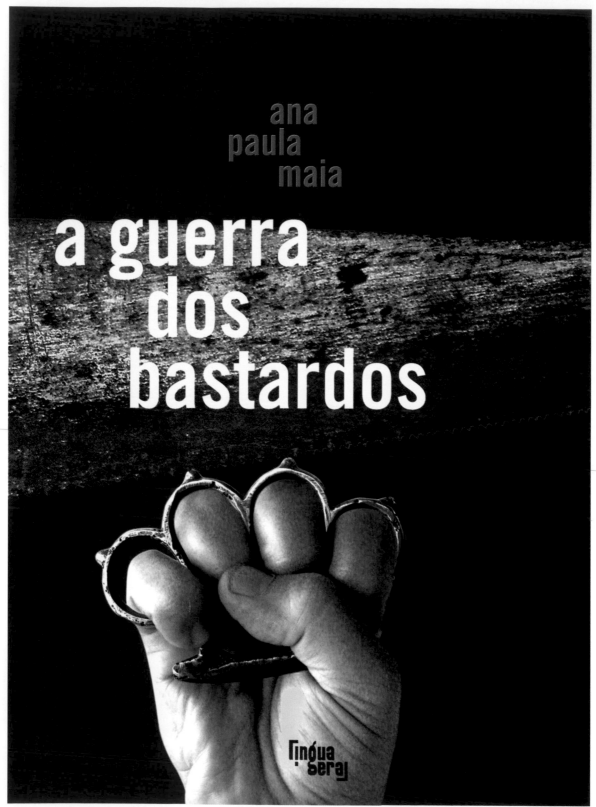

ana
paula
maia

a guerra
dos
bastardos

> *A guerra dos bastardos* > poster > Língua Geral

> *Brasil em cartaz* > poster > Brazilian poster exhibition in Chaumont

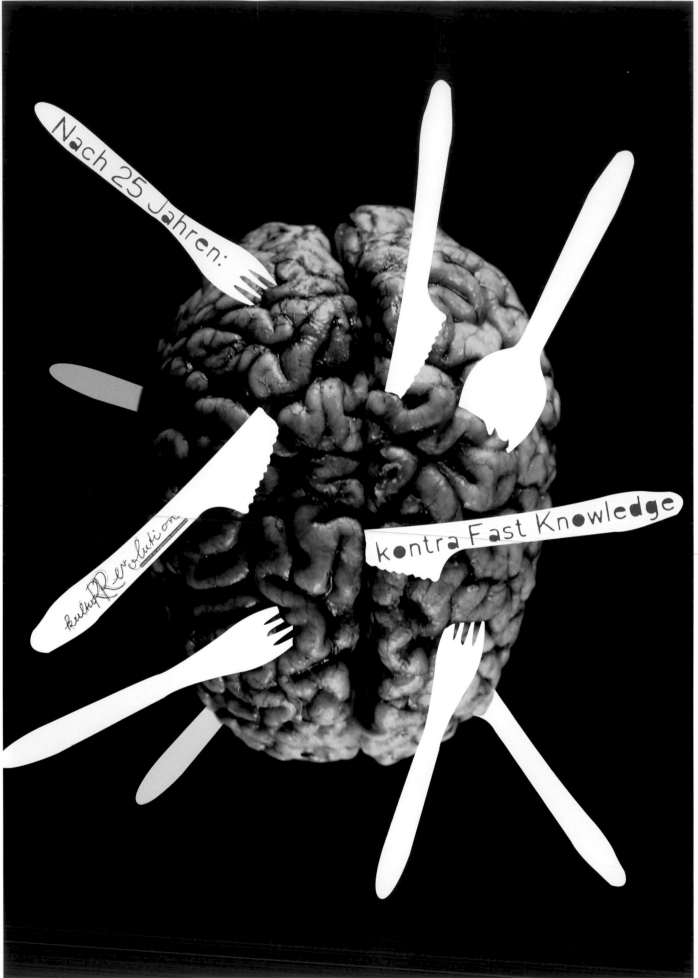

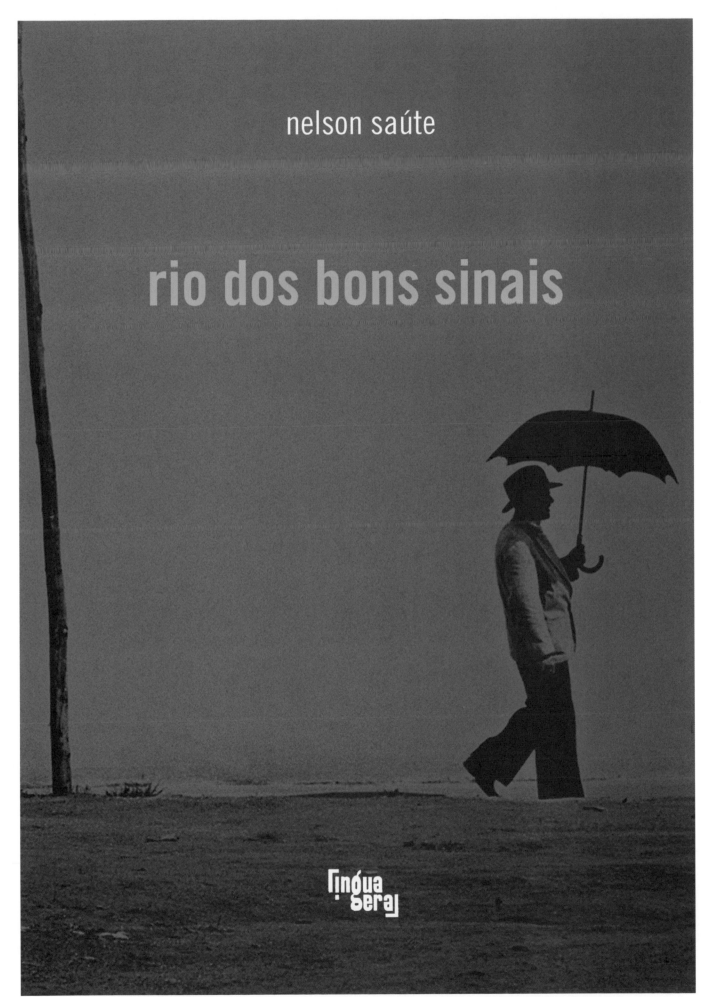

nelson saúte

rio dos bons sinais

língua geral

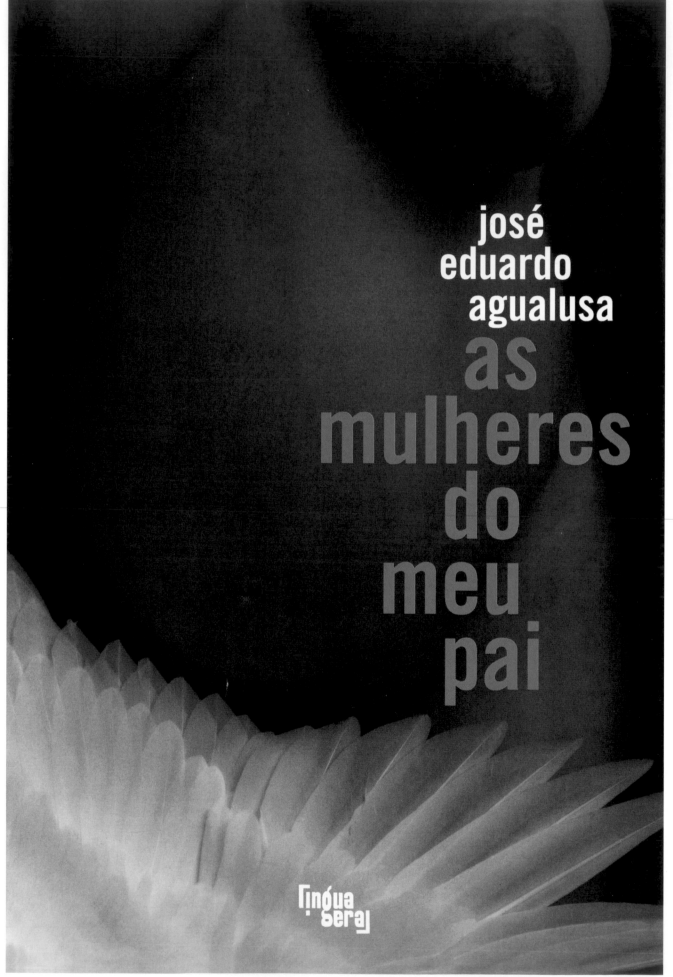

josé
eduardo
agualusa

as
mulheres
do
meu
pai

língua geral

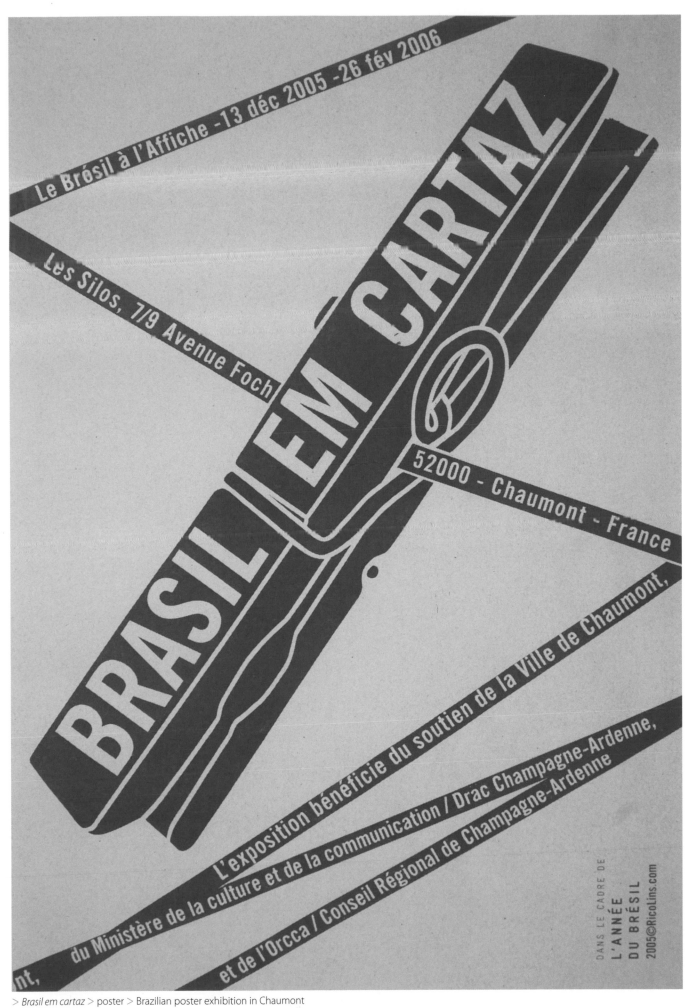

The poster shows:

Le Brésil à l'Affiche -13 déc 2005 -26 fév 2006

Les Silos, 7/9 Avenue Foch

BRASIL EM CARTAZ

52000 - Chaumont - France

L'exposition bénéficie du soutien de la Ville de Chaumont,
du Ministère de la culture et de la communication / Drac Champagne-Ardenne,
et de l'Orcca / Conseil Régional de Champagne-Ardenne

nt,

DANS LE CADRE DE
L'ANNÉE
DU BRÉSIL
2005©RicoLins.com

> *Brasil em cartaz* > poster > Brazilian poster exhibition in Chaumont

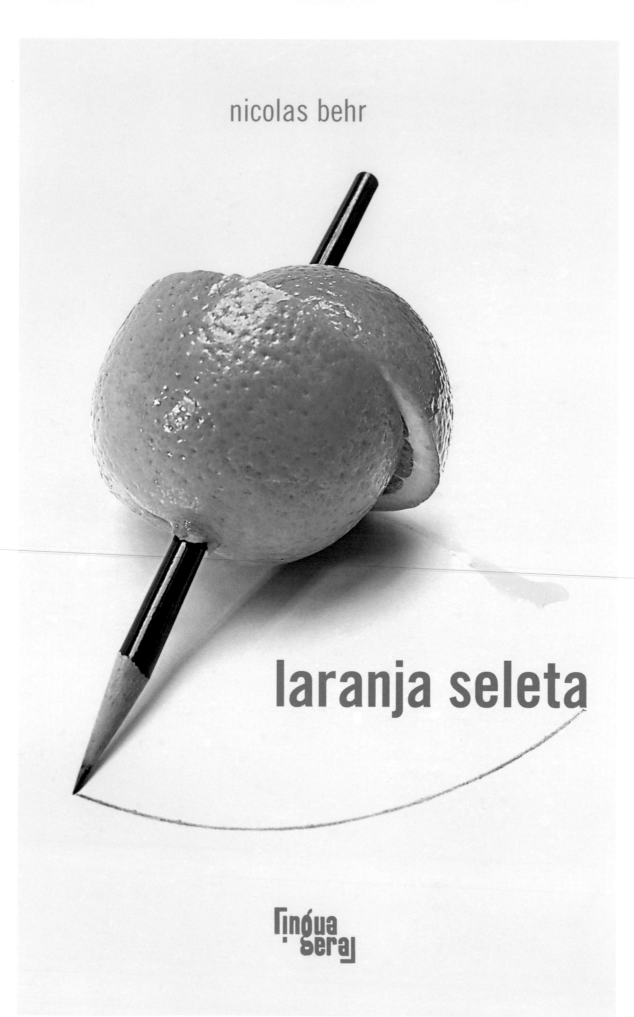

nicolas behr

laranja seleta

língua geral

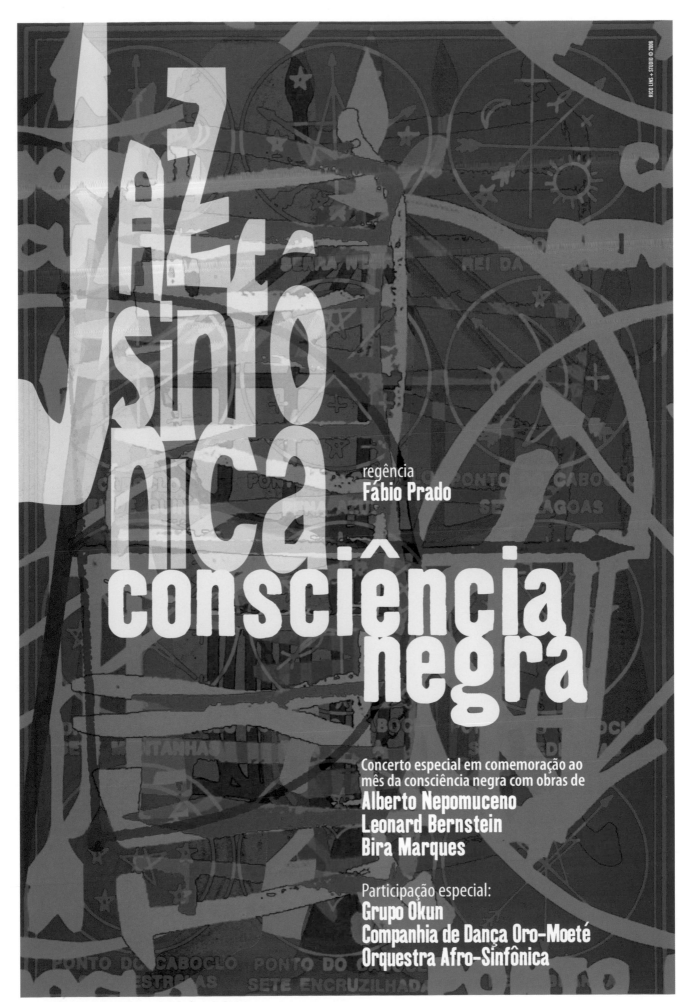

regência
Fábio Prado

consciência
negra

Concerto especial em comemoração ao
mês da consciência negra com obras de
Alberto Nepomuceno
Leonard Bernstein
Bira Marques

Participação especial:
Grupo Okun
Companhia de Dança Oro-Moeté
Orquestra Afro-Sinfônica

Rudi Meyer

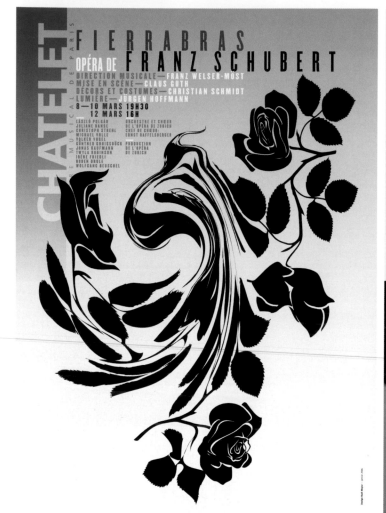

> *Fierrabras* > poster > Théâtre du Châtelet

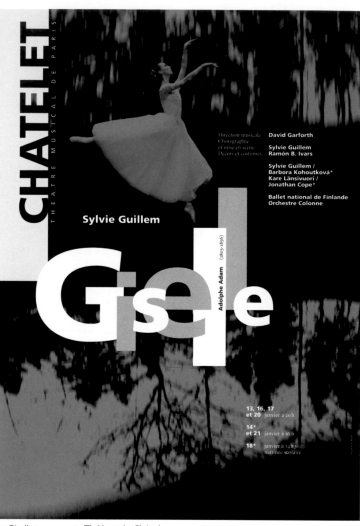

> *Giselle* > poster > Théâtre du Châtelet

27, rue des Rossignols
91330 Yerres
France
+33 1 69 49 31 93
design@rudi-meyer.com
www.rudi-meyer.com
Portrait: Louise Holloway

> Having taken classes under Armin Hofmann and Emil Ruder at the Basel School of Design, Rudi Meyer moves to Paris in 1964. There he starts work as a graphic designer of products and interiors, as photographer, cartographer and freelance typologist. He has designed logotypes and corporate identity programs for Waterman and Banque Nationale of Paris, and posters for Esso, the Festival du Marais in Paris, Kieler Woche… At present, he works on books, catalogs and annual reports for international companies like Michelin, Polaroid and Renault. Meyer has designed around a hundred posters for the Théâtre du Châtelet in Paris, and has worked for such cultural exhibitions and museums as the MNHAA in Luxembourg. He has worked as a cartographer for the SNCF and the Regional Train Network of Paris. As a professor, he has inspired an entire generation of graphic designers by stressing the importance of the basic principles of design and typographic research.

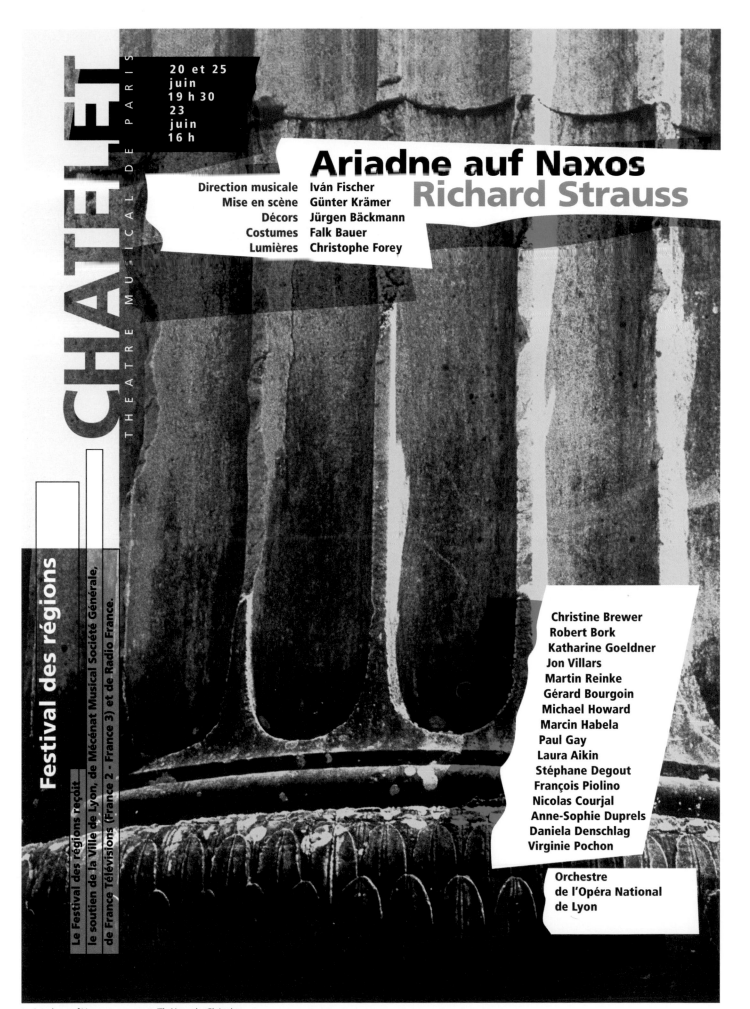

20 et 25 juin 19 h 30 23 juin 16 h

CHÂTELET

THÉÂTRE MUSICAL DE PARIS

Ariadne auf Naxos
Richard Strauss

Direction musicale	Iván Fischer
Mise en scène	Günter Krämer
Décors	Jürgen Bäckmann
Costumes	Falk Bauer
Lumières	Christophe Forey

Festival des régions

Le Festival des régions reçoit
le soutien de la Ville de Lyon, de Mécénat Musical Société Générale,
de France Télévisions (France 2 - France 3) et de Radio France.

Christine Brewer
Robert Bork
Katharine Goeldner
Jon Villars
Martin Reinke
Gérard Bourgoin
Michael Howard
Marcin Habela
Paul Gay
Laura Aikin
Stéphane Degout
François Piolino
Nicolas Courjal
Anne-Sophie Duprels
Daniela Denschlag
Virginie Pochon

Orchestre
de l'Opéra National
de Lyon

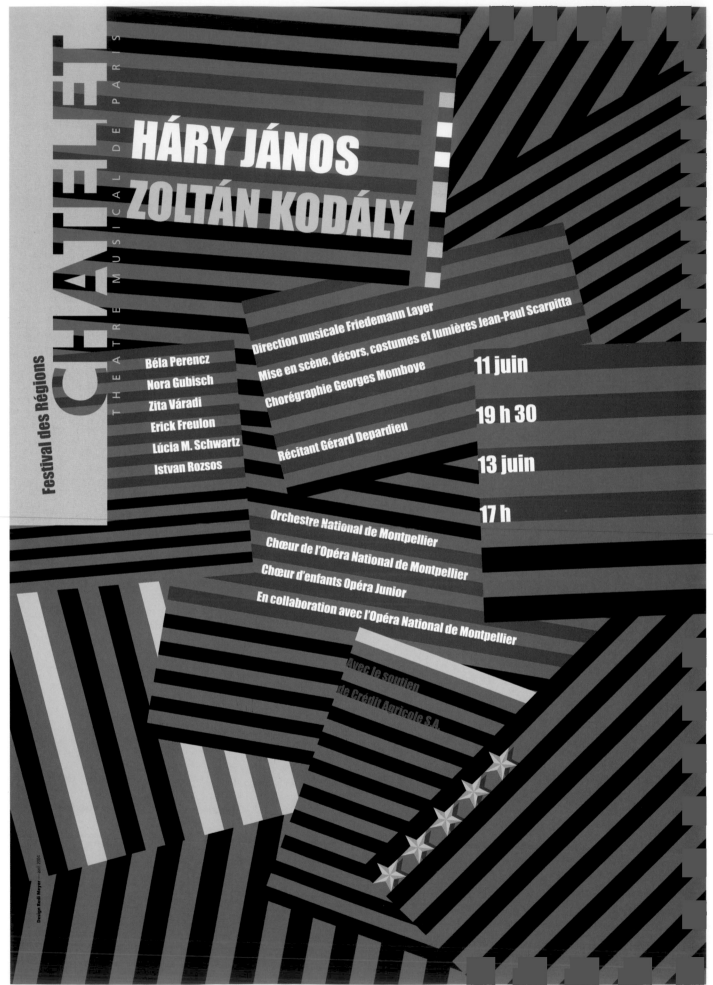

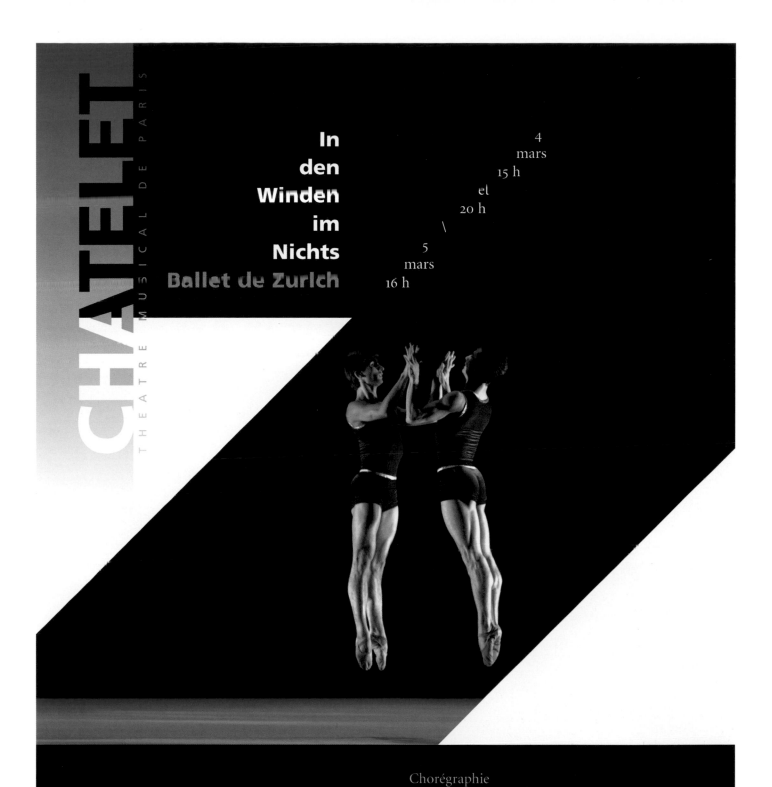

CHÂTELET
THÉÂTRE MUSICAL DE PARIS

**In
den
Winden
im
Nichts**
Ballet de Zurich

4
mars
15 h
et
20 h
\
5
mars
16 h

Chorégraphie
et
costumes
Heinz Spoerli
Musique
de
Johann Sebastian Bach

23
26
29
novembre
19 h 30

28
novembre
16 h

Angels in America

Barbara Hendricks
Julia Migenes
Roberta Alexander
Omar Ebrahim
Derek Lee Ragin
Donald Maxwell
Topi Lehtipuu
Daniel Belcher
**Orchestre composé
de musiciens solistes**

Opéra
de **Peter Eötvös** (né en 1944)
d'après la pièce originale
de **Tony Kushner**
Livret de **Mari Mezei**
Création mondiale
**Commande et production
du Théâtre du Châtelet**
Direction musicale Peter Eötvös
Mise en scène Philippe Calvario
Décors Richard Peduzzi
Costumes Jon Morrell
Avec le soutien de Pierre Bergé

Design Scott Meyer — septembre 2004

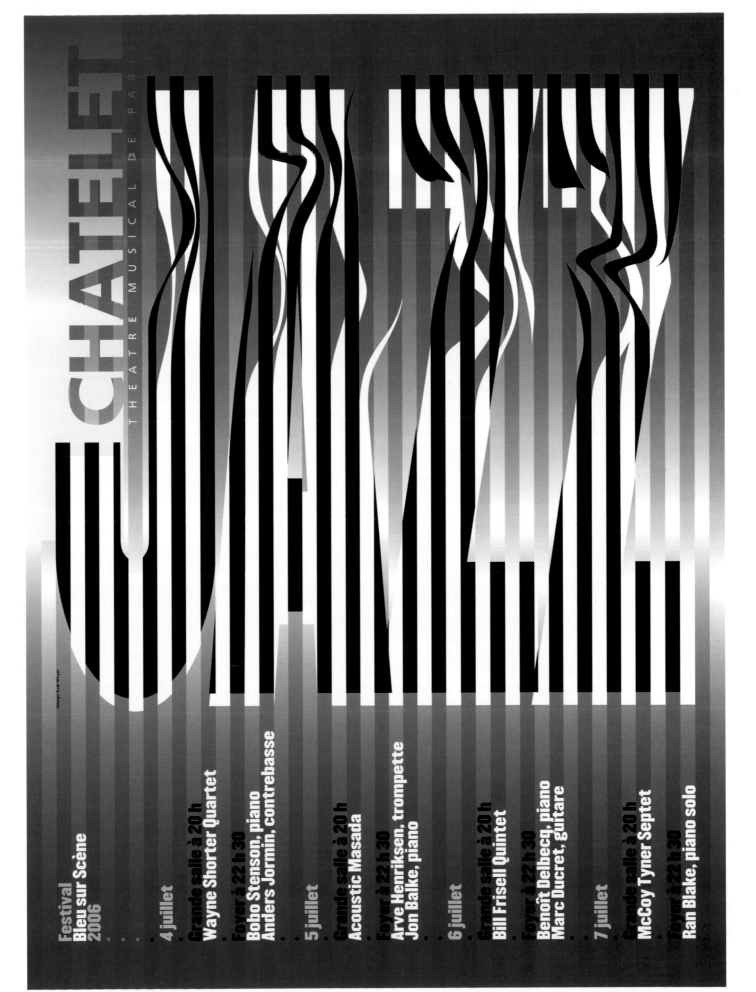

Kieler Woche 1987
20.–
28. Juni

design Rudi Meyer, Paris

LVMH
MOËT HENNESSY · LOUIS VUITTON

1000 places pour les jeunes

Saison 2008 à la Salle Pleyel

LVMH invite 1000 jeunes
amateurs de musique fréquentant
les conservatoires de la Ville de Paris
à assister aux concerts les plus prestigieux
de la saison musicale parisienne

Vendredi 25 janvier
Hommage à Herbert von Karajan
Orchestre Philharmonique de Berlin
Seji Ozawa, direction
Anne-Sophie Mutter, violon

Mercredi 30 janvier
Orchestre de Paris
Christoph Eschenbach, direction
Daniel Barenboïm, piano

Jeudi 7 février
Orchestre de Paris
Neeme Järvi, direction
Vadim Repin, violon

Lundi 17 mars
Récital Martha Argerich, piano

Mardi 18 mars
Ensemble contemporain
Pierre Boulez, direction
Mitsuko Uchida, piano

Mercredi 19 mars
Concert
Autour de Martha Argerich
et de ses invités

Jeudi 10 avril
Orchestre Symphonique de Cincinnati
Paavo Järvi, direction
Nickolaï Luganski, piano

Jeudi 17 avril
Orchestre de Paris
Jiri Belohalvek, direction
Nelson Freire, piano

Vendredi 18 avril
Orchestre National de Russie
Mikhail Pletnev, direction
Gidon Kremer, violon

Samedi 24 mai
Orchestre du Concertgebouw d'Amsterdam
Mariss Jansons, direction

Samedi 7 juin
Orchestre du Gewandhaus de Leipzig
Riccardo Chailly, direction
Leonidas Kavakos, violon

Jeudi 19 juin
London Symphony Orchestra
Bernard Haitink, direction

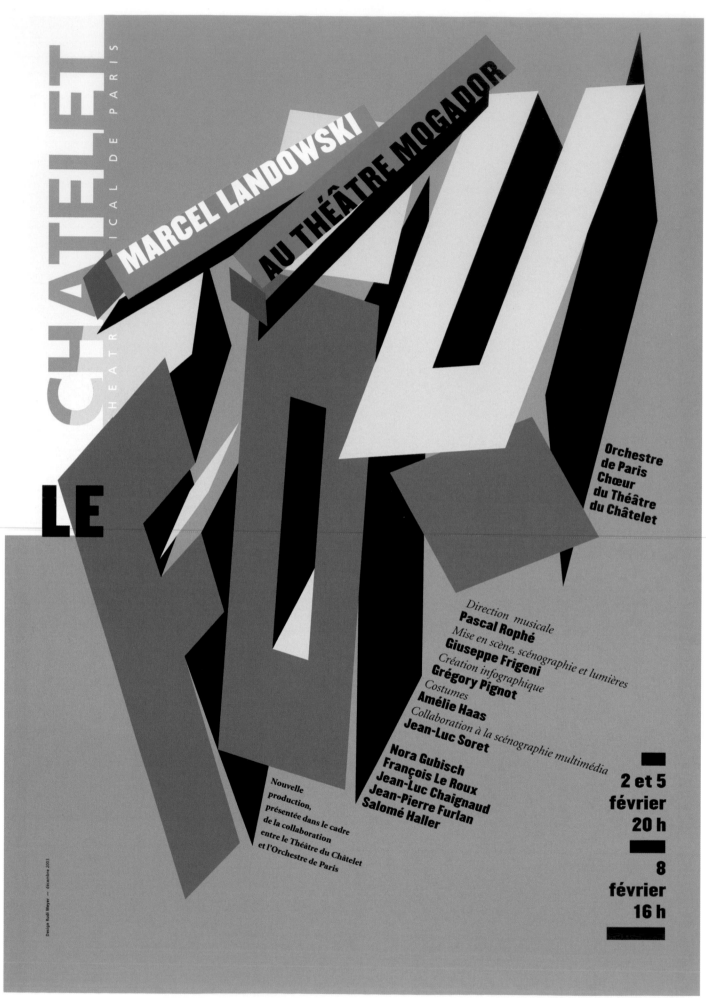

LE FOU

CHÂTELET
THEATRICAL DE PARIS

MARCEL LANDOWSKI
AU THÉÂTRE MOGADOR

Orchestre
de Paris
Chœur
du Théâtre
du Châtelet

Direction musicale
Pascal Rophé
Mise en scène, scénographie et lumières
Giuseppe Frigeni
Création infographique
Grégory Pignot
Costumes
Amélie Haas
Collaboration à la scénographie multimédia
Jean-Luc Soret

Nora Gubisch
François Le Roux
Jean-Luc Chaignaud
Jean-Pierre Furlan
Salomé Haller

**2 et 5
février
20 h**

**8
février
16 h**

Nouvelle
production,
présentée dans le cadre
de la collaboration
entre le Théâtre du Châtelet
et l'Orchestre de Paris

Design Rudi Meyer — décembre 2003

Théâtre du Châtelet
Jeudi 19 janvier
Récital Daniel Barenboïm, piano

Théâtre des Champs-Élysées
Vendredi 27 janvier
Orchestre Philharmonique de Radio France
Myung-Whun Chung, direction
Jin Wang, violoncelle

Théâtre des Champs-Élysées
Mercredi 1er février
Récital Evguéni Kissin, piano

Théâtre des Champs-Élysées
Jeudi 23 février
Orchestre National de France
Kurt Masur, direction
Beaux-Arts Trio

Théâtre du Châtelet
Vendredi 3 février
Récital Nelson Freire, piano

Théâtre du Châtelet
Mardi 28 février
Récital Murray Perrahia, piano

Salle Gaveau
Mardi 7 mars
Récital Lise de la Salle, piano

Théâtre Mogador
Mercredi 8 mars
Orchestre de Paris
Esa-Pekka Salonen, direction
Maxim Vengerov, violon

Théâtre des Champs-Élysées
Lundi 13 mars
Orchestre du Gewandhaus de Leipzig
Riccardo Chailly, direction
Nelson Freire, piano

Salle Gaveau
Jeudi 30 mars
Récital Tatjana Vassilieva, violoncelle

Théâtre Mogador
Jeudi 27 avril
Orchestre de Paris
Pascal Rophé, direction
Roger Muraro, piano

Théâtre des Champs-Élysées
Jeudi 18 mai
Orchestre National de France
Kurt Masur, direction
Nelson Freire, piano

Théâtre du Châtelet
Vendredi 19 mai
Récital Yundi Li, piano

Théâtre du Châtelet
Mercredi 31 mai
Récital Alfred Brendel, piano

Théâtre du Châtelet
Jeudi 15 juin
Récital Maurizio Pollini, piano

Théâtre des Champs-Élysées
Jeudi 22 juin
Orchestre National de France
Kurt Masur, direction
Vadim Repin, violon

LVMH
MOËT HENNESSY • LOUIS VUITTON

1000 places pour les jeunes
Saison 2006
LVMH invite 1000 jeunes
amateurs de musique fréquentant
les conservatoires de la Ville de Paris
à assister aux concerts les plus prestigieux
de la saison musicale parisienne

Design Rudi Meyer pour PLI Édition

Ruiz+Company

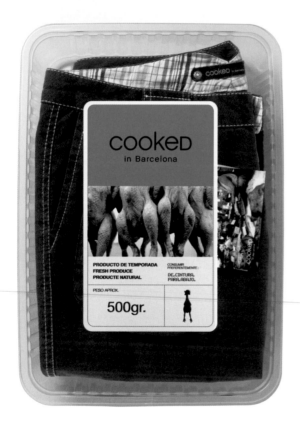

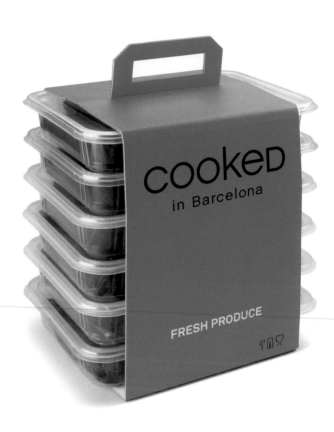

Zamora, 45, 5º, 2ª
08005 Barcelona
Spain
+34 93 253 17 80
estudio@ruizcompany.com
www.ruizcompany.com

> Advertising creator, art director and graphic designer, David Ruiz has worked for the advertising agencies of Saatchi & Saatchi, Publis, CGK and Bassat Ogilvy & Mather. Named a member of the International Graphic Alliance, he has been awarded over 80 national and international awards, among them the Graphic Advertising Grand Prize won by Spain at the Clio Festival in San Francisco for a Levi's 501 campaign. His work has been published in numerous international and national books and magazines. He has been on the juries of the Laus Awards, Eurobest, New York Festival, Art Directors Club of New York and the European Art Directors Club. In 1993, David Ruiz and Marina Company founded the graphic design studio Ruiz+Company, which now has a staff of nine professionals. This team is comprised of creators, art directors and graphic artists who are specialized in the creation of innovative designer concepts for brand names.

> *D=B* > poster > Barcelona Center of Design

NO HAY
DOS PERSONAS
IGUALES

DESDE QUE NACIMOS
HEMOS ESTADO EN
CONSTANTE EVOLUCIÓN.

HOY INICIAMOS UNA
REVOLUCIÓN.

UNA NUEVA ETAPA QUE
EMPIEZA RENOVANDO POR
COMPLETO LA IMAGEN DE
SILESTONE.

BE
UNIQUE

SILESTONE®
by COSENTINO

> *Silestone* > pamphlet > Cosentino

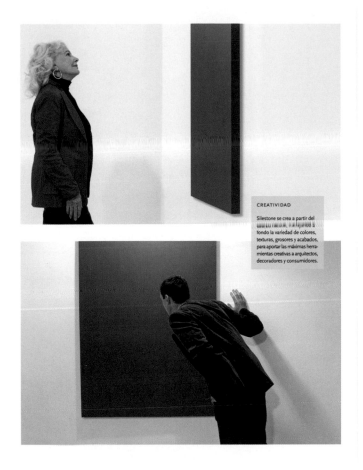

CREATIVIDAD

Silestone se crea a partir del cuarzo natural, trabajando a fondo la variedad de colores, texturas, grosores y acabados, para aportar las máximas herramientas creativas a arquitectos, decoradores y consumidores.

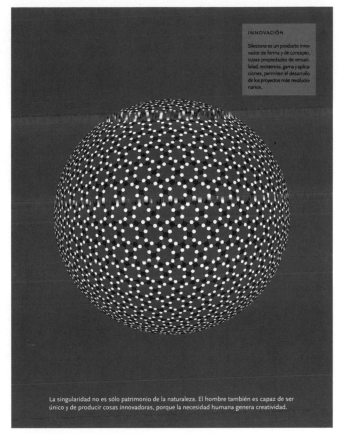

INNOVACIÓN

Silestone es un producto innovador de forma y de concepto, cuyas propiedades de versatilidad, resistencia, gama y aplicaciones, permiten el desarrollo de los proyectos más revolucionarios.

La singularidad no es sólo patrimonio de la naturaleza. El hombre también es capaz de ser único y de producir cosas innovadoras, porque la necesidad humana genera creatividad.

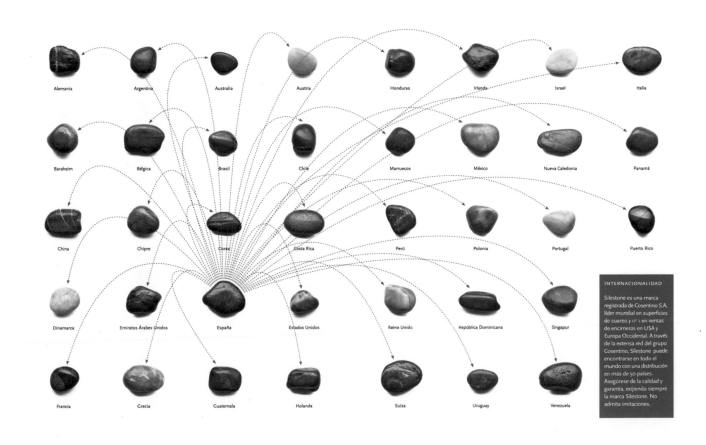

Alemania — Argentina — Australia — Austria — Honduras — Irlanda — Israel — Italia

Baraheim — Bélgica — Brasil — Chile — Marruecos — México — Nueva Caledonia — Panamá

China — Chipre — Corea — Costa Rica — Perú — Polonia — Portugal — Puerto Rico

Dinamarca — Emiratos Árabes Unidos — España — Estados Unidos — Reino Unido — República Dominicana — Singapur

Francia — Grecia — Guatemala — Holanda — Suiza — Uruguay — Venezuela

INTERNACIONALIDAD

Silestone es una marca registrada de Cosentino S.A, líder mundial en superficies de cuarzo y nº 1 en ventas de encimeras en USA y Europa Occidental. A través de la extensa red del grupo Cosentino, Silestone puede encontrarse en todo el mundo con una distribución en más de 50 países. Asegúrese de la calidad y garantía, exigiendo siempre la marca Silestone. No admita imitaciones.

Una serie de músculos especializados –casi todos ellos pares– controlan el elocuente repertorio de expresiones faciales del hombre. Dos pares corren a lo largo de los lados de la nariz para levantar los labios y la nariz en gesto de incredulidad (dibujo 13) y otro para levantar la boca en una sonrisa (3). La banda muscular que recorre la frente es uno de los pocos músculos sin pareja que produce expresiones faciales.

1. Dolor silencioso
2. Escepticismo
3. Hilaridad
4. Interés burlón
5. Pregunta burlona
6. Normal
7. Amenaza en broma
8. Diversión
9. Sorpresa
10. Dolor agudo
11. Travesura
12. Amargura
13. Incredulidad
14. Concentración
15. Miedo
16. Cinismo aburrido
17. Rábia

ruiz+company les desea felices fiestas 2006

> *Felicitación R+C* > drop-down menu > personal project

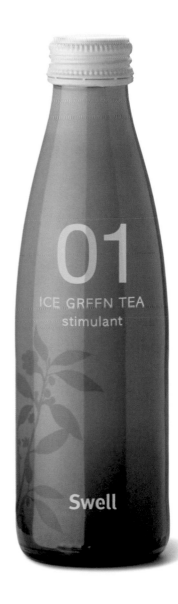

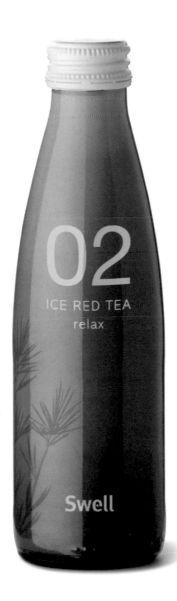

> *Swell Ice Tea* > packaging > Swell

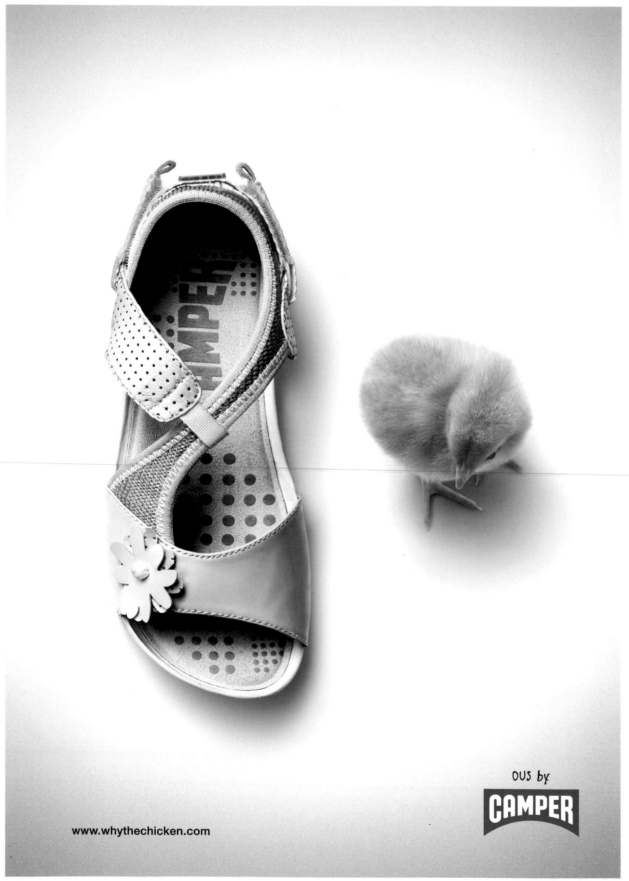

www.whythechicken.com

OUS by

CAMPER

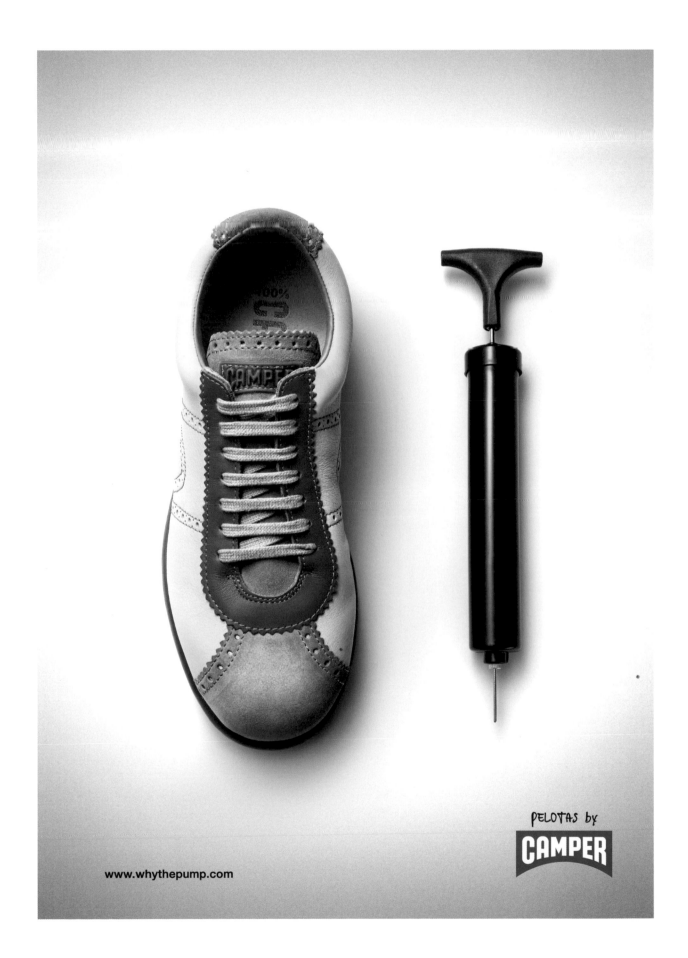

www.whythepump.com

PELOTAS by
CAMPER

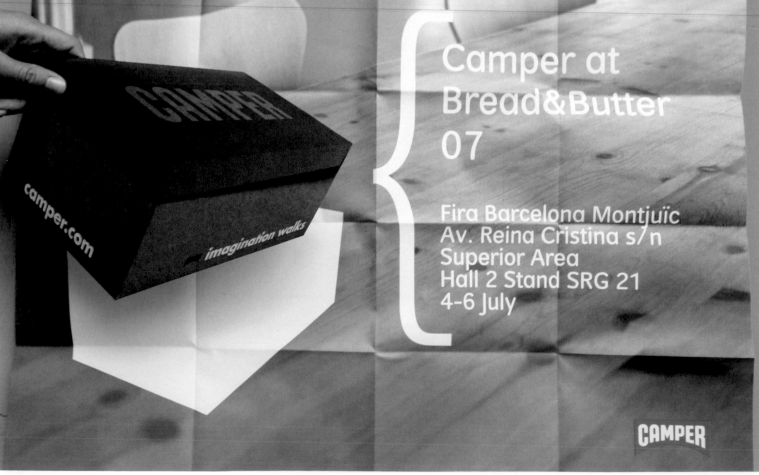

{ Camper at
Bread&Butter
07

Fira Barcelona Montjuïc
Av. Reina Cristina s/n
Superior Area
Hall 2 Stand SRG 21
4-6 July

CAMPER

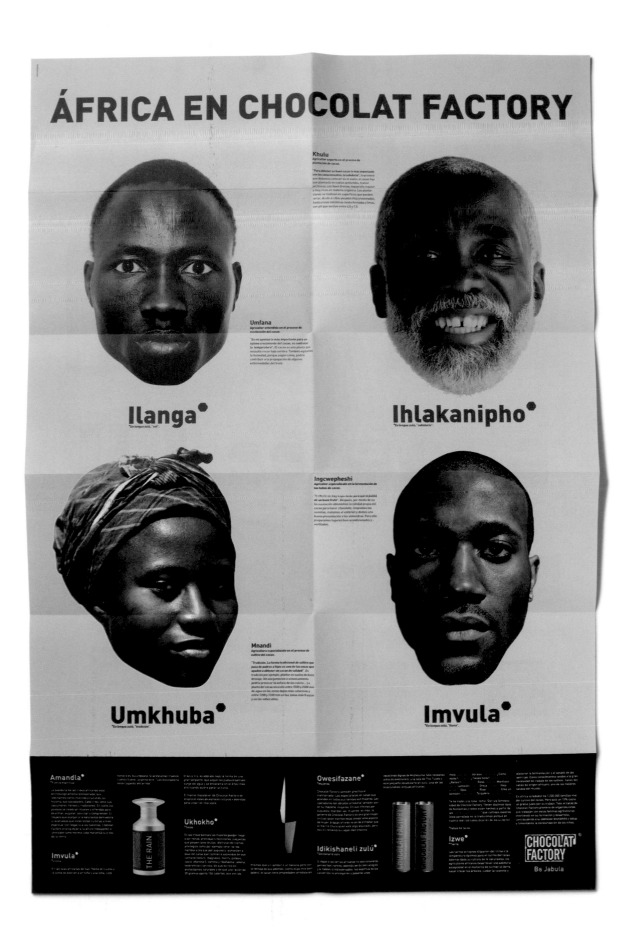

Saed Meshki

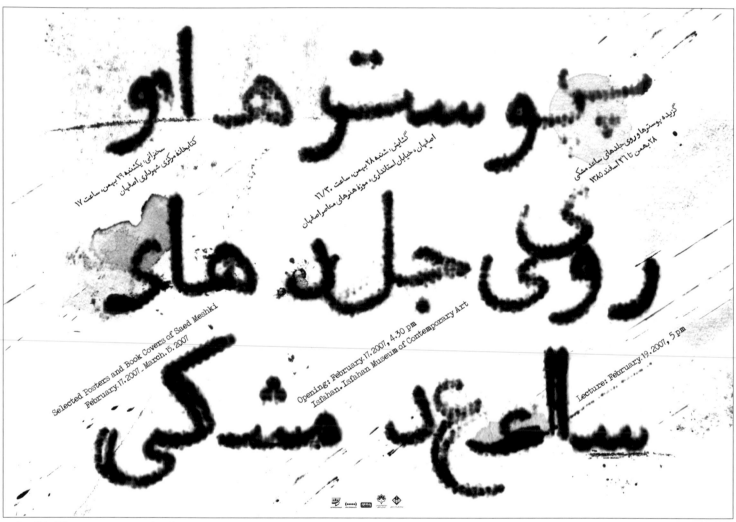

> *Saed Meshki* > poster > personal project

No. 11, 55th Street
Asadabadi Avenue
Tehran 14349 54975
Iran
+98 21 77 60 74 72
saed@saedmeshki.com
www.saedmeshki.com

> Designer Saed Meshki was born in 1964 in Iran and began his artistic activity at the age of 24. During his 18 year career he has worked freelance on cultural projects out of his own studio. Saed studied graphic design at the Faculty of Fine Arts at Tehran University and now gives classes there. He is a member of the International Graphic Alliance, the Iranian Graphic Design Society and the director of *Neshan*. In 2001, together with three artists of his genera-tion, he founded the 5th Color Group with the goal of creating a link between graphic design in Iran and the rest of the world. Saed has been a member of the selection committee in the 7th Iranian Bien-nial of Graphic Design, a member of the jury at the 1st Iranian Self-Promotion Posters Biennial and the 5th Exhibition of Children's Books Illustrators. In re-cent years, Saed has focused on book design.

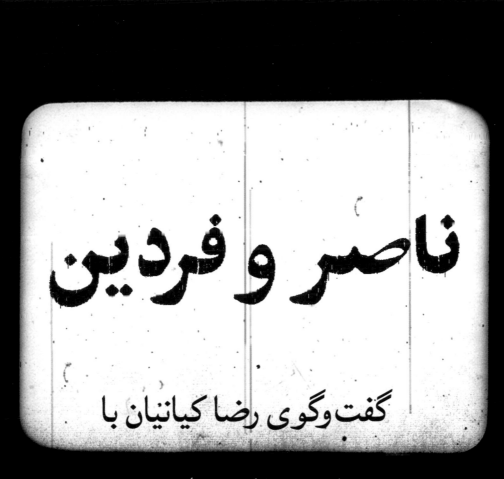

ناصر و فردین

گفت وگوی رضا کیانیان با

ناصر ملک مطیعی

محمدعلی فردین

نشر مشکی

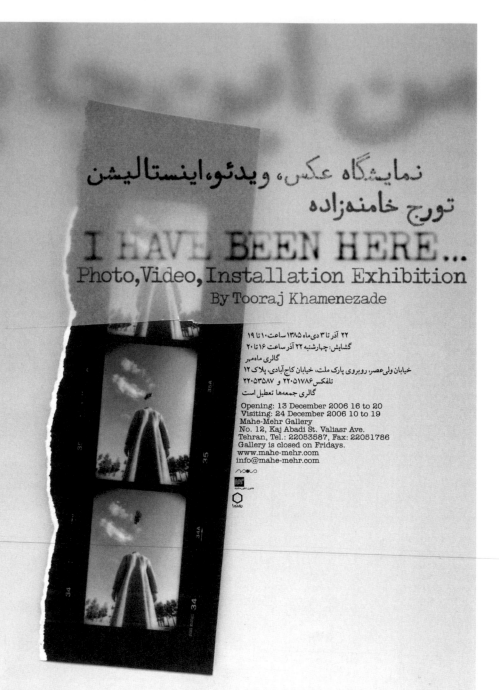

هفتادمین سال تولد مرتضی ممیز

نمایشگاه ۴۱ پوستر از ۴۱ طراح گرافیک جهان

The 70th Birth Anniversary of Morteza Momayez
Exhibition of 41 Posters by 41 International Graphic Designers

ساعت ۱۷، تهران، خانه‌ی هنرمندان ایران، ۴ تا ۱۰ شهریور ۱۳۸۵ Opening Saturday 26 August 2006, 5.00 PM, Tehran, Iranian Artists' Forum

برگزارکننده:

با همکاری:

آفساله ممیز

> The 70th Birth Anniversary of Morteza Momayez > poster > Iranian Artists Forum

نشر مشکی

گفت‌وگوی رضا کیانیان با

بهرام بیضایی ▪ مازیار پرتو ▪ کیومرث پوراحمد

بهرام دهقانی ▪ علیرضا زرین‌دست ▪ عزیز ساعتی

کارول کراوتس ▪ محمود کلاری ▪ عباس گنجوی

بازیگری در قاب

> Interview with Editors and Directors of Photography > cover > Meshki Publication

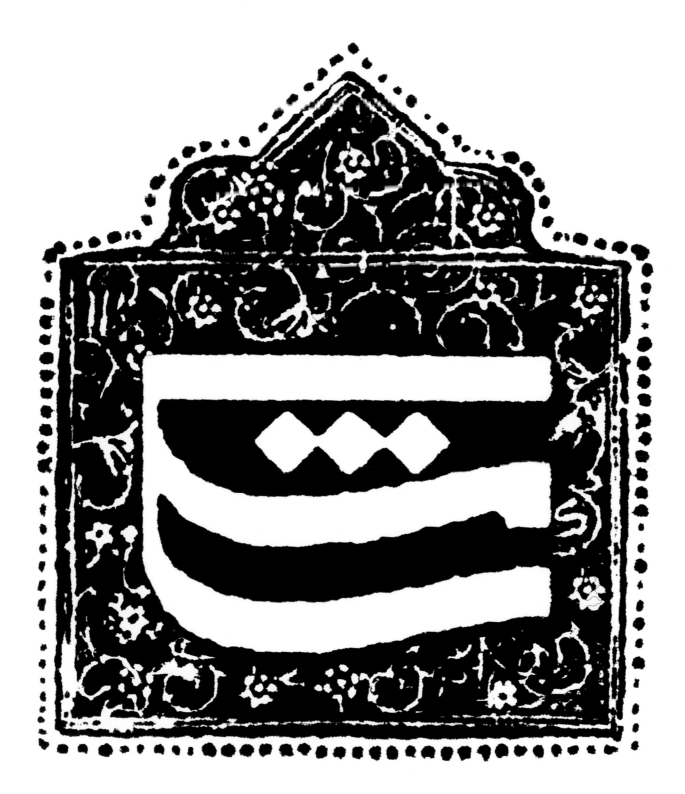

> *Saed Meshki* > logo > personal project

Sagmeister

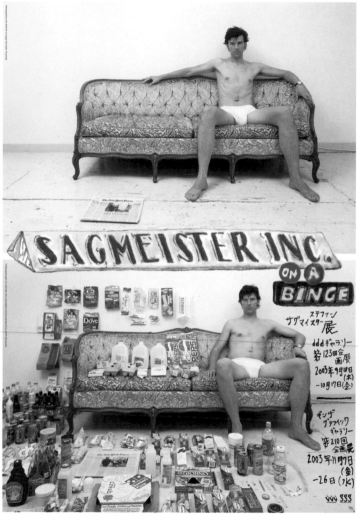

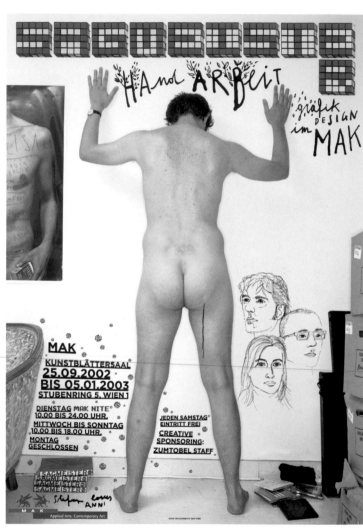

> *Sagmeister Inc. Exhibit GGG DDD* > poster > DDD Gallery, Osaka, and GGG Gallery Gallery, Tokyo > photo: Tom Schierlitz

> *Sagmeister Inc. Exhibit MAK* > poster > MAK > photo: Tom Schierlitz

222 West 14 Street
Suite 15 A
New York NY 10011
United States
+1 212 647 1789
info@sagmeister.com
www.sagmeister.com
Portrait: Cris Cassady

> Born in 1962 in Bregenz, Stefan Sagmeister studied graphic design at the University of Applied Arts Vienna (Austria). In 1987, he moved to New York upon receiving a grant to study at the Pratt Institute. At 29, he began working with Leo Burnett in Hong Kong. In 1993 he returned to New York to work with Hungarian graphic designer Tibor Kalman at M&Co. In the same year, Sagmeister opened his own studio, Sagmeister Inc. Sagmeister is considered one of the most innovative and influential graphic designers today. His conception and application of graphic design goes beyond traditional notions to become art, paintings and conceptual sculptures. His work is known thanks to the record covers of musicians like The Rolling Stones, Talking Heads and Lou Reed, and books like that of Mariko Mori *Wave UFO* for The Kunsthaus Bregenz, which at the same time function as sculptural objects.

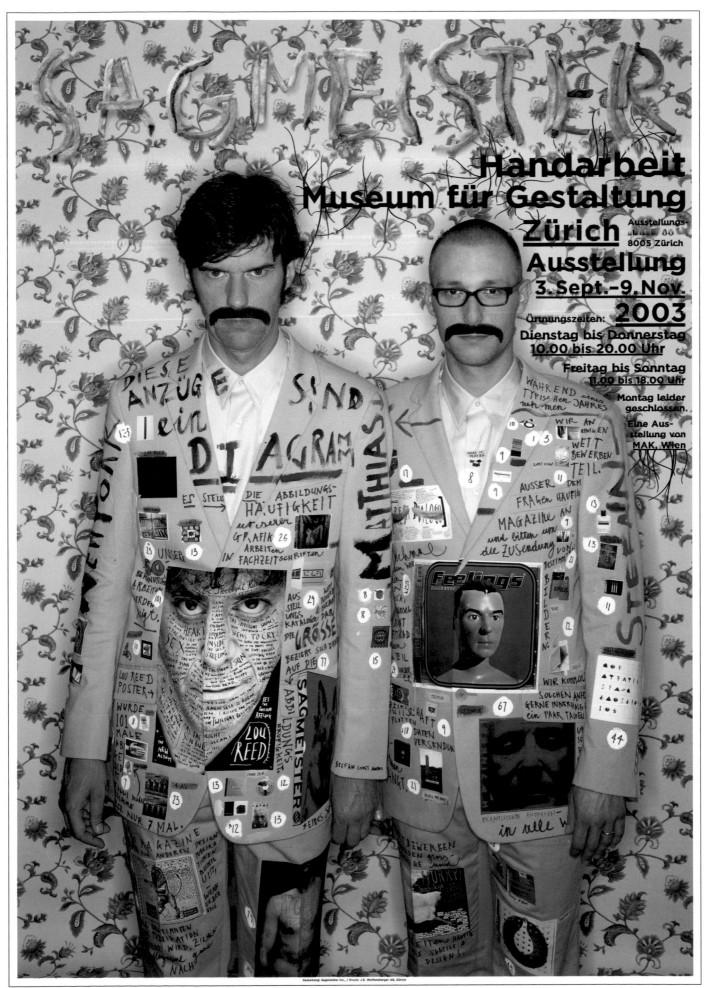

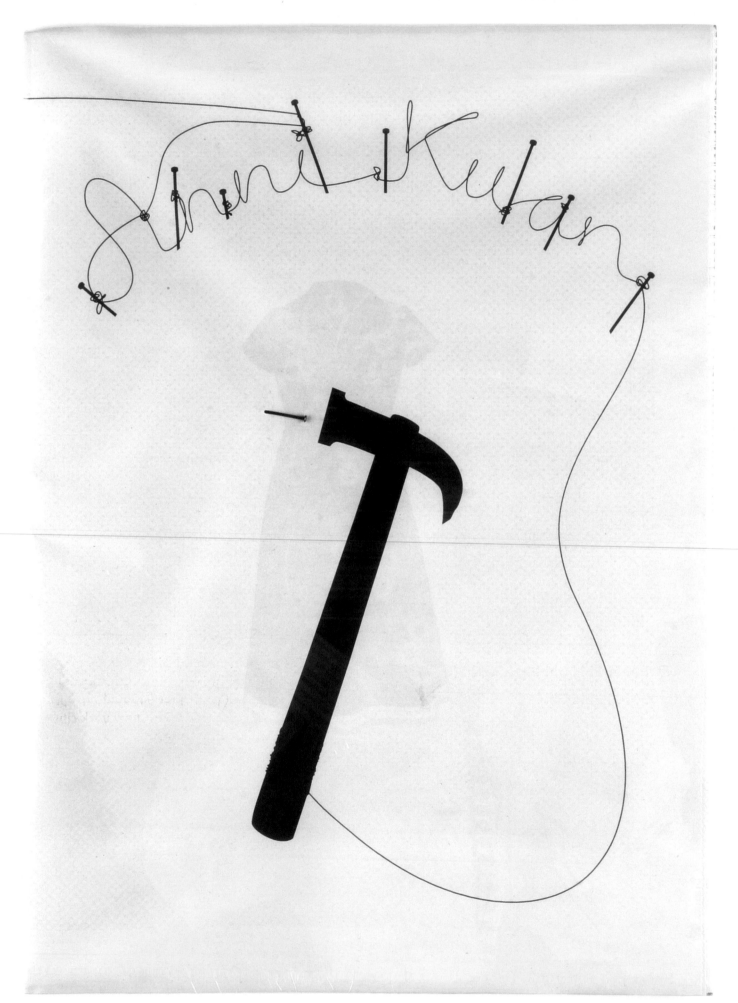

> *Anni Kuan Pin* > poster > Anni Kuan

> *Anni Kuan Slider* > poster > Anni Kuan

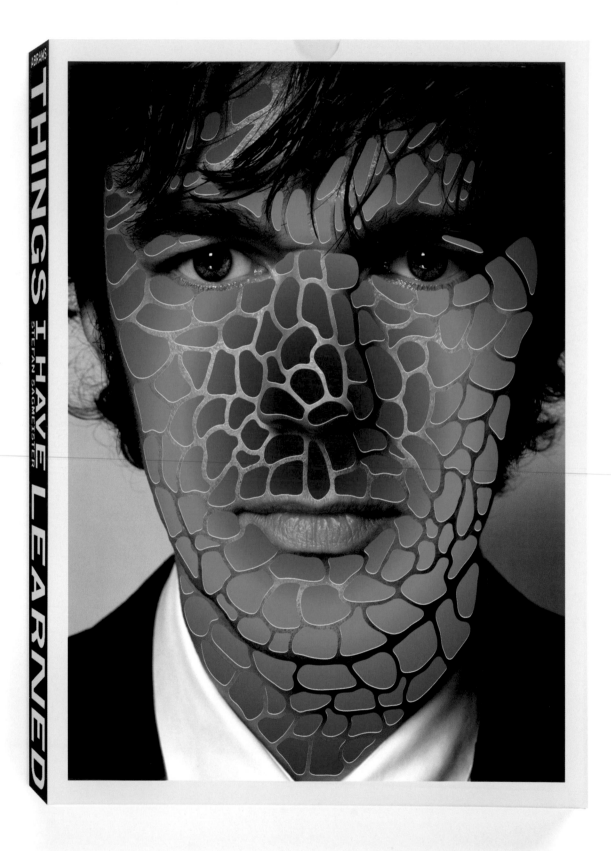

THINGS I HAVE LEARNED

STEFAN SAGMEISTER

ABRAMS

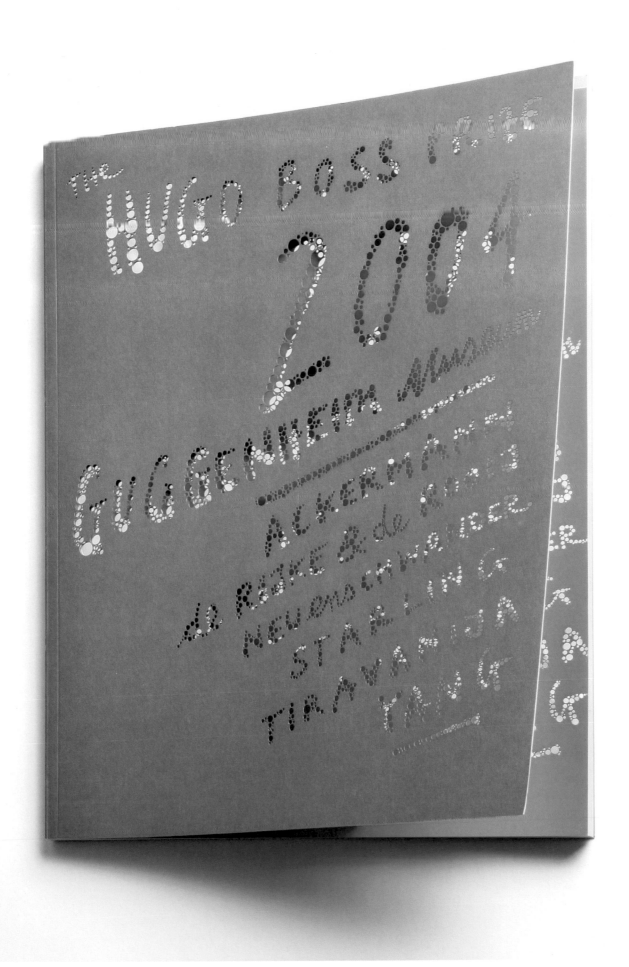

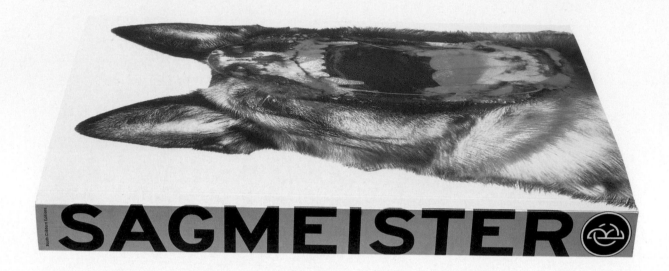

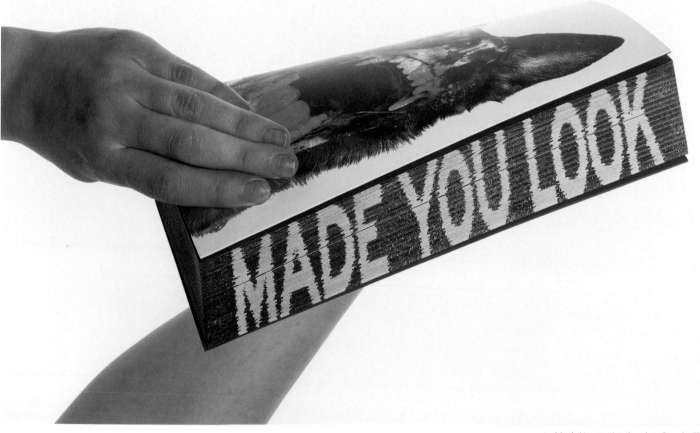

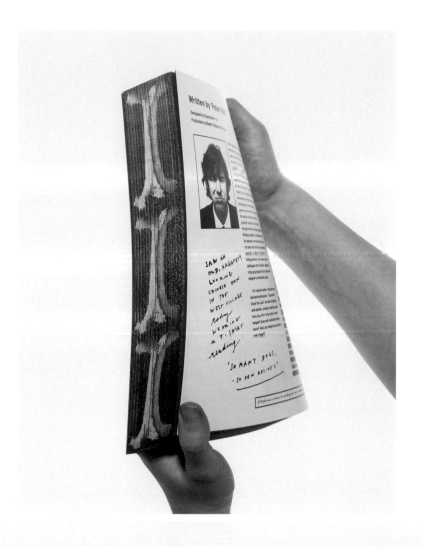

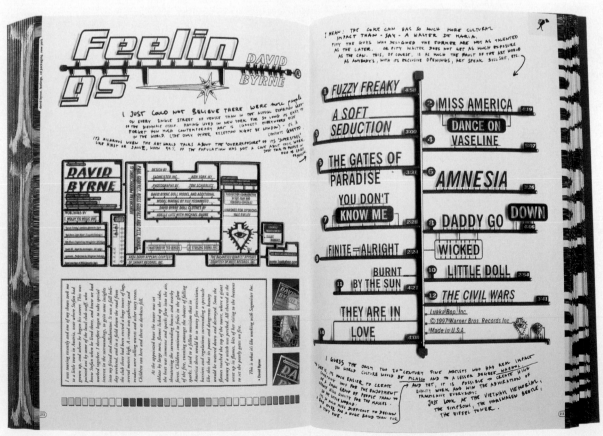

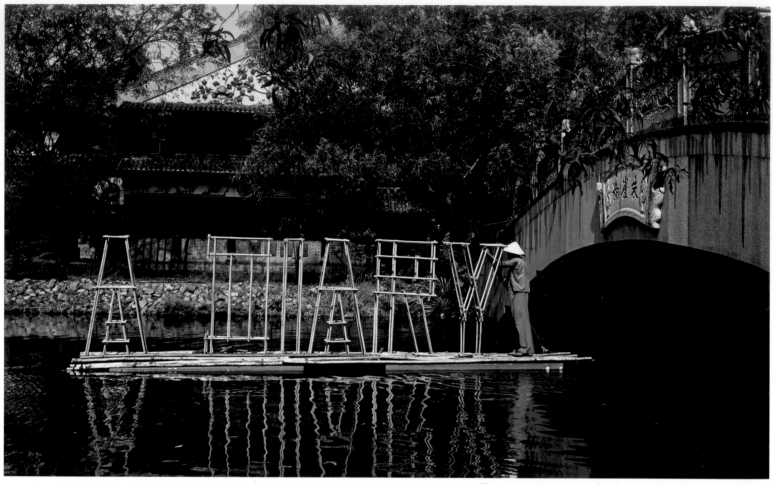

> *Things I Have Earned in My Life so Far* > installation > personal project

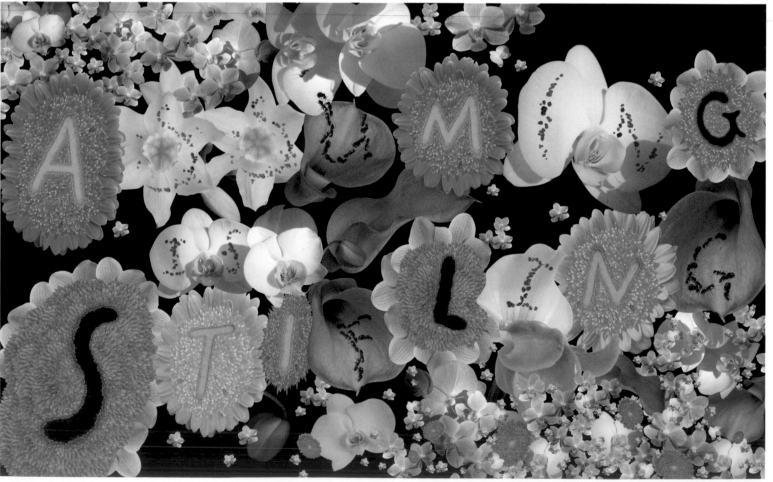

> *Assuming is Stifling* > poster > Dai Nippon Printing Company > photo: Matthias Ernstberger

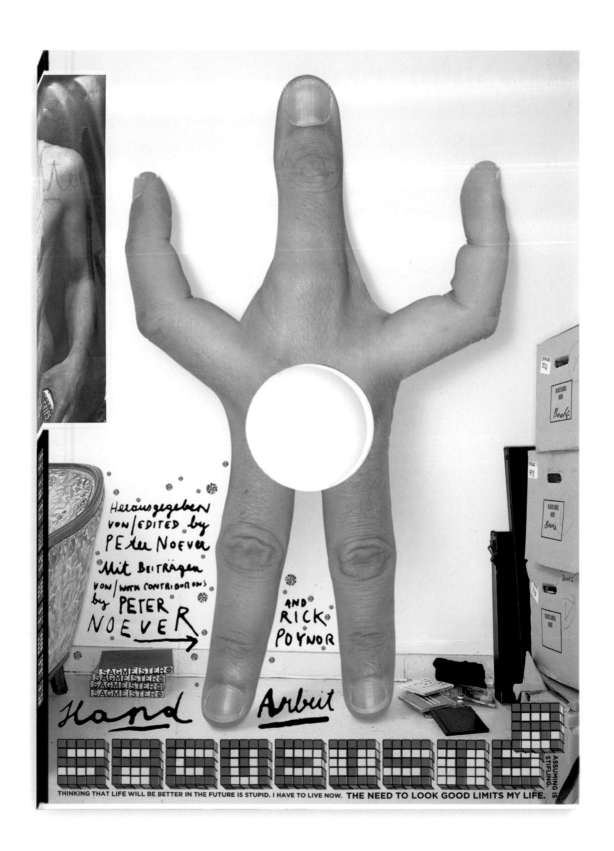

Shinnoske

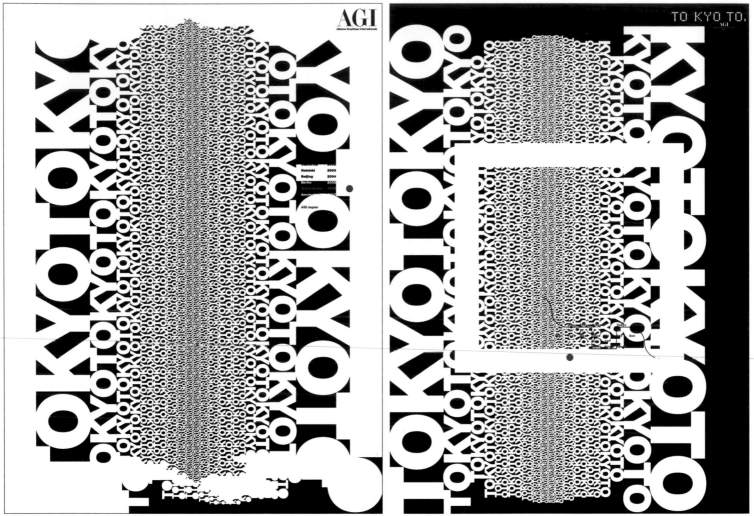

> *TO KYO TO* > poster > International Graphic Alliance Japan

2-1-8-602 Tsuriganecho
Chuoku
Osaka 540-035
Japan
+81 6 6943 9077
info@shinn.co.jp
www.shinn.co.jp

> With a degree in design from the Osaka University of Arts in 1974, Shinnoske Sugisaki created his studio Shinnoske Inc. (1986), where he doubles as creative director and president. Sugisaki has designed advertising, corporate identities and typography for some of Japan's most important businesses and organizations: Panasonic, Mitsubishi Pharma, Mainichi Broadcasting, Morisawa and Suntory, among others. His more personal and experimental work has been exhibited in cities like Tokyo, Osaka, Beijing, Shanghai, Hong Kong, New York and São Paulo. He has given classes at the Seian University of Art and Design and at the Seian Junior College of Art and Design. He has received prestigious awards from the Art Directors Club of New York and the International Poster Triennial in Toyama. Shinnoske is a member of the International Graphic Alliance and the Japan Graphic Designers Association, among other institutions.

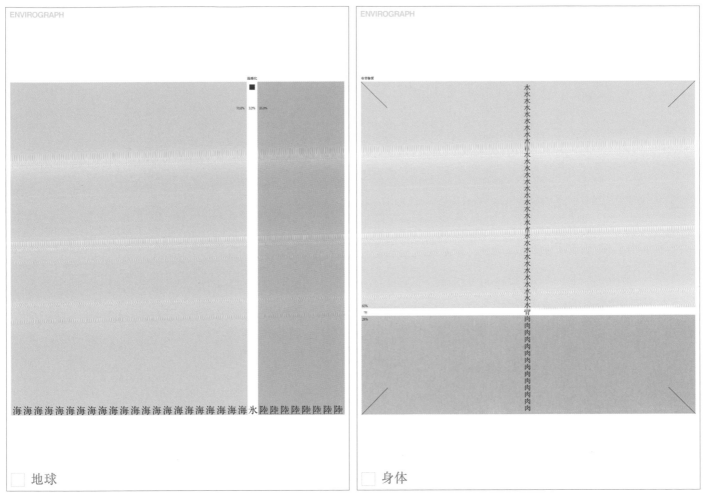

ENVIROGRAPH

地球

ENVIROGRAPH

身体

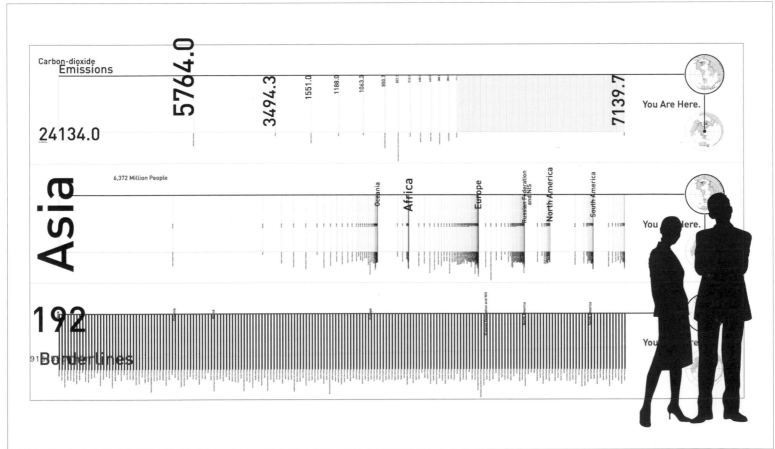

> *Envirograph* > poster > Heiwa Paper

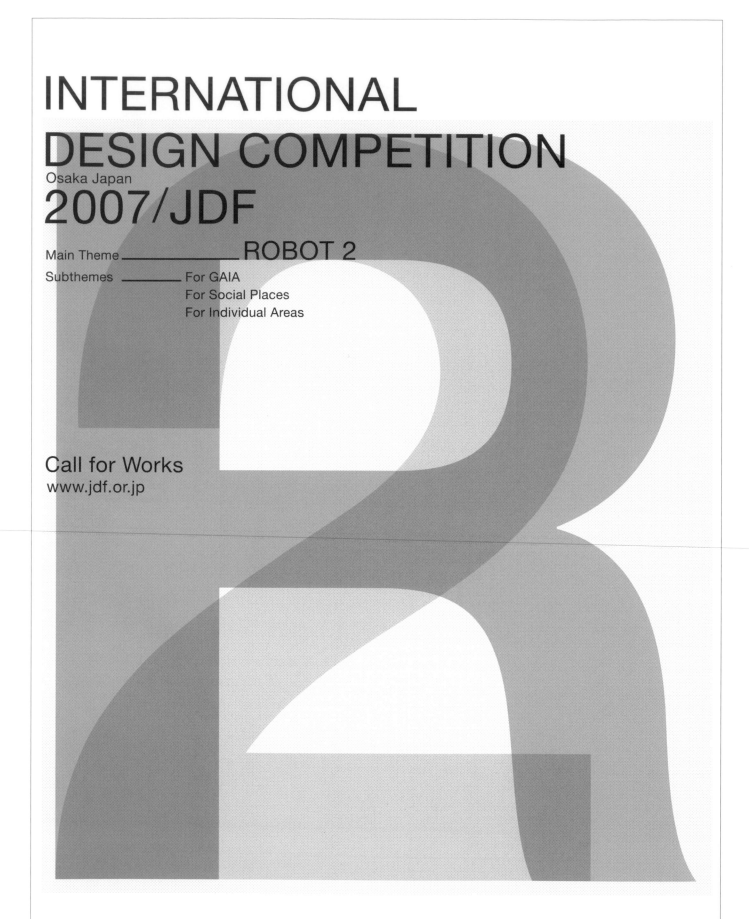

INTERNATIONAL
DESIGN COMPETITION
Osaka Japan
2007/JDF

Main Theme —————— ROBOT 2
Subthemes ————— For GAIA
For Social Places
For Individual Areas

Call for Works
www.jdf.or.jp

国際デザインコンペティション 2007/JDF

財団法人 国際デザイン交流協会
JAPAN DESIGN FOUNDATION JETRO Japan External Trade Organization

Bunraku

World Intangible Heritage

> *Theater Brava!* > poster > Mainichi Broadcasting System

TO-KO

透光

紙をデザインする
Paper Design Sakura Project Six Exhibition 2006

国立文楽劇場

BUNRAKU

Ningyo Johruri Bunraku
World Intangible Heritage

So+Ba

> Small+Beautiful > book > Ichii

5-29-20 Kyodo
Setagaya-ku
Tokyo 156-0052
Japan
+81 3 3706 2360
info@so-ba.cc
www.so-ba.cc

> Swiss designers Alex Sonderegger and Susanna Baer have worked in Tokyo for eight years. In 2001 they created the So+Ba design studio in the same city. The studio was named by uniting the first two letters of each designer's name. The name also refers to the studio's location; it was formerly a soba shop (Japanese noodles). Their designs demonstrate a keen fascination in combining typography with illustrations. Upon approaching each new project, they examine the product and company, compiling images to develop various strategies. Afterwards, these are united to distill a unique visual language. This design team does not have a particular style. Instead they believe that a graphic designer must be a craftsman and be able to work with many different styles.

la bibliothèque des arts

1860 - 2007

criss+cross

design en suisse
design from switzerland

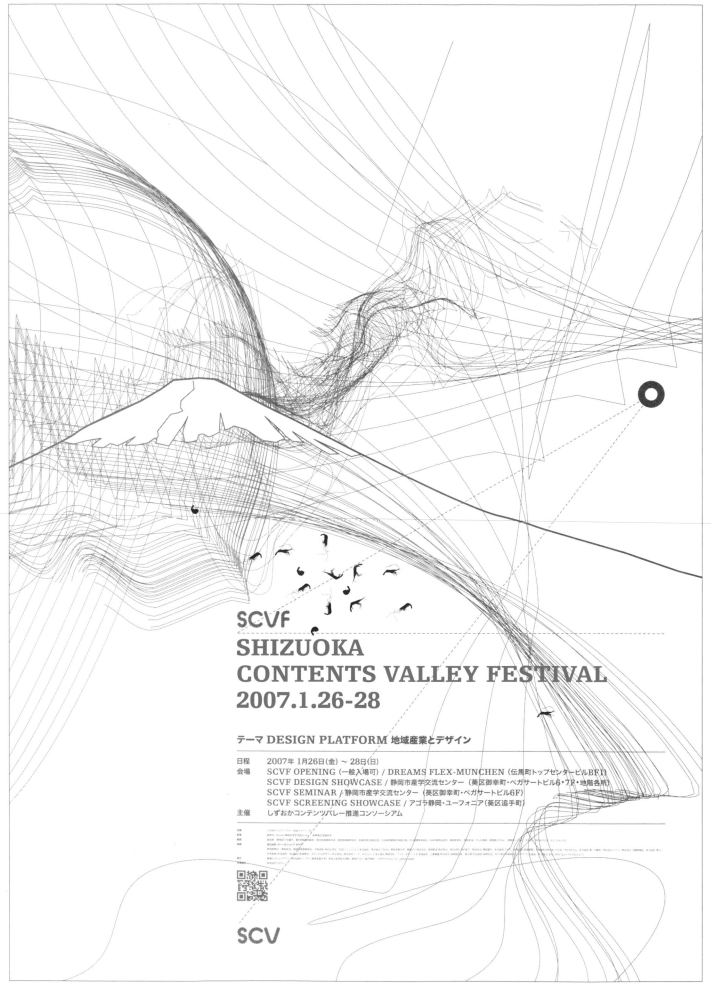

SCVF
SHIZUOKA
CONTENTS VALLEY FESTIVAL
2007.1.26-28

テーマ DESIGN PLATFORM 地域産業とデザイン

日程　2007年 1月26日(金) 〜 28日(日)
会場　SCVF OPENING (一般入場可) / DREAMS FLEX-MUNCHEN (伝馬町トップセンタービルBF1)
　　　SCVF DESIGN SHOWCASE / 静岡市産学交流センター (葵区御幸町・ペガサートビル6・7F・地階各所)
　　　SCVF SEMINAR / 静岡市産学交流センター (葵区御幸町・ペガサートビル6F)
　　　SCVF SCREENING SHOWCASE / アゴラ静岡・ユーフォニア(葵区追手町)
主催　しずおかコンテンツバレー推進コンソーシアム

SCV

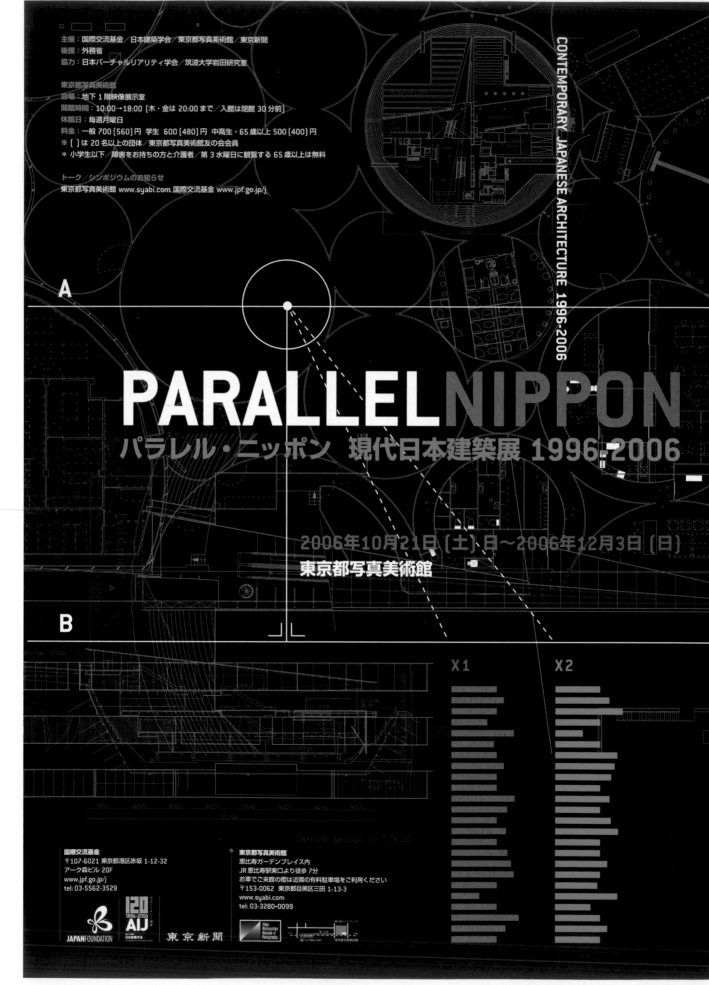

> *Parallel Nippon* > flyers > Japan Foundation

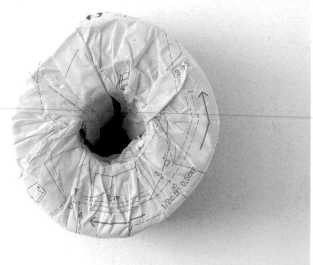

裸の王さま
The Emperor's New Clothes

A project by Edwina Hörl

www.edwinahoerl.com

Edwina Hörl

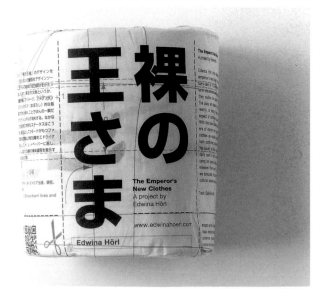

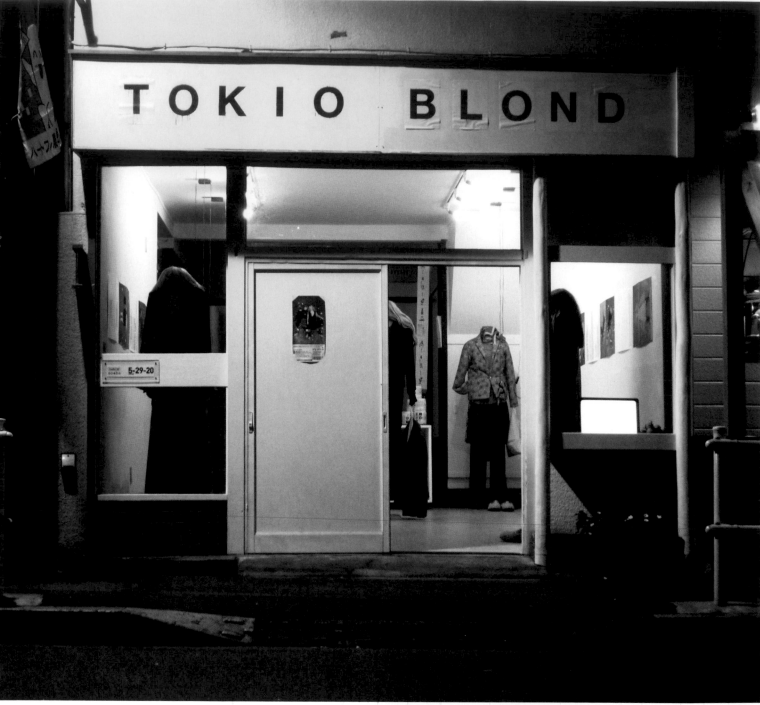

> *Tokio Blond* > catalog > Edwina Hörl, Evergreen

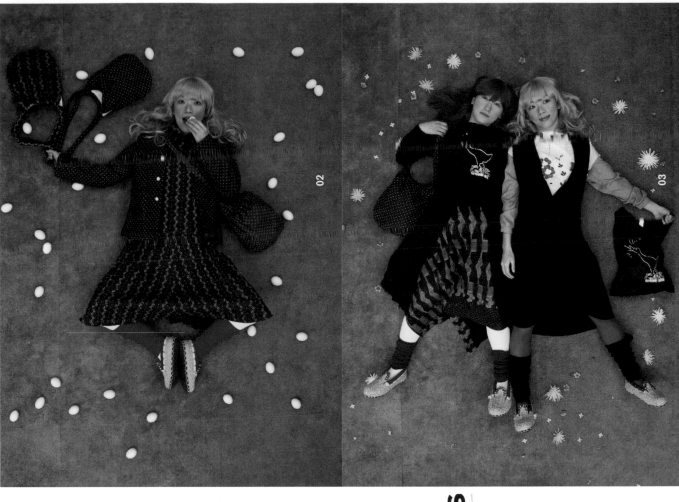

ins künstliche Gras

Spitzen von den Grenzen: Folkloren aus den alten Zeiten, österlich, pfingstlich, greifst du mir ins Haar: so haben wir als Kinder Blüten geworfen, Blüten gestreut vor den Prozessionen, die goldenen Strahlen der Monstranz, darüber der Himmel, getragen an vergoldeten Pfosten. Die eine Hand auf deinem Bauch, das ist Wärme und Vertrauen, Edwina, sagt die Tasche gold und blau. Mongolische Hosen und ein Abendrock vom Ländlerball. Ich liebe diesen Gürtel aus geflochtenem Stoff zum blau-türkisen Mantel. Sound, spricht es unter dem Herzen hervor. Lausch!

Da liegen sie, kräftig, derb, die Beine ausgewinkelt, in einem Doppel-A: Gans/ Gans, die Doppelung

Affirmation, Bejahen, Anerkennen, Ausstieg aus Zeit in die Sehnsucht des Privaten, in das kleine Träumen, ins Große hinaus.

auch auf Brust und Tasche, in einer Diagonale geht das durch das Bild fort. Gestreut und konzentriert, geformt und aufgelöst, in diesen dualen Bezügen spielen hier die Formen, die Dreieckskomposition der Körper, die zusammen wiederum ein A ergeben: **Ja –**

Bleib ich hier? Schaust du auf? Bist du da? Siehst du mich? Nimmst du mich wahr? Schau, ich habe mich für dich angezogen. Sieh auf mich herab, du kleines Tier. Da schweben wir, über der Wiesen, hoovering, sagt man zur Kolibribewegung (kolibrieren?), aber wir flattern nicht, keine Luftwirbel, kein mühsames Rudern mit den Flügel, kein Flügelschlag, kein Wie-sich-über-Wasser halten, kein Sinken auf den Grund: Wir schweben als Wolke. Wie eine Wolke sind wir da, sehen hinunter, knapp über dem Boden,

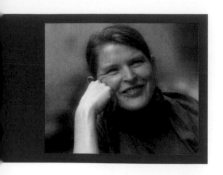

Studio Annelys de Vet

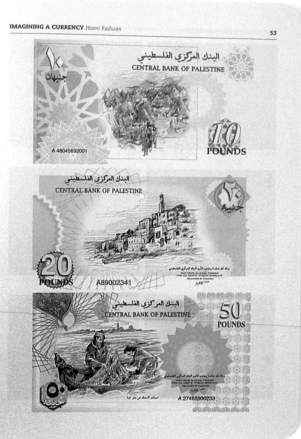

> *Subjective Atlas of Palestine* > book > personal project

Nieuwe Uilenburgerstraat 5
1011 LM Amsterdam
The Netherlands
+31 20 638 6401
there@annelysdevet.nl
www.annelysdevet.nl

> As a graphic designer educated at the Arts Academy of Utrecht and the Sandberg Institute (Amsterdam), Annelys de Vet explores the role of design in relation to public and political discourse. Parallel to her work for clients such as Thames & Hudson, Droog Design, KPN, TPG Post, Rijksgebouwendienst and Appel art space, she has edited various books, among them: *Subjective Atlas of the European Union, from an Estonian Point of View*, which demonstrates new images for Europe designed by students at the Tallinn School of Art; *Subjectieve Atlas van Nederland*, which attempts to influence perceptions of national identity and was made by students at the Design Academy Eindhoven; and *The Public Role of the Graphic Designer*, which investigates the designer's responsibilities in the cultural domain. De Vet has taught classes at the Design Academy Eindhoven for a few years and presently directs its Man & Communication Department.

VALUE FOR MONEY CHECKBOOK # 000/750

When I hear the word design, I take out my checkbook*

VALUE FOR MONEY

13th presentation of Droog Design
during Salone del Mobile
Galeria Postart, Milano
April 13th-17th, 2005

Value for Money Checkbook
is a publication of Droog Design
Concept and design Annelys de Vet
English translation Michael Gibbs
Print Joos Mooi Drukwerk
Binding Weinmann BV Grafische Afwerking
Numbered edition 750

© Droog Design, 2005

*Modified from Jean-Luc Godard's film 'Le Mépris', from
which Barbara Kruger used the premise: "When I hear the
word culture, I take out my checkbook".

VALUE FOR MONEY CHECK FOUR

Name Twentyfiveeurostool, twentyfiveeurochair, twentyfiveeuroarmchair
Designers Niels van Eijk & Miriam van der Lubbe, 2005
Size 45 x 45 x 70 cm, 45 x 75 x 45 cm, 45 x 75 x 45 cm
Material birch multiplex, underlay, chipboard

I value the design because:

€ stool € chair € armchair
birch multiplex underlay chipboard

V EIJK & V D LUBBE

I prefer the following outlay:
☐ € stool
☐ € chair
☐ € armchair

I value the design because:

Signature:

VALUE FOR MONEY CHECK NINE

Name Stakhanov ceramics
Designer Joris Laarman, 2005
Size Ø 11,5 x 6,5 cm
Material ceramics

I value the design because:

€ one soup bowl €€€€€ some soup bowls €€€€€€€€€ stack of soup bowls

LAARMAN

I prefer the following outlay:
☐ € one soup bowl
☐ €€€€€ some soup bowls
☐ €€€€€€€€€ stack of soup bowls

I value the design because:

Signature:

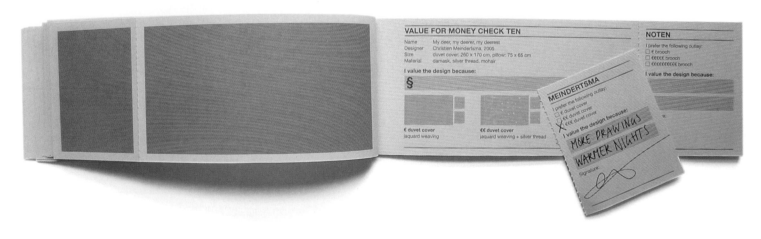

VALUE FOR MONEY CHECK TEN

Name My deer, my deerer, my deerest
Designer Christien Meindertsma, 2005
Size duvet cover: 260 x 170 cm, pillow: 75 x 65 cm
Material damask, silver thread, mohair

I value the design because:

€ duvet cover €€ duvet cover
jaquard weaving jaquard weaving + silver thread

NOTEN

I prefer the following outlay:
☐ € brooch
☐ €€€€€ brooch
☐ €€€€€€€€€ brooch

I value the design because:

MEINDERTSMA

I prefer the following outlay:
☐ € duvet cover
☐ €€ duvet cover
☒ €€€ duvet cover

I value the design because:
MORE DRAWINGS
WARMER NIGHTS

Signature:

> *Subjectieve Atlas van Nederland* > book > personal project

44 | What if?
Itay Lahav

	NETHERLANDS	ISRAEL
AREA (km²)		
Total:	41,526	20,770
Land:	33,883	20,330
Water:	7,643	440
POPULATION:	16,407,491	6,276,883

As an Israeli living in Holland I try to bring my background and its conflict closer to the Dutch public. This map is an attempt to simulate this conflict on Dutch ground and thus make it clearer for the Dutch to relate and react to it. What if Holland was about to give the total area of Gaza and the West Bank (about 6.000 km² of occupied territory) back to the Palestinians?

What if? | 45

Mediterranean Sea

LEBANON

Haifa

Tel Aviv

SYRIA

West Bank

Gaza

Jerusalem

Be'er sheva

JORDAN

EGYPT

SAUDI ARABIA

- Israeli occupied, status to be determined

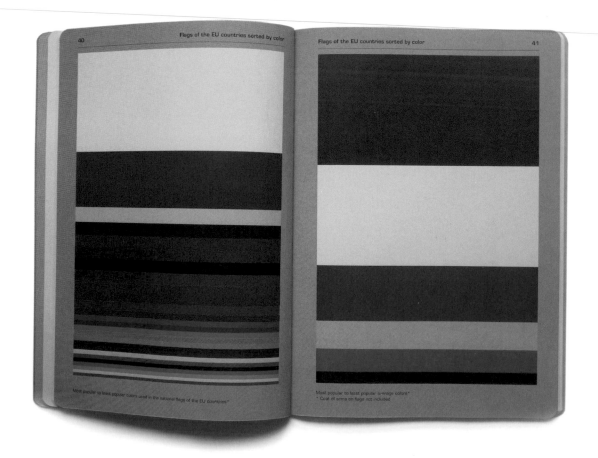

> *Subjective Atlas of the European Union* > book > personal project

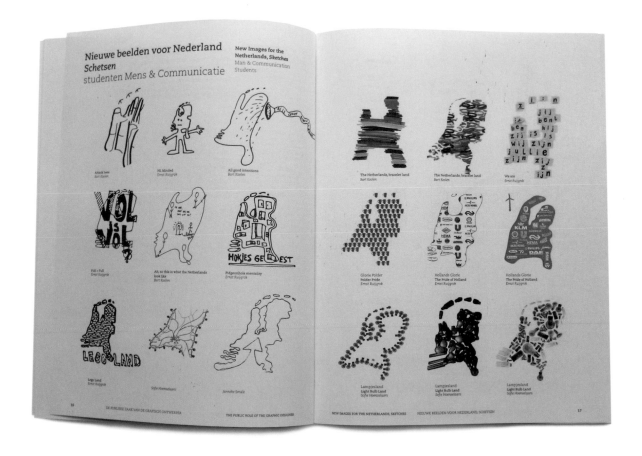

Studio Dumbar

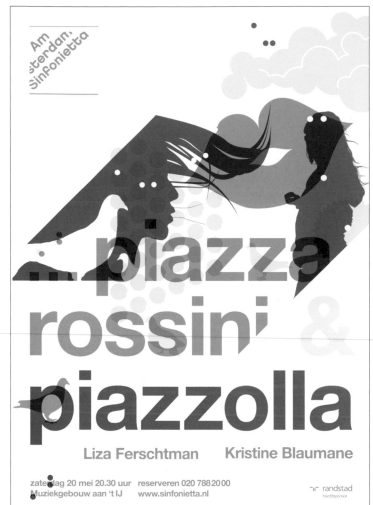

> *Piazzolla* > poster > Amsterdam Sinfonietta

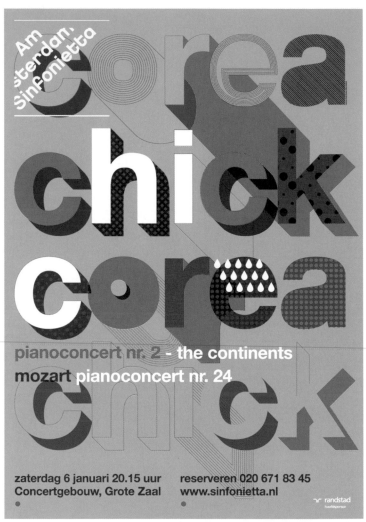

> *Chick Corea* > poster > Amsterdam Sinfonietta

Lloydstraat 21
3024 EA Rotterdam
The Netherlands
+31 10 448 22 22
info@studiodumbar.com
www.studiodumbar.com

> Designer Gert Dumbar created Studio Dumbar in 1977. From the start, it became the studio for top-notch design by employing the talents of individual designers to create powerful design solutions. Their work is internationally known and includes various awards, exhibitions, workshops and conferences from all over the world. Studio Dumbar divides its projects between visual branding and free spirit. This is one of the aspects that makes Studio Dumbar a fountain of creativity for its clients and an attractive work environment for its designers. More and more businesses are discovering the strategic and commercial relevance of design: Studio Dumbar created the term "visual branding" as a description that references the crucial role of design in business. Some of their projects revolve entirely around design, foregoing themes of strategy. These projects are called "free spirit" and are related more to artistic and cultural realms.

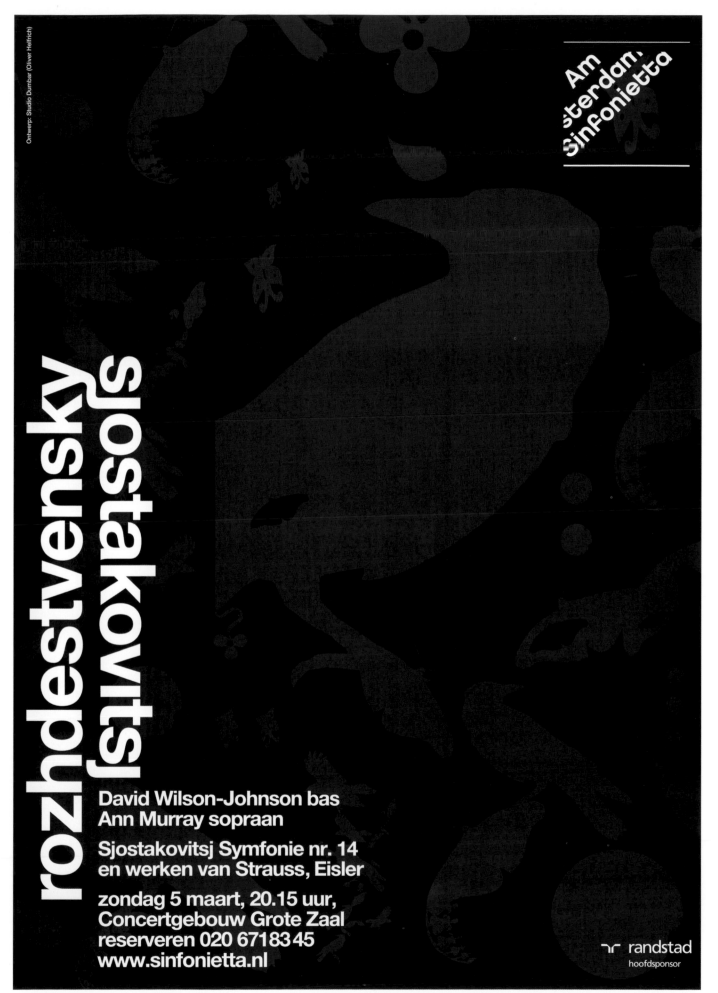

Ontwerp: Studio Dumbar (Oliver Helfrich)

Amsterdam Sinfonietta

rozhdestvensky
sjostakovitsj

David Wilson-Johnson bas
Ann Murray sopraan

Sjostakovitsj Symfonie nr. 14
en werken van Strauss, Eisler

zondag 5 maart, 20.15 uur,
Concertgebouw Grote Zaal
reserveren 020 6718345
www.sinfonietta.nl

randstad
hoofdsponsor

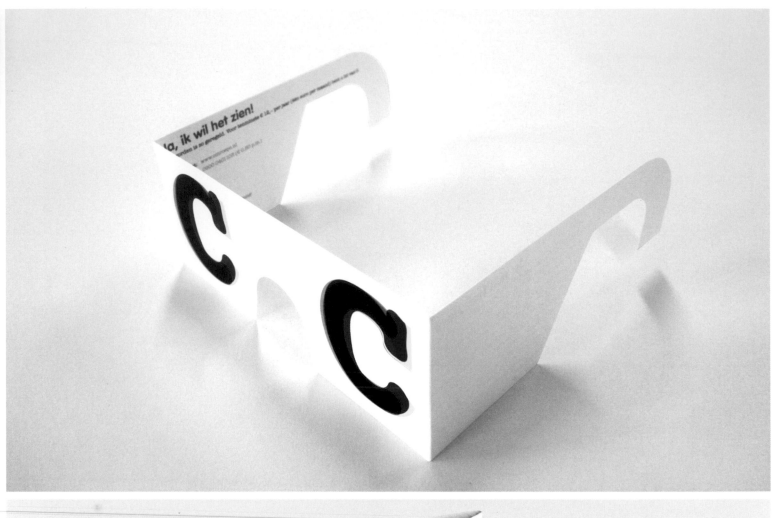

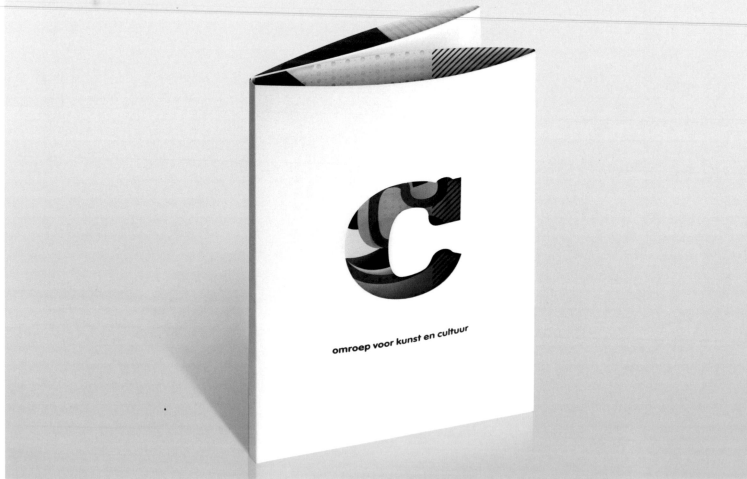

> *C Broadcasting Organisation* > flyer > Ad 's-Gravesande, Omroep C

Verbod op verkoop beneden inkoopprijs een internationale _vergelijking

Welke EU-landen kennen een wettelijk verbod van VBI, hoe is dat vormgegeven en hoe vaak wordt dat toegepast?

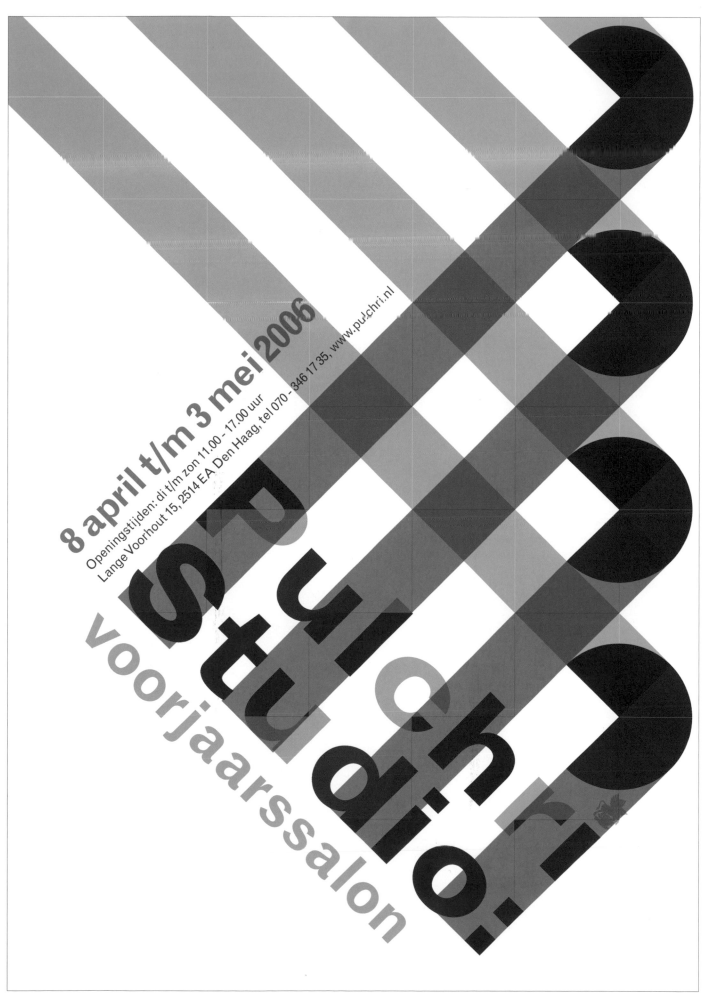

8 april t/m 3 mei 2006
Openingstijden: di t/m zon 11.00 - 17.00 uur
Lange Voorhout 15, 2514 EA Den Haag, tel 070 - 346 17 35, www.pulchri.nl

voorjaarssalon

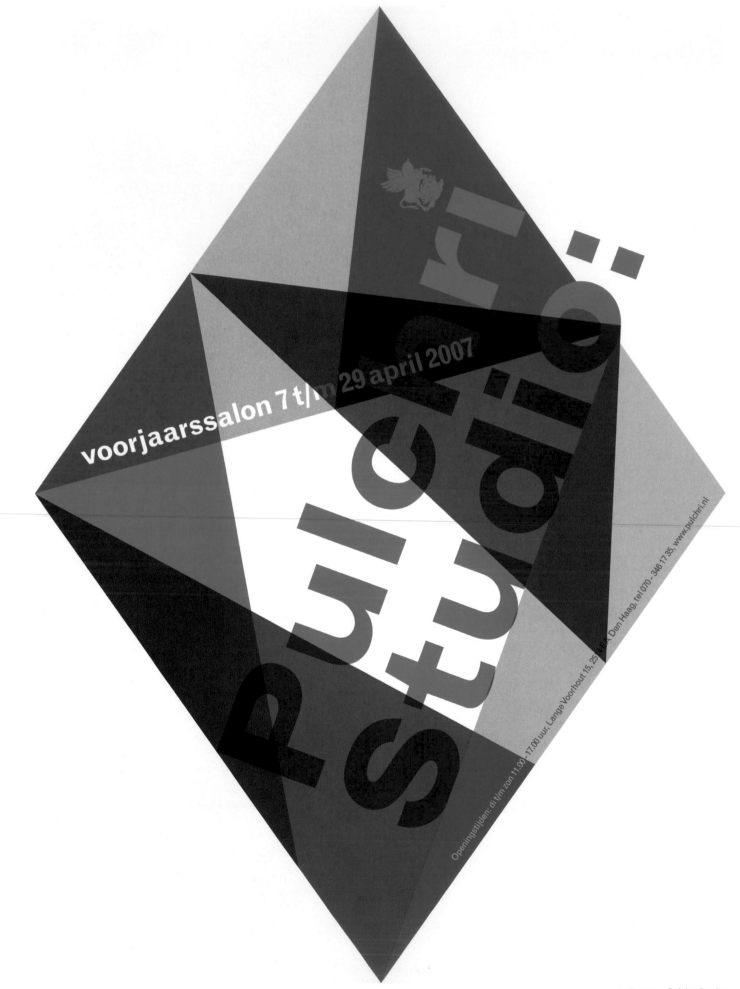

voorjaarssalon 7 t/m 29 april 2007

Openingstijden: di t/m zon 11.00-17.00 uur, Lange Voorhout 15, 25 14EA Den Haag, tel 070 - 346 17 35, www.pulchri.nl

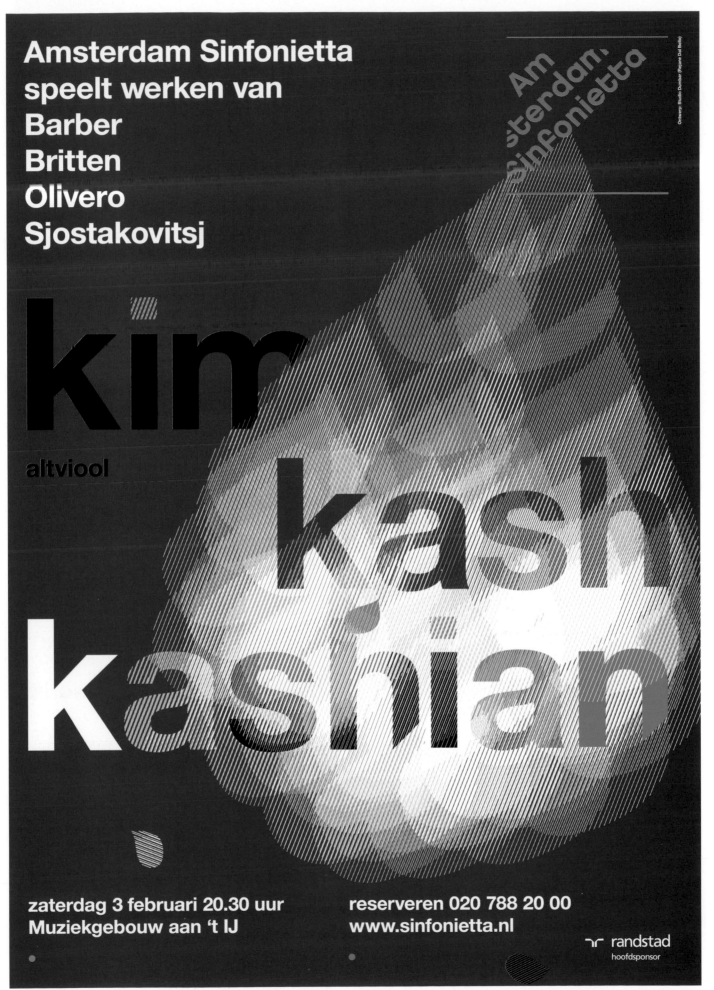

The Grafiosi

> *DJ Frankie* > poster > Ministry of Sound

> *Elite Force* > poster > Ministry of Sound

A-4 Anand Niketan
New Delhi 110021
India
+91 11 460 16595
pushkarthakur@thegrafiosi.com
www.thegrafiosi.com

> Precociously initiated into the world of computers and art, Pushkar Thakur's education was aimed at the start towards software engineering only to end up with a passionate dedication to art and graphic design. Pushkar created The Grafiosi (2004), now a design studio that provides aesthetically rich and competent solutions. His art continues to develop with time and has been shown at select exhibitions in New Delhi and other countries. Digital art as an expressive media is still a new concept in India and contemporary language develops in such a way that the rate of commercial progress is slow. His work has started to become known and currently he is on the way to creating a new mark in this medium of expression. Far from the mundane, his artistic works reach deeply into the imagination, emotions and thought through such varied interests as art, photography, technology, literature, music and voyages.

The
Kri foundation
and Kat Katha present
15 minute
fringe festival
curated by the
youth Parliament

featuring
Imagination. challenges. Progressive minds. creativity. expression
theatre. film. dance. Stand up comedy. music. visual art. martial arts

your art. unleashed.

date. december 26 & 27. 2008
time. 7.00pm
venue. amaltas hall India habitat centre, lodhi road

free entry

For more information, contact 98181 31566 / yp.silhouette@gmail.com

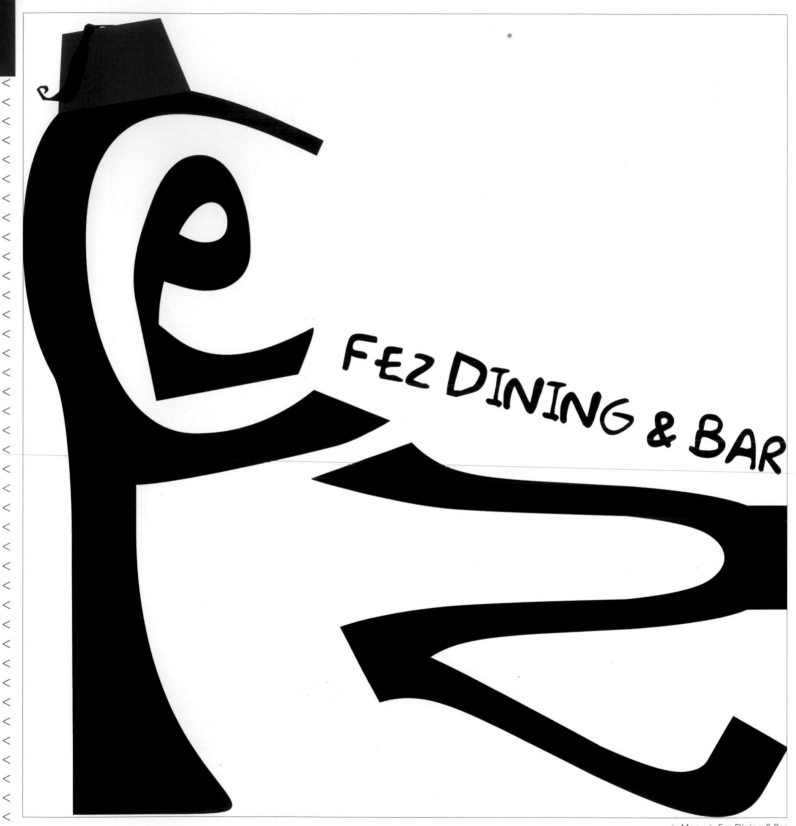

FEZ DINING & BAR

Peroni	275
Tiger	275
Corona	275
Heineken	275
Asahi	275
Carlsberg Pint	130
Fosters Pint	115
Kingfisher 650 ml	165
Fosters 650 ml	165
Castle 650 ml	165
Draught Mug	100

HAPPY HOURS 4 - 8 PM

CLEANSERS
(NON ALCOHOLIC BEVERAGES)

Fresh Lime (Sweet/ Salted/ Mix)	80
Cold Coffee	100
Ice Tea (Lemon/ Peach)	100
Blaster (Cold Coffee with Hershey's Chocolate Sauce)	100
Raspberry Lemonade (Raspberry, Lime, Sugar topped with Soda)	100
Cranberry Cooler (Cranberry, Grape Juice, Lime)	120
Lychee Sling (Lychee, Orange, Pineapple, Grape Juice, Lime)	120
Elrado (Guava, Orange, Mix Fruit Juice, Soda)	120
Juicy Julep (Pineapple, Orange, Lime, Mint, Raspberry Flavor topped with Ginger ale)	120
Fruit Punch (Assorted Juices, Ice Cream, Strawberry Flavor)	120
Virgin Mojito (Lemon Chunks, Brown Sugar, Mint topped with Soda)	120

HAPPY HOURS 4 - 8 PM

THE URBAN BAR

N 4, N Block Market . G.K. 1 . New Delhi 48
www.urbanpind.com

EXTENDED HAPPY HOURS TILL MIDNIGHT
INCLUDES ALL IMFL + DOMESTIC BEER

+ FREE SALSA CLASSES FROM 9PM ONWARDS

Reservations: +91 9818805909 . +91 11 32514646 / 5656 . urbanpind@gmail.com
All house rules apply . right of admission reserved

The Grafiosi

Thonik

centraal museum

> Logo > Centraal Museum, Utrecht

Weesperzijde 79d
1091 EJ Amsterdam
The Netherlands
+31 20 468 3525
studio@thonik.nl
www.thonik.nl

> Nikki Gonnissen and Thomas Widdershoven started out as Studio Gonnissen and Widdershoven in 1993. Afterwards, in 2000, they changed the studio's name to Thonik, a combination of the owner's names. Presently, Thonik boasts a team of 10 designers apart from the two founders. This design studio practices graphic design (corporate design, book design, etc.) and develops communication concepts for advertising campaigns. Thonik offers a clear style with a heavily conceptual focus. Aside from designers, Nikki Gonnissen and Thomas Widdershoven are also active professors. At the same time, they are part of committees at Fonds BKVB and the Mondriaan Foundation. Thonik generally works with cultural and collective institutes. Some of their clients are: the Amsterdam School of Arts, De Balie, Centraal Museum of Utrecht, *Jong Holland*, Boijmans Van Beuningen Museum, Gouda Museum, Tropen Museum, and Sonsbeek.

I really love this place

24 maart 2001 - 29 juli 2001

centraal museum

> Logo > Centraal Museum, Utrecht

centraal museum krant

C C **GRATIS**
C
C C **Nr 3** najaar 99

centraal Nicolaaskerkhof 10
museum 3512 XC Utrecht

Open, open open open open, open!

**Open, open open! Open! Open!
open, open, open! Open open, o-
pen open! Open! open! Open o-
pen open open, open! Open! open
open! Open!!!**
Open open open open. Open, open. Open
open open! Open! Open! open, open, o-
pen! Open open open open! Open, open!
Open! Open! open, open, open open.

Open! Open! open, open, open open.
Open! Open, open open! Open! Open!
open, open, open! Open open, open.O-
pen! Open open open open, open! Open!
open! Open!
Open! Open, open, open. Open open
open open! Open, open! Open open, o-
pen open! Open, open! Open open, open!
Open! Open open open open, open! O-

pen. Open! Open! Open, open, open! O-
pen. Open. Open, open, open!

Open! Open! Open!
Open! open! open, open! Open. Open
open open, open! open, open! Open! O-
pen open! open open! Open, open! Open!
Open open open open! Open, open! open!
Open! Open! open, open, open open o-

pen! Open, open open. Open! Open!
open, Open open open open! Open, open!
Open! Open! Open! open, open, open
open.Open, open open! open open! Open,
open! Open Open open open open! Open,
open! Open!!!
Open! Open open open! Open. Open. O-
pen open! Open open open! Open! Open!
open, open! Open open,open!

> *Open* > poster > Centraal Museum, Utrecht

Centraal Museum, Utrecht
7 november 2004 → 10 april 2005

C C C
C C C
centraal
museum

Vikingen!

Vikingen! is een samenwerkingsproject van: Centraal Museum - Utrecht /
Rheinisches-Landes Museum - Bonn / Rheinische Friedrich-Wilhelms-Universität - Bonn /
Vikingschepenmuseum (Vikingeskibsmuseet) - Roskilde

met dank aan
HGIS-Cultuurprogramma
Provincie Utrecht

provincie :: Utrecht

> *Vikingen!* > poster > Centraal Museum, Utrecht

BIJZON
DERE
BEGUN
STIGERS

museum van
boijmans beuningen

 *Begunstigers* > poster > Boijmans Van Beuningen Museum

Programm
22. Januar – 5. März 2006
Asta Gröting, The Inner Voice
Letizia Battaglia, Passione Giustizia Libertà
(Gedenkschrift Gerechtigkeit Freiheit)

Marta Herford
Museum Zentrum Forum

MARTA Herford
Goebenstr. 4 - 10
32052 Herford
Fon + 49 (0) 5221 99 44 30 0
Fax + 49 (0) 5221 99 44 30 23
info@marta-herford.de
www.marta-herford.de

Workshops und Führungen,
individuelle Buchungen,
Kindergeburtstage und
Anmeldungen
Fon + 49 (0) 5221 99 44 30 15
bildung@marta-herford.de

Öffnungszeiten Ausstellung:
Dienstag bis Sonntag und an
Feiertagen 11-18 Uhr
Am ersten Mittwoch im Monat (1.2.2006, 1.3.2006)
sowie am Samstag, den 11.2.2006, jeweils 11-21 Uhr
Montag geschlossen

Eintrittspreise
Eintritt: 6,- € (ermäßigt 3,- €
Kinder bis 10 Jahre frei)
Jahreskarte: 30,- € (ermäßigt 15,- €)
Familienticket: 12,- €
Veranstaltungspreise entnehmen
Sie bitte den jeweiligen Angaben.
Kartenvorverkauf an der
Museumskasse.

In der Zeit vom 9.-21. Januar ist das Museum wegen
Ausstellungsumbau eingeschränkt geöffnet; die Galerien
sind nicht jederzeit begehbar. Der Eintritt ist frei.
Architekturführungen werden auch in diesem Zeitraum
angeboten.

MARTA Café Restaurant
Fon + 49 (0) 5221 12 23 11

> *Marta Herford* > poster > Zentrum Forum Museum

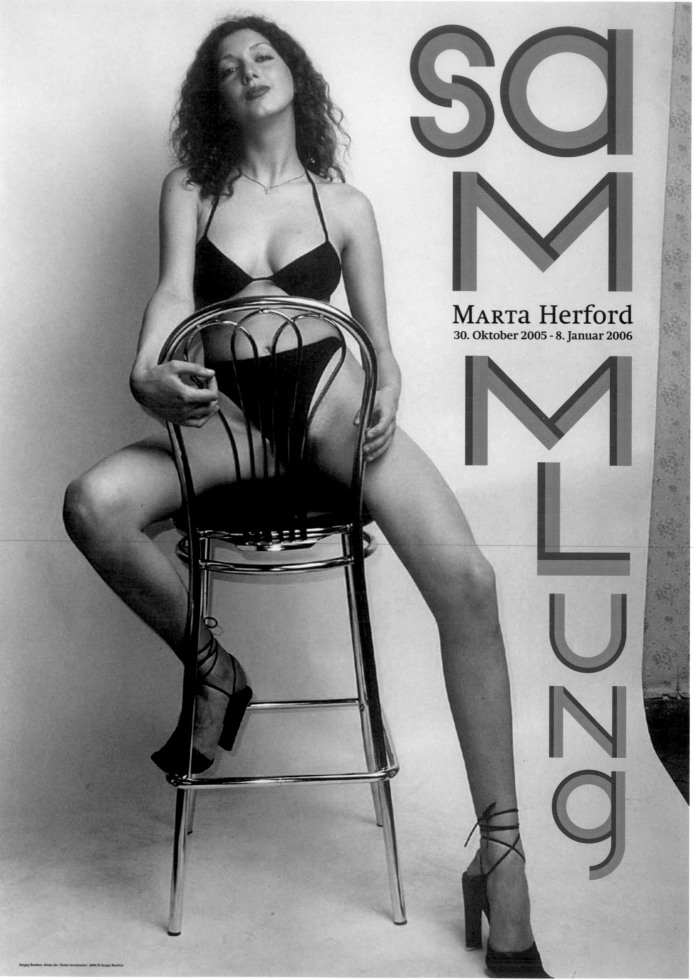

sa
M
M
luNg

Marta Herford
30. Oktober 2005 - 8. Januar 2006

Sergey Bratkov, From the 'Series Secretaries', 2000 © Sergey Bratkov

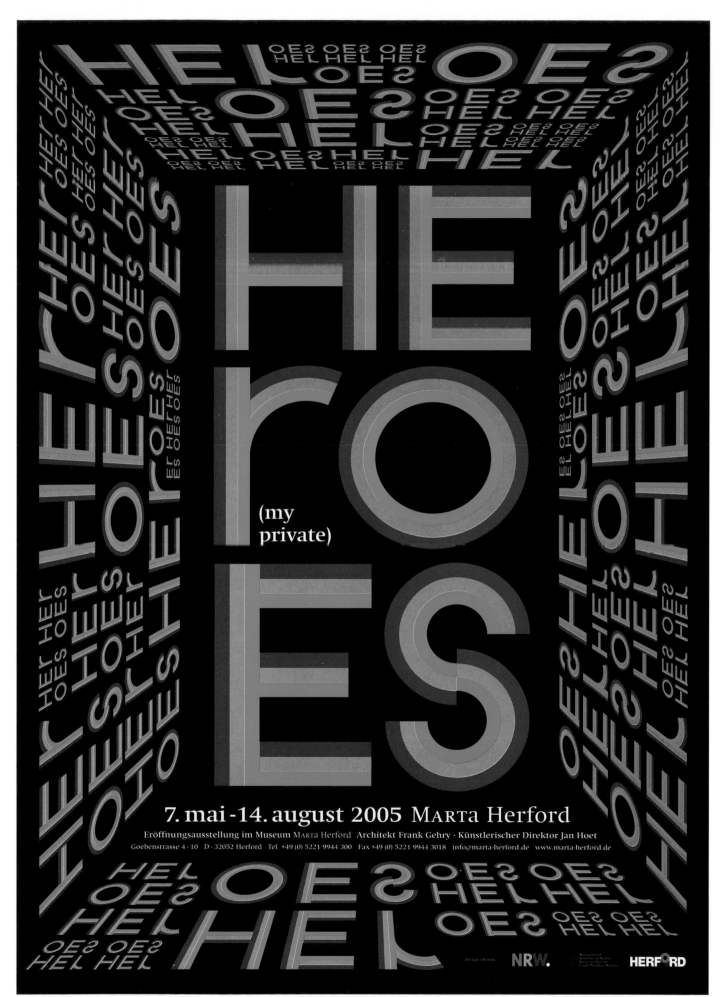

> *Heroes* > poster > Marta Herford

Tommy Li Design
Workshop Limited

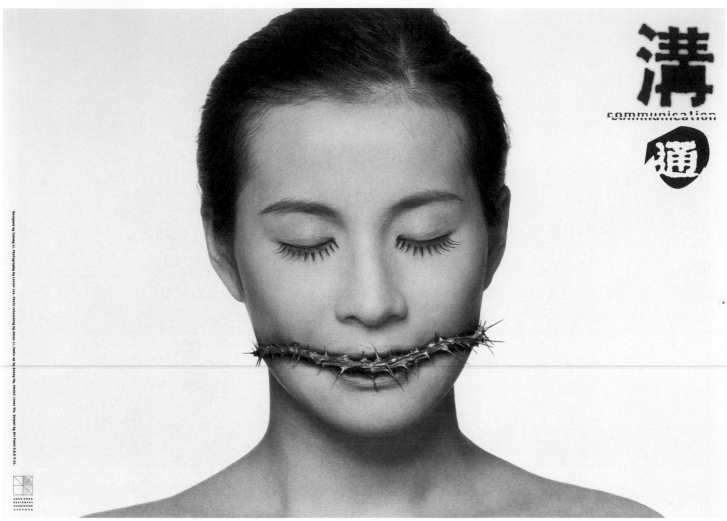

> *Communication* > poster > Hong Kong Designers Association

Rm 2401
Honour Industrial Centre
6 Sun Yip Street
Chai Wan
Hong Kong
+852 2834 6312
info@tommylidesign.com
www.tommylidesign.com

> A master of design among today's generation, Tommy Li is known for his dark humor and visually daring designs. Straddling the wide area between Hong Kong, China, Macau and Japan, he is one of the few designers to penetrate the international market. His most distinctive achievement till now has been to receive four awards from the Art Directors Club of New York. Tommy was also presented with The Overall Best Graphic Design Award from the Chartered Society of Designers in Hong Kong for three years in a row (1994, 1995 and 1996), in addition to receiving the Artist of the Year Award in 1997. Tommy Li is the only Chinese designer to be invited by the Japanese government to participate in the design for the Kaido city emblem. In addition, one of Japan's top-selling magazines, *Agosto*, cited Tommy as the only graphic designer with the potential to provoke a huge influential impact in Hong Kong over the next decade.

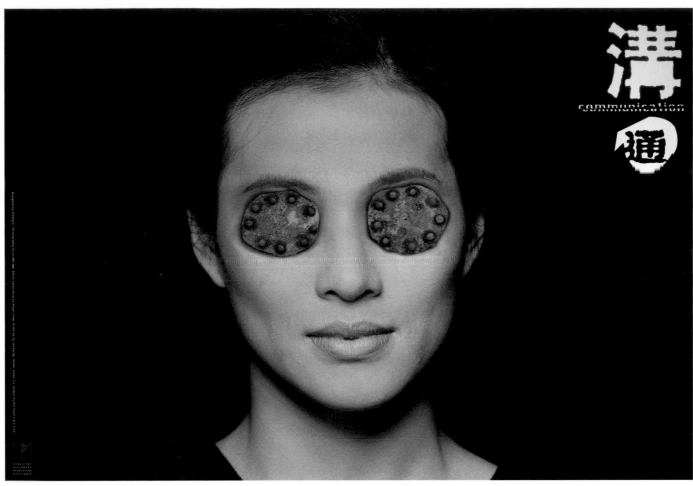

> *Communication* > poster > Hong Kong Designers Association

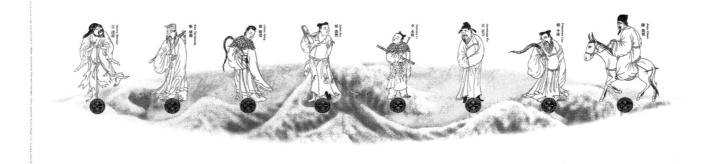

> *Eight Graphic Designers from Hong Kong* > poster > GGG Gallery, Tokyo

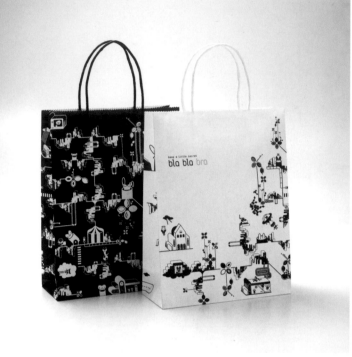

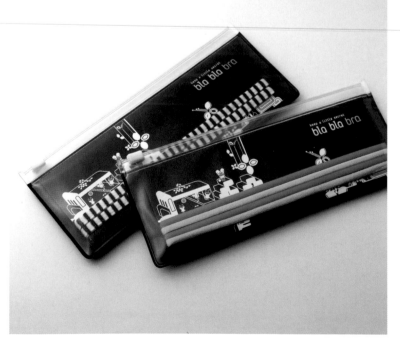

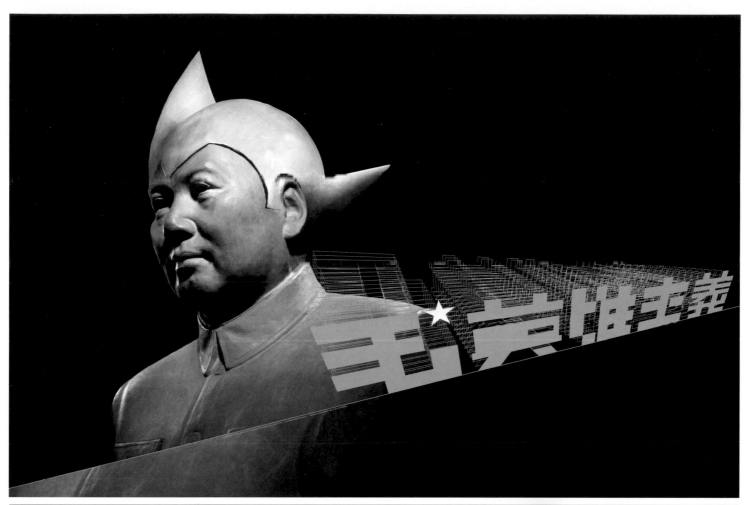

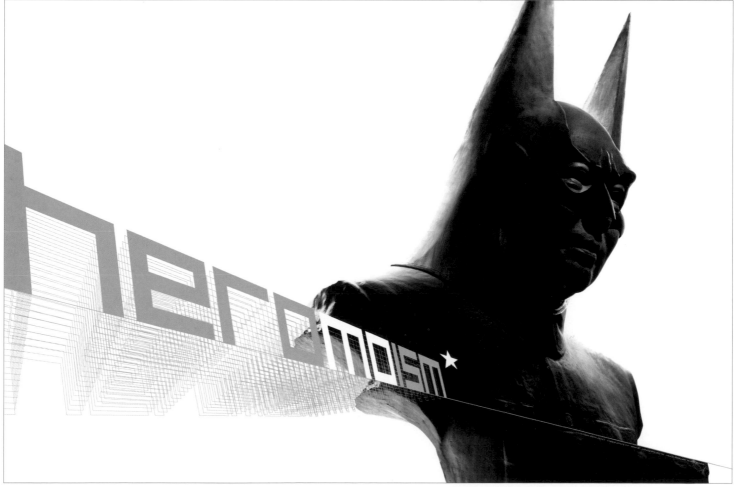

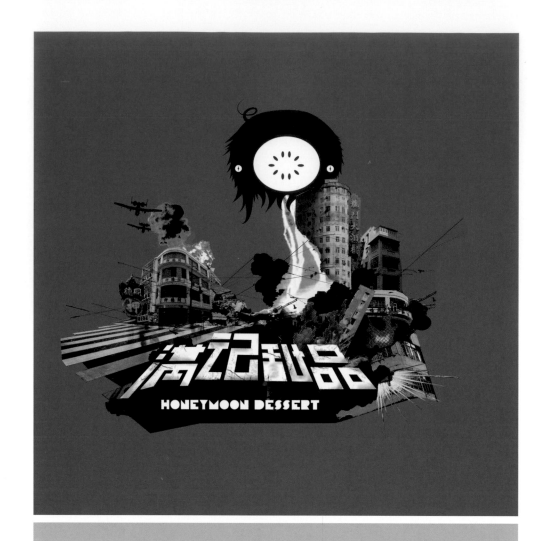

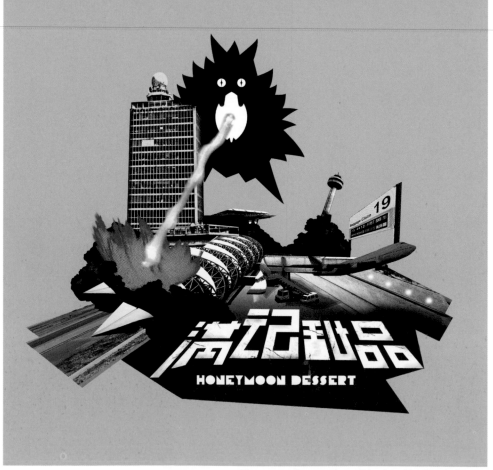

> *Honeymoon Dessert* > brand identity > Handmade Dessert

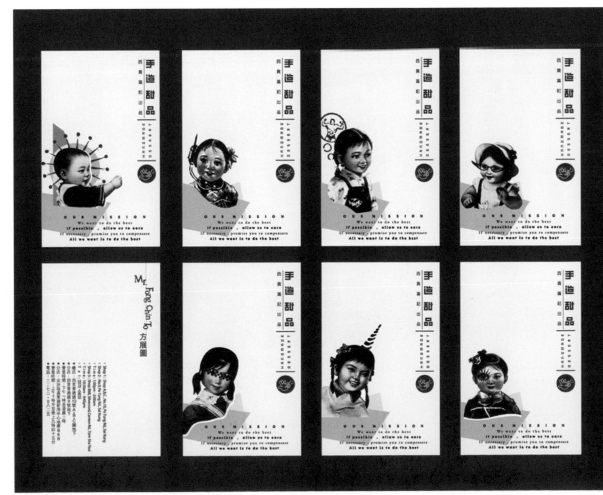

> *Handmade Shopcard* > cards > Handmade Dessert

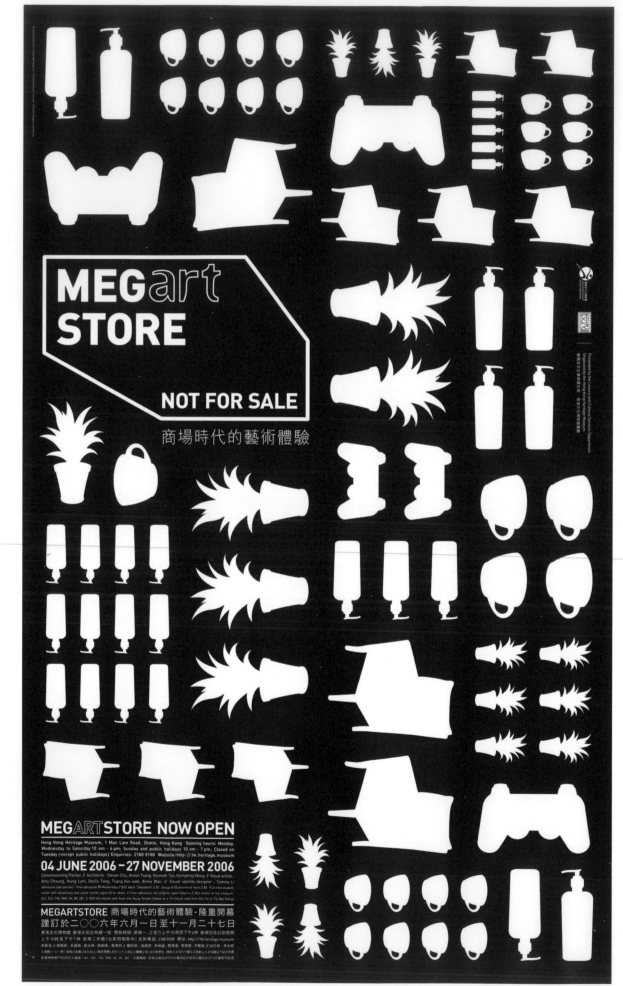

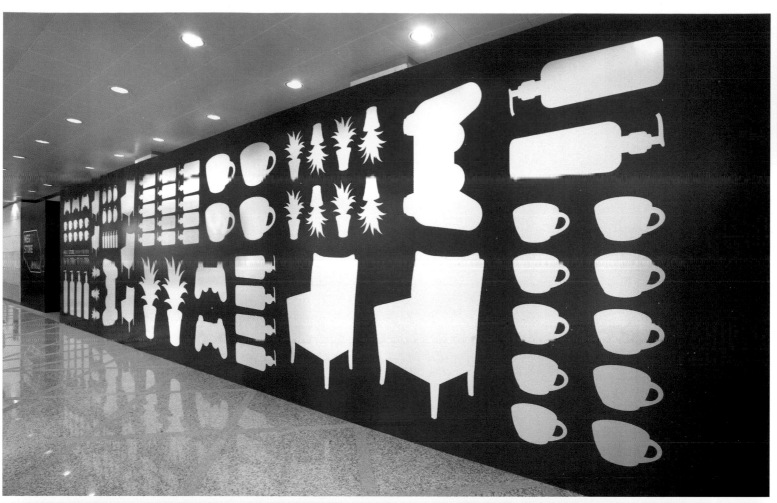

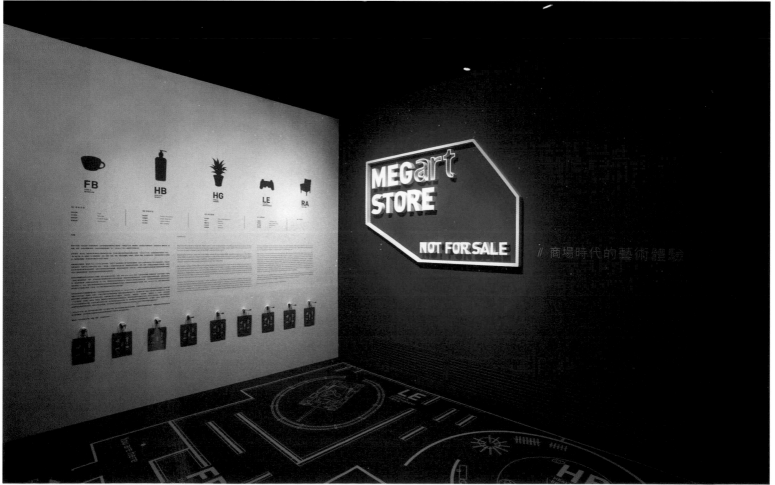

Uwe Loesch

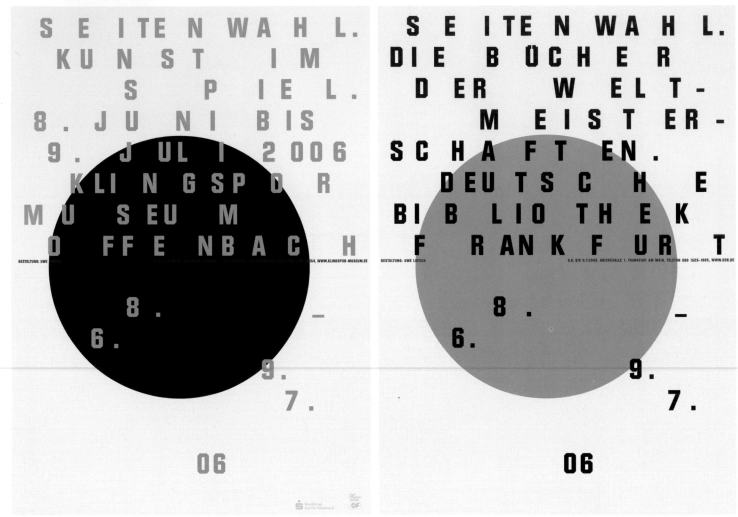

> *The Books of the World Cups* > poster > Klingspor Museum > *The Books of the World Cups* > poster > German National Library, Frankfurt

Mettmanner Strasse 25
40699 Erkrath
Germany
+49 211 55 848
contact@uweloesch.de
www.uweloesch.de

> Professor of communication design at the University of Wuppertal (Germany), Uwe Loesch is one of the most important international designers in the world of contemporary poster design. He is a member of the International Graphic Alliance, the Type Directors Club of New York and the Art Directors Club of Germany. He has received numerous international awards, among them the 2004 Red Dot Award. As a member of the jury, Uwe has been a part of various international contests and in 2004 was named president of the Ningbo International Poster Biennial in China. His work has been internationally recognized, especially in the fields of poster design, corporate design and corporative culture. His posters inspire contemplation and, without using decorative graphics of commercial character, encourage communication. His minimalist posters have been shown in over 30 exhibits throughout the world.

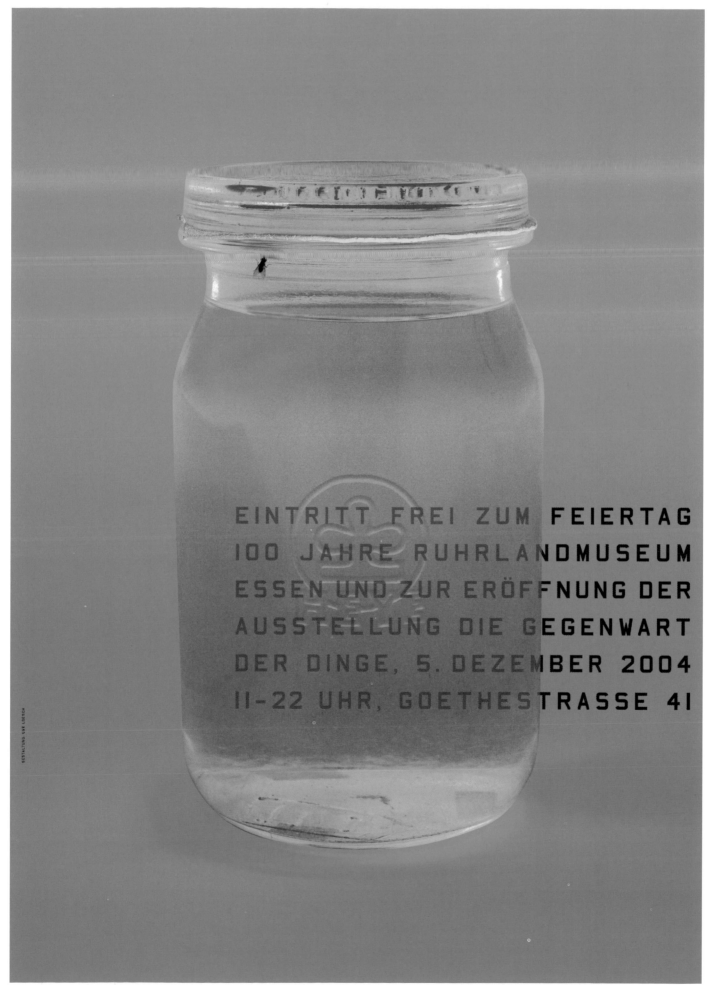

EINTRITT FREI ZUM FEIERTAG
100 JAHRE RUHRLANDMUSEUM
ESSEN UND ZUR ERÖFFNUNG DER
AUSSTELLUNG DIE GEGENWART
DER DINGE, 5. DEZEMBER 2004
11-22 UHR, GOETHESTRASSE 41

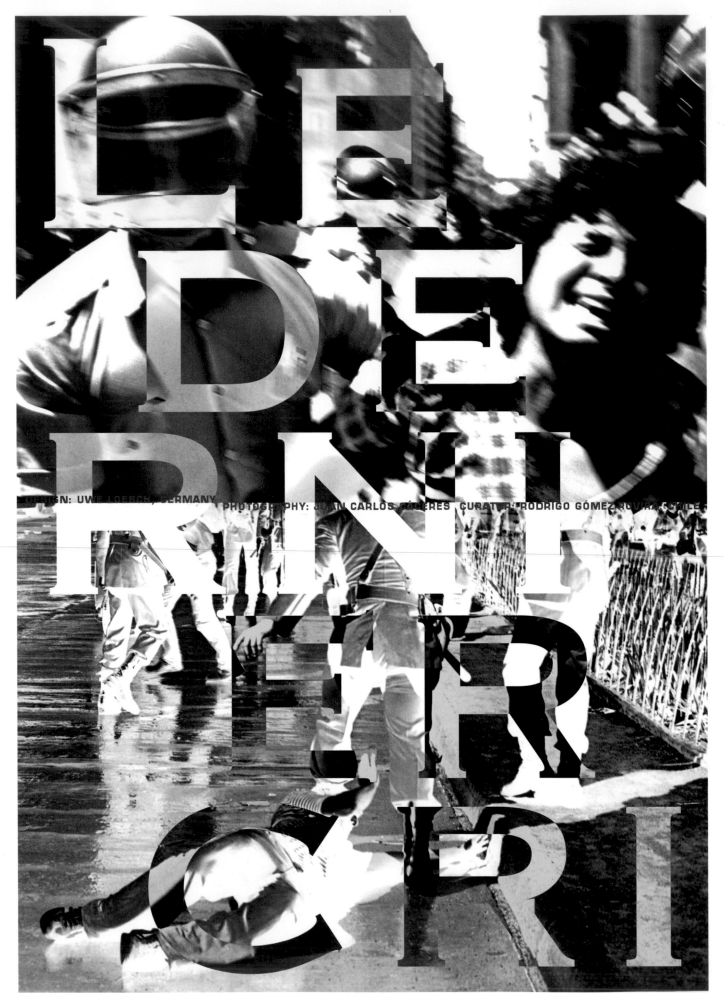

DESIGN: UWE LOESCH, GERMANY PHOTOGRAPHY: JUAN CARLOS CÁCERES CURATOR: RODRIGO GÓMEZ ROVIRA, CHILE

> *Le dernier cri* > poster > Anatome Gallery

31. März bis 28. Mai 2006 Klingspor Museum Offenbach

Gestaltung: Uwe Loesch

Im KulturKarree der Stadt Offenbach, Herrnstrasse 80, Telefon 069 8065-2164 und -2954, www.klingspor-museum.de

Sparkasse.
Gut für Offenbach.

OF

anja harms

kunst der buchkunst

7 april bis 28 mai 2006

klingspor museum offenbach

Klingspor Museum Offenbach im KulturKarree der Stadt Offenbach. Herrnstrasse 80. www.klingspor-museum.de

> *Anja Harms-Art of Book Art* > poster > Klingspor Museum

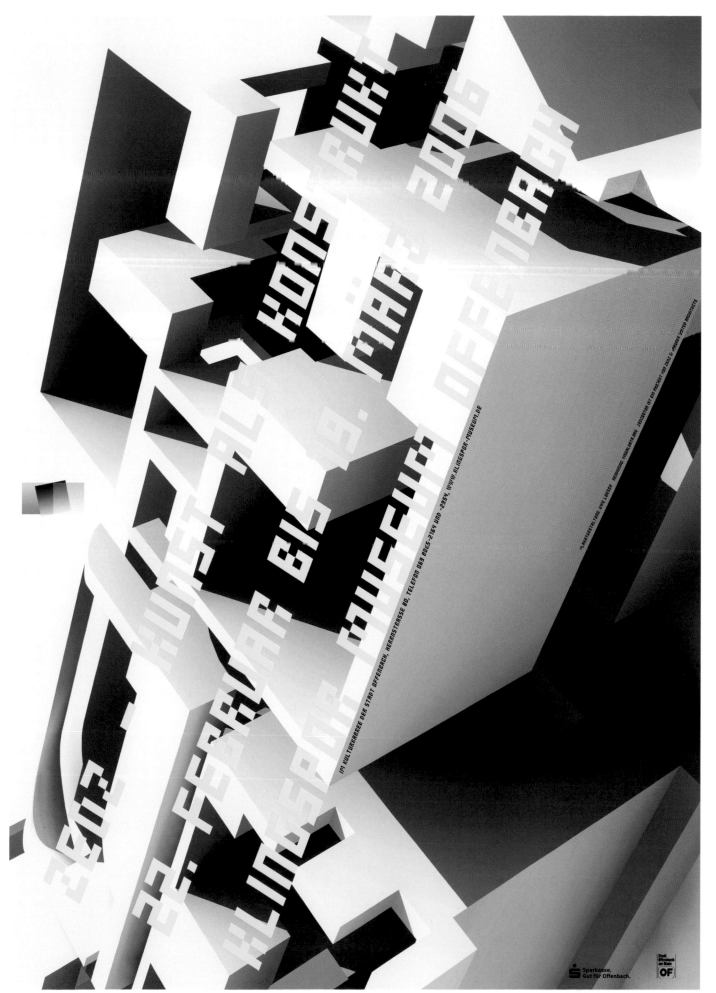

Reclam
– Kunst
der
Verbrei
tung.
Samm
lung
Georg
Ewald
22.
Februar
bis
2. April
2006
Kling
spor
Muse
um
Offen
bach
.

Gestaltung: Uwe Loesch

Im Kulturkarree der Stadt Offenbach, Herrnstrasse 80, Telefon 069 8065–2164 und –2954, www.klingspor-museum.de

Umbruch —
Kunst der
schönen Schrift.
Gebr. Klingspor,
Rudolf Koch,
Alfred Finsterer

Im KulturKarree der Stadt Offenbach, Herrnstrasse 80, Telefon 069 8065-2164 und -2954, www.klingspor-museum.de

Juli bis
25. September 2006
Klingspor Museum
Offenbach

Gestaltung Uwe Loesch

Berthold

FALLEN HALOS
RAYAH REDLICH
24.6. – 5.9.04
MUSEUM FÜR ANGEWANDTE KUNST FRANKFURT AM MAIN

MUSEUM

FÜR ANGEWANDTE KUNST

FRANKFURT

SCHAUMAINKAI 17

60594 FRANKFURT AM MAIN

DIENSTAG BIS

SONNTAG 10-17 UHR

MITTWOCH 10-21 UHR

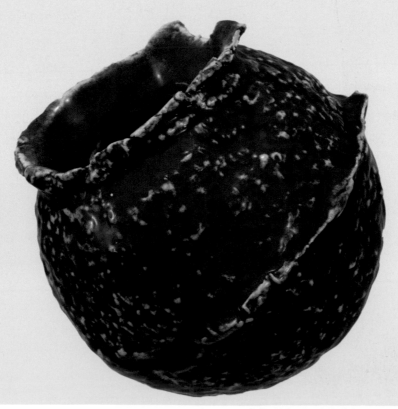

STADT FRANKFURT AM MAIN

> *Fallen Halos, Rayah Redlich* > poster > Museum of Applied Arts, Frankfurt